Album of the Damned

Album of the Damned

Snapshots from the Third Reich

Paul Garson

Academy Chicago Publishers

This book is dedicated to the life and work of Simon Wiesenthal

*The publication of this book was made possible
in part by the generosity of Joseph Wolfberg.*

Published in 2008 by
Academy Chicago Publishers
363 West Erie Street
Chicago, Illinois 60654

Library of Congress Cataloging-in-Publication Data on file with the publisher

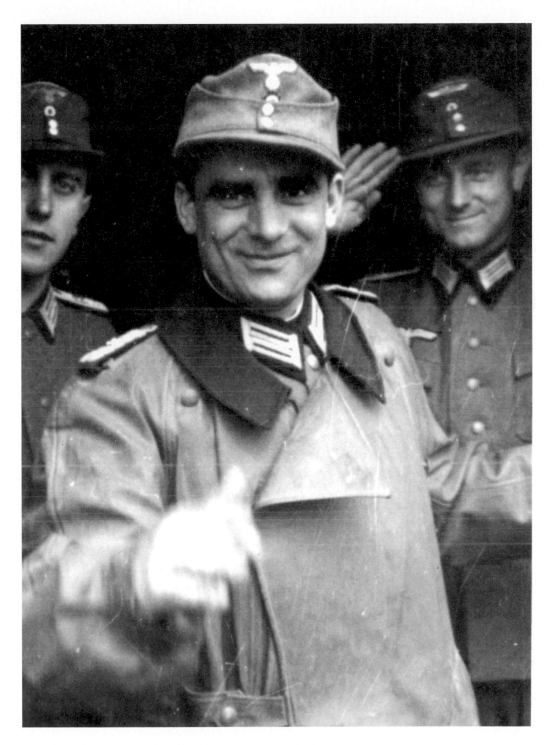

Welcome to the Third Reich

"Explaining is not excusing; understanding is not forgiving. Not trying to understand the perpetrators in human terms would make impossible not only this study but any history of Holocaust perpetrators that sought to go beyond the caricature."
— Christopher R. Browning,
Ordinary Men: Reserve Battalion 101 and the Final Solution in Poland

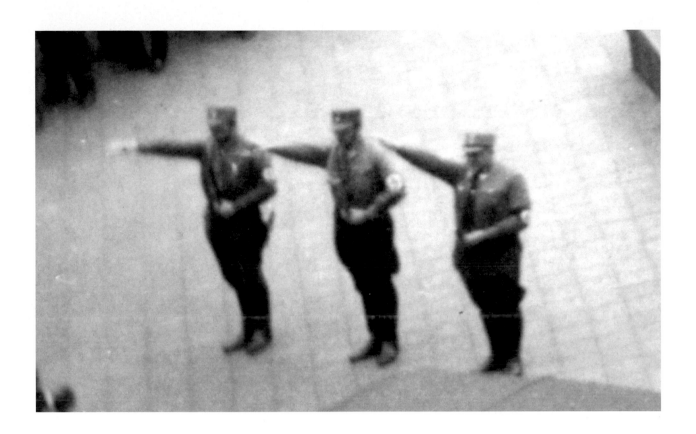

Timeline: The Third Reich 1933–1945

1933 Adolf Hitler becomes Chancellor of Germany—Nazi Party assumes control—dictatorship begins; Dachau concentration camp opens

1934 SA leadership liquidated

1935 First series of Nuremberg Laws enacted depriving Jews of citizenship rights

1936 Rhineland reoccupied by Germany; Italy, Germany and Japan sign treaties

1937 Buchenwald concentration camp opens

1938 Germany annexes Austria; Jews now totally excluded from public life; November 9 "Kristall-nacht"—Jewish synagogues, businesses, hospitals, cemeteries and homes attacked across Germany

1939 In Reichstag speech, Hitler predicts the extinction of Jews if Germany forced into war; euthanasia programs against handicapped and retarded Germans; on September 1, Germany invades Poland and WWII begins with France and Great Britain declaring war on Germany soon after; mass murders begin in Poland against Polish leadership, priests and intelligentsia as well as Jews; Germany and Italy sign the "Pact of Steel," May, 1939.

1940 Germany invades and conquers Denmark, Norway, France, Belgium, Netherlands; Polish Jews locked in ghettos awaiting Final Solution; Japan joins the Axis; Germany, Italy and Japan sign the Tripartite Pact. The first experiments with Zyklon B occur in the Buchenwald concentration camps—250 Gypsy children from Brno were the test subjects.

1941 Germany invades USSR on June 22; mass shootings commence of Jews, gypsies, Communist political leaders; largest mass shooting takes place in Kiev in September with over 30,000 Jewish men, women and children shot in two days. First experiments with Zyklon B on Russian POWs at Auschwitz. Gas vans used to kill Jews at Chelmno death camp.

1942 Wannsee Conference delineates plan for Final Solution; main extermination camps of Auschwitz, Majdanek, Chelmno joined by Sobibor, Belzec, Treblinka.

1943 Jews revolt in Warsaw Ghetto. Ghetto is destroyed by SS. Death camps work overtime. Russians turn tide against German invaders at Stalingrad.

1944 American and British forces successfully attack German-held Europe on June 6 — "D-Day." Red Army continues advances against German military. Loss of war by Germany is apparent. Germans make special effort to annihilate last large population of Jews, those in Hungary. Soviets liberate many death camps.

1945 Allied forces reach Germany; Nazis refuse to surrender; Jews sent on death march as camps are threatened with liberation; Hitler commits suicide in April; Germany surrenders. War in Europe officially ends on May 8th.

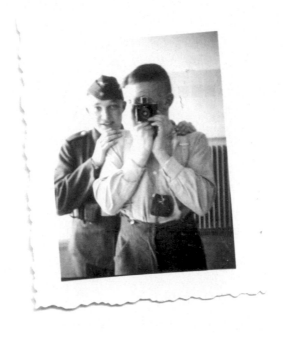

Contents

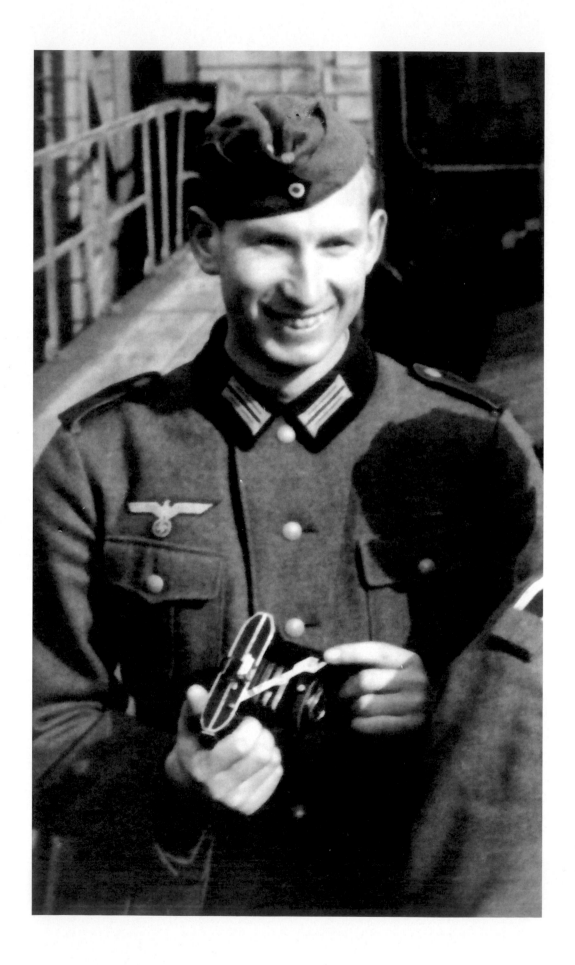

Introduction

The Cameras and Cameramen

The photos seen here were for the most part taken by German soldiers and some civilians, a few by professionals "embedded" with the troops, but for most part amateurs taking snapshots for friends and family. The cameras used were often 35mm, produced by Leica, Agfa and Contax, featuring advanced design and excellent optics, lenses that often saw all too clearly. Most of the photos, when originally printed, measured only 3.5 x 2.5 inches, some smaller, some larger, some even turned into personal postcards. Many were kept in albums when soldiers brought them home after the war, and, later, relatives offered them for sale. Other images were captured by the Soviets and after the fall of the USSR became available on the open market via the medium of the internet, which itself made the compilation of these photos possible.

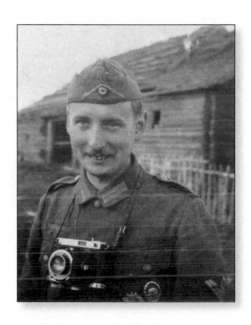

A Tale Told in Black and White

Viewing WWII photographs in black and white is problematic. On the one hand it seems to best capture the intensity of the life and death struggle and to symbolize that clear distinction between our concepts of Good and Evil. Black and white imagery, however, also draws the blood out of the photos, leaving us with images apparently from another world, one devoid of color. Not our world. Their world. As if there were no connection. Then again, when looking at rare color images or colorized photographs, they don't seem quite "right." How could vivid, brilliant color exist in such Stygian darkness?

Point of Origin

Acquired from Argentina, Australia, Austria, Belgium, Canada, Estonia, Germany, Holland, Israel, Italy, Latvia, Lithuania, Norway, Poland, the Ukraine and the U.S., these unique images, selected for their composition and subject matter as well as their historic merit, do not, for the most part, depict overt bloodshed and destruction. Yet lurking just below the black and white surface, something unsettling reaches out, a muted echo of the madness that gripped an entire nation

and unleashed a level of barbarism upon the world that was, and in great part remains, literally unimaginable. With these photos we look into that surreal world and into the very faces of average men and women, often smiling faces, and ask, how was it possible? How was it possible for such ordinary people to commit such extraordinary crimes?

Time stands still in these images. Each photo is accompanied by text that provides some historical background as well as analysis of the image that, I hope, offers some insight into a phenomenon that is essentially unfathomable.

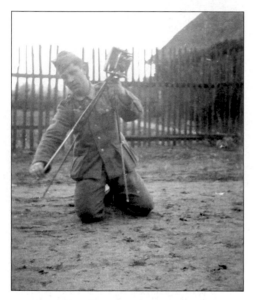

How It All Began

Over the course of some twenty-five years of writing for magazines, I have published hundreds of general interest feature articles as well as hundreds of my own photographs. This book project began with someone else's photograph, a grinning group of German police sitting on their motorcycles, an original WWII era image I had chanced upon and bought it to help illustrate a story on German motorcycles for one of the magazines for which I write. I had no intention of writing anything more than the one story. I was not an historian or a "specialist" on the subject of the war. But the images I discovered grabbed me and wouldn't let go. I wanted to know more. I wanted to see more.

I was hooked or, according to my friends and family, obsessed, and eventually purchased hundreds of photos, including entire German soldiers' photo albums, documents, personal letters and even dozens of hours of original German WWII newsreels, and regularly visited the Simon Wiesenthal Center Museum of Tolerance. I began buying and reading books concerning the era, many out of print, and eventually had some 200 volumes (a miniscule fraction of the books on the subject) dealing with all levels of the German military and in particular the War in the East . . . the Ost.

I realized there was another war that we in the West barely understand, a war of annihilation so intense in its hatred and perversity that it eventually turned upon itself, devouring almost an entire generation of Germans as well as the victims of its aggression. This is the war from their side of the camera, "snapshots" taken mostly by German soldiers as souvenirs or to send home to family and friends. As a result, they comprise a unique, personal and fundamentally disturbing record that is at turns bizarre, compassionate, chilling, malevolently humorous and as twisted as the Swastika.

As a professional photographer myself, I sought out the individual images that spoke to me on various levels, mind, spirit and gut, as it were, involving both an objective and subjective process. I felt compelled to show them to others, to attempt to shed some light on that great darkness. Often I found only more darkness. But the photos themselves were, in many senses, an illumination. Through them we can see what the German soldiers saw, where they pointed their cameras . . . and then ask ourselves why, why this subject, this moment?

Disclaimer

The nearly 400 photographs seen here comprise perhaps a few minutes of human history, the cumulative time it took the various camera shutters to snap and capture the images—but a brief glimpse into the Third Reich that lasted twelve agonizing years.

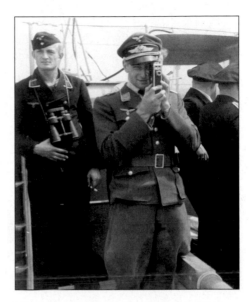

Just as the photos cannot take in the entire scope of the Nazi regime and the war it wreaked upon the world, the accompanying text makes no claims at covering the subject matter in any complete manner. Entire libraries have been devoted to each of the myriad elements briefly touched upon here. I chose the photos that "spoke" to me and let them lead me where they would. The images and the words, I hoped, would encourage the reader to conduct his or her own research down the almost infinite paths to which they lead and thereby add some measure of understanding to an era in history when human civilization shook itself to its very foundations and where justice was abrogated by ordinary individuals capable of extraordinary evil.

Finally, a note about the organization of the photographs. Rather than a strict chronological arrangement, I chose to place them within groups of interest, for example, Religion, Anomalies, Family, etc. While a relatively small number of the pictures therefore appear out of sequence, I felt that the overall impact of the whole was greater by choosing the latter method.

Acknowledgments

This book would not have been possible without the monumental effort of the journalists, historians, writers and survivors whose work I called upon to caption the photos I had collected. Their listing in this book's bibliography contains an invaluable resource for those who would pursue a further study of the subject. As for any errors found within this book, they would be mine alone.

I would like to thank Janette Goldberg from the Los Angeles Museum of Tolerance/Simon Wiesenthal Center bookstore for her continued encouragement of this project and Nancy Hartman at the United States Holocaust Memorial Museum for help in identifying certain photos. I thank Rheba Massey of the Fort Collins, Colorado Public Library Oral History Archive for the transcripts of her interviews with American soldiers. I thank the Ludwig Volgelstein Foundation for the grant that enabled me to purchase several of the photographs seen in this book and Gary Williams for his contributions that enable me to continue my research. Special thanks to Gerhard L. Weinberg for his help in editing the text.

And to Anita and Jordan Miller and the staff of Academy Chicago Publishers, including Sarah Olson and Jacob Schroeder, who took on this opus, my deep appreciation for their sincerity, compassion and understanding of what I was attempting to do and for their personal and professional attention to its production.

Paul Garson
Los Angeles
August 2008

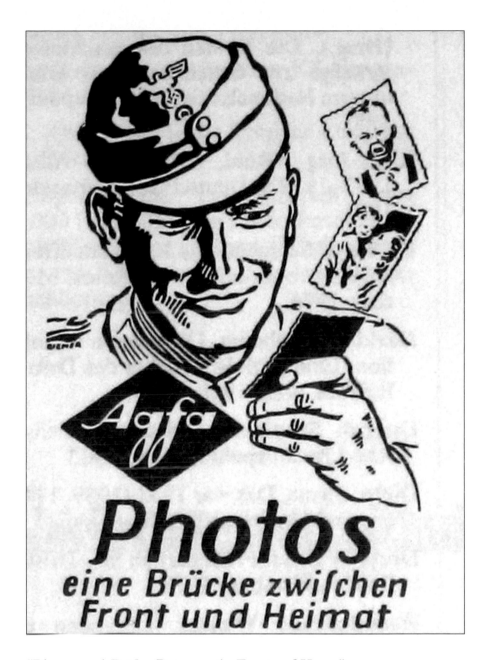

"Photos — A Bridge Between the Front and Home"

The words in this ad for Agfa film products appeared in WWII-era German newspapers and magazines. They also echo the intent of this book: to be a bridge between the past and the present.

The photographs seen here were taken by anonymous photographers wearing the various uniforms of the Third Reich. Just as the names of the individuals behind the cameras are lost to history, the subjects also remain unidentified. These images, and the indelible effects of the War, will never fade away.

In the Beginning

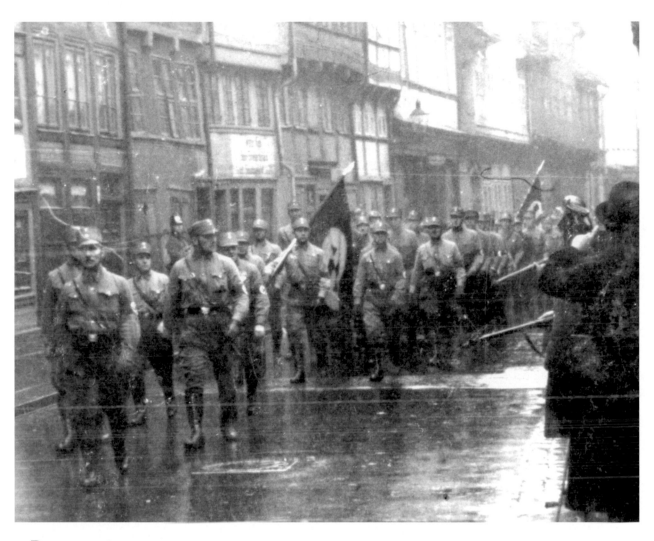

Demonstration

A rare image from the streets of Munich circa 1925, as "Brownshirts," members of the fledgling Nazi Party, parade through the rain-wet streets. On the right, rifles are held by the Weimar Republic's army, the *Reichswehr*, as they stand to the side while the demonstrators pass. Another intrepid cameraman photographing the scene is himself caught by the camera.

The Nazi Party was not named the "Nazi Party" or "National Socialist German Workers Party" until 1920. It was called the "German Workers Pary" when it was founded in 1919 by Anton Drexler, Gottfried Feder, Dietrich Eckart and Karl Harrer. It had been banned by the Weimar government due to its inflammatory activities, but the ban was lifted in January, 1925. The SS was formed in March. Known as the Black Order, it consisted of only eight men, but would eventually reach over one million.

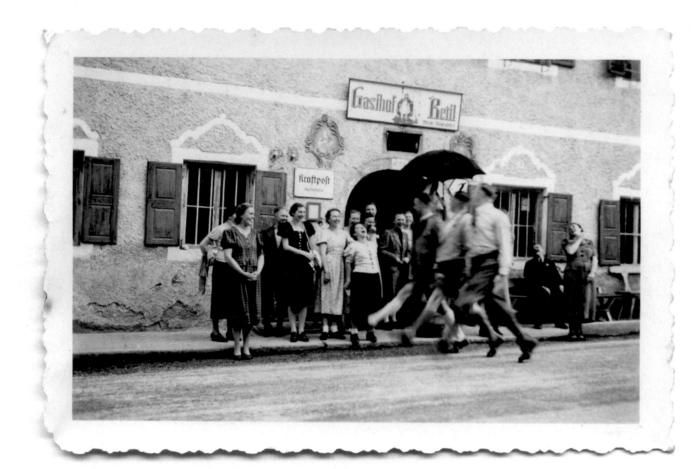

Goose Stepping at the Gasthof

A trio of German civilians, two dressed
in traditional lederhosen, performs an
apparently hilarious rendition of the
Nazi goosestep for the amusement
of patrons of a roadside guesthouse.
Apparently they don't mind being pho-
tographed, although the local Gestapo
might take interest in their anti-patriotic
antics.

The *Encyclopedia of German Resistance to the Nazi Movement* edited by Wolfgang Benz and Walter H. Peble, cites some 7,000 individuals they consider "resistors" within Germany, including Communists, Socialists, Jews, Christians, Jehovah's Witnesses, members of the military, women, young people and émigrés. There are also 550 biographies of those considered by the editors to be the main opponents of the Third Reich.

Prior to its ascent to power, the Nazi Party was recognized for what it was and what it portended by many German intellectuals, artists and journalists, although their warnings obviously went unheeded. In 1930, three years before Hitler took power, the poet Kurt Tucholosky wrote, "Germany, don't you see that the Nazi is braiding a funeral wreath for you?"

Another German poet, Heinrich Heine (1797–1856), wove some prophetic words as well. A century before the Third Reich, and in response to protests by workers over intolerable conditions, he wrote, "Doomed be the fatherland, false name, / Where nothing thrives but disgrace and shame, / Where flowers are crushed before they unfold, / Where the worm is quickened by rot and mold—We weave, we weave." He was even more prophetic when he wrote, "Where one burns books, one will, in the end, burn people." Although Heine had converted to Protestantism, the Nazi regime insisted that his still-popular works be marked "author unknown" in poetry collections published in the Greater Reich because of his Jewish background.

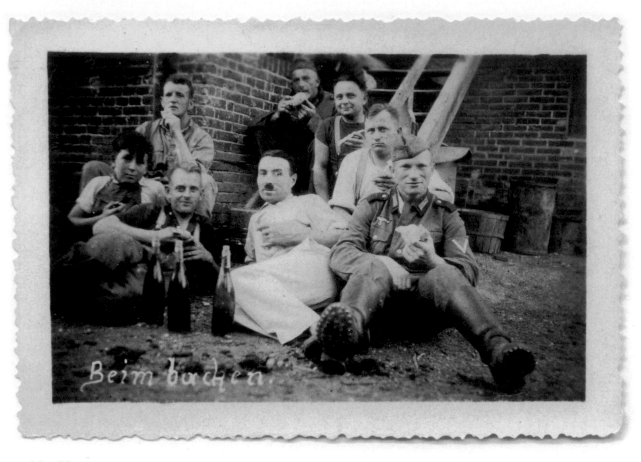

Beim backen.

Not Him

Civilians and soldiers share lunch together with a "lookalike" sporting a popular moustache of the day. The photo presents an eerie juxtaposition of benign smiling faces clustered around the Hitleresque man dressed all in white, surrounded by his apostles munching sandwiches.

Adolf Hitler, an Austrian by birth, granted German citizenship in February, 1932, assumed control of his "adopted" country in January, 1933 and immediately began the remaking of Germany within his personal "world view" or *Weltanschauung*. Every sector of society was affected, literally the warp and woof of the country's cultural fabric radically rewoven, although the underlying thread of endemic German anti-Semitism helped to create the background. From 1933 to September, 1939 when Hitler unleashed the dogs of war, Germany prospered, its economy revitalized as was the morale of its people long suffering from years of financial and political instability. In a scant six years Der Führer had enthralled a nation and indoctrinated them mind, body and spirit as the rightful masters of the world. Another six years would pass before Germany would be brought to ruin . . . mind, body and spirit . . . taking with it much of Europe.

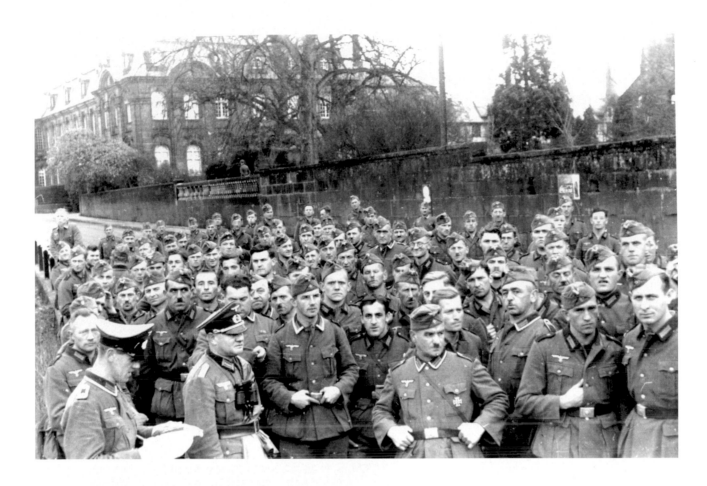

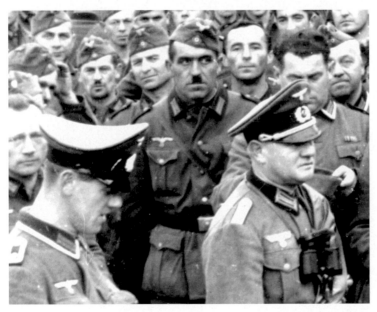

15 Adolfs

In this large group portrait of soldiers, several assume dramatic postures for the camera while at least fifteen sport a popular moustache.

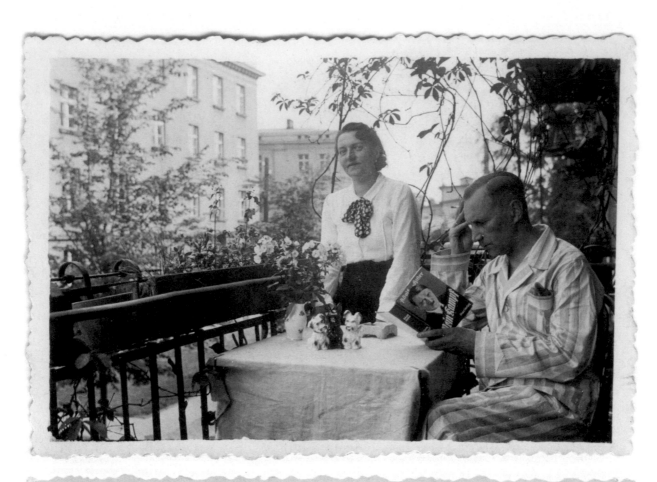

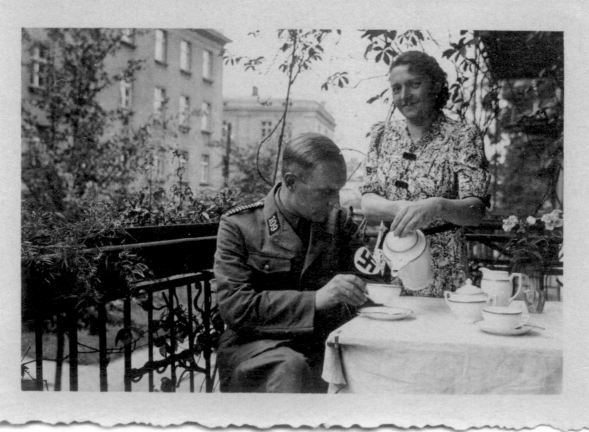

8

Required Reading

Top: Clad in pajamas, this man concentrates on *Mein Kampf*, his wife standing by dutifully. Munich circa 1930, perhaps.

Bottom: Now dressed in his SA "Brownshirt" uniform, he concentrates on his coffee cup as his wife pours.

Hitler, styling himself a man of integrity, waived his government salary as Chancellor, but earned millions in royalties from his "best seller." A copy was given to each new-married couple. By 1945 it had been translated into 16 languages, and 8,000,000 copies had been sold by war's end. Fifty thousand copies were bought in Turkey in 2005 during a period of nationalistic fervor.

Because of the color of their uniforms, the members of the *Sturmabteilung* ("Storm Detachment) or SA were known as the "Brownshirts," the group of street fighters originally formed to act as rough and ready protection at early Nazi gatherings in case of attack from rival right wing or Communist groups. Their average-looking faces convey the banality of evil that would mark the Third Reich when the citizenry of an entire nation succumbed to the bloodlust of National Socialism. Eventually, the crude, brutal but faithful and politically fanatical Ernst Roehm, a captain during WWI, was given control of the SA. Roehm, fed up with conditions in Germany and seeking adventure, had been serving as an instructor in the Bolivian army, but returned home when summoned by Hitler to train the storm troopers after the elections of 1930 went well for the Nazis.

Numbers vary somewhat, but by 1931 the SA had grown to 100,000 members, within a year had swollen to 400,000 and by 1933 to over two million. Roehm, a proponent of violent revolution, saw his troops as revolutionaries and argued for the Socialist side of National Socialism while Hitler was less Socialist and more nationalist and pragmatic, preferring to use the existing political system as a legitimate means of gaining power. The large numbers and hooligan nature of the general SA membership, as well as widespread homosexuality in the upper ranks, was viewed as a corrupting threat to the regular army (*Reichswehr*) whose own commanders offered Hitler their support if the power of the SA was eliminated. On the Night of the Long Knives in June, 1934, Hitler and his SS liquidated the leaders of the SA including Roehm, Hitler's longtime comrade and close friend. Hundreds of other SA members were shot during the ensuing "Blood Purge."

Roehm was 47 when killed by the SS. In retaliation for his betrayal, a secret group of SA members formed a "death squad" and during 1934–1935 assassinated over 150 SS members as an act of revenge. At the Nuremberg Tribunals, the SA was charged with war crimes, but not convicted although the SA existed until 1945.

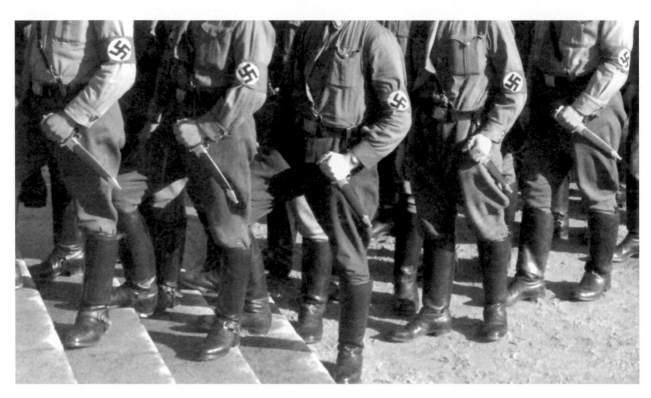

**The Ordered Ranks of the
Disorderly SA**

Perfectly posed for this group portrait,
a contingent of SA present an image in
opposition to their true street thug char-
acter. Each in lock step, each clutch-
ing his dagger of honor inscribed with
"Alles für Deutschland—Everything for
Germany."

PART ONE

The Home Front

Cameras and Cameramen · Monuments, Memorials and Medals · Love, Romance and Marriage ·
Family · Children of the Third Reich · Cult of Perfection · Transition—RAD · War Games · Essen und
Trinken · Music · Humor in Grey Uniform · Transportation · Animals · Anomalies · Religion

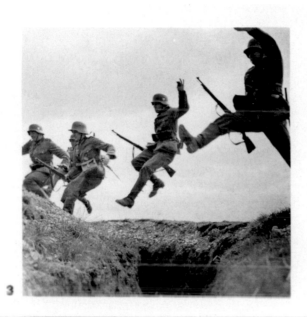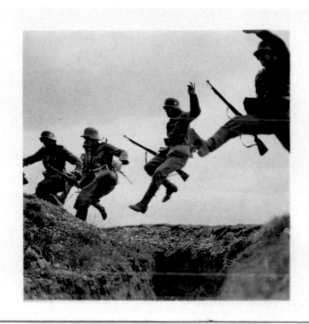

Blitzkrieg in 3-D

This photo, taken by acclaimed photographer P.K. Weber and titled "The Campaign in the West"—Photo Number 3—was one of a series of stereoscopic images produced for the public in cooperation with the German military. The images were viewed through special glasses and produced a 3-D effect.

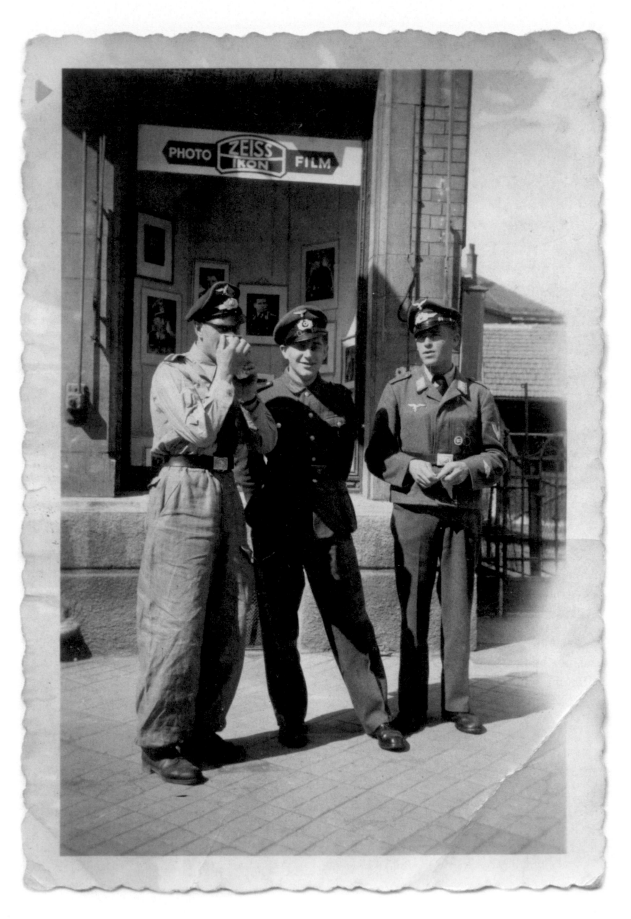

16

Photos within Photos

A German photography shop advertises Zeiss Ikon film and camera products as members of the German army (*Heer*) and air force (*Luftwaffe*) pose for the camera. Prominently displayed in the window are photos of military heroes of the Third Reich who were treated as superstars and exploited by Josef Goebbels's propaganda ministry to full effect.

The largest employer in Dresden was Zeiss Ikon with more than 10,000 people, including thousands of foreign workers and concentration camp slave labor. Dresden was famous for its historic architecture, beautiful porcelains and for its destruction late in the war by British and American firebombing, a continuing controversy. The city, with no air defenses, had been virtually untouched and was crowded with hundreds of thousands of refugees fleeing the fast-approaching Red Army when on Feb. 13–14, 1945, over a thousand Allied bombers in a three-wave attack dropped high explosives and incendiaries creating a firestorm that incinerated an estimated 50,000 men, women and children.

Dresden was considered a military target because it contained important railway links for troop transport to the east as well as to Czechoslovakia and its production of war materiel for Germany. The city also contained manufacturing sites for aircraft components, anti-aircraft guns, automotive parts and poison gas.

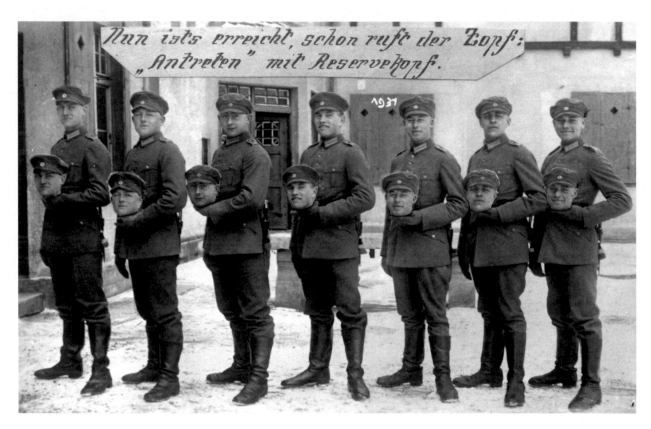

Korp und Kopf

This "trick" photograph was a popular format for German soldiers looking for a souvenir to send to family and friends. Here it is used to attract recruits to the Reserve Corps in 1931. The image echoes the barbarism that would engulf Europe a few years later or as a graphic metaphor . . . how the German people would "lose their heads" over the mesmerizing rantings of Adolf Hitler.

Ironically, decapitation by guillotine was a much used method of execution during the Third Reich. Brother and sister Sophie and Hans Scholl, members of the University of Munich-based anti-Nazi movement "White Rose," after interrogation by the Gestapo, were executed by guillotine on February 22, 1943. The pamphlet that led to their deaths read: "Germany's name will remain disgraced forever unless German youth finally rises up immediately, takes revenge, and atones, smashes its torturers, and builds a new, spiritual Europe."

The People Vote

On August 19, 1934, 89.93% of German voters said "yes" to Adolf Hitler's plebiscite on his new dictatorial powers.

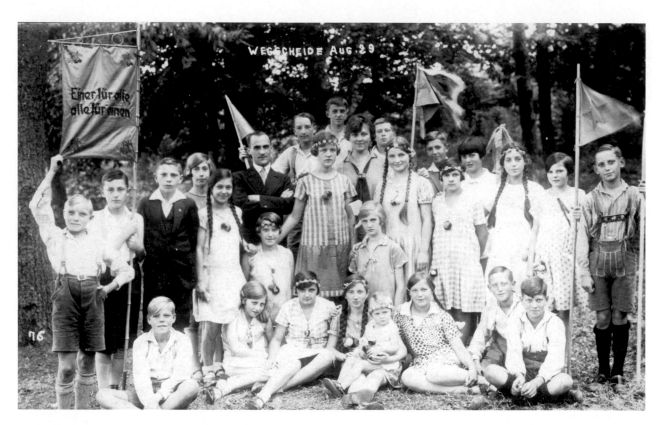

"All for One"

Members of a pre-Third Reich German youth group pose with their motto inscribed on a pennant . . . *Einer für Alle, Alle für Einen* . . . perhaps echoing the The Three Musketeers' refrain. With the Nazi takeover, all such sports and social youth organizations were swallowed up by the Hitler Youth and similarly "politically correct" groups.

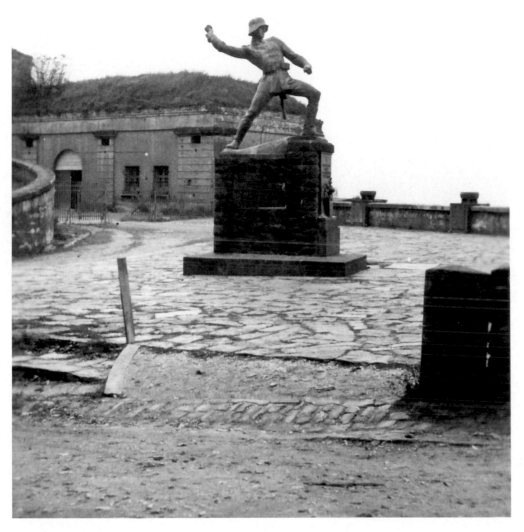

The God of War

A World War I statue captures the image of a German soldier throwing the distinctive "potato masher" hand grenade.

During the First World War, Germany and its Central Powers allies, Austria-Hungary, Bulgaria and the Ottoman Empire, were responsible for the deaths of some 3,500,000 soldiers. Their opponents, the Allies, including Britain, France, Russia and the U.S., lost 5,100,000. Of that number Britain lost 743,000 while the French lost 1,380,000, with 25% of Frenchmen aged 18–30 dying in that war. The memory of the carnage affected all sides; however, Germany subscribed to the "stabbed in the back" myth and hungered to revenge the honor of the *Wehrmacht* and of Germany itself.

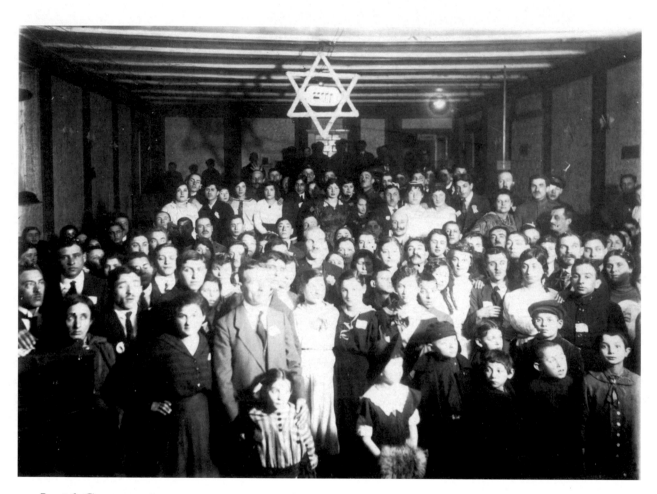

Jewish Congregation

This group portrait was taken on February 26, 1918, with World War I grinding to an armistice later in November. Many German Jews served in the military with distinction. Fifteen years later their world had turned upside down. Jewish veterans who held Iron Crosses from WWI received some "preferential treatment" and were sent to non-extermination concentration camps, but only as a temporary reprieve.

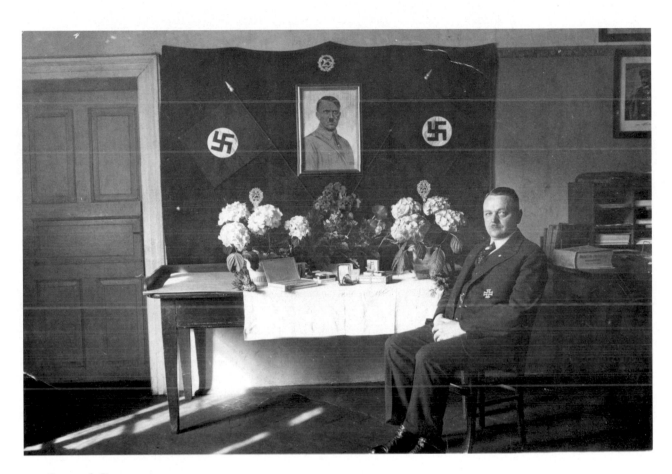

Second Generation

A member of the older generation,
wearing his WWI Iron Cross, sits
before his personal shrine to the New
Order.

Swastika — Logo of the Third Reich

Although the Nazi Party in Germany transformed the ancient *Hakenkreuz* or swastika into an emblem of evil, for the rest of the world the design has historically represented luck, peace, even laughter and joy as well as the sun and power. "Swastika" is derived from the Sanskrit *svastika*—"su" meaning "good," "asti" meaning "to be," and "ka" as a suffix . . . "to be good."

First appearing some 3,000 years ago and found on coins and pottery of ancient Troy, it is still used to ward off evil in Tibet, while Irish farmers employ a variation called the "Brigit's Cross" and the Cuna Indians of Panama decorate their blouses with colorful swastikas. It is prevalent in Navajo medicinal ceremonies and in Japanese Buddhist art and even as a design element on the Capitol building in Washington, D.C. The symbol was often found on cigarette cases, postcards and coins. During World War I, the swastika appeared on the shoulder patches of the American 45th Division. However, as the result of its identification with the destruction wrought by the Third Reich, all the ancient alternate meanings of the swastika have been eclipsed.

Various explanations seek to illuminate the choice of the swastika for the symbol of Nazism. Some point to an individual, a dentist, Dr. Friedrich Krohn, a member of the Nazi Party, who brought it to Hitler's attention. However the swastika had a relatively longstanding place in pre-Nazi Germany after being popularized by mid-1800s German nationalists seeking a graphic means to overcome the stigma of Germany as a fledgling country, having only become a unified nation in 1871. Linked to ancient Aryan/Indian origins, the swastika seemed to create a connection to a long and historic Germanic history. It began appearing as a common symbol of German nationalism in the early 1900s including in Joerg Lanz von Liebenfels' anti-Semitic periodical *Ostara*.

Hitler referred to a need for a potent symbol within the pages of his *Mein Kampf.* "In red we see the social idea of the movement, in white the nationalistic idea, in the swastika the mission of the struggle for the victory of the Aryan man, and, by the same token, the victory of the idea of creative work, which as such always has been and always will be anti-Semitic."

Perhaps it was its ancient connotation of power (or the twisting of the universally powerful image of the Christian cross) that appealed to the needs of the Third Reich for an appropriate "logo." On August 7, 1920, it was adopted as the official emblem and flag of the Nazi Party.

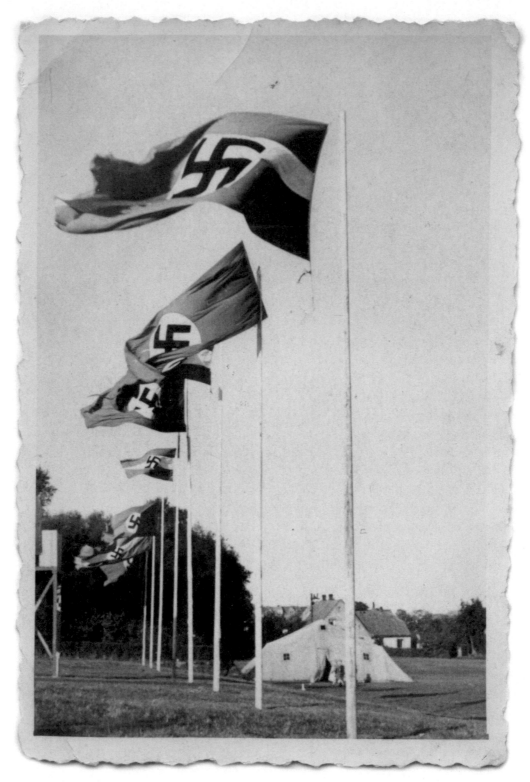

Twisted Flags

Swastikas shudder in the wind blowing through a Hitler Youth camp as a pair of young soldiers-to-be enter their windowed tent.

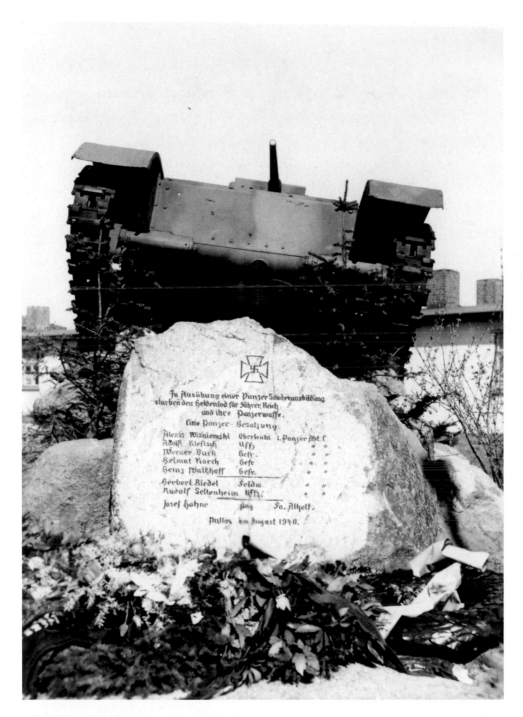

Metal Coffin

A *Panzer* tank is the center point for
a memorial to its crew that died in
August, 1940. The names of the dead
are inscribed on the monument along
with words glorifying their sacrifice for
Führer, Reich and *Panzer* Corps.

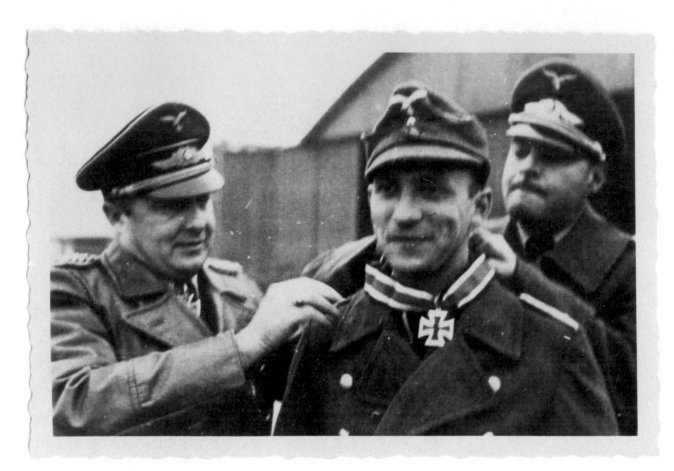

Proud Moment

It was a proud moment in a soldier's life to receive the Iron Cross as evidenced by this soldier's beaming face as well as by the officers' expressions as they award the decoration. In this case, the honor is even greater as the medal is the Knight's Cross, one of only 7,361 awarded for exceptional valor as compared to 6,000,000 Iron Crosses won during the course of the war.

The Iron Cross award, introduced in 1813 by King Frederick William III of Prussia, then at war with Napoleon, would later become a prominent emblem of Nazi Germany and a highly respected commendation awarded for bravery and leadership to members of the *Wehrmacht*, SS, SD, *Luftwaffe* and *Kriegsmarine*. WWII Iron Crosses have "1939" inscribed in the center.

The Iron Cross comes in two grades, Second Class and First Class. The Iron Cross First Class could be awarded only to one who had previously received the Iron Cross Second Class, therefore more highly prized. Both the medals looked very similar and were worn in the same position on the lower left side of the uniform. When the Iron Cross First Class was awarded, the Iron Cross Second Class was symbolized by a small ribbon attached to a button.

Adding further luster to the decoration, on September 1, 1939, the Knight's Cross of the Iron Cross was created by Hitler, himself an Iron Cross recipient during WWI (ironically upon the recommendation of a Jewish officer). Perhaps not coincidentally, the date of the creation was also the very day of the invasion of Poland. The Knight's Cross was hung on the neck by a striped black, white and red ribbon.

The rarest of all was the Knight's Cross of the Iron Cross with Golden Oak-leaves, Swords and Diamonds, an award Hitler intended for the 12 most honored serviceman from all branches after the war ended. Only one was awarded prior to the end of the Third Reich. It went to Hans Ulrich Rudel, a *Luftwaffe* pilot credited with destroying 518 Russian tanks, 150 flak and artillery positions, 700 trucks, the sinking of a Russian battleship, a Russian cruiser, a Russian destroyer, 70 Russian landing craft and hundreds of other targets. Rudel flew 2,530 combat missions (still a world record) with 11 air victories. Shot down 32 times and losing a leg, he survived the war. Returning to Germany in 1953 from Argentina (a close friend of Juan Perón), he became a candidate for the neo-Nazi Reich Party. He was then a successful businessman. He died at 66, in December, 1982.

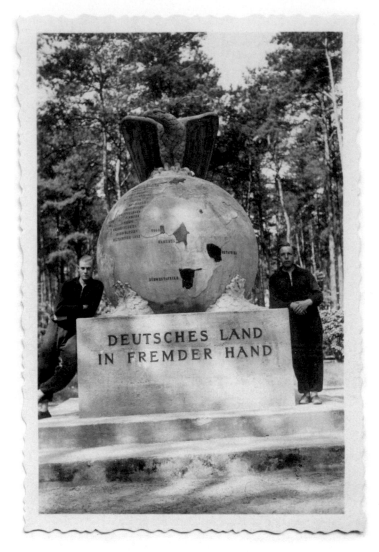

DEUTSCHES LAND
IN FREMDER HAND

"German Lands in Foreign Hands"— Doberitz, Summer 1935

A monument attests to the loss of German colonial and territorial lands as the result of World War I and the resulting sanctions imposed on the country. With envy, the Third Reich looked out upon the world and the rich resources controlled by its French and British adversaries and wanted its own colonies.

One of the cornerstones of Nazi ideology was the creation of more living space or *Lebensraum* for the German *Volk* and that would be accomplished by whatever means necessary.

Doberitz was a center of military training including a sniper's school as well as the formation ground in September, 1944 of the 272nd *Volks-Grenadier* Division composed of 10,000 men culled from the *Luftwaffe* and Navy, as well as veterans, all remnants of divisions that had been decimated in previous combat. These troops would take part in the bloody battle of the Huertgen Forest during the retreat to the Rhine.

Despite the hopes expressed by the monument, Germany would not regain any of its lost colonies.

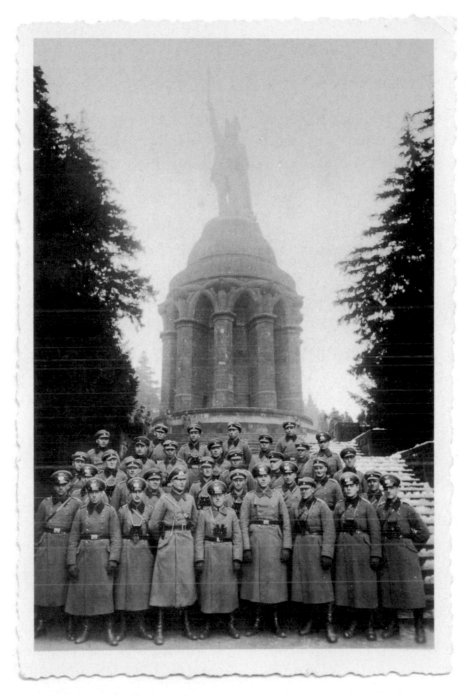

Scharnhorst **Sailors at the Statue of Arminius**

Dressed in their post-1938 issue great-coats with dark green collars, crew-members of the German battlecruiser *Scharnhorst* pose at the steps of a monu-ment to Arminius, a Germanic prince who vanquished three Roman legions in 9 A.D. His carefully planned ambush annihilated some 30,000 soldiers, achieving a great victory for the Ger-manic tribes and liberating them from Roman rule. This statue was erected in 1875 near Detmold in the Teutoburg Forest where the battle was fought, and Arminius later became part of the Third Reich's pantheon of Germanic heroes.

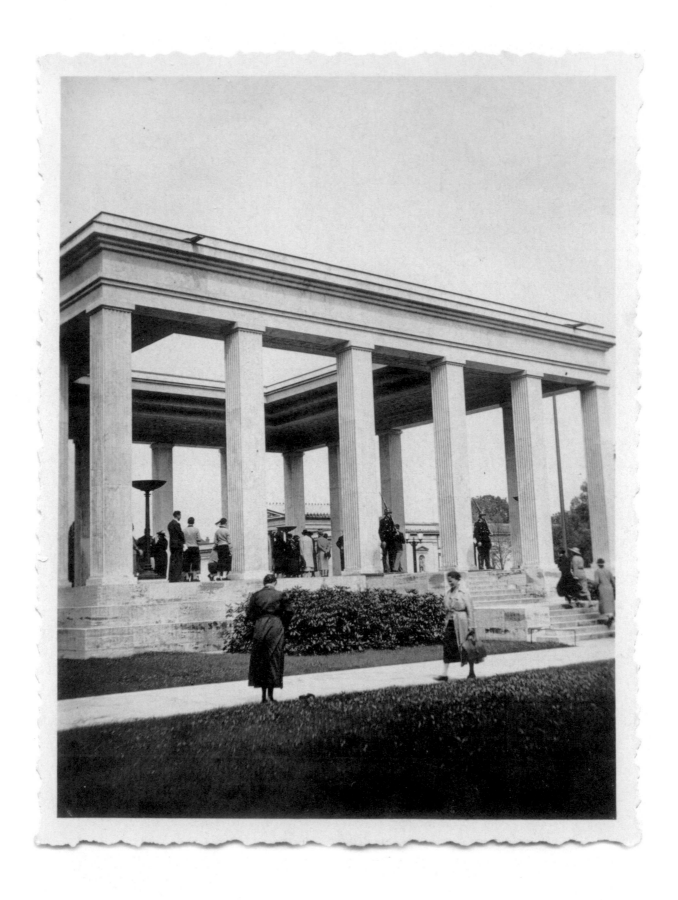

32

Hall of Heroes

Someone has photographed a woman in a dark overcoat in the process of snapping a photo of the *Feldherrenhalle*, the Hall of Heroes. Between the square pillars to the left can be seen a father and his nattily dressed twin sons paying homage to the fallen Nazi saints. A gaggle of *Hausfrauen* stand reverently in the center of the structure. A pair of SS guards the entrance.

Those who passed the Hall of Heroes were required to give the "Heil Hitler" salute. The most sacred shrine of the Third Reich, the cold sterility of the pseudo-classic memorial reflects Hitler's taste in monumental architecture.

Located in Munich's *Odeonplatz*, it memorialized the street riot caused by NSDAP demonstrators on November 9, 1923, when soldiers and police of the Weimar government shot fourteen of its members. As a result of the so-called "Beer Hall Putsch" incident, Hitler was sent into relatively comfortable confinement behind the walls of Landsberg Prison where he wrote *Mein Kampf (My Struggle)* in which he outlined his vision of the Third Reich as well as forecast the fate of its "enemies."

The *Feldherrenhalle* became the focus of an annual ceremony held November 9 commemorating the early heroes of the Nazi party during which time new SS recruits were sworn in with a rendition of "We Gather Together to Receive the Lord's Blessings."

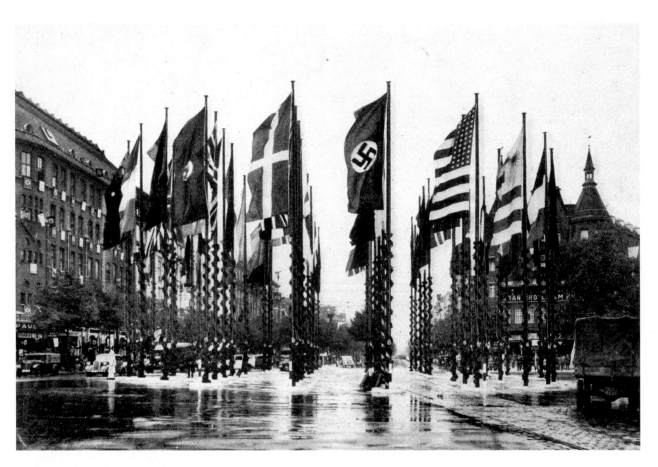

Olympic Companions

The Stars and Stripes fly alongside the swastika as Berlin hosts the 1936 Olympics. Chosen before Hitler ascended to power, Berlin would spend $25,000,000 to present the 1936 Eleventh Olympiad.

In August, 1936 Germany hosted the Olympics in Berlin. Putting on a softer face for the international community, the Nazis turned down the level of their anti-Semitic activities with a three-week moratorium on overt repression. Characterized by the Nazi media as a "festival dominated by Jews," the attitude changed when Hitler decided it would serve as a showcase for the achievements of the Third Reich. Dignitaries from other countries were courted and feted, and many fell under the spell of the Nazi movement. Göring, Himmler and other Nazi potentates staged elaborate parties reminiscent of French court extravaganzas and costing millions of German marks. Notable Americans who supported the pre-war Nazi movement included Henry Ford and Charles Lindberg.

For the opening ceremonies, a choir of 3,000 sang "Deutschland" and the "Horst Wessel Song" while 40,000 SA men stood in formation. One hundred and ten thousand spectators cheered in jubilation when shot-putter Hans Woelke received the first gold medal ever won by a German in track and field. During the games, Hitler himself handed out awards, many to German athletes, but discontinued the practice when American black athletes, "racial inferiors" according to Nazi doctrine, began receiving medals. Jesse Owens would earn four gold. Despite Hitler leaving the arena, the crowd cheered Owens, the hero of the games.

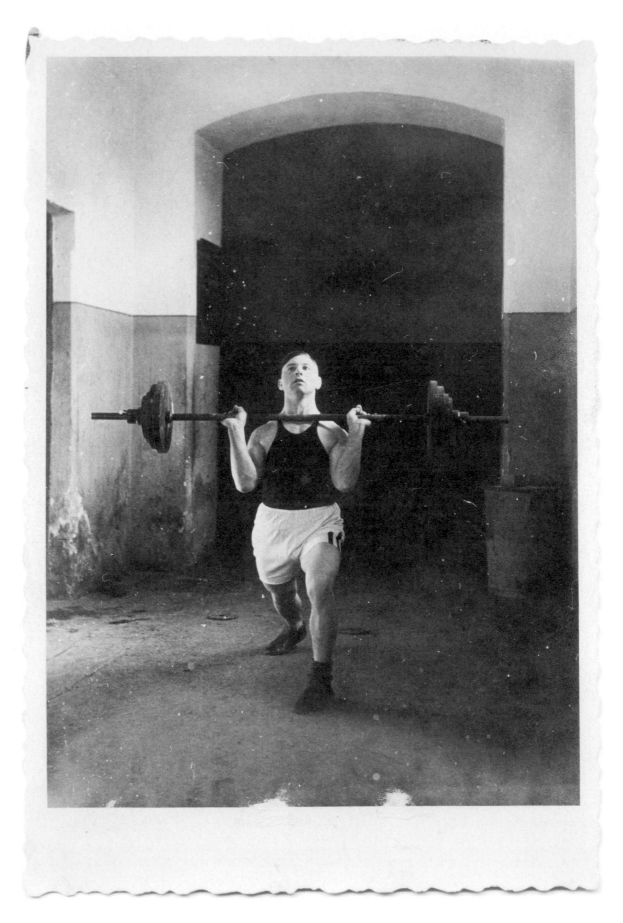

36

Kraft Durch Freude

A powerful weightlifter strains beneath his barbell.

At the opening ceremonies to the 1936 Berlin Olympics, German weightlifter Rudolf Ismayr gave the athlete's oath: "We swear that we will take part in the Olympic Games in loyal competition, respecting the regulations which govern them and desirous of participating in them in the true spirit of sportsmanship, for the honor of our country and the glory of sport." Of the fifteen medals in the five weightlifting categories, German athletes were awarded five, including a silver in the middleweight division won by Ismayr.

Athletic training was a major part of the Third Reich's "Strength Through Joy" programs intended to glorify the superior Aryan race. Featuring a wide range of events, they were organized to test and train the youth of Germany and prepare them for the "struggle" ahead. Sports achievements were rewarded with medals often worn on soldier's uniforms along with their combat decorations.

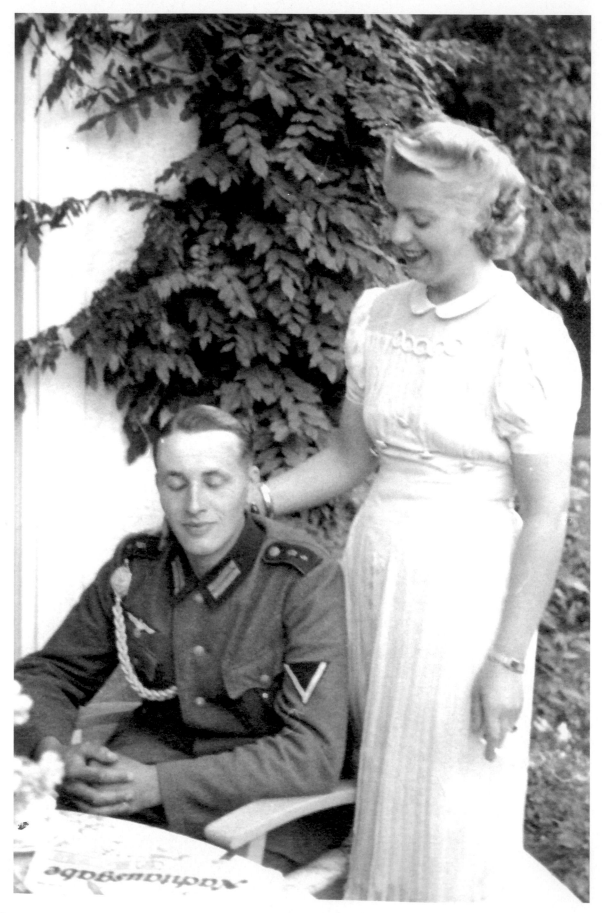

The Aryans

Models of Nazi Aryan perfection, a cosmopolitan couple enjoy a meal on the patio. The soldier wears the marksmanship lanyard. The woman, in a white dress of purity, places one gentle hand on the object of her affections, a cigarette held genteelly in the other.

In this pre-war photo, the woman is actually at odds with the Nazi position that condemned the health hazards of tobacco. Women who smoked in public were often accosted on the street by their fellow citizens who brought to their attention the Party line.

The Nazi ideology instituted the concept of a racial hierarchy that placed the Aryan in the position of ultimate superiority and the world's rightful master race, all others subservient. The Aryan, with the Nordic race as its crowning achievement, was equated with the nobility of blood, the apotheosis of body, mind and spirit. Hitler envisioned a pure Aryan-Nordic race, free of contamination from lesser biological taints, the main enemy and threat to that goal being the Jews. So intensely focused on the substantiation of the Aryan creed were the Nazis, that they mounted hugely expensive expeditions searching for "the proof," traveling as far as Tibet. While Nazi scientists kowtowed to Hitler and supported the race myth with spurious discoveries, the rest of the world's experts ridiculed their findings, but to no avail.

In the ultimate irony, all that was idealized as beauty and perfection in the world was given the torch by Nazi ideology. Eventually, this became the embodiment of self-destruction epitomized by Hitler's own megalomaniacal last orders to destroy Germany because its people had failed him by losing the war, and did not deserve to survive.

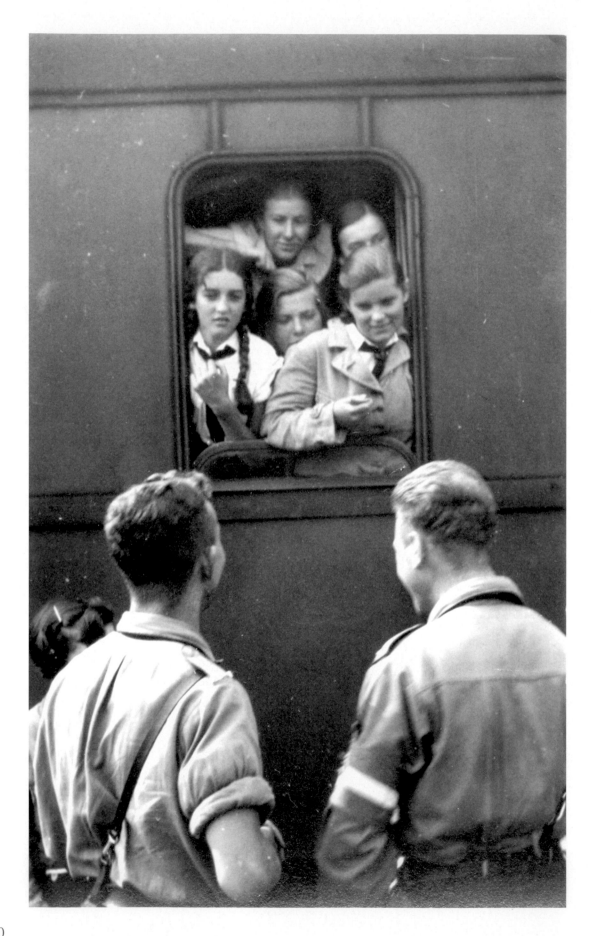

Boys and Girls

Framed by the window of their train a group of BDM girls swoon over handsome HJ boys.

Young girls of the League of German Girls or *Bund Deutscher Madel* (BDM) were instructed in physical fitness, hygiene and motherhood. By 1937, it was the world's largest girls' organization with an estimated membership of nearly 3,000,000. Activities were similar to the *Hitlerjugend* (HJ) for boys and included meetings, trips and camping as well as "toughening up" sports.

As "vessels of the Third Reich" and the mechanisms for the production of new German soldiers, these girls were reared in the Nazi ideological mindset in which intellectual pursuits for females were considered "corrosive" and education was limited. Women were barred from several occupations; for example, they were not allowed to become lawyers and were allotted only 10% of the university student openings. Their allotted position in the Third Reich was motherhood and taking care of their warrior husbands. The Master Race literally meant man was the master of woman.

German children, including girls of the BDM, joined forces with the SS and the Police Battalions to forcibly evict Polish peasants from their homes in order to create *Lebensraum* for ethnic Germans relocated by the Nazi regime to repopulate the homes and land of the *Untermenschen*. The children, eager and enthusiastic to please their Führer, had been prepared for their duties as members of the Hitler Youth, the BDM, and the Labor Service (RAD). Singing "Deutschland, Deutschland über Alles," they would march through the annexed Polish and Czech towns to place the German stamp on the new territories.

A German girl student, after watching the SS evict Polish villagers, wrote in 1942: "Sympathy with these creatures?—No, at most I felt quietly appalled that such people exist, people who are in their very being so infinitely alien and incomprehensible to us that there is no way to reach them. For the first time in our lives, people whose life or death is a matter of indifference."

Some of the most fanatical fighters at the end of the war facing the Allies were members of the Hitler Youth, often fighting to the death.

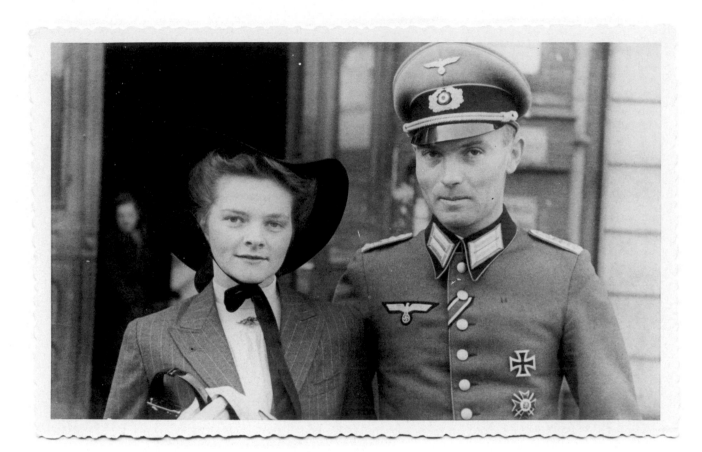

Perfect Pairing

A stylish couple, she in her Katherine
Hepburnish chapeau, he in his tailored
officer's uniform and Iron Cross awards,
pose for the camera, elegant in their
bearing and confidence, epitomize
perfect Third Reich pairing.

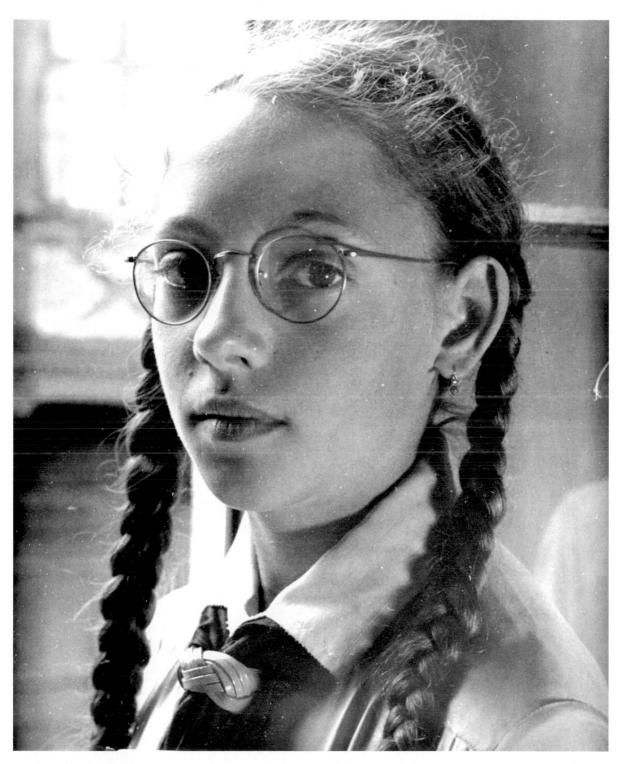

BDM girl in pigtails

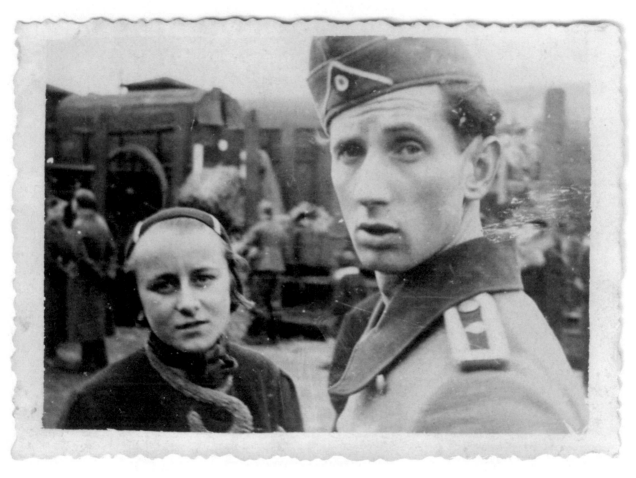

A Moment in Calais

Caught unawares at a train station in Calais, France, a young German soldier appears startled by the cameraman. A young girl, perhaps French, wears an expression of sadness, grief? Is it simply an encounter between two young people at the seaport on the English Channel, or are the soldier and girl bidding farewell, or is she Jewish and being deported? There is no way to know.

The Allies' intricate plan of deception convinced the Germans that the invasion of Fortress Europe would take place at Calais, distracting them from the D-Day beaches at Normandy. However, Calais suffered near-total destruction during the ensuing battles.

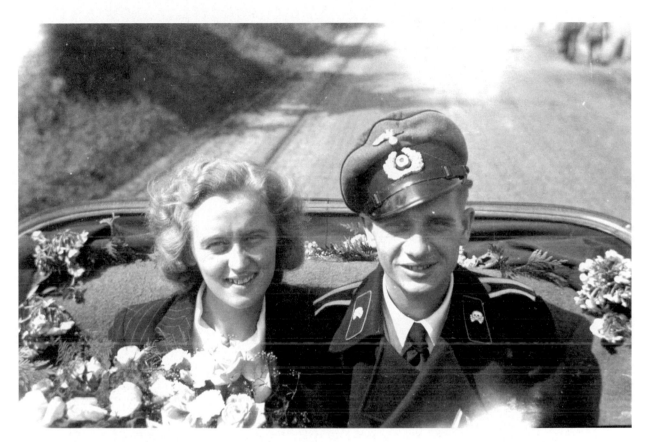

Open Car

Carrying a bouquet of flowers, a couple enjoys a ride in an open car. He wears the *Totenkopfverbände* or Death's Head black uniform of a *Panzerman*. The symbol was also worn by the SS who manned the concentration camps.

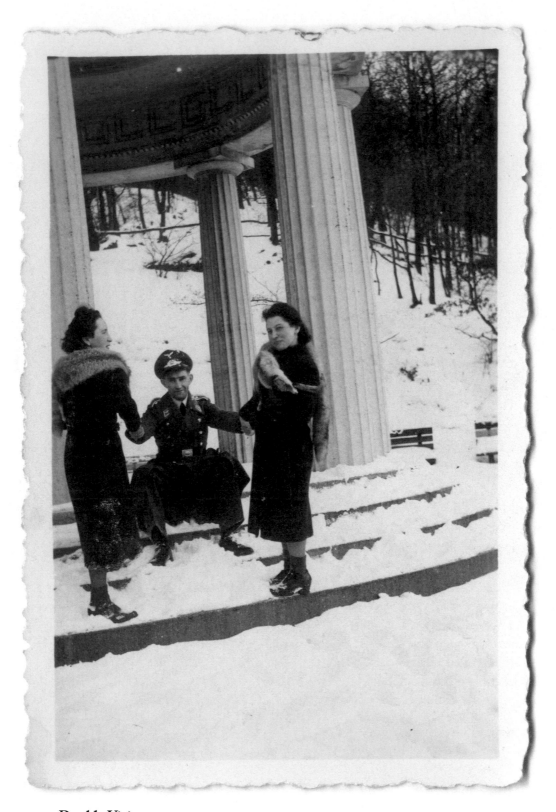

Double Vision

A *Luftwaffe* officer entertains twin sisters who share a penchant for fox stoles.

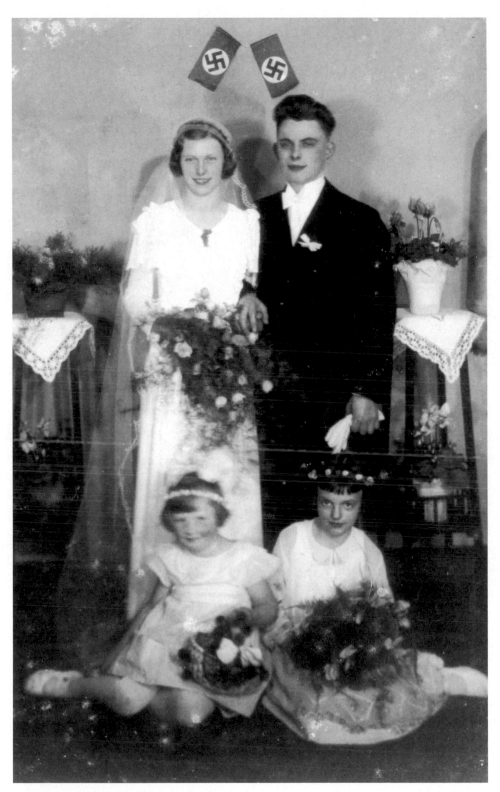

Stamp of Approval

An angelic young couple's wedding portrait includes swastikas floating over their heads.

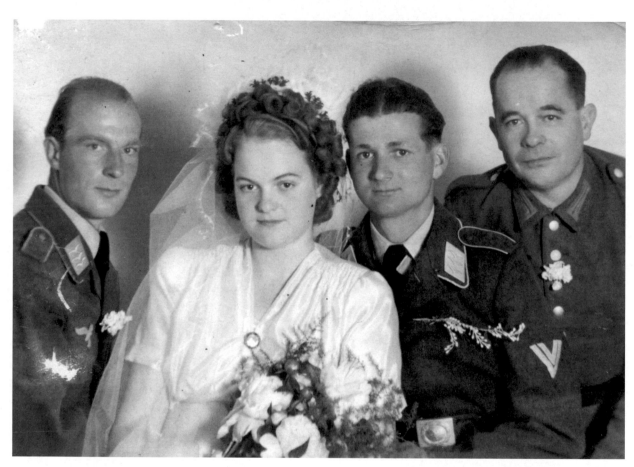

Marriage Vows

The institution of marriage was strongly promoted by the Nazi regime principally to produce new racially pure citizen soldiers to replace those consumed by the war. Cash bonuses (and copies of *Mein Kampf*) were awarded to newly-weds while mothers who produced four or more offspring received medals and commendations. Marriage ceremonies were often civil affairs, but some were held in churches with clergy officiating.

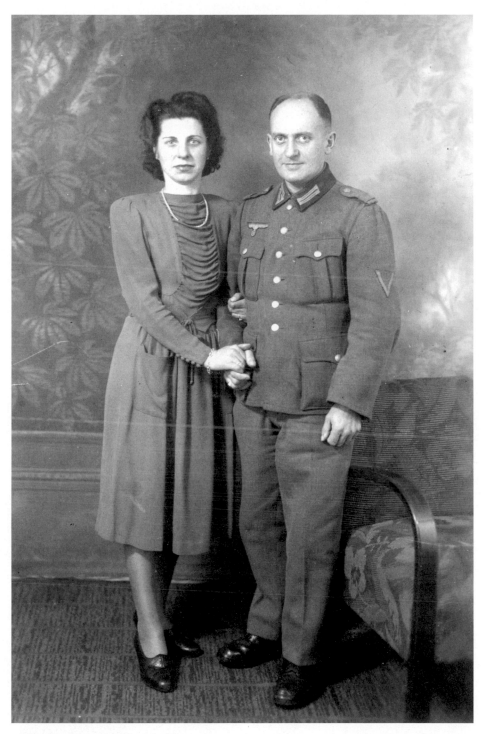

"Berlin January 18, 1945"

With German cities including Berlin under constant aerial bombardment and the Allies advancing from the West, the Soviets from the East, there is less than four months before the war grinds to its end. Alfred and Elli take time for a portrait and write the date on the back.

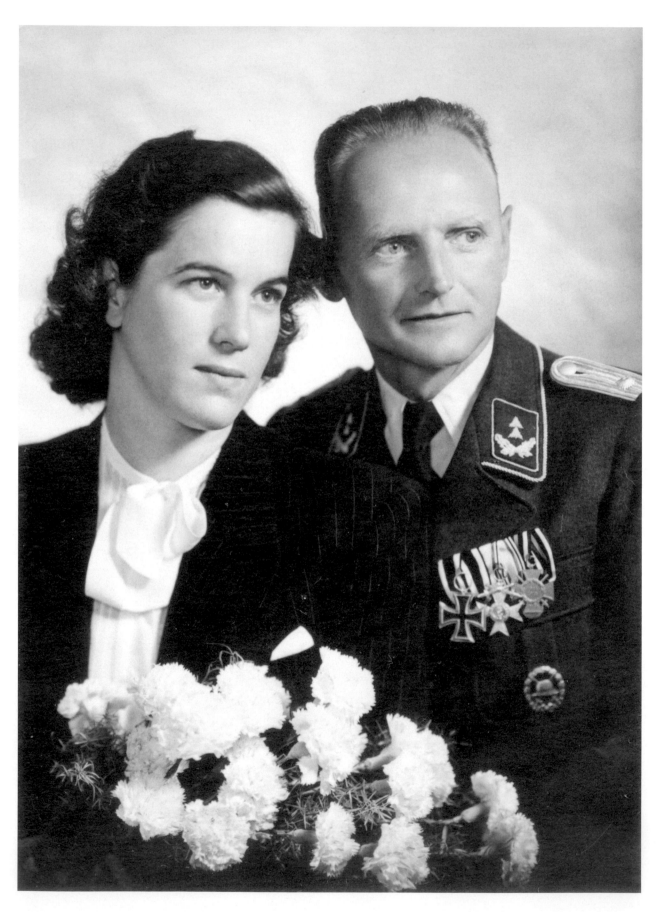

50

Warrior Wedding

An unidentified highly decorated *Luftwaffe* officer has his portrait taken with his wife by a professional photographer, A. Haecher, in the Bavarian city of Augsburg. His decorations include the War Merit Badge, Iron Cross and Wound Badge.

This *Luftwaffe* hero's enemy, Britain's Wing Commander John Nettleton, would be awarded the Victoria Cross for his part in the bombing raid against Augsburg.

Augsburg was an RAF bombing target on April 17, 1942, and then again on February 25, 1944. The first attack, a dangerous daylight raid by the Lancaster bombers, was on the main U-boat diesel engine factory to cut fuel for Germany's U-boats wreaking havoc in the Battle of the Atlantic and also a test of the new four-engined aircraft. Judged a success during the war, post-war analysis showed quite otherwise, with little damage inflicted on the enemy. Seven of the bombers were downed. Thirty-seven men died, another twelve were taken prisoner.

The 1944 air raids on Augsburg followed the by-then established formula of British bombers by night, American Eighth Air Force bombers by day, for virtually round-the-clock bombing of German cities, towns and sometimes villages. The second bombing mission, including 594 British aircraft, targeted the *Messerschmitt* aircraft plant. High explosives and incendiaries destroyed the center of Augsburg, where firefighting was made difficult by the city's frozen river. Allies' losses were twenty-one RAF aircraft or 3.6%. At least four of these were due to accidental mid-air collisions.

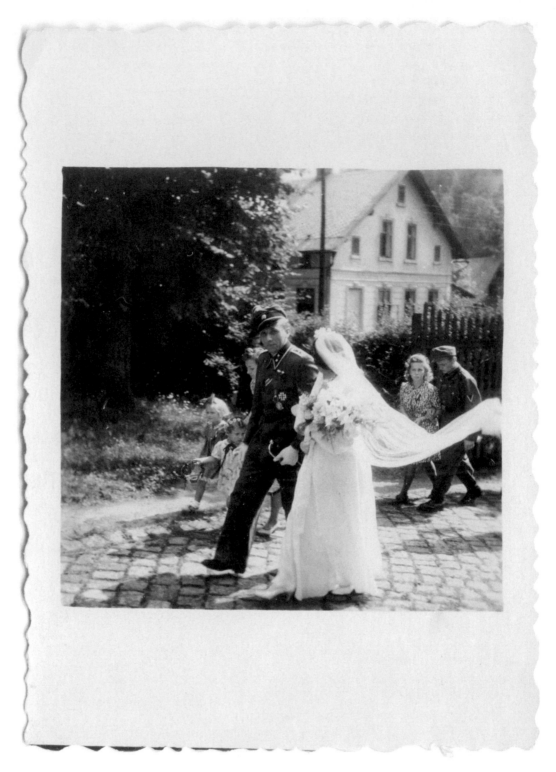

Deathshead Wedding

An SS officer, highly decorated and wearing the *Totenkopf* ("Death's Head") insignia on his cap, looks at the cameraman, his foot frozen in mid-step. His beautifully gowned bride, her diaphanous veil trailing behind her, gazes at her new husband.

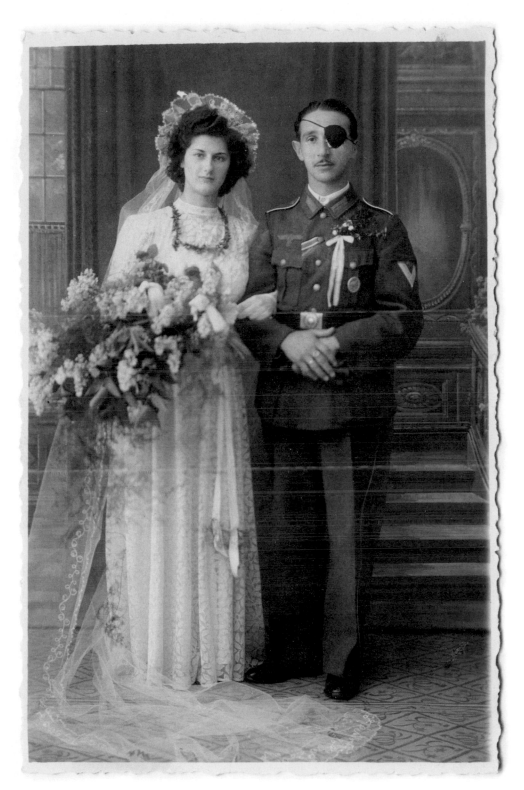

Blind Love—May 22, 1943

In this professional wedding portrait,
the bride wears an exquisite wedding
dress, her highly decorated new husband
still able to see her beauty with one eye.

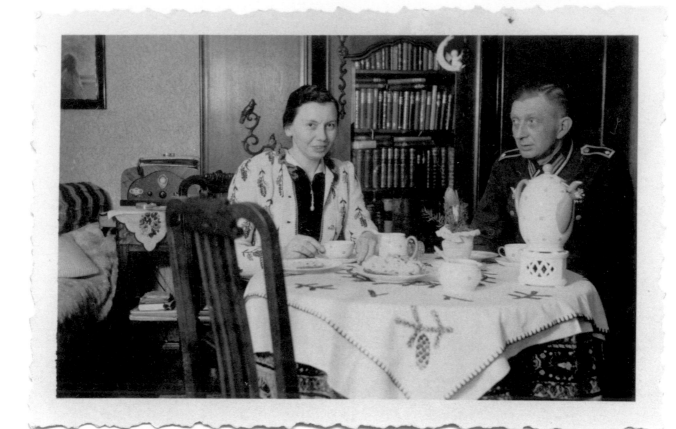

Breakfast Finery

A senior *Wehrmacht* officer seems to
stare with a look of surprise or disbelief
at something his wife may have just
said. She wears a beautifully stitched
jacket that bears resemblance to the
table cloth, perhaps both her own
handiwork.

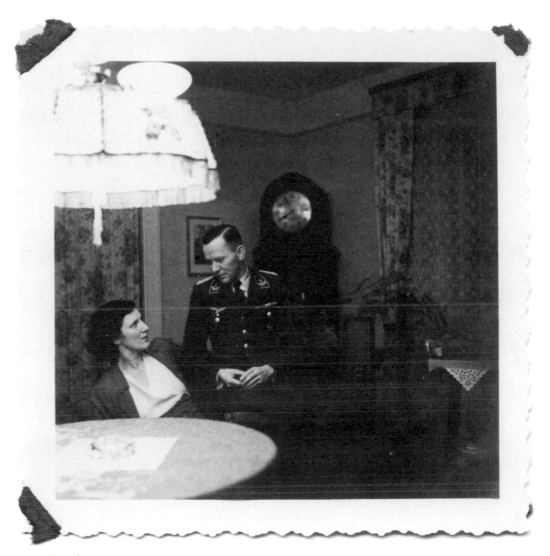

Confrontation

What surprising, perhaps shocking news has just been announced is anyone's guess. The moment, four minutes before eight, is frozen in time.

While the Third Reich proclaimed marriage and procreation a patriotic duty, divorce was relatively simple if the union could not produce children.

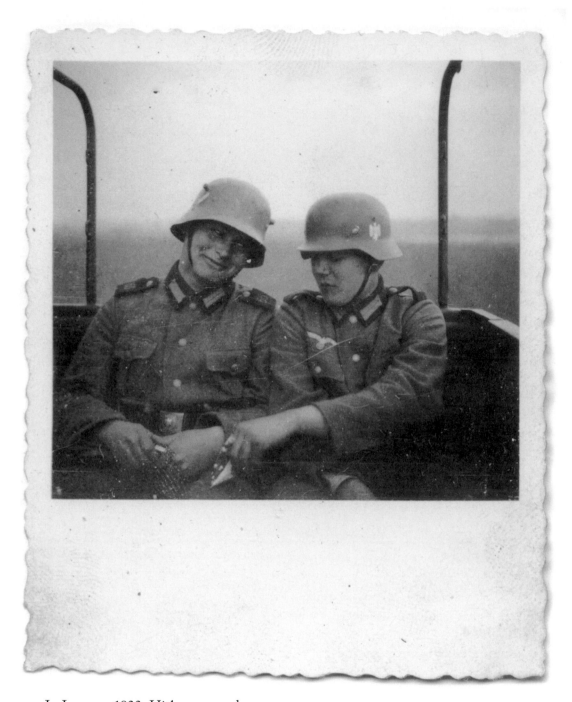

In January, 1933, Hitler assumed power. Subsequently, a number of laws went into effect: prostitution was banned, gay bars and hotels were closed, and nudism and pornography were declared illegal. Soon afterward, the head of police was asked to "pay special attention to transvestites and to deliver them to concentration camps if necessary."

Nazi persecution of "undesirables" included homosexuals who, in prison camps, wore a pink triangle to distinguish their "crime."

Himmler, head of the SS, determined to rid his organization of homosexuals, ordered that once discoverd, the men should be demoted, expelled and, after found guilty by court martial, imprisoned for the duration of the war. But he gave his generals secret instructions that these homosexuals should not go to prison, but should be sent to a concentration camp where they would be "shot while attempting to escape."

By law all homosexuals were to be sterilized, along with the blind and "malformed," and those suffering from drug addiction, epilepsy, schizophrenia and "hysteria." In actual fact, homosexuals were not sterilized, but were castrated. By 1935, 56,000 people had been subjected to this law. After the war the German government refused to give reparations to homosexuals, as they had to other persecuted groups, because they were still listed as criminals under the law.

In 1942, the Reich Ministry of Justice publicly adopted the death penalty for homosexuals. The number of homosexuals who perished in concentration camps is uncertain, figures ranging from 10,000 to over 400,000.

Some of the Third Reich's "sex laws" were less strictly enforced. For example prostitution was tolerated, or indeed, promoted as a deterrent to homosexuality and a means by which to increase the population. At the front, special brothels were established to service Himmler's unmarried SS men. Medically supervised, they included 600 women "recruited" in 1943 from Paris, Poland, Bohemia, and Moravia who were opportioned among 60 brothels with a client rate of 50 each per day.

Several of the State's prostitutes were utilized in a special research project at a Stuttgart installation where the women were required to wear special sheaths to collect their partner's semen, which was then gathered for tests to devise a plasma substitute. Lesbians, though not sent to concentration camps, were subject to forcible impregnation or sent to brothels as a means to "cure" them of their affliction.

In addition, the Third Reich established the so-called *Lebensborn* "Founts of Life" facilities. Unmarried women could have their children raised there. Kidnapped babies and children thought to be "Aryan" looking were also sometimes raised there.

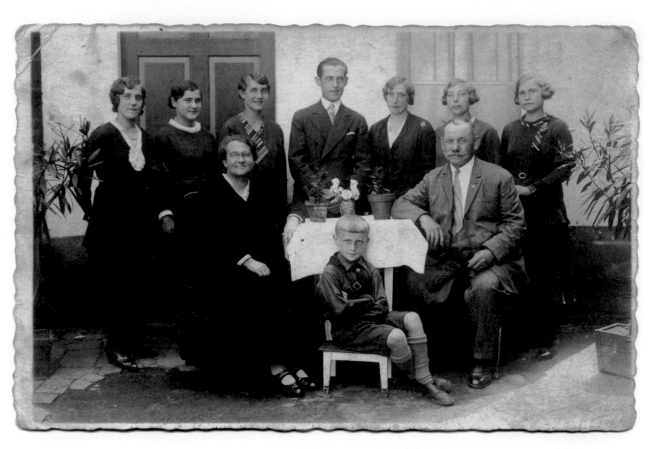

Family Portrait with one Hitler Youth

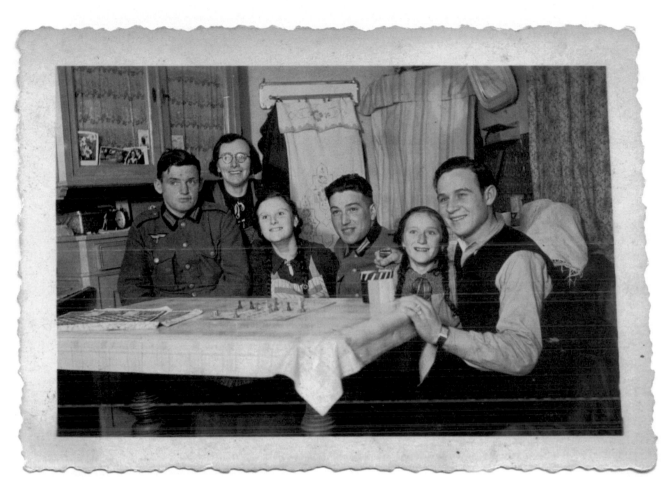

In Service to the Fatherland

A family gathers around the cozy kitchen table, two sons in uniform. A chess game is in progress. Photos of family and friends are posted on the cabinet behind them. All beam at the camera except one son who seems wary. One wonders if the family will be issuing "death cards" for two brothers.

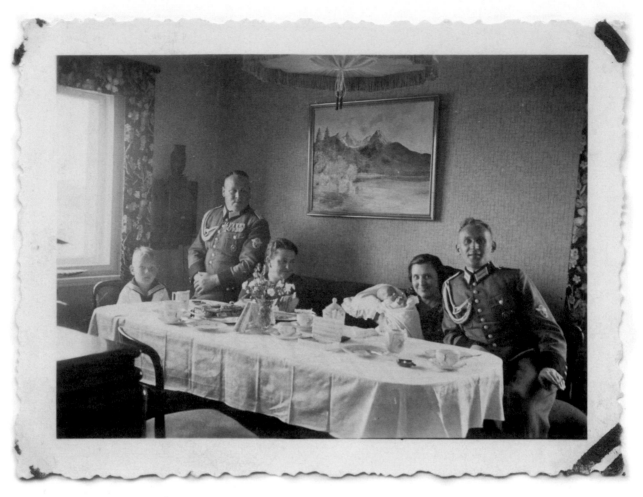

Another Family Gathering

Two families sit around a well-appointed dining room table, their fine china and children on display. One seems to glower at the other.

Both uniformed men wear the insignia of the Police Battalions, many of which were direct perpetrators of the racial war in the East. Over a million men, women and children were to shot to death by special killing teams in conjunction with *Einsatzgruppe*, SS, SD as well as regular army units. The Police Battalions, among the leaders in the Nazi racial war of annihilation, were usually older men, many previously civilian policemen who, after Germany's defeat, returned to their pre-war occupations and in great part were never brought to justice and, in fact, were able to conceal their crimes and those of their comrades for decades.

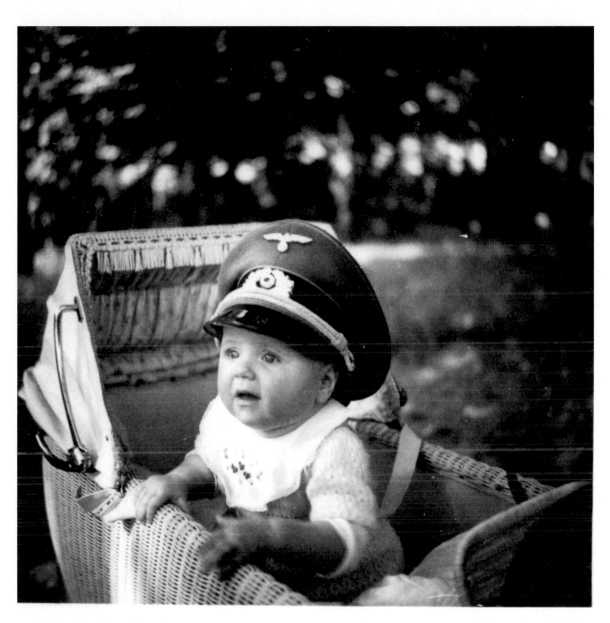

From Cradle to Grave

Wearing a *Wehrmacht* officer's cap, an
infant peers out from his baby carriage.
His indoctrination as a warrior citizen
has already begun.

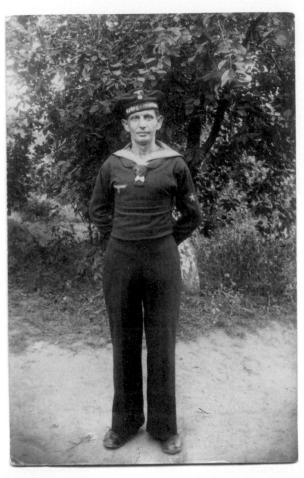

Sailor

An older *Kriegsmariner* poses with his wife and daughter who, like most teen-agers, seems not too happy to pose for the camera.

The *Kriegsmarine* was formed in 1833 when Germany began re-arming. Although outmanned and outgunned by its enemies, Germany's surface ships served with distinction, but incurred heavy losses early in the war (while its U-boats wreaked havoc until Allied anti-submarine techniques virtually wiped them out).

When Hitler took power, the German Navy had its own traditions and did not appear enthusiastic enough about Nazi ideology. In addition, there was the matter of Admiral Wilhelm Canaris, Chief of the *Abwehr*, the High Command of the German Army's military counter-intelligence service. While he detested the Versailles Treaty's impositions on Germany and had a near paranoid fear of Communism, he was at odds with Nazi mob violence and brutality. While opposed to the Gestapo and the treatment of Poles, he followed his orders and cooperated with the SD in their operations. Vacillating in his affections for the Nazi Party and Hitler and minimally effective at his job, he apparently was also the one who suggested identifying Jews with a yellow star.

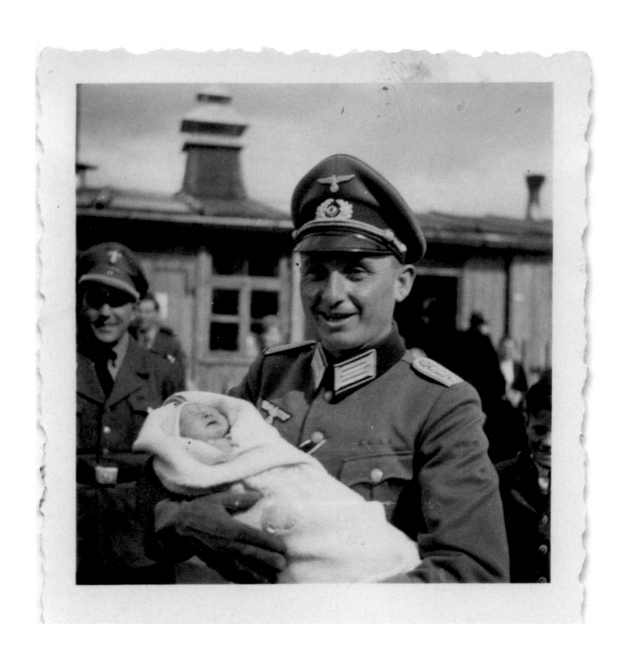

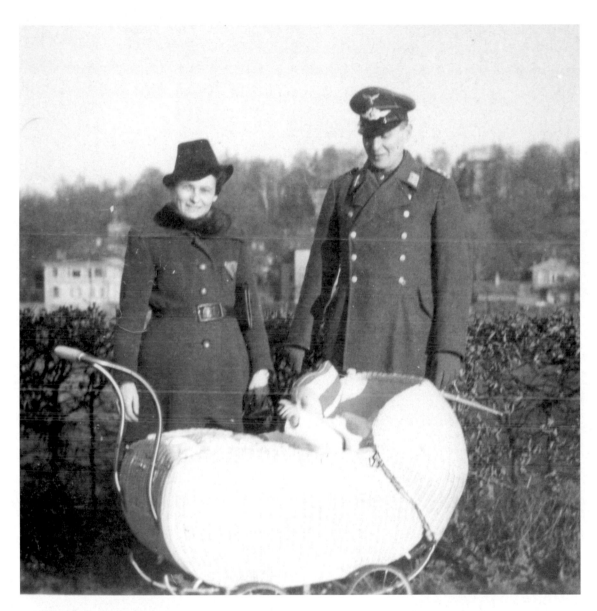

The Baby Carriage

Stylishly dressed and ensconced in an elegant baby carriage, a child points at something that has caught its eye. The proud parents smile into the camera, the mother's rather drab apparel echoing her husband's uniform, her coat most likely fashioned from an army field coat as was common practice at the time. Militarism had permeated literally every fiber of the country.

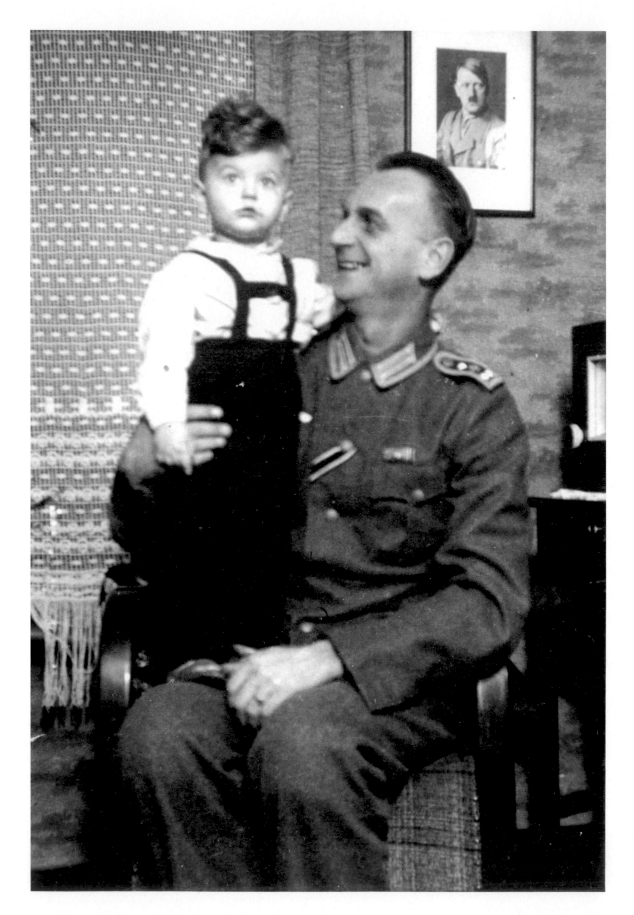

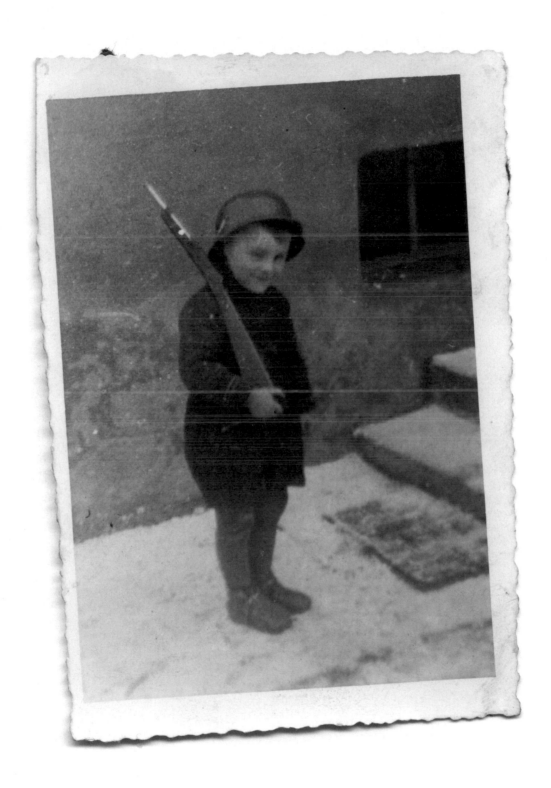

Childsplay

A postcard depicts a child playing not with a sailboat but launching an *Unterseeboot* with a caption that translates to "Get the Enemy."

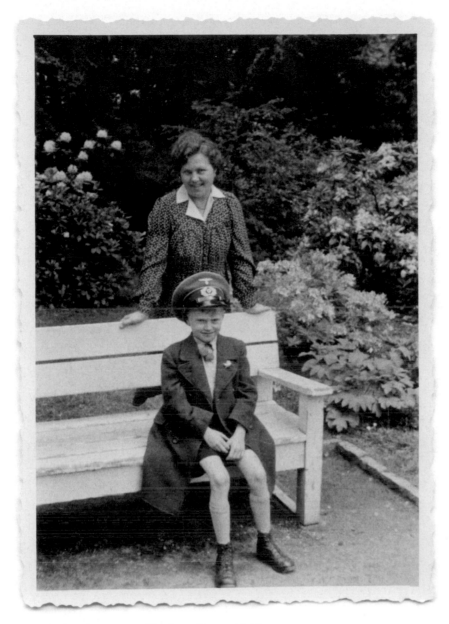

Stolze Mutter—Görlitz, June, 1943

A mother poses proudly behind her son who, sitting very straight on the bench, dons a soldier's dress cap, perhaps his father's. While flowers surround them, a dense darkness lurks close behind.

A notation on the back of the photo tells us it was snapped on a summer's day in 1943 in the city of Görlitz—today the easternmost city in Germany. Prior to the outbreak of war, it was the site of a Hitler Youth training camp, then became the location of a POW camp eventually housing Polish, Russian, British Commonwealth, Belgian, French and also some 1,800 American prisoners. At the closing days of the war, the British and American POWs suffered through "death marches" as they were forced deeper into Germany as the liberating Red Army advanced into the area. A few weeks prior to the photo Görlitz was visited by Third Reich's Propaganda Minister Josef Goebbels, who gave his infamous "Total War" speech on February 18, 1943.

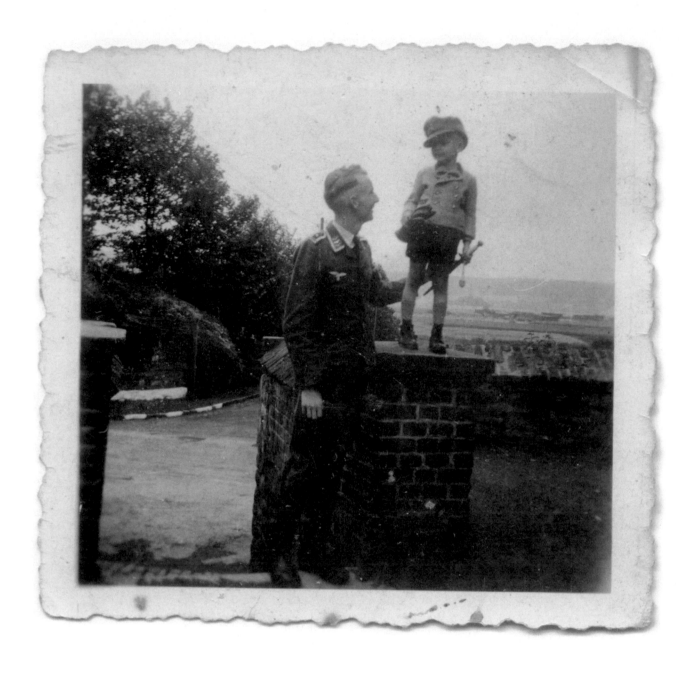

70

Luftwaffe **Legacy**

An officer of the German air force gazes up at his young son who wears his father's cap and officer's dagger. The boy, perched on a pedestal, seems a metaphor for the Third Reich's militarism and its glorification of the soldier-citizen. He grasps a glove that one day will fit his small hand and returns his father's loving gaze.

Hermann Göring, a highly decorated WWI aviator and commander of the famous Flying Circus fighter group, was appointed by Hitler as Supreme Commander of the *Luftwaffe*. Addicted to morphine as the result of serious injuries sustained at Hitler's side during the 1923 Beer-Hall Putsch in Munich, he was characterized as "fat, glamorous and magnetic with impeccable manners." Prone to ostentatious uniforms, hunting, collecting fine (looted) art, he also created the concentration camp in Oranienburg and directed the Blood Purge in 1934 that eliminated the SA leadership. Rather a jolly fellow and popular with the public, he even laughed at the many jokes about himself. Meanwhile, he saw to the expulsion of Jews from German life. He married the beautiful Carin von Fock who later died of tuberculosis. Göring, devastated, installed her body at his estate north of Berlin that he named Carinhall. He failed to bring England to its knees as he had promised Hitler and later was considered a traitor. While convicted of war crimes at Nuremberg, he acquired cyanide and committed suicide at age 53, cheating the hangman's noose. Before his death he prophesied, "In 50 or 60 years there will be statues of Hermann Göring all over Germany. Little statues, maybe, but one in every German home."

* * * *

According to German records, thirty four *Luftwaffe* fighter pilots had confirmed "kills" of 150 or more to their credit while two, Erich Hartmann and Erich Gerhard Barkhorn, posted 352 and 301 respectively, most registered on the Eastern Front. Hartmann survived 11 years in a Russian prison camp and returned to Germany. Barkhorn, who would pilot the then-radical ME-262 jetfighter, survived the war, passing away in 1983 at the age of 64.

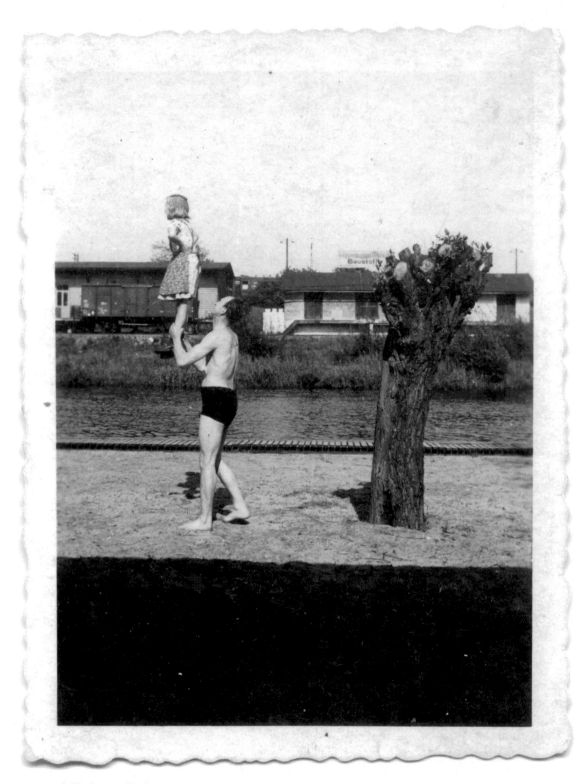

A Delicate Balance

A father and daughter perform a balancing act for the cameraman. An ominous-looking tree, its limbs severed, stands in mute counterpoint.

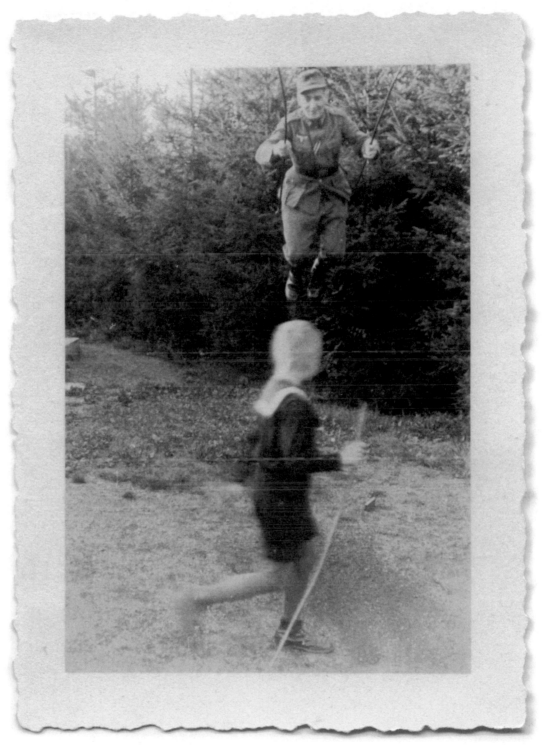

Freeze Frame—August, 1943

A young boy dashes in front of a soldier perched on a swing. The soldier smiles down at the boy. He has been awarded the Iron Cross Second Class as indicated by the ribbon attached to the second button of his tunic. He will soon return to the Front. The boy wears a youth group uniform, naval in appearance, and perhaps dreams of serving in the *Kriegsmarine*. Even now he seems to be walking into the path of the swing, into harm's way.

In His Father's Footsteps

Pimpf

A boy, aged 10–14, who joined the *Jungfolk* was known as a *Pimpf* or "cub," and after an initiation consisting of Nazi ideology and physical feats, went on to learn semaphore signals, the laying of telephone wires and the use of small arms, all in preparation for matriculating into the Hitler Youth.

HJ

Founded in 1926, the *Hitlerjugend* or Hitler Youth organization accepted boys, after careful racial screening, at the age of 14. Hitler summed up the organization's import when he said, "A violently active, dominating, brutal youth—that is what I am after." By 1935, 60% of German youth were members of the HJ under the direction of Baldur von Schirach. Each carried with pride a knife inscribed with the motto "Blood and Honor." HJ became the main form of mass education and involved weekend-long programs including camping, hiking, even trips to other countries. Rarely did HJ members see their families, so strong was the grip of the Party which became their new "family of blood and steel." When the boys turned 18, they graduated into the Party, then into the SA. At 19, they spent six months working at manual labor or in farmers' fields under strict military discipline as members of the *Reichsarbeitdienst*, the State Labor Service or RAD where they shouldered shovels in anticipation of rifles. Service in the *Wehrmacht* followed or, if accepted, the SS. For millions of young Germans it would be to the ends of their short lives.

Von Schirach was sentenced to 20 years for war crimes and released in 1966.

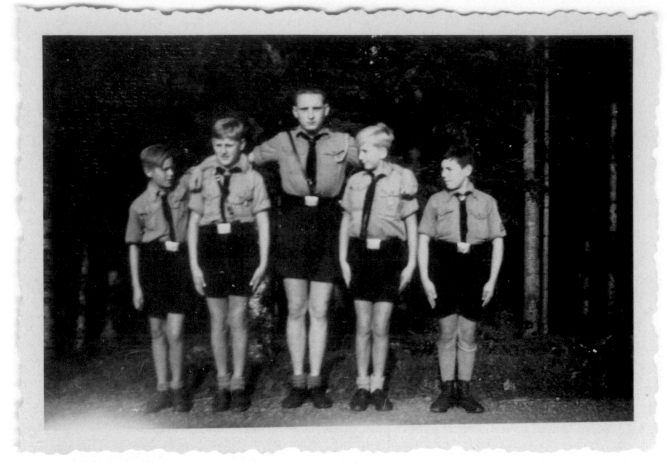

Der Führer in Miniature

An HJ leader gathers his young charges who stand dutifully at attention.

His withering stare echoes the fanatical determination espoused by the Nazi leadership. Perhaps he would go on to join the vaunted SS. Warping the idealism and naiveté of Germany's youth, the Third Reich coaxed killers out of children who attacked Russian tanks with their bodies and gleefully murdered prisoners in concentration camps. Hitler Youth indoctrination began in 1926 and ended in 1945 leaving several thousand teen-aged HJ still infused with Nazi doctrine.

"We all believe on this earth in Adolf Hitler, our Leader.

We believe that National Socialism will be the only creed for our people.

We believe that there is a God in Heaven who created us, leads, and directs us.

And we believe that this God has sent us Adolf Hitler so that Germany should be a foundation stone in all eternity."

— Words appearing on a
Hitler Youth poster

Three Brothers-in-Arms

Emulating his two older brothers, members of the *Luftwaffe*, a proud and happy young soldier-to-be wears a uniform tailored for him, while the helmet is something he will have to grow into. While not old enough for frontline combat, at the closing days of the war, others of his age, both boys and girls, acting as *Flakhelfer* or "flak helpers," will man the anti-aircraft guns defending Berlin and other German cities from Allied bombing. Many remained dutifully at their posts and did not survive.

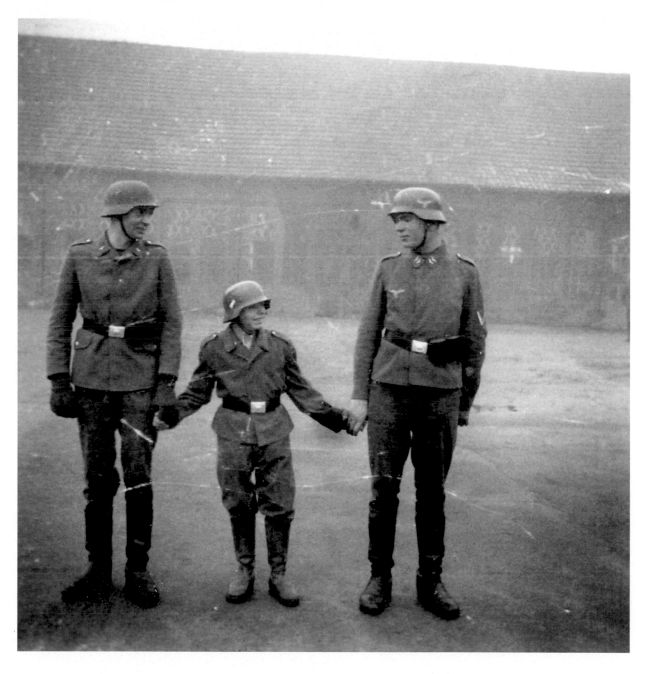

80

The Salute

With one hand holding a bottle of milk, a young boy gives the Hitler salute, which has become mandatory throughout Germany. Children were encouraged to inform on their parents if they failed to put proper enthusiasm into the "greeting," which was required for all occasions. The "Hitler salute" became required of the *Wehrmacht* as well Ironically, Hitler preferred the standard military salute, but it was the SA that evolved the straight-armed variation in place of the traditional salute. Accompanying the salute one uttered "Heil Hitler!" yet another part of the campaign to inspire national devotion to the Führer.

The boy, a member of the 10–14 year-old boy's youth group that preceded membership at age fourteen into the Hitler Youth, poses with his fellows for a group portrait along with their adult directors.

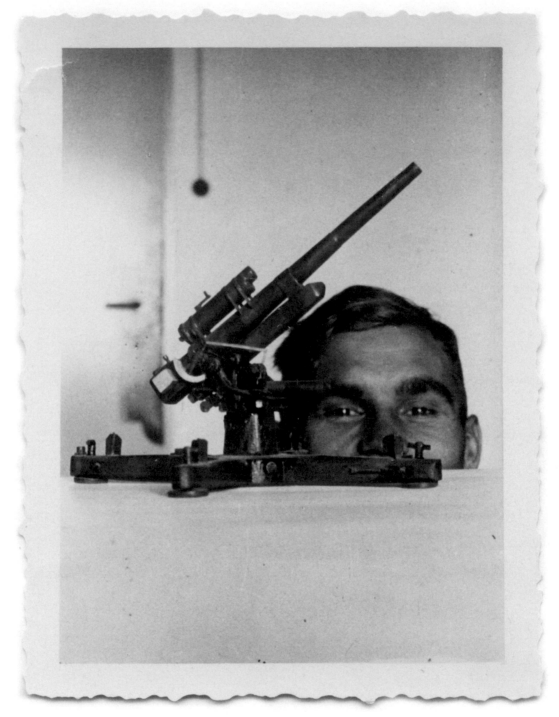

Scale Model

Perhaps dreaming of the day when he will join the gun crew of a German 88mm anti-aircraft cannon, the young man's eyes seem to glow with reverence from behind the scale model.

First appearing in 1943, the 88 Flak 41, capable of firing a 21 lb. shell nearly seven miles, was both feared and respected and saw action on all fronts, both for air defense and later employed as a potent and dreaded anti-tank and anti-personnel weapon, the PAK 43.

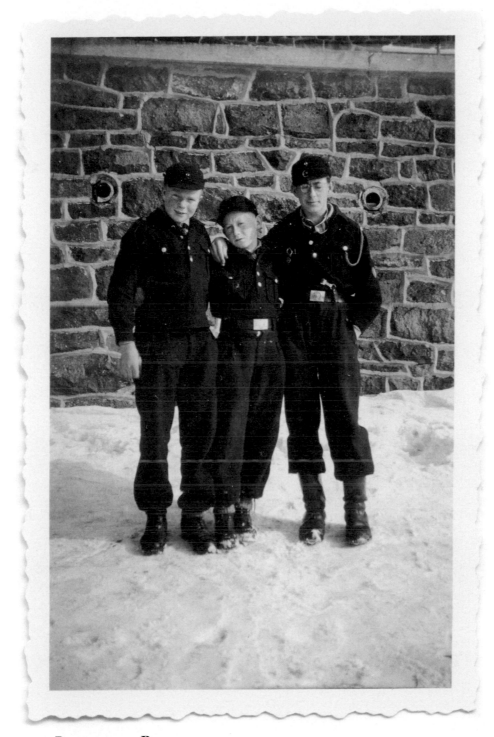

***Panzermen* to Be**

A trio of Hitler Youth members proudly
pose in their winter uniforms that
mimic the black apparel of the vaunted
tank corps, whose *Panzers* personified
the Third Reich's strategy of *Blitzkrieg*
or lightning war.

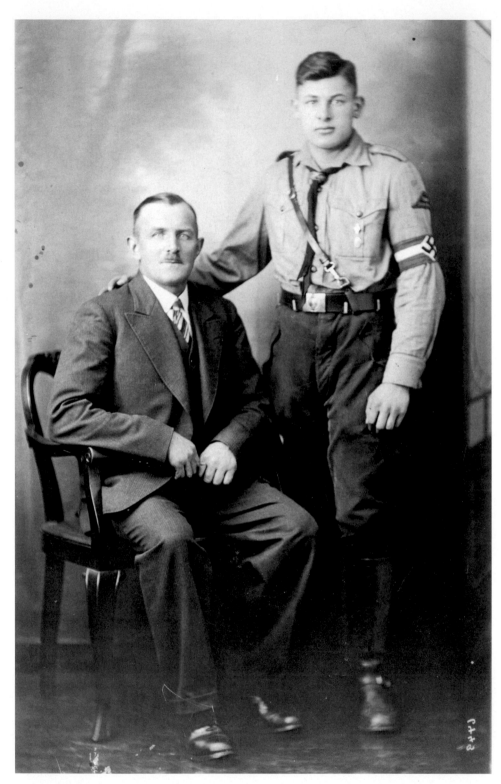

Proud Papa

A proud father sits for a formal portrait
with his stalwart Hitler Youth son.

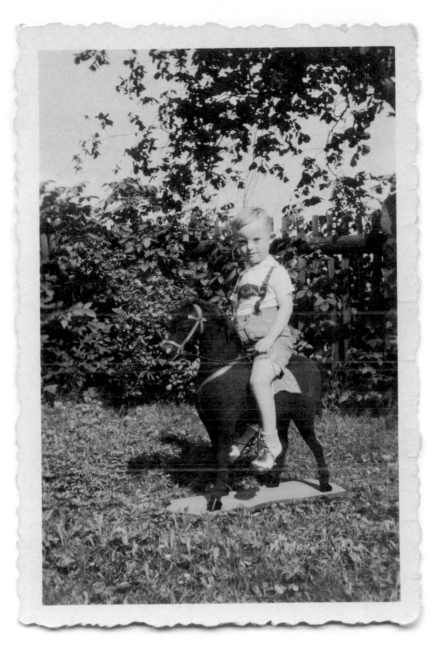

Pony Boy

A boy in Lederhosen rides a toy horse

In their effort to create a genetically "pure Aryan race," the Nazi regime enacted a program of mass euthanasia whereby the physically and mentally handicapped among the German population were put to death. It continued until 1945; children like the boy above and an estimated 150,000–200,000 others were put to death. The techniques were later extrapolated toward the mass extermination programs of the Third Reich.

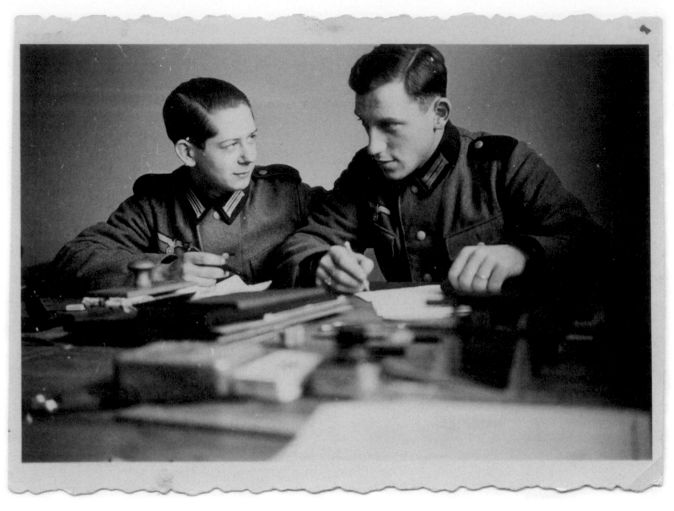

Mentor

A young cadet takes guidance in the art of war. In addition to tactics, strategy and weapons, great emphasis was placed on personal hygiene and social graces including ballroom dancing and equestrian skills. There was also emphasis on high moral character, but a "new morality" that displaced the decadent Christian morality with that of the Nazi World View—a brave new, coldly brutal world where the physically flawed and the "racially impure" had no rights or place among the *Volk* of the Greater German Reich. The Nazi leadership learned very early on that children could be taught to believe anything and believe it fiercely.

Experts on propaganda, the Nazi regime insinuated their racist theories into the earliest stages of childhood instruction. Perhaps the most notorious of children's books were those published by the Third Reich's foremost anti-Semite, Julius Streicher, himself a former teacher. He had earned the Iron Cross in WWI and risen to lieutenant and afterward formed, in 1919, a political party based on anti-Semitism, eventually joining the Nazis in 1921. In 1923 he founded *Der Stürmer*, the most virulent and violent anti-Jewish publication in Germany. Among the articles he published, many pornographic, were those declaring Christ was not a Jew. Hitler was a fan of the publication, but not Göring, who was more than vexed when Streicher stated that the corpulent *Reichsminister's* daughter had been conceived by artificial insemination.

Streicher's publishing house produced three anti-Semitic children's books with some 100,000 copies read in many German schools. Authored by a young art student, Elwira Bauer, the first of the three was titled *Trust No Fox on his Green Heath . . . And No Jew on his Oath*, a phrase made popular by Martin Luther, himself an anti-Semite.

Bauer's book, replete with garish anti-Semitic illustrations, begins:

"The Father of the Jews is the Devil,
At the creation of the world
The Lord God conceived the races:
Red Indians, Negroes, and Chinese,
And Jew-boys, too, the rotten crew.
And we were also on the scene:
We Germans midst this motley
 medley—
He gave them all a piece of earth
To work with the sweat of their brow.
But the Jew-boy went on strike at once!
For the Devil rode him from the first.
Cheating, not working, was his aim;
For lying, he got first prize
In less than no time from the Father of
 Lies.
Then he wrote it in the Talmud."

A sadist and a rapist, Streicher appropriated vast amounts of Jewish property for himself and friends. Hitler finally had to place a ban on his speaking while an investigation into his improprieties by Göring ultimately saw Streicher divested of his party rank and position, but he continued his activities, particularly agitating against the Jews and calling for their destruction. Judged guilty of war crimes at Nuremberg and executed upon the gallows, his last words were "Heil Hitler."

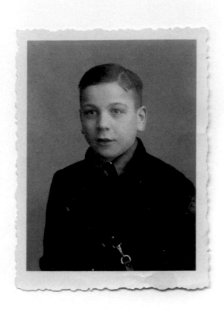

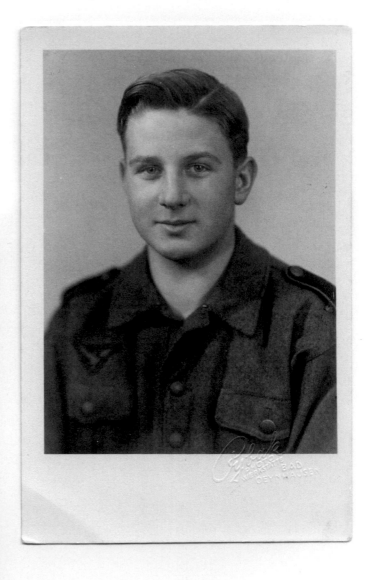

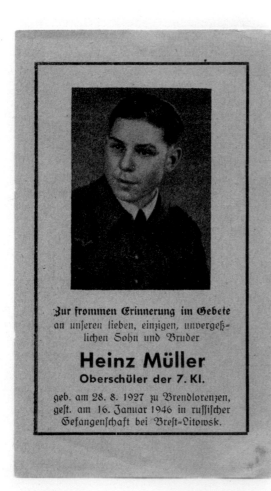

Zur frommen Erinnerung im Gebete
an unſeren lieben, einzigen, unvergeß-
lichen Sohn und Bruder

Heinz Müller

Oberschüler der 7. Kl.

geb. am 28. 8. 1927 zu Brendlorenzen,
geſt. am 16. Januar 1946 in ruſſiſcher
Gefangenſchaft bei Breſt-Litowsk.

A Page in a Life

Three images encapsulate the life of Heinz Muller from his childhood through his membership in the Hitler Youth, and then while still a schoolboy his entry into military service where he is taken prisoner, eventually to die in January, 1946 in a Russian POW camp at Brest-Litovsk at age 19.

In November, 1941, the Germans established a Jewish ghetto in the Belorussian city of Brest-Litovsk. On October 15, 1942, German execution teams operating in the area, including members of Police Battalion 307 and the 162nd Infantry Division of the regular Army, shot men, women and children. Statistics vary, but reliable sources put the number of deaths between 25,000 and 50,000. The Soviets liberated the area on July 28, 1944.

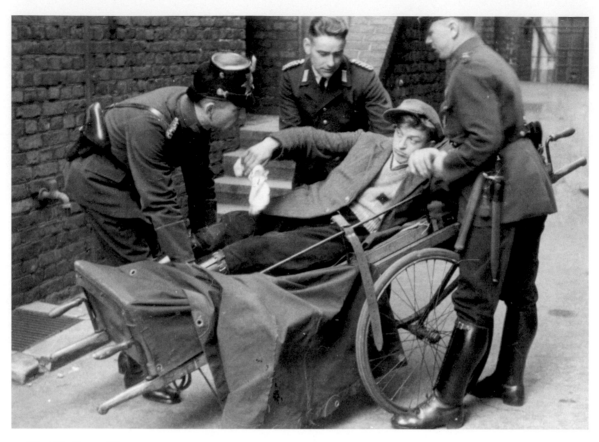

The Undesirables

Civilian policemen unload a disabled young boy from his special cart designed for the handicapped. What fate awaits him is uncertain.

Four centers for the extermination of mental asylum patients were established by January, 1940 as part of "T-4" operation designed to purge German blood of the retarded and genetically afflicted. The "passports to death" were signed by the country's leading psychiatrists and pediatricians. Thousands would die in the facilities' relatively small gas chambers, taking twenty or fewer victims at a time, shades of things to come.

As noted in the prologue to *The Cruel World* by Lynn H. Nicholas, the last of the "undesirable" children to be murdered, in this case by lethal injection after weeks of deliberate starvation, was a Richard Jenne, the son of German parents. Listed as a "feeble-minded idiot" the four-year-old was killed by the head nurse of a Munich mental institution on May 29, 1945. The war had officially ended several weeks earlier, on May 8. The nurse later admitted to ending the lives of 211 other children.

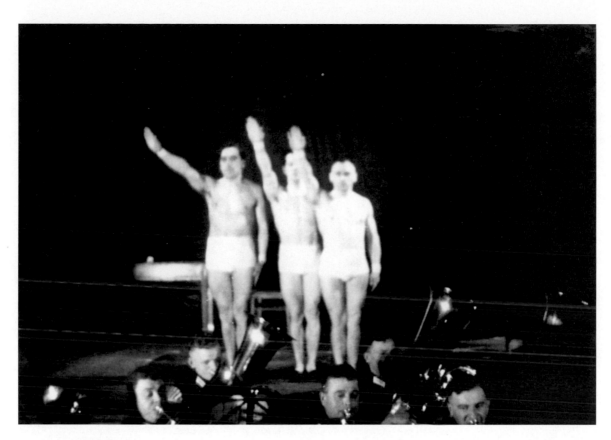

Cult of Perfection

German Police Day—Pilsen, March, 1940. One can almost hear the martial music blaring as the semi-naked, incandescent figures give the Nazi salute.

Nazi ideology contained strict racial guidelines formulated on pseudo-scientific interpretations that were used to determine who would be accepted into their New World Order. Here, three "specimens" seem to be on display on stage while musicians play at their feet. The scene is a rally for *Polizei* (Police) unit recruits, many assimilated from the regular civilian police, part of Himmler's plan to merge the SS mentality with the police and prepare them for war, both as combat troops and as members of the extermination squads that followed in the wake of the *Blitzkrieg*.

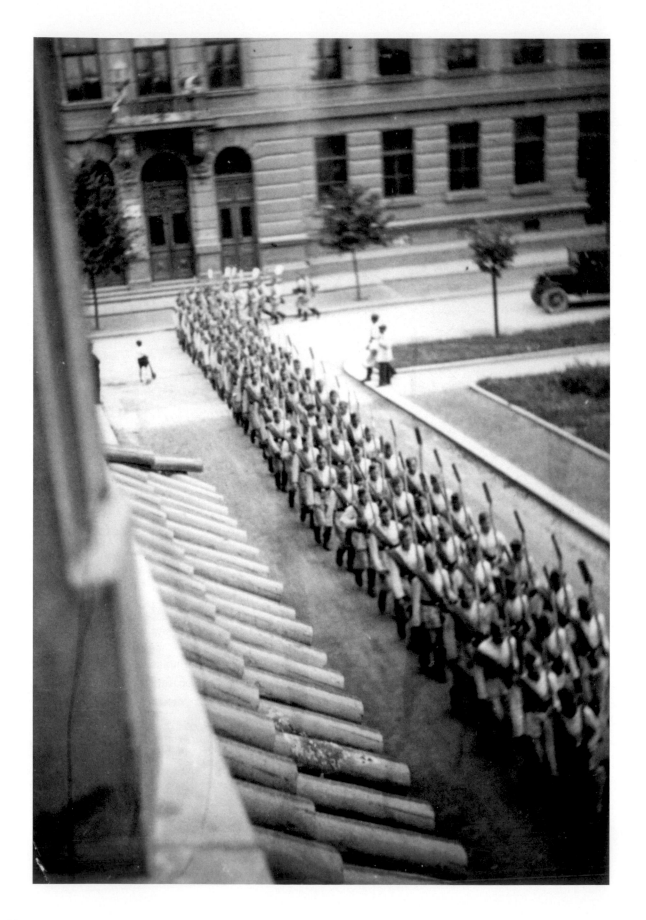

The Spade Soldiers—RAD

In preparation for their entry into the *Wehrmacht*, all eighteen-to-twenty-five year olds, male and female, were inducted into the compulsory State Labor Service or *Reicharbeitdienst*, aka RAD, established in July, 1934.

As part of his efforts to solve the unemployment problem facing Germany in the early 1930s, Hitler implemented RAD initially to form labor battalions for those without work, then transitioned them into the armed forces. Training for the males was arduous, discipline was brutally strict and in the military mold, spades shouldered as rifles, the labor camps run like army compounds. Length of RAD service was six months with members often working side by side with farmers in their fields, echoing the Nazi "blood and soil" philosophy. It was a "classless" organization, no special privileges granted or denied because of education, occupation or social class. Women also entered RAD, working with peasant women in their homes. Hitler accomplished his goals of putting people to work and preparing the young for war, all the while skirting Treaty of Versailles restrictions on military development.

94

Casting A Long Shadow

A young RAD man squints against the late afternoon sun in the family's backyard. His father, back to the cameraman, putters at some task while his mother pauses from her knitting to shield her eyes from the glaring sun that blinds her to the violent fate awaiting her son.

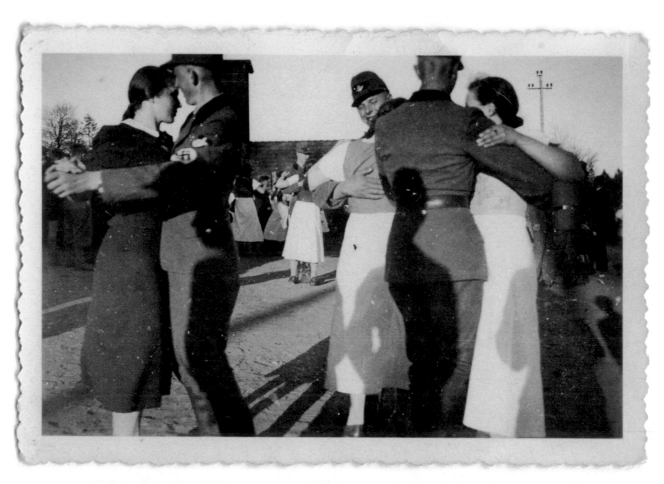

Shape Shifting Dancers

RAD men dance rather boldly, pressing themselves against maidens of the BDM. Social interactions between racially correct couples were encouraged as was prolific childbirth within or without the institution of marriage. Special homes were created for unwed mothers and no stigma was attached to such births. It was for these new Germans that *Lebensraum* or "living space" was required, a rationale for the Nazi war of expansionism.

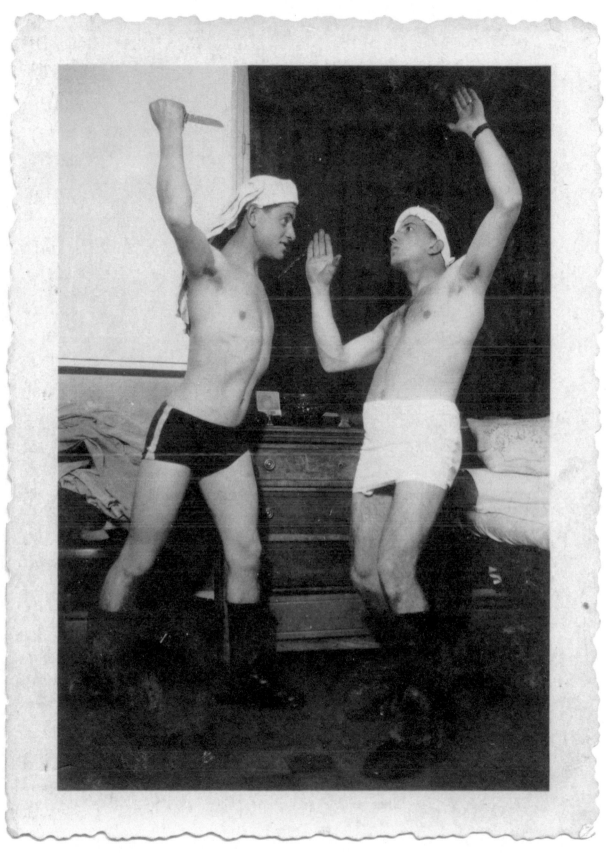

War Games

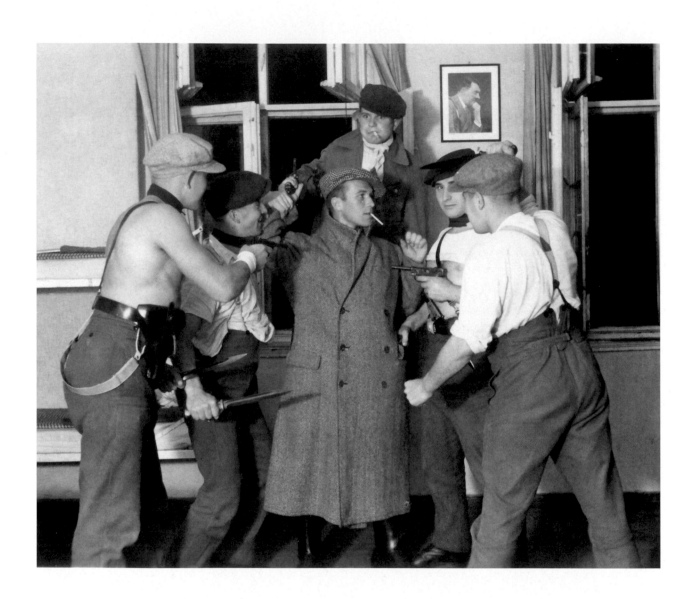

War Games

German soldiers often photographed each other acting out scenes that place a whole new emphasis on the term "war games," their "toys" razor-sharp daggers and 9mm pistols. Oddly enough, they have turned their weapons on each other, and though "practicing" for the battles to come, the images presage the eventual self-implosion of the Third Reich upon its own people as Hitler, citing the German people's failure to follow his leadership and produce victory for him, ordered the total destruction of German industry and infrastructure, thwarted only when Albert Speer, Minister of Armaments and War Production, disobeyed the Führer's orders to implement the plan.

In this group of photos we see young recruits playing at murder with their daggers, staging the capture of enemy spies, and aiming their Luger automatics at the "enemy."

(Albert Speer would be the only defendant at the International Military Tribunal in the Nuremberg War Crimes Tribunal to take responsibility for his actions and admit to his guilt, although in a limited way, insisting that his work was economic and technological rather than political, and that he took no part in the crimes his work made possible. He was sentenced to twenty years in Spandau Prison and released in 1966. His 1970 book *Inside the Third Reich* was an international best seller. Later research unearthed his complicity with slave labor and knowledge of concentration camps and mass murder.)

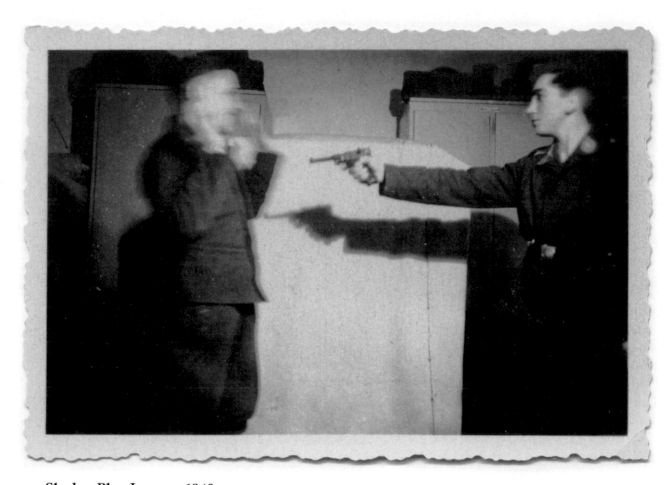

Shadow Play, January, 1940

Young soldiers pose dramatically with a Luger 9mm Parabellum semi-automatic pistol. In the service of the Third Reich, the Luger cast a long shadow across Europe and became emblematic of both Nazi advanced technology and its evil machinations.

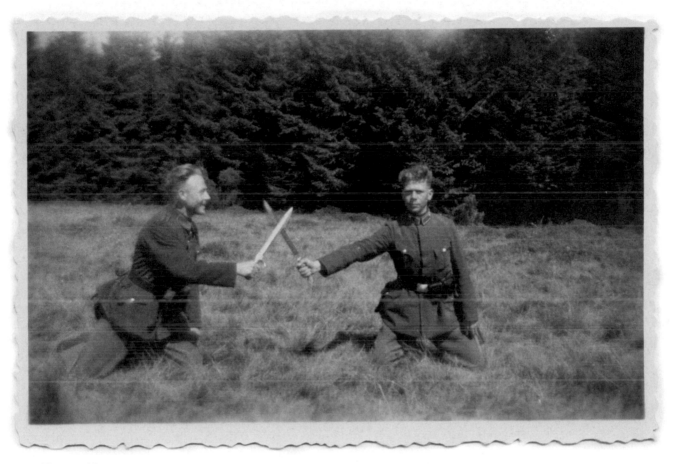

Crossed bayonets

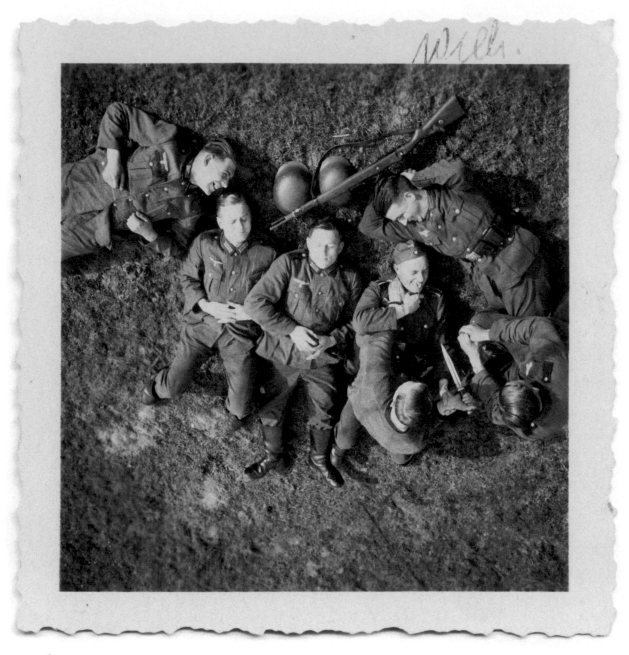

Overview

In this strikingly composed photo, as if viewed by the spirit of a fallen comrade floating overhead, a group of young *Soldaten* basks happily in the sun. One of their number takes the opportunity to practice his skills with the bayonet, while another's rifle points ominously toward the neck of a napping friend.

The German military often grouped members of the same town or village together into small combat units, a method by which to strengthen their personal bonds and thereby insure their strong cohesiveness as fighters.

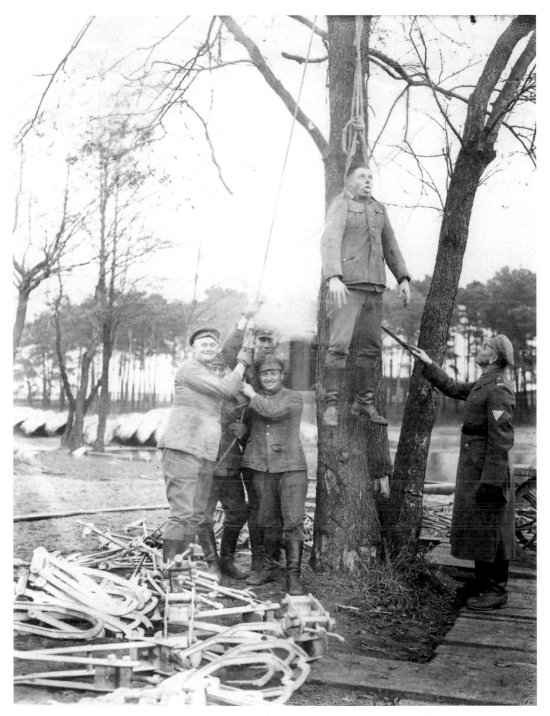

Gallows Humor

Soldiers play at hanging a comrade
while their officer prods him with his
bayonet.

Essen und Trinken

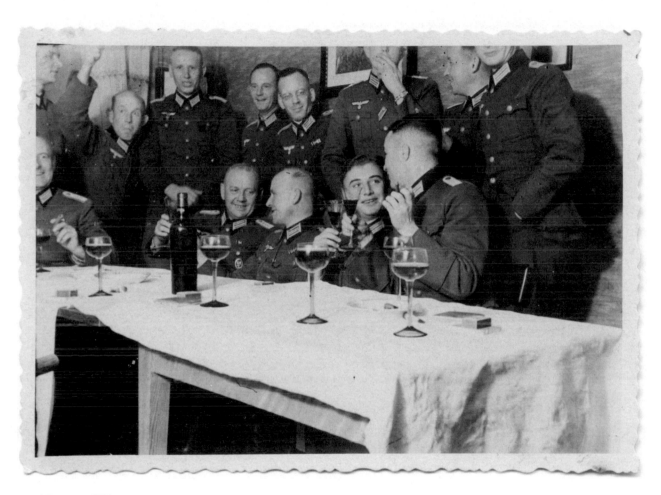

Fruits of Victory

Fine French wine flows as a group of officers celebrate Germany's whirlwind defeat of France in six weeks time. Toasts are raised to the Führer and Fatherland, cigars are lit. The gloating follows the sweet taste of revenge, Germany wiping away the stain of the First World War's Versailles Treaty, which they felt had been unduly severe and degrading. Hitler made the French sign the Armistice in the same train car used to sign Germany's WWI armistice. The gloating smiles would soon be freezing into grimaces in the Soviet winter.

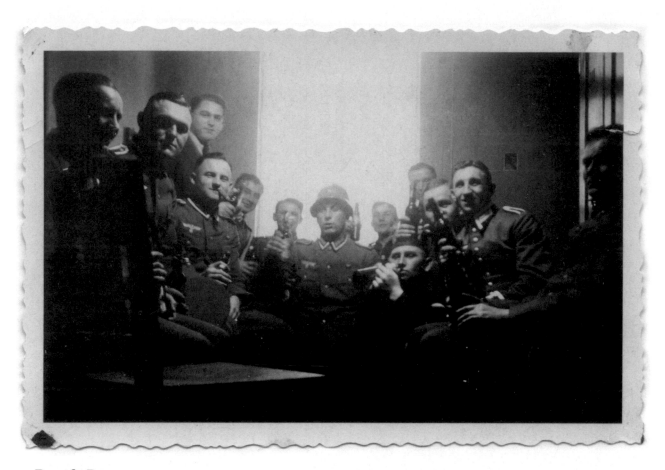

Beatific Beer

In this almost religiously imbued scene, a group of twelve *Wehrmacht Soldaten* gather round the central figure of a soldier wearing the distinctive German steel helmet, the scene brightly backlit by a window streaming light into the room.

Adolf Hitler was staunchly opposed to smoking or drinking, while Himmler, obsessively incensed about drinking among his SS, had several SS men punished for abuse of alcohol. While Germany spearheaded the earliest research into the debilitating effects of alcohol and tobacco, seeing them as "genetic poisons," beer continued to be the staple beverage of the *Wehrmacht*.

French Bread

Burdened with a load of freshly baked breads, soldiers in occupied France pause for a photo.

At Nuremberg, Gunther Otto, a butcher, age 21, testified that when he was assigned to a train carrying fresh meat to the German troops he saw the following incident in Lvov, Poland: "The members of the meat train and the bakery company systematically rounded up all Jews who could be found based on their facial characteristics and their speech, as most of them spoke Yiddish. 1st Lt. Braunnagel of the bakery company and 2nd Lt. Kochalty were in charge of rounding them up. Then a path was formed by two rows of soldiers.

Most of these soldiers were from the meat train and the bakery company, but some of them were members of the 1st Mountain Hunter Division. The Jews were then forced to run down this path and while doing so the people on both sides beat them with their rifle butts and bayonets. At the end of this path stood a number of SS and *Wehrmacht* officers with machine pistols, with which they shot the Jews dead as soon as they had entered into the bomb crater (being used as a mass grave). About fifty to sixty Jews were killed in this manner."

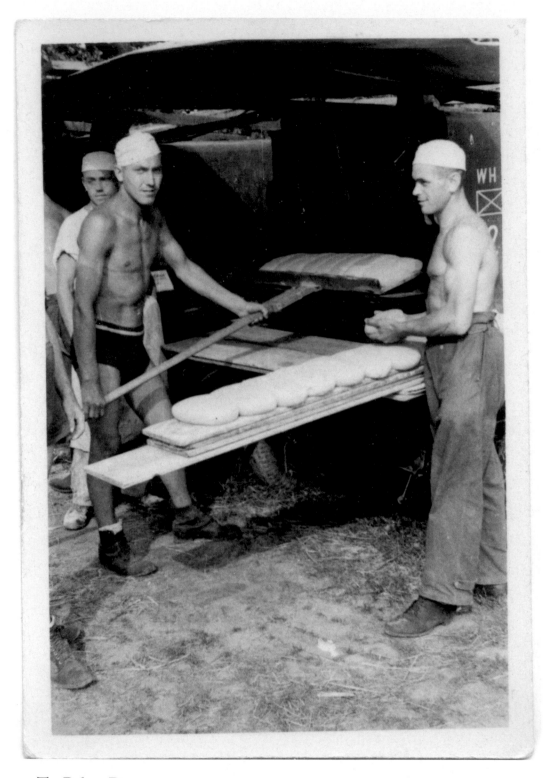

The Bakers Dozen

The bakers of bread for the soldiers do
their hot work.

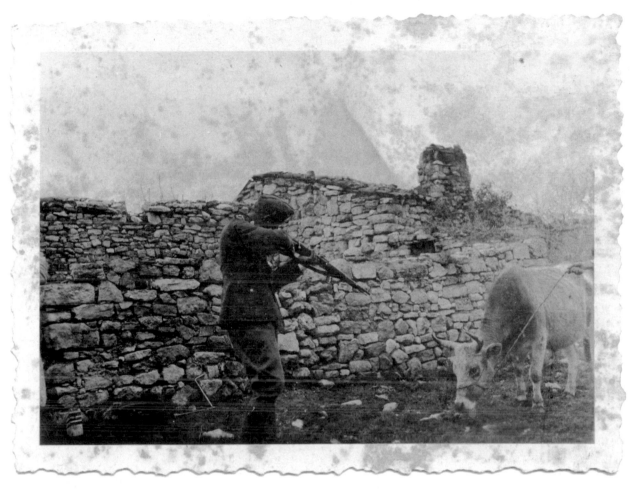

Fresh Meat

A soldier takes aim with his Mauser at the head of a cow that seems to wear an expression of baleful resignation. A helping hand holds a rope halter tied round its head.

Himmler, speaking to his SS leaders on October 4, 1943, about the deaths of their enemies, added, "We will never be hard and heartless when it is not necessary; that is clear. We Germans, the only ones in the world with a decent attitude toward animals, will also adopt a decent attitude with regards to these human animals: but it is a sin against our own blood to worry about them and give them ideals, so that our sons and grandchildren will have a harder time with them."

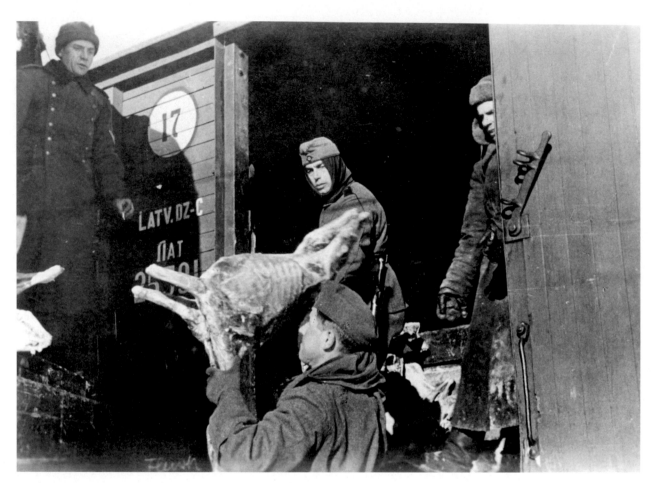

Latvian Exports

Provisions are prepared for transport to
Greater Germany.

Because the Nazi regime feared that low morale would undermine the war effort, they took special pains to see that wartime rations were the highest in Europe. The lands conquered by the German military machine were stripped of their foodstuffs, not only to feed German citizens, but as part of an overall plan to promote widespread starvation among the subjugated peoples. The plan envisioned by the German Ministry of Agriculture in 1940 projected the death of some 30,000,000 Russian civilians. Toward that goal, by early 1942, some 2,100,000 Soviet POWs had died, most by enforced starvation. Hundreds of thousands more of all nationalities would slowly starve to death in concentration and labor camps across Europe.

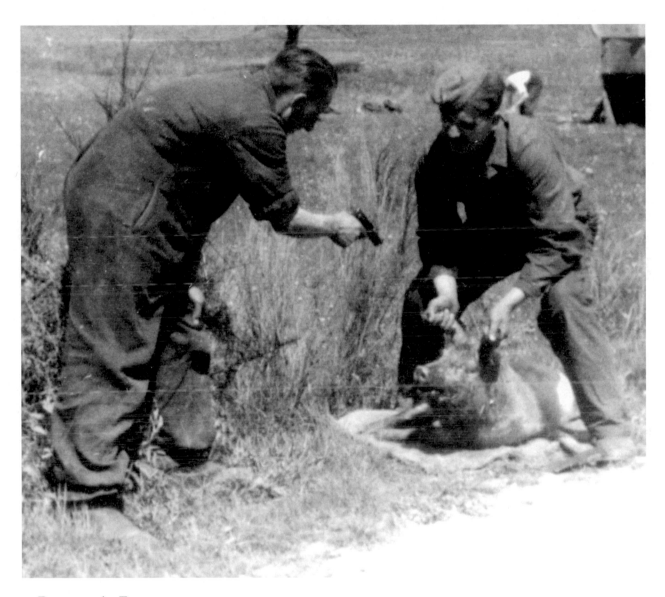

Between the Eyes

Two soldiers, members of a field kitchen crew, "process" a pig. A cloth has been placed beneath the animal. The man holding its ears seems aware of his unenviable position, the gun pointed in his direction as well as at the pig.

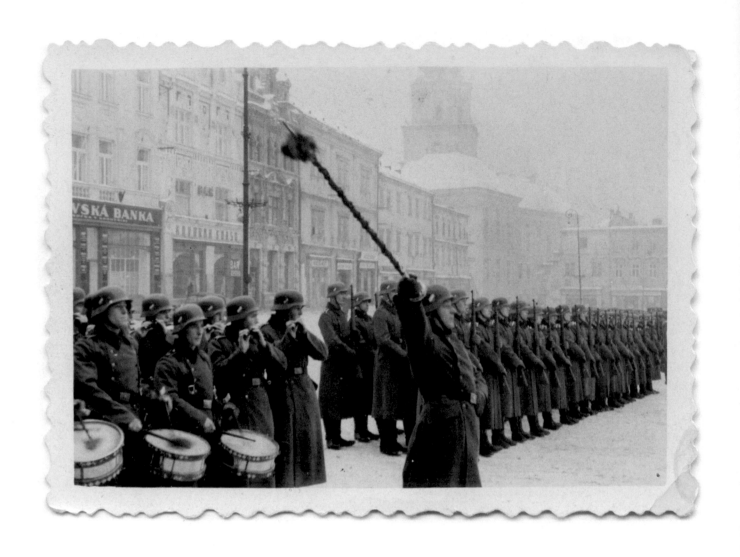

Music

A German Army band plays in a Polish Street, the leader's baton held high.

Music played an integral role in the Nazi regimen that sought to continuously inundate and condition its citizens' senses with the "correct attitude." Richard Wagner's epic music was considered the hallmark of the Third Reich; Hitler adored the composer. Other, lighter music was played in government subsidized theaters and broadcast on the radio as were the strident martial songs sung by soldiers off to war.

* * * *

Hitler's appreciation of Wagner's music was complemented by the composer's intense anti-Semitism. His views are contained in an 1850s booklet *Das Judentums in die Musik* (*Judaism in Music*) in which Wagner proclaimed that the Jews poisoned public taste in the arts.

Also approved for Third Reich consumption was the "good German music" of Anton Bruckner and Ludwig van Beethoven.

A well-known name in contemporary music today is Herbert von Karajan who in the 1930s was the youngest director of an opera company in Germany. As a result of his membership in the Nazi party, ostensibly to gain better conducting positions, he was banned after the war from conducting for three years, but was eventually appointed the permanent director of the Berlin Philharmonic Orchestra in 1958, gaining worldwide eminence as one of Europe's most popular conductors. He died in 1989.

Another contemporary composer of the day, the famous Richard Strauss, held an important position with the Nazi musical hierarchy, but did not take part in the persecution of fellow musicians who were Jewish; in fact he regularly refused to fire Jewish musicians and continued to work with Jewish librettist Stefan Zweig. He also had a Jewish daughter-in-law, which put him at odds with the Nazi regime. By 1935 he was forced to resign his position and his music was censored. He died in 1949.

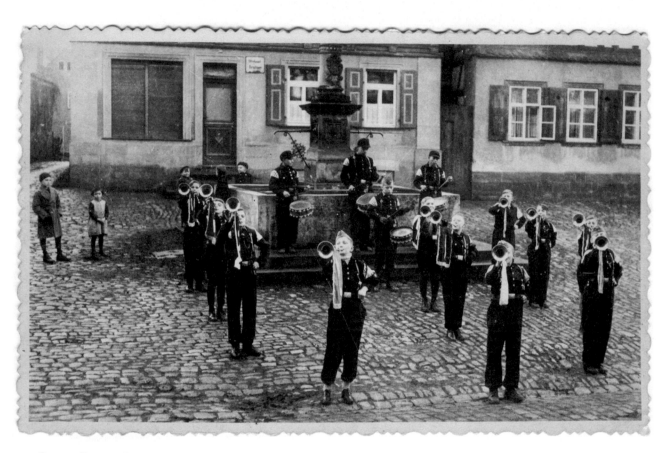

Street Serenade

A Hitler Youth orchestra plays on a
cobblestoned street for a small audience.

Swallows Nest

A young RAD recruit wears the distinctive musician's *Schwalbennester* or "Swallows Nest" insignia on his shoulders.

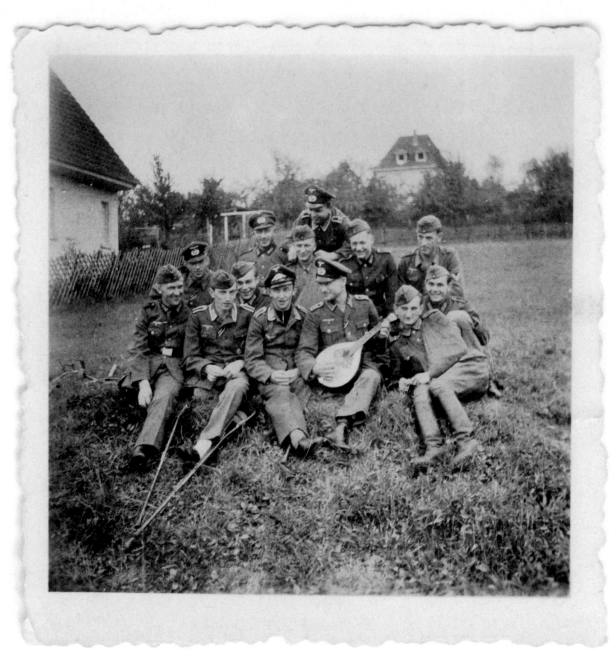

One Lute, Four Less Legs

A one-legged soldier strums a tune upon
a lute for the enjoyment of his comrades,
including three fellow amputees.

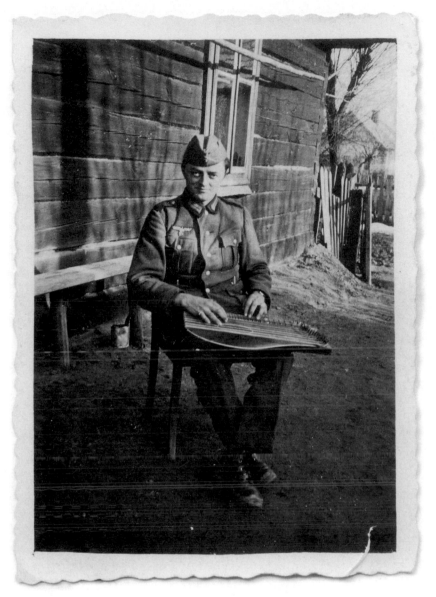

Zither Player in Russia

A soldier enjoys a moment with his chosen instrument, the zither, a popular folk instrument.

Alfred Rosenberg, an early member of the Nazi Party described as a "party intellectual," was editor of the Nazi official newspaper the *Volkischer Beobachter* (*National Observer*). In addition, he was the temporary head of the Nazi Party while Hitler was in prison. A rabid anti-Semite, he was assigned to a special task force charged with collecting the best musical instruments and musical scores for use in a special university to be built in Hitler's hometown of Linz, Austria. To accomplish his task, his area of operation included the looting of all forms of Jewish property in Germany and the occupied territories.

Humor in Gray Uniform

Punchline

Three officers share a joke, perhaps at
the expense of France, which fell
to German forces in just six weeks.

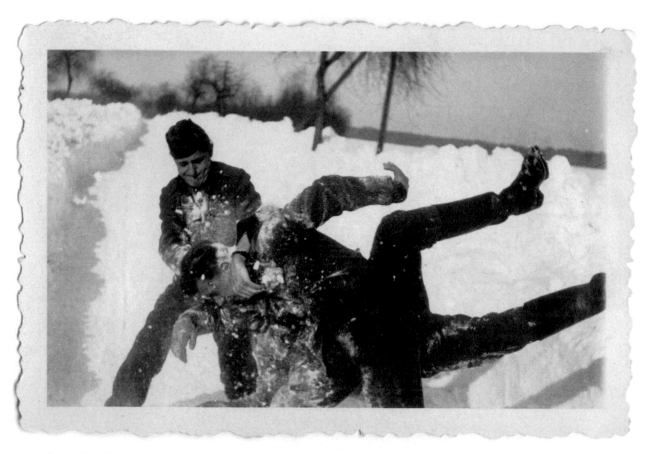

Swastika Snowmen

Three soldiers' violent contortions seem
to create the image of a swastika.

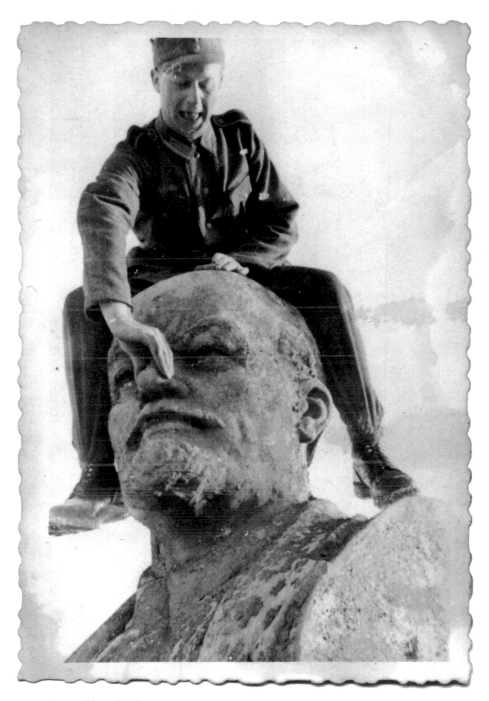

Lenin Tweaked

A soldier has climbed atop a monolithic statue of Lenin and given the father of Communist Russia a good nose tweaking.

Hitler saw two archenemies facing Germany, the Communists or Bolsheviks, and the Jews. Nazi ideology targeted both for annihilation. The Slavs under Soviet control would be "liberated" to become slaves for the Aryan race while the Jews would be eliminated altogether, thus safeguarding the future of the Thousand Year Reich.

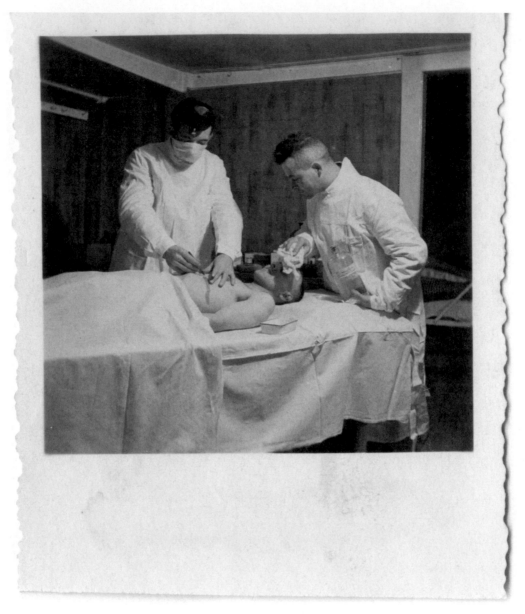

Medical Breakthrough

All is not what it seems in this photo-
graph. The "patient" is smiling and the
"surgeon" behind the mask is holding
not a scalpel, but a fountain pen, the
operation a posed prank, an adjunct of
the young recruits "war games"
that in reality would not prepare them
for the carnage they would create or
endure.

The German military could rely on some of the latest advancements in battlefield medicine, due in part to the country's achievements in the healing arts.

The treatment of wounds was advanced through the vivisection of concentration camp prisoners and experiments that included stuffing wounds with dirt, oily rags and infectious materials, then gauging the effect of various remedies. Prisoners were also subjected to intense cold as well as simulated high altitudes without protection.

German physicians also took part in the euthanasia programs that sought to eliminate the medically and genetically "unfit" from the general population, eventually killing some 200,000 men, women and children. Doctors also aided the mobile killing teams in the East. In Ukraine, with the capture of Kiev, Dr. Wilhelm Gustav von Schuppe and his team of twenty-one physicians and SS men managed within six months, from September 1941 to March 1942, to kill more than 100,000 people, those deemed "unworthy of life," primarily by lethal injection. The murdered included Jews, Gypsies and Turkmen. Twenty-one individuals killing, by hand, 100,000 individuals. It averaged out to 500 a day.

* * * *

During testimony at the post-war Nuremberg "Doctors Trial" of December, 1946, twenty-three physicians and administrators were brought before the court for war crimes. Sixteen of the doctors, the so-called major defendants, were found guilty, seven executed on June 2, 1948. Several others received life sentences, all of which were reduced. Gustav von Schuppe was not among the twenty-three as he was not considered a "major" defendant.

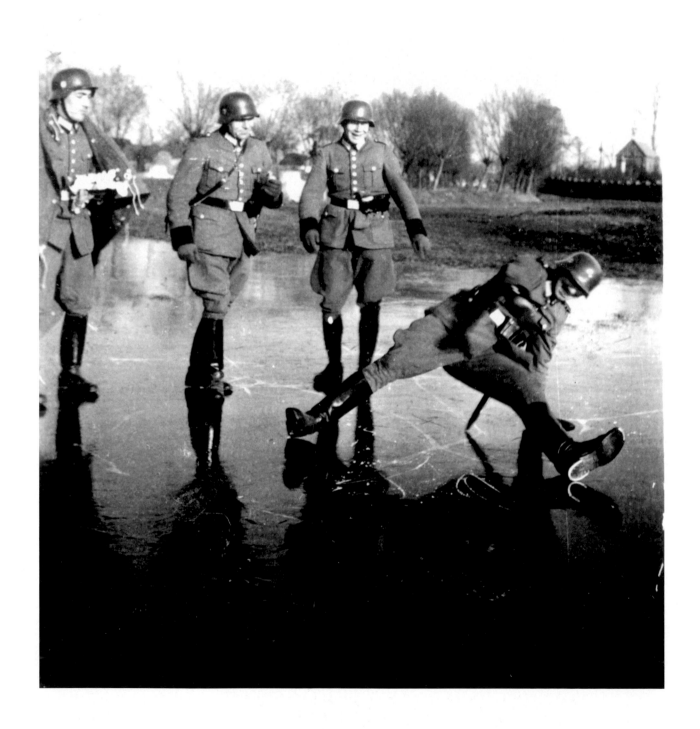

126

Fall from Grace

A powerfully built, elegantly uniformed soldier slips on icy ground, his steel heeled, hobnailed boots tracing his fall from grace. His comrades, seeming to enjoy his dilemma, offer no assistance.

The trio are members of the *Polizei* units that in great part served to implement Hitler's racial war. They would wreak carnage across Eastern Europe as part of the killing teams that scoured city, town and village in search of their quarry, Jews and partisans. The black-appearing cuffs of their uniforms are actually dark brown.

The Police Battalions, composed of 500–550 men each, were composed in large part of individuals who served as pre-war civilian policemen before being transitioned into the military. Many were relatively old for first combat, in their 30s and had no special training in preparation for their duties as mass murderers even against unarmed prey.

However, it was not uncommon for one man to shoot more than a hundred people in a day. For example, on September 29–30, 1941, Police Battalion 45, among others, took part in the shooting of 33,771 Jews at Babi Yar at Kiev in Ukraine. It was one of thirty-eight such Police Battalions active in thousands of killing operations across Poland and the Soviet Union.

Those *Polizei* who survived the war were repatriated to Germany where they resumed their civilian positions and, for the most part, were never brought to any form of justice; in fact they helped their comrades to escape retribution by concealing the evidence of their crimes.

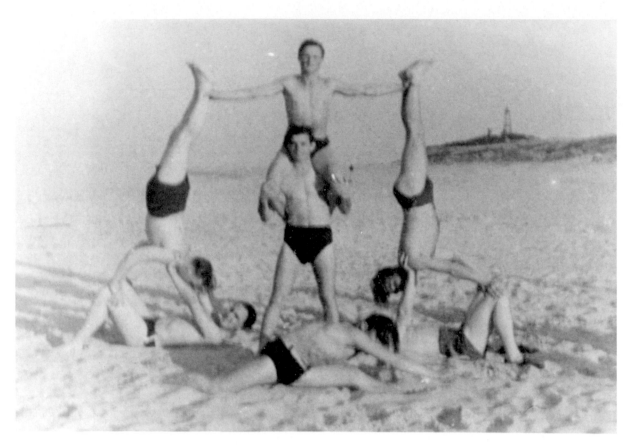

On the Beach

Crew members from the German submarine *U-221* enjoy time above water.

Setting sail on May 9, 1942, under the command of Oberleutnant Hans-Hartwig Trojer, the *U-221* engaged in five Atlantic war patrols, sinking eleven Allied ships. On September 29, 1943, the submarine was attacked by British aircraft off the southwestern coast of Ireland. Returning fire, the *U-221* shot down the *Halifax* but was also sunk. All fifty crew members were killed.

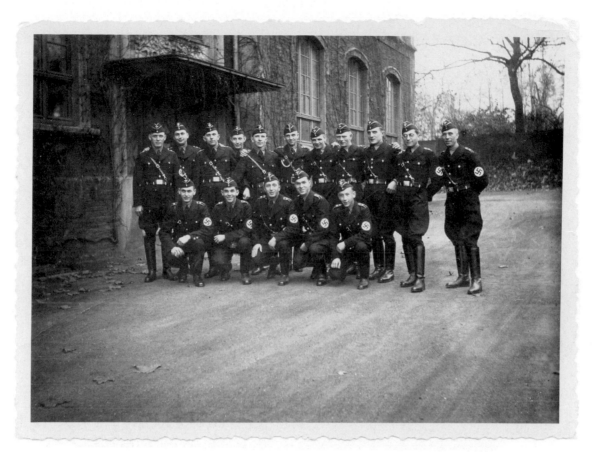

Driving School

Members of the NSKK gather for a portrait.

Nazi ideology penetrated every facet of German life, including automobiles and motorcycle ownership.

Martin Bormann, Hitler's private secretary, head of the Party Chancellery, founded the *Nationalsozialistisches Kraftfahrkorps* (NSKK) in April, 1930. At first, it was operated by the SA. The NSKK took over all German motorclubs in September, 1933 and included 350,000 members. After the annexation of Austria, membership grew to half a million. By January, 1939, the NSKK was training *Wehrmacht* drivers and with the outbreak of war in September, it provided transport for the construction

of the Siegfried Line, assisted in traffic control, resettlement of *Volksdeutsche* from Soviet-controlled areas and other duties that included joining in the action taken against the Polish city of Bydgoszcz on October 10, 1939, just a few weeks after the German invasion of Poland.

Using a prepared list of "enemies" compiled by the SS in advance, 150 members of the NKSS along with 370 German army soldiers, 80 Order Police and 150 ethnic-Germans from the area rounded up civic leaders and professionals, shooting nearly 100.

Sinister Staff Car

A young SS man strikes a threatening pose next to his equally intimidating Mercedes-Benz 320 Long Staff Car. The cabriolet-style cloth roof folded down to provide an open air ride for the officers who occupied its luxurious upholstered seats. The shadow of the photographer is glimpsed against the cobblestones.

Pressed into the service of the Third Reich, as were many German companies of the time, Mercedes-Benz eventually relied on some 30,000 forced laborers and prisoners of war. Some engaged in work stoppages and, as a result, were shipped to concentration camps. After 1941, Mercedes-Benz was essential to the construction of Nazi Germany's *Luftwaffe* and war machine. After the war, the first Mercedes factory to open was located in Argentina.

The use of slave labor has also been attributed to Ford subsidiaries operating in Germany during the war. Henry Ford, an early supporter of Adolf Hitler and the Nazi party, contributed to the campaign coffers of the NSDAP and was awarded the Grand Cross of the Order of the German Eagle by Hitler for service to the Third Reich. During this pre-war re-armament period, 1937 and 1938, the German subsidiary of Ford Motors, *Ford Werke AG,* had willingly become involved in Hitler's war preparations.

Ford eventually issued a statement acknowledging slave labor was used at the plant, but added somewhat of a disclaimer, stating company historians, writing in the 1950s, had determined that the company "lost contact with its German operations" before the United States entered the war; however Ford agreed to "look further into the allegations."

An estimated 10,000 men, women and children, mostly non-German and non-Jewish, were pressed into working at *Ford Werke AG* in Cologne and included French POWs, Russians, Ukrainians, Italians, and Belgian civilians, as well as concentration camp inmates from Buchenwald. Conditions were summed up as "barbarous."

By 1943, *Ford Werke* had doubled its profits in great part because of slave labor, but they did manage to produce 60% of the 3-ton tracked vehicles for the German forces.

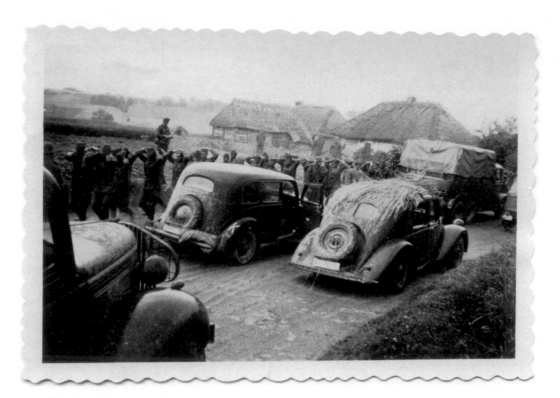

VW for Victory

Long lines of Russian POWs, taken in the early stages of the German invasion of the USSR, file by various *Wehrmacht* vehicles including a *Volkswagen* complete with hay camouflage.

Automobiles and trucks of many sizes and descriptions served the German military . . . Mercedes, Opel, Maybach, Bussing-NAG, *Volkswagen* and Horch . . . an array of staff cars as well as three-ton trucks that served as infantry carriers and cargo/supply purposes.

Ferdinand Porsche, an Austrian citizen, supplied the German forces with the VW based *Kubelwagen*, their version of the American Jeep. *Kubelwagen* roughly translates as "a tub with wheels." An amphibious variation, appropriately called the *Schwimmwagen*, featured a propeller mounted in the rear behind the engine which the driver could engage in the water.

A joint venture by Hitler and Porsche, the *Volkswagen* or "People's Car" was originally slated to be called the KdF-Wagen ("*Kraft durch Freude*" or "Strength through Joy"), but the unwieldy name didn't appeal to the German public. Only 630 of the cars were made before WWII began, most going to Hitler and his cronies. After the war, Ferdinand Porsche was imprisoned in France, though later cleared of war crimes, and it was his son, Ferry, who introduced the now famous Porsche sportscar to the world.

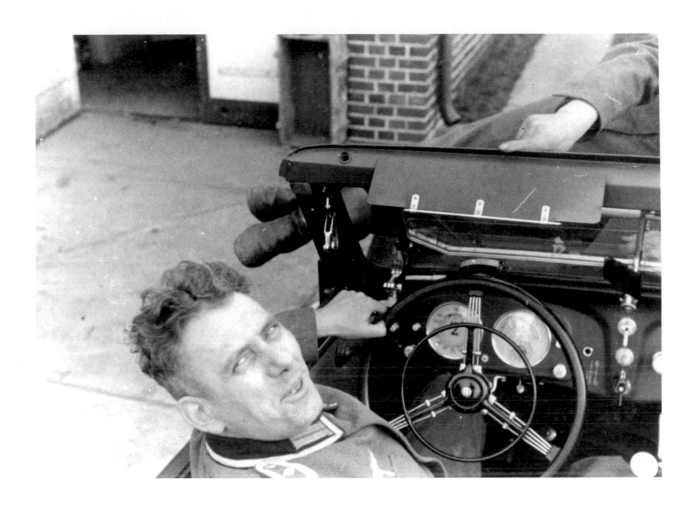

Combat Engineers

Members of a *Pionier* battalion pose with the massive 8-ton hybrid wheeled-and-tracked vehicle, the SdKfz Troop Carrier. Capable of traversing a variety of terrains, it performed various duties including pulling artillery and anti-aircraft weapons or, in this case, construction materials by a cargo trailer. Powered by a Maybach engine and capable of 45 mph, it was manned by two men and could carry nine more on its three bench seats. Armor plating, ranging from 6–10 mm, provided protection from small arms fire. Maybach engines also powered the famous *Panzer* and Panther tanks, the latter a 700hp, 12-cylinder design.

Weary Travelers

The German military traveled by rail in an extensive and highly efficient system that functioned in part to the last days of the war.

Here we see average foot soldiers, *Landsers*, laden with the tools of their trade, and weary from their long travels either to the front or returning home on leave.

Innocent Bystander —
The Railroadman

An unknown railroad man in an unknown place wears an armband identifying him as in the service of the German military, perhaps a member of the *Bahnschutzpolizei*, the German State Railway (*Deutsche Reichsbahn*) security personnel composed of mainly middle aged and older men with prior police experience or WWI service. Their responsibilities, both undercover and in uniform, included checking travel papers and identity documents, defending against partisan attacks, and related duties.

Here he pauses from his duties to take a smoke and to pose for a snapshot. In the background, barbed wired fences, railroad tracks and perhaps the hint of a watchtower to the far left. A woman walks on the path toward him, perhaps on her way to the train station. The railroad man is but one of the myriad cogs in the wheel of the 50,000 mile rail transportation system that enabled the Third Reich to wage war and racial murder. Over 1.4 million people were employed by the railway system.

While an elaborate system of rail networks, the *Reichsbahn*, carried troops and munitions to the front, special trains called *Sonderzüge* (Death Trains) also fed the death camps in Poland, the human fuel for their flaming pyres. Often, extermination operations took precedence over the needs of the military, trains assigned to transport Jews superceding the transport of much needed troops. As Pulitzer Prize– winning author, Richard Rhodes, says in his book *Masters of Death*, "Murdering the Jews had become more important than winning the war. Murdering the Jews, in Hitler's eyes, was equivalent to winning the war, even if it brought down ruin on Germany."

A still-smoldering point of controversy centers on the lack of Allied intervention in the operation of the death camps of which they had full knowledge. Bombing of the rail lines leading to Auschwitz and the other killing centers might have disrupted the apparatus of death. The trains would not have run on time.

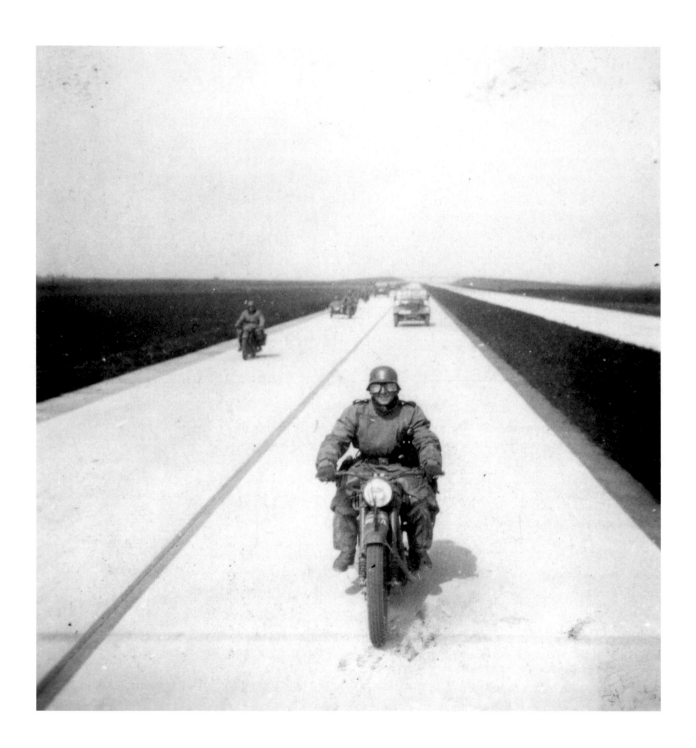

All Roads Lead to the *Autobahn*

Hitler ordered the construction of the first *Autobahns*, not so much for civilian traffic, but to aid in the speedy transport of his war machines, especially his *Panzer* tanks. He had however directed Ferdinand Porsche to manufacture the first "People's Car," the soon-to-be ubiquitous *Volkswagen* designed to flow one day in endless streams across the Greater Reich's advanced roadways. But as the war turned against Germany, the new VWs had to wait for another day and the superhighway was enlisted as a makeshift aircraft runway for the few remaining *Luftwaffe* fighters. But in this photo, snapped when the Third Reich was at its zenith, the *Autobahn* was a dream road obviously enjoyed by this *Wehrmacht* motorcyclist.

After the war, Germans often lauded Hitler as the person who produced the *Volkswagen* and created the *Autobahn*. However, they would be incorrect in assuming that Hitler "invented" the *Autobahn* concept since it was preceded by Berlin's Avus experimental highway (basically a high speed test track) built between 1913–1921, followed in 1929 by construction of the 12-mile long *Köln* (Cologne)–Bonn *Autobahn*, which was inaugurated in August, 1932, by the then mayor of Cologne, Konrad Adenauer, an avowed anti-Nazi, who would years later become the first Chancellor of post-war Germany (1949–1963). At the 1932 *Autobahn* opening ceremony, Adenauer accurately predicted, "*So werden die Straßen der Zukunft aussehen.*" ("This is how the roads of the future will look.")

However, once he assumed power, Hitler did add 3,000 kilometers (1,860 miles) of superhighway to the existing system. While the Nazi Party trumpeted the increased employment benefits of constructing the roads, further expansion efforts ceased by 1941 due to the pressures of the war; the labor carried out for the most part by Russian POWs. And, in reality, most military materials were transported by rail so the *Autobahn's* ultimate contribution to the war effort was less than touted. However, the *Autobahn* concept apparently impressed Gen. Dwight Eisenhower when he entered the conquered Reich so that in 1956, as President of the United States, he would sign a bill to create the U.S. interstate highway system.

Modern Germany's *Autobahn* system is now composed of 11,000 km (6,800 miles) of superhighway, a quarter built during the Third Reich. In April, 2006, the German government announced, after 50 years of resistance, that it would agreed to the opening of the files of the International Tracing Service (ITS) at Arolsen, a massive amount of documentation that stretches 15 miles, three miles longer than the first *Autobahn*.

Lehre dein Kind:

Lehre dein Kind, alles Lebende zu schützen!

Lehre dein Kind, die Schönheit der Natur zu sehen!

Lehre dein Kind, daß die Tiere Mitbewohner dieser Welt sind, und daß wir kein Recht haben, ihnen Fallen zu stellen und sie von der Erde auszurotten!

Lehre dein Kind, daß derjenige, der sich mit Tieren nicht zu befreunden weiß und keine Kameradschaft mit Hund, Katze, Pferd oder sonstigen Geschöpfen im Pelz- oder Federkleid findet, nie die richtige Lebensfreude haben kann, und sei er auch noch so reich, in Wirklichkeit sich seelisch arm fühlen wird!

Lehre dein Kind, nie nutzlos zu töten und nie zum Zeitvertreib Tiere zu verletzen, zu verstümmeln oder zu zerstören.

Lehre dein Kind, daß ein gefangenes und angekettetes Tier nicht weniger leidet, als ein menschliches Wesen!

Lehre dein Kind, daß, wer für sich Mitleid und Sympathie verlangt, dies auch jedem andern Lebewesen zubilligen muß!

Aus „Das Tier", Verlag Dr. Höhne — Ulm a. D

Lost in Translation

A German postcard produced during the Third Reich sums up the Nazi's "enlightened" views on other life forms. The tragic irony of this prose-poem is all too obvious.

TEACH YOUR CHILDREN:

Teach your child to protect all living things.

Teach your child to see the beauty of nature.

Teach your child that animals are cohabitants of this world and that we have no right to set traps for them or to eradicate them from the earth.

Teach your child that those who do not know how to befriend animals and find no companionship in a dog, cat, horse or other fur- or feather-clad creature can never find true pleasure in living; rich though they may be, they will in reality feel spiritually poor.

Teach your child never to kill needlessly and never to injure, mutilate or destroy animals as a pastime.

Teach your child that a captive and tethered animal suffers no less than a human being.

Teach your child that those who desire compassion and sympathy for themselves must also accord this to every other living creature.

Omen

A blackbird perches on a cannon barrel
somewhere in Russia. A notation on the
photo identifies him as "Jacob."

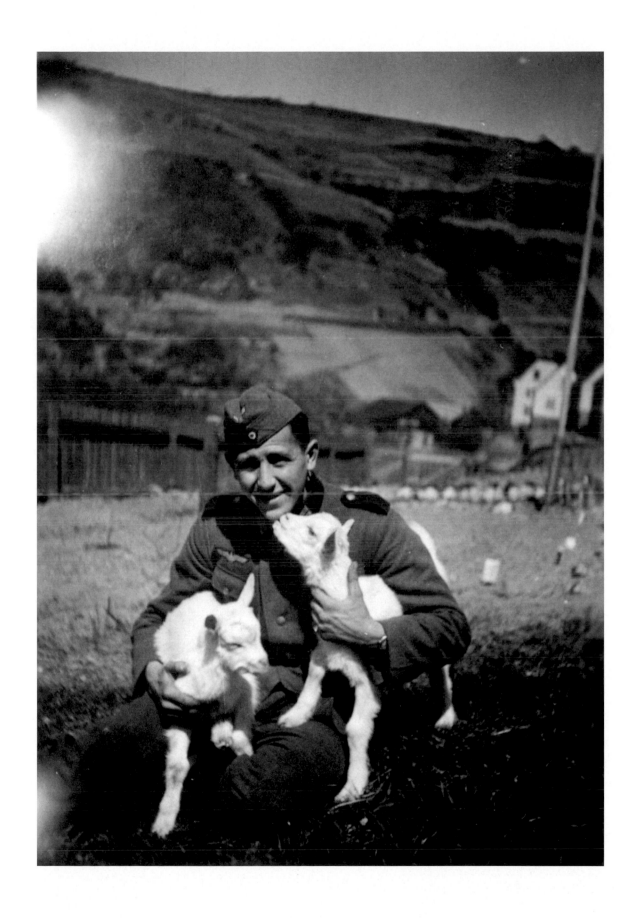

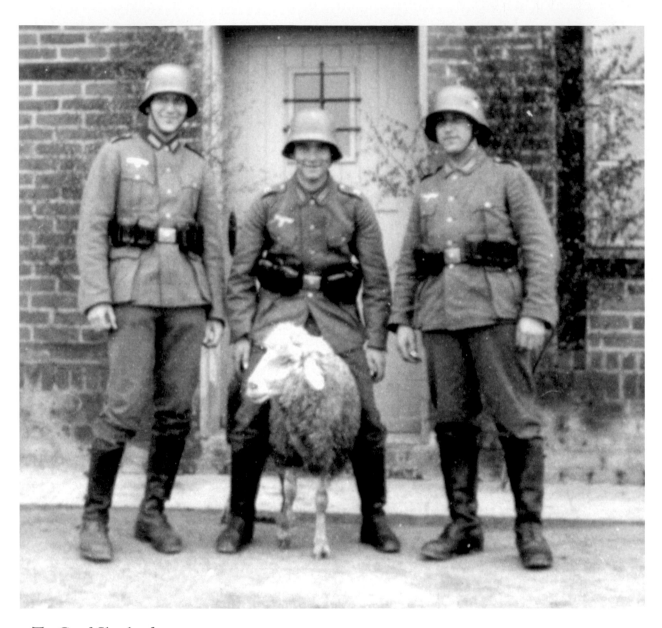

The Good Shepherds

Three soldiers pose for a photograph with a cooperative four-legged companion.

Chancellor Konrad Adenauer, leader of the newly "de-Nazified" post-war Germany, described his generation, those who had followed in the bootsteps of Hilter, as "carnivorous sheep."

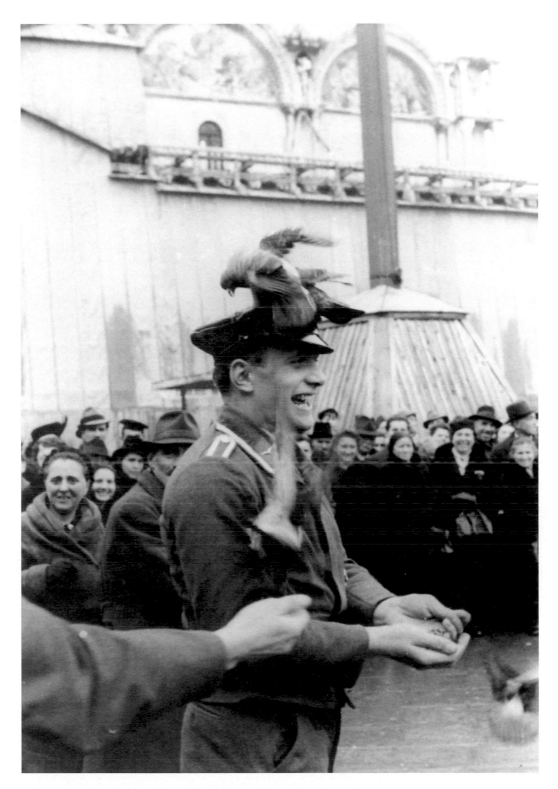

Pigeons

At the moment this photo was snapped,
pigeons were objects of delight, but as
the war brought devastation and famine,
most would disappear from city squares.

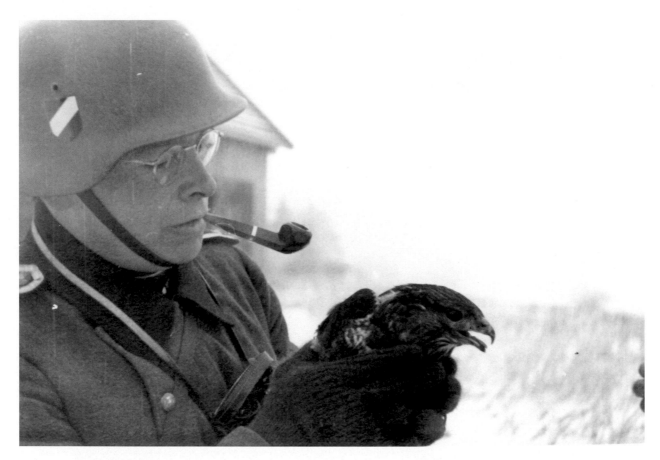

Keeper of the Hawk

A pipe-smoking soldier carefully grasps
a hawk, perhaps a unit mascot.

For centuries the eagle, in single or
dual representation, was employed by
kings and rulers of Germany. The Third
Reich, while deleting previous heral-
dic forms, devised their own, using a
stylized eagle clutching a swastika. The
image of an eagle appeared in a number
of variations including as a motif for the
German Army National Emblem.

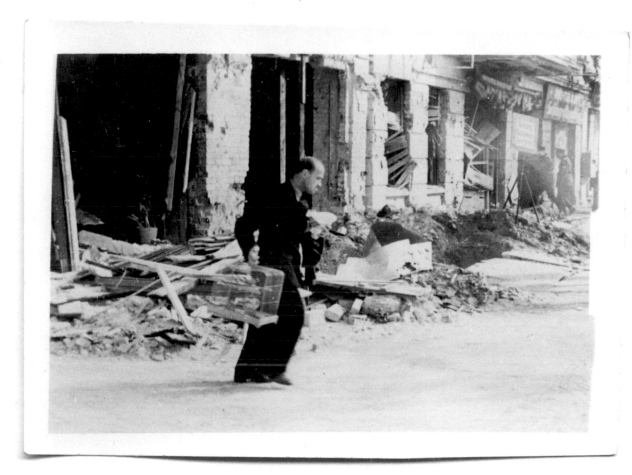

Bird in the Hand

A civilian trudges through a bombed-out German city street, a birdcage in hand. To his left two German soldiers step into the scene of devastation.

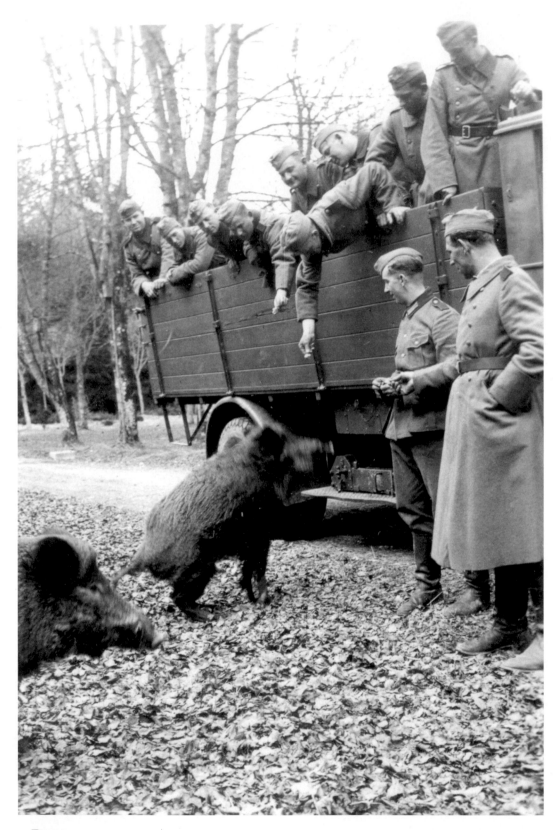

Boars

Soldiers on an excursion stop to feed the
tame boars.

All Ears

Luftwaffe soldiers whisper a secret to a
four-legged friend.

Requisitioned Transport

Soldiers try their luck with a camel cart, the photo dated October, 1942, the location, the Russian Steppes. During this month, German troops pushed the defenders of Stalingrad almost into the Volga, but the tide would soon turn and with it the fate of the Third Reich.

Reindeer Reconnaissance

German soldiers marched across Western Europe and then north toward the Arctic Circle and east toward the Asian Steppes as the Third Reich extended its grip and expanded its menagerie of animals.

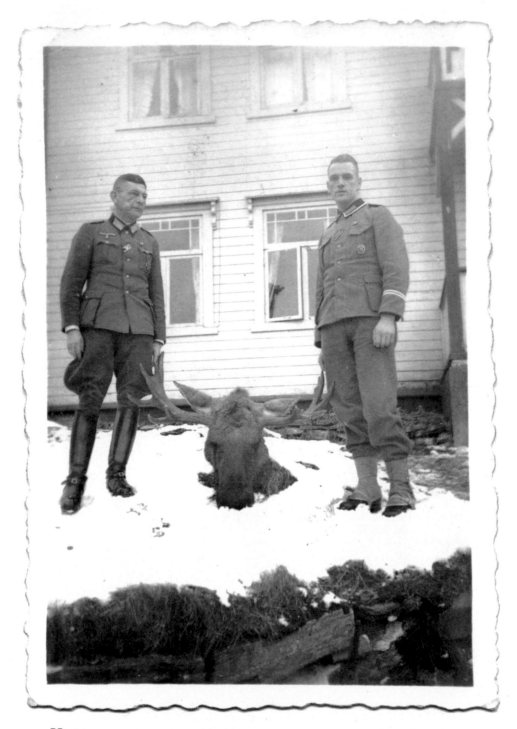

Hunters

Father and son show off their trophy,
the head of a moose. Both men wear the
ribbon for the Iron Cross Second Class,
the father also wears the Iron Cross
First Class, attesting to their bravery
in combat. By his boots and spurs, the
older man is a member of the cavalry.

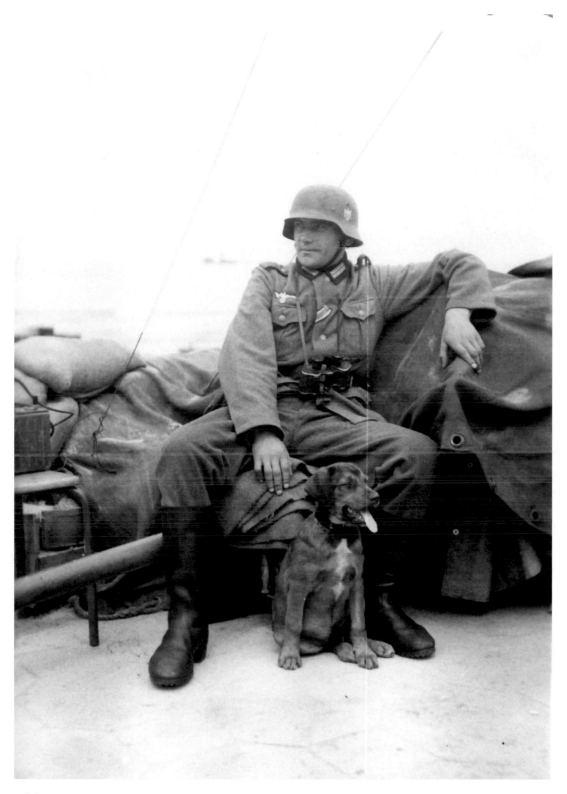

Norway

An officer, with his dog, enjoys a
temporarily peaceful cruise through a
Norwegian fjord.

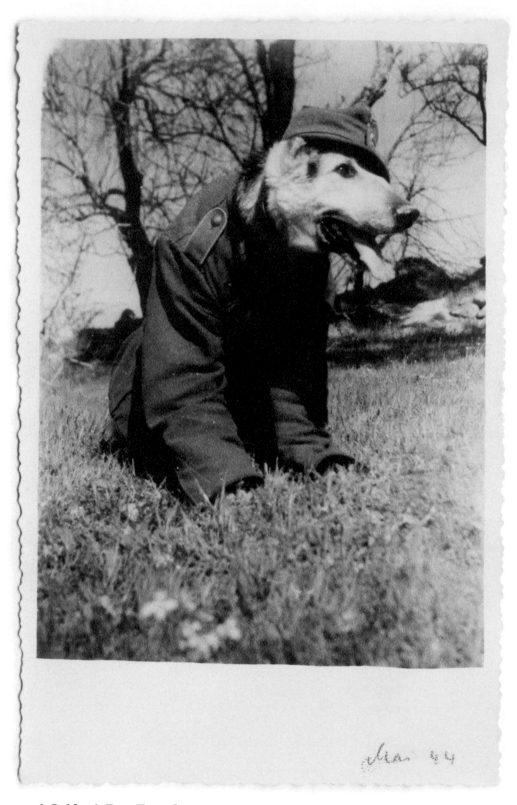

A Soldier's Best Friend

A notation on the reverse of this photo says "In memory of Adi" and is dated May, 1944.

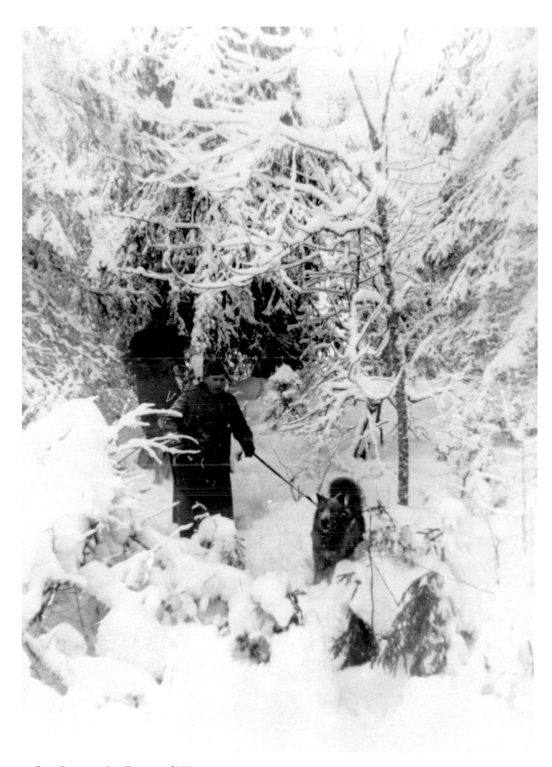

Let Loose the Dogs of War

Field police use their dogs to hunt for the enemies of the Third Reich be they "bandits," a euphemism for partisans, or for Jews in hiding.

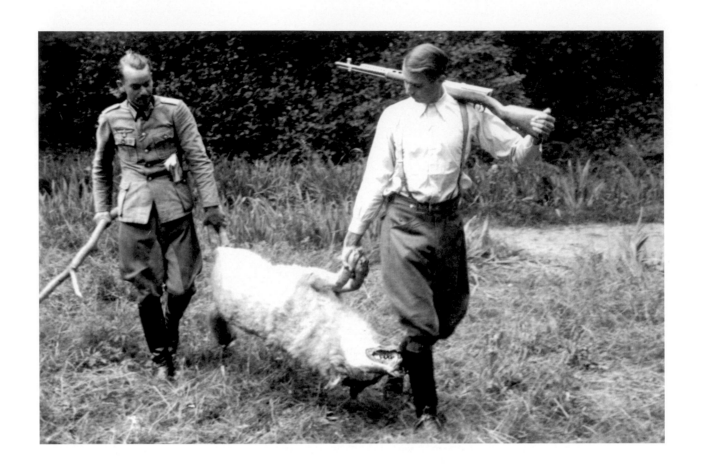

Werewolf

Two soldiers take time off for some hunting and bring back a wolf, its jaws locked in a death grimace.

When Hitler was with his ardent admirer, Winifred Wagner, daughter-in-law of the famous composer, Richard Wagner, her pet name for the Führer was *"Wölfchen"*—Little Wolf.

Hitler had a sister named Paula, but forced her to change her last name as he systematically distanced himself from all relatives due in part to reported instances of hereditary mental illness and also some question about his grandfather's bloodline. The new name he gave to his sister was Paula Wolf.

When Hitler ordered a forward headquarters built in northern Poland, it was called "Wolf's Lair." In preparation for the Führer's occupation of the command center, the Security Service saw to it that an area within a 60-mile radius was "cleansed" of all Jews.

Today about 200,000 people visit the site annually, one in three from Germany. Locals offer a variety of souvenirs including ashtrays in the shape of a skull and a chess game with pieces shaped as German soldiers, SS officers and Hitler as king.

* * * *

During the last gasps of the Third Reich, an organization called "Werewolf" was formed by self-styled "resistance" fighters. The Werewolf members hoped to infiltrate and continue the fight behind enemy lines as Germany was overrun by the Allies. They threatened death to any German who didn't support them, but were ordered to disband by Admiral Karl Dönitz after Hitler's death. The term "Werewolf" has also been associated with special detachments of English-speaking German soldiers dressed in American uniforms that did succeed in infiltrating U.S. lines where they switched roadway signs and created other behind-the-lines disruptions. When captured, they were usually shot as spies.

Trained for Pain

A cane-wielding German guard sets his dogs on a prisoner.

SS guard and later deputy commandant at Treblinka, Kurt Franz, trained a dog named Barihe, originally mild mannered, to attack prisoners, specifically in the groin area.

Franz, having worked at Belzec, arrived at Treblinka in late October, 1943, and eventually took part in its dismantling. A minimum of 700,000 Jews died at Treblinka, including some 300,000 from the Warsaw Ghetto during the period of July 22, 1942, to October 3, 1942. Franz was finally brought before a German court in September, 1965. Evidence included a photo album found at his home titled "*Schöne Zeiten*" or "The Good Times" in which along with pictures of family were photos of his work at Treblinka. Sentenced to life imprisonment, he was released in 1993 because of old age, and continued to live in Dusseldorf.

Police Man and Police Dog

A member of the *Polizei* poses for a formal studio portrait with his four-legged colleague, a German Shepherd.

Himmler's SS had incorporated over 250,000 men into the German Police forces by August, 1940. First implemented in the wake of the invasion of Poland, the Police Battalions joined the SS, SD and *Gestapo* all charged with enforcing the edicts of the Third Reich that included eliminating those considered threats of a military, political and racial nature. In Poland, they were to prepare for the expulsion of the western Polish population to be replaced by Germans, the elimination of Polish intelligentsia, the eradication of the Polish Jews and to combat guerilla insurgency.

In just the first eight months between September 1, 1939, and May 1, 1940, the combined efforts had forced some 186,000 people from their homes and murdered another 52,000.

Cat Lovers

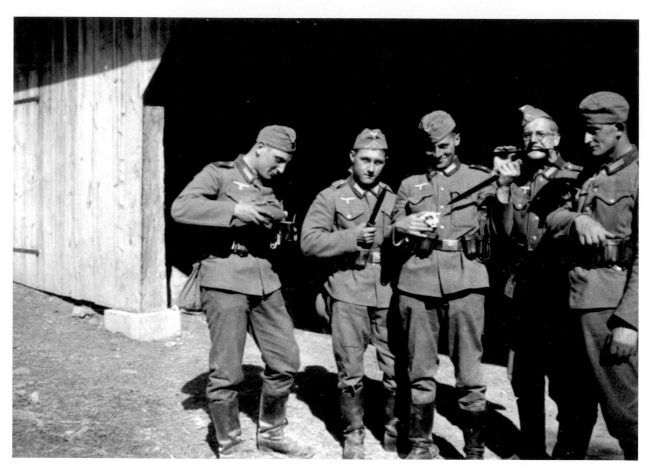

Less Than Nine Lives

A group of young soldiers play with
their daggers and a small kitten.

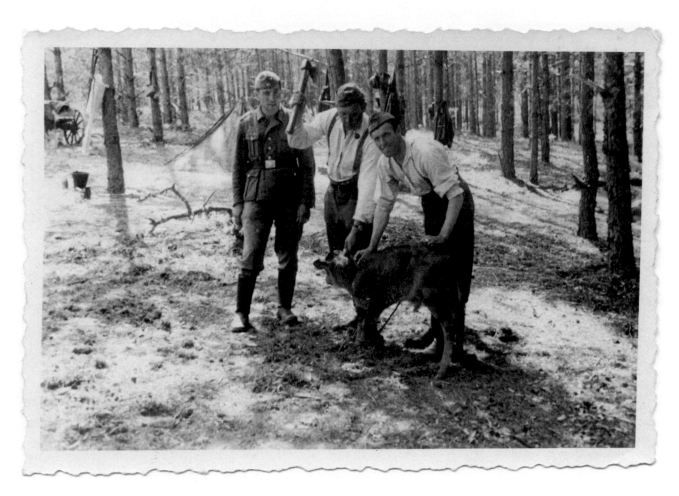

Calf Killers—July, 1943

Striking Similarities

A soldier tends to a piglet while its large
mother stands nearby

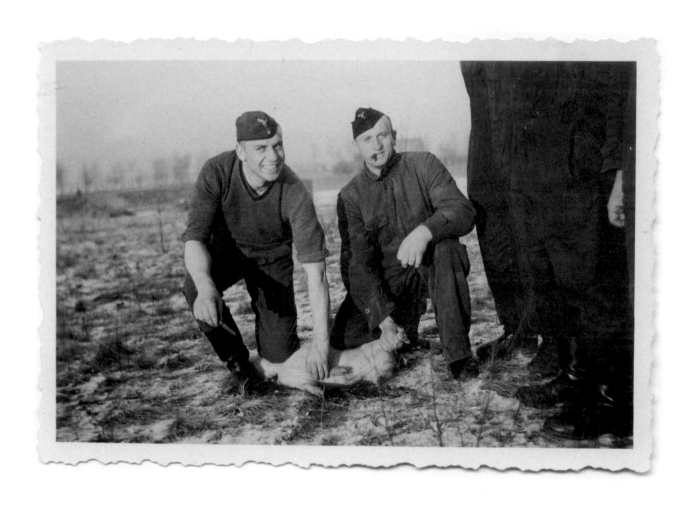

Anomalies

The National Socialists envisioned a Third Reich that would govern a new Pan-Europe cast in its own "superman" image of Aryan racial purity. Strict guidelines as to physical as well as ideological characteristics were established for membership in the SS, but were apparently more lax in other arms of the military. While soldiers were indoctrinated to think of themselves not as individuals, but as part and parcel of the State, one wonders how the not-so-supermen felt amongst their more "ideal" brothers at arms.

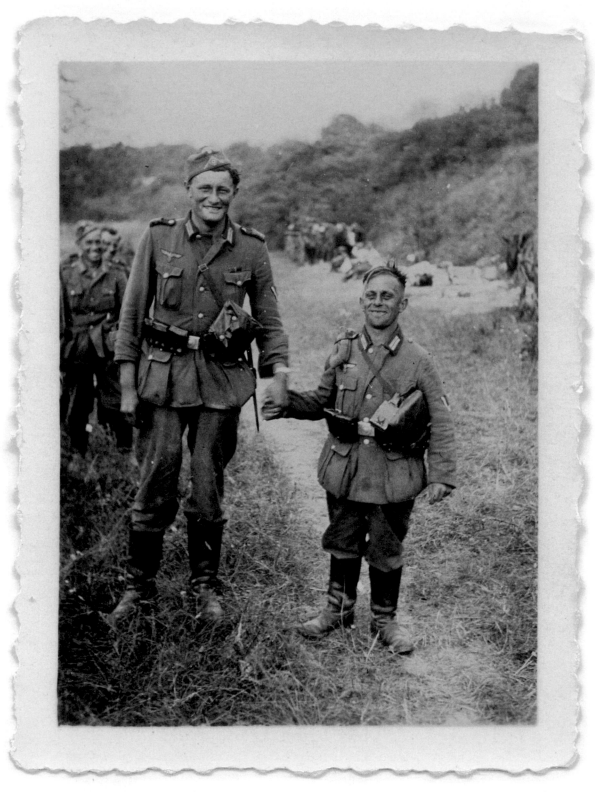

The Not Quite *Übermensch*

With apparent good-natured success,
the cameraman has brought the tall and
short of it together for a photo op.

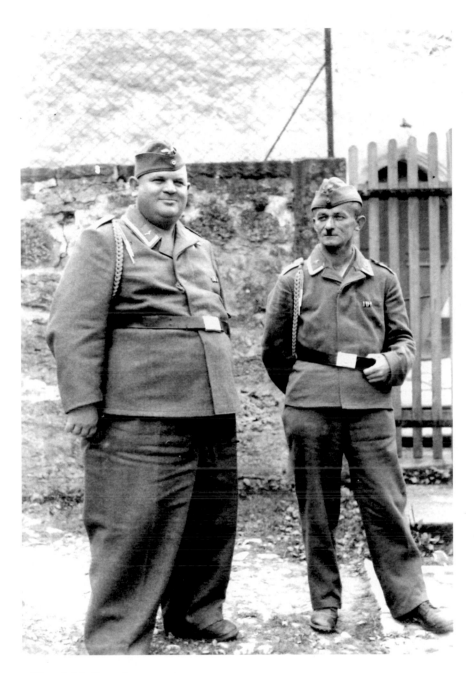

The Odd Couple

In this photo, the "Oliver and Hardy" pair of *Luftwaffe Soldaten* could be friends. Or perhaps the two were singled out for the photo because of their striking differences or due to their similarity to the duo of slapstick American comedians popular in Germany, but known as "Dick und Duff."

While they may be the butt of some photographer's joke, the German military strongly supported the guideline that personal achievement, rather than social standing or education, was the criterion by which individuals were judged and promoted. However, physical fitness and form were also of considerable importance, so these two air force men, far from the Nazi image of the Aryan ideal, were most likely not selected for elite divisions.

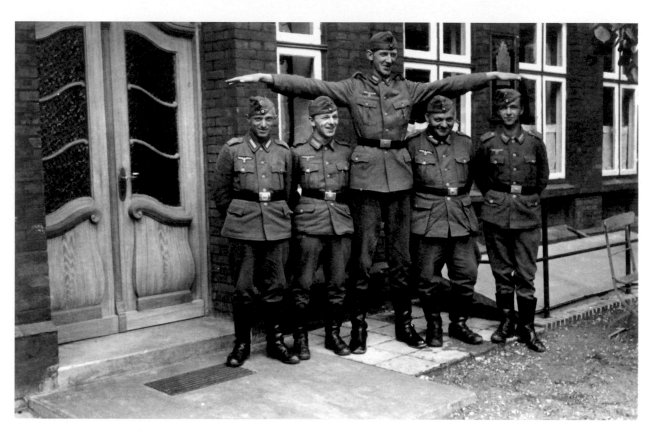

A Cut Above

This very tall soldier was a popular figure, his picture cropping up in various soldier's photo albums. His ultimate fate is unknown.

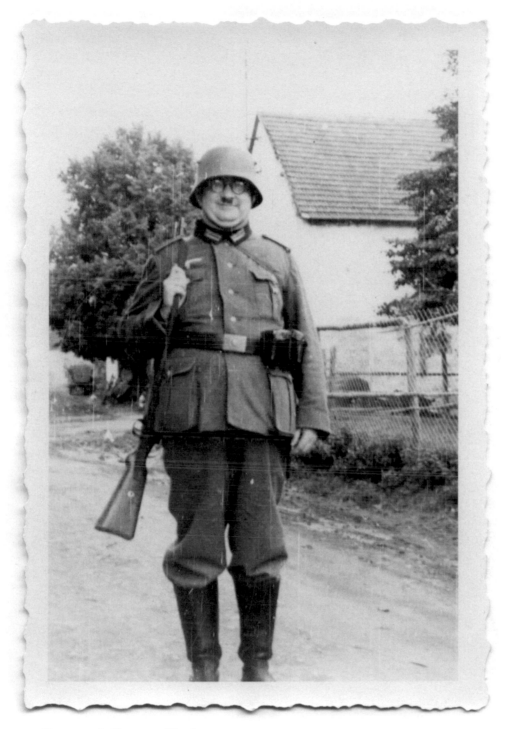

Someone's Favorite Uncle

A comparison is inescapable to "Sgt. Schultz" of the popular TV series "Hogan's Heroes." With his thick eyeglasses, portly demeanor and warm smile, this soldier seems more like someone's favorite uncle than a highly trained killing machine. Individuals deemed less "suited" for combat were assigned other duties until the end of the war when all, including cooks and clerical workers, were thrust into the maelstrom, perhaps even Sgt. Schultz here.

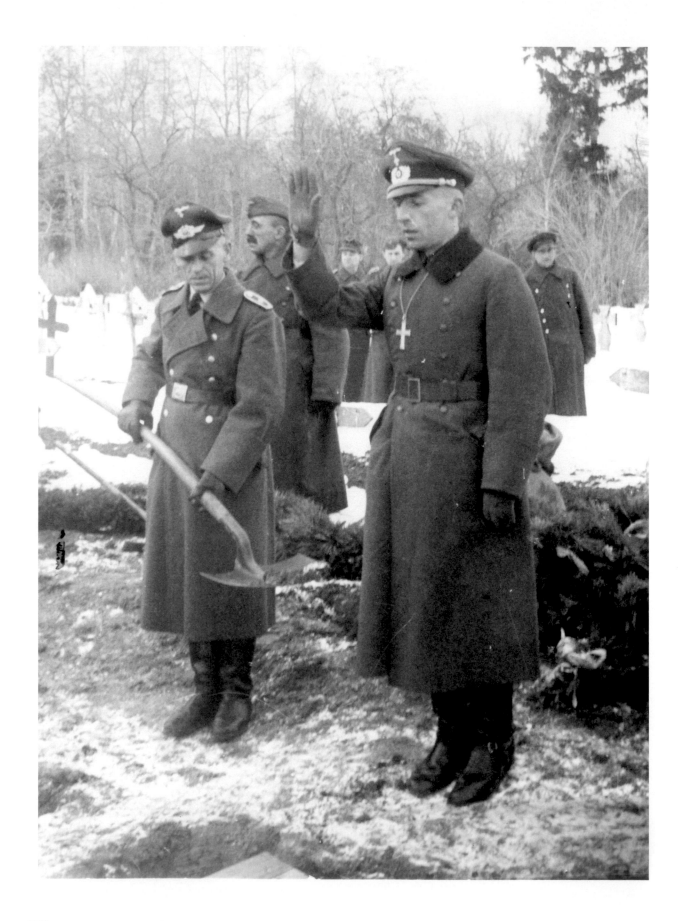

Dust to Dust

Although the Nazi ideology attempted to do away with Christianity and supplant it with its religion of politics, traditional religion, both Catholic and Protestant, co-existed within the *Wehrmacht* if, by sharp contrast, not within the SS which, in fact, desecrated houses of worship when it came upon them. Hitler, himself a lapsed Catholic, referred to "Providence" in place of God in his speeches. Oddly enough, the infantryman's standard belt buckle was inscribed with "*Gott Mit Uns*"—"God With Us"—while a number of priests and ministers served as military chaplains, several dying in combat.

While Christian crosses were used to mark *Wehrmacht* graves, the SS resorted to the pagan runic triangle. In the early years of the war, great ceremony was attached to honoring the fallen, but on the Russian front, as the body count grew, mass graves came into use.

In this photo, a chaplain gives the final prayer for the dead as the first shovelful of soil is readied, the simple wooden coffin just visible in a grave freshly cut into the frozen earth. The chaplain's hand is raised in final benediction and not in the Nazi salute.

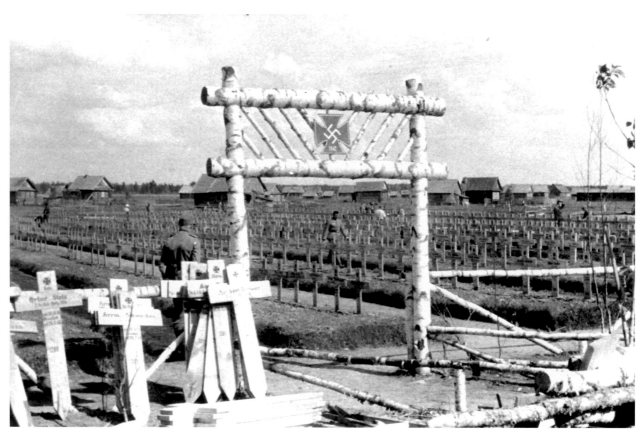

Cemetery

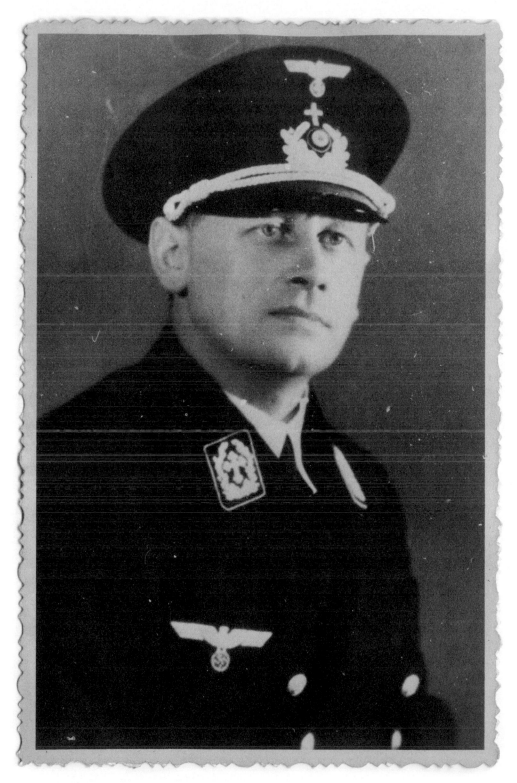

Holy Vestments

A studio portrait of a *Kriegsmarine* (Navy) chaplain. The only distinguishing element identifying him as a member of the clergy is the cross on his cap.

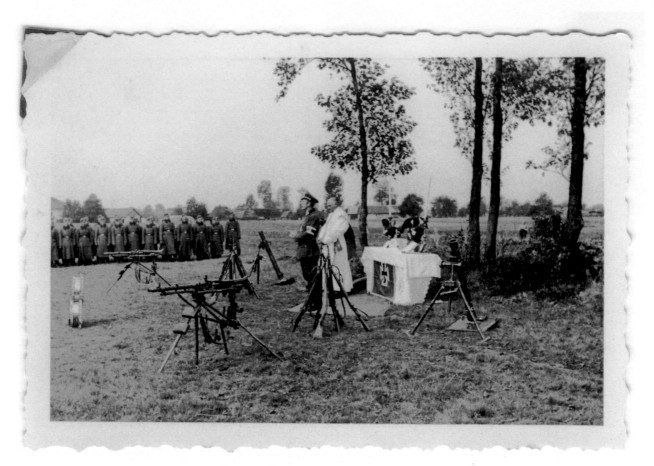

Blessing of the Machine Guns

A member of the clergy, surrounded by the latest in German machine guns, ministers to troops in the field.

From the official *Wehrmacht* Handbook for Catholic Priests:

Prayer for Leader, People and Army

Let us pray!

Bless our German People in your kindness and strength and drive deep into our heart the love of our Fatherland.

Let us be a heroic epic and worthy of our ancestors. Let us guard the beliefs of our ancestors like a holy treasure.

Bless the German Army, which has been called upon to safeguard the peace and pro-

tect the Homeland. And give the troops the strength for the highest sacrifice for Leader, People and Fatherland.

Bless especially our Leader and Commander-in-Chief in all the tasks that confront him. Let us see, under his leadership, the holy task of devotion to People and Fatherland, so that we, through faith, obedience and loyalty will reach the Eternal Home in the Domain of Your Light and Peace. Amen.

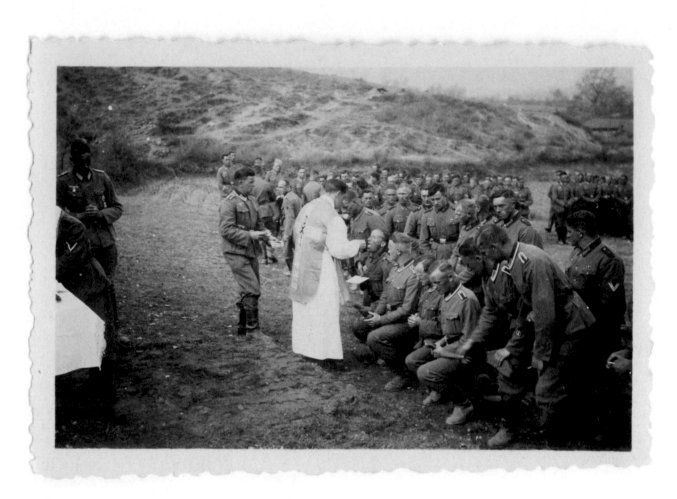

Communion—Russia, March 4, 1944

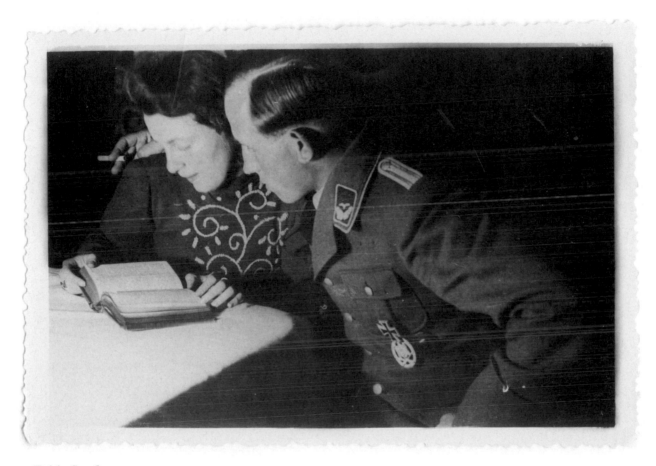

Bible Studies

A combat-decorated *Luftwaffe* officer
and his wife read the scriptures.

Many Germans were deeply religious
and followed their Catholic and Prot-
estant faiths despite the conflict with
official Nazi ideology.

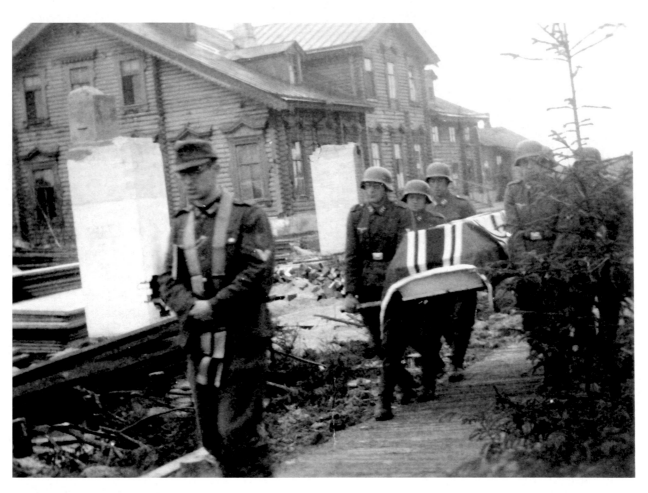

Two Crosses, One of Iron

Somewhere in Russia, an army chaplain leads a funeral procession amidst the rubble of war. The soldier-priest owes allegiance to two crosses, his faith and the Iron Cross Second Class indicated by the ribbon attached to his uniform's second button.

Dem Gebete der Gläubigen und dem hl. Opfer seiner Mitbrüder empfehlen wir den hochw. Herrn

Gottfried Ornetsmüller

Zimmermeisterssohn in Andorf 60
Kooperator in Feldkirchen (Innkreis)
Sanitätsgefreiter eines Infanterieregiments

Er opferte sein junges und geweihtes Leben im 28. Lebensjahre, im dritten Jahre seines Priestertums, am 26. September 1941 bei einer Waldschlacht im Kessel von Kiew, getreu dem Fahneneid, bei Betreuung eines schwerverwundeten Kameraden in Erfüllung seiner Soldatenpflicht und in Ausübung der christlichen Nächstenliebe. Sein Leichnam wurde im Regimentsfriedhof von Mestetschko-Beresany nach Einsegnung durch einen Priesterkameraden beigesetzt.

Gottfried Ornetsmüller

geboren am 1. März 1914 in Andorf, bereitete sich mit hingebungsvollem Eifer im Knabenseminar Koll. Petrinum (1926-1934) und im Priesterseminar zu Linz (1934-1940) auf den Priesterberuf vor, empfing am 2. Juli 1939 im Dom zu Linz die hl. Priesterweihe. Nach nur zweimonatiger, eifriger seelsorglicher Wirksamkeit in Feldkirchen (Innkreis) wurde er im April 1940 zum Sanitätsdienst einberufen.

Sein Talent, besonders in Musik, verwendete er ganz zur Ehre Gottes und erfreute damit in seiner sonnigen, heiteren Art auch die Mitmenschen.

R. I. P.

Deathcard for a Medic Priest

Gottfried Ornetsmüller, a Catholic priest, ordained in 1939, joined the *Wehrmacht* as a medic in 1940. He was killed in action on September 26, 1941, at age 27, near Kiev while coming to the aid of his wounded comrades. He was buried in Beresany, Russia.

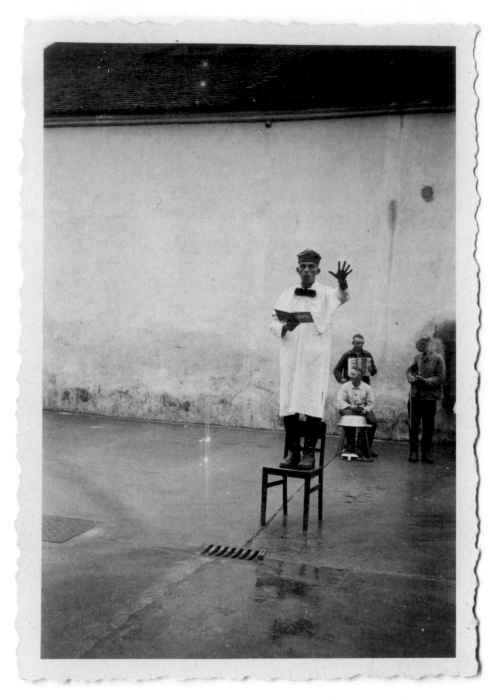

Mocking Tones

While musicians play in the background a German soldier pretends to preach a sermon.

While both Catholic and Protestant clergy tended to the spiritual needs of the German army, if not the SS, the Church often fell victim to the Nazis, particularly in Poland. In 1939, of some 10,000 clergy in Poland, almost 20% died during the war at the hands of the Germans.

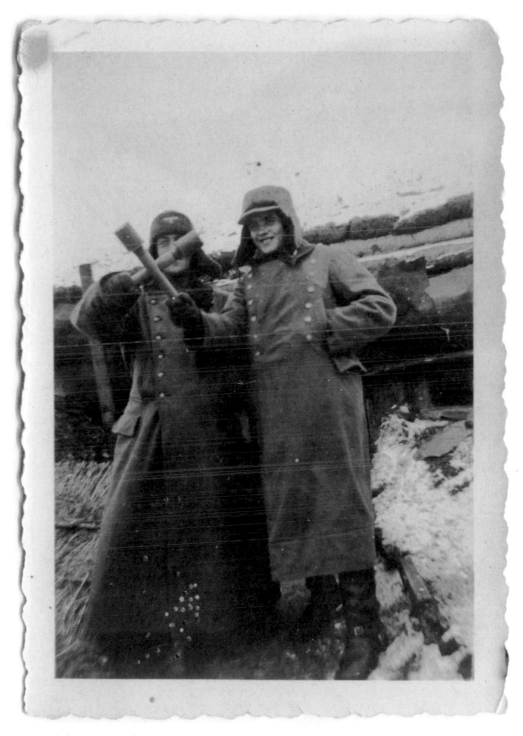

The New Religion

Some time during the Russian winter
of 1941, when soldiers had not been
issued cold weather uniforms, two
young soldiers, still in good cheer, cross
stick grenades, perhaps in celebration of
Christmas.

PART TWO

Prelude to War

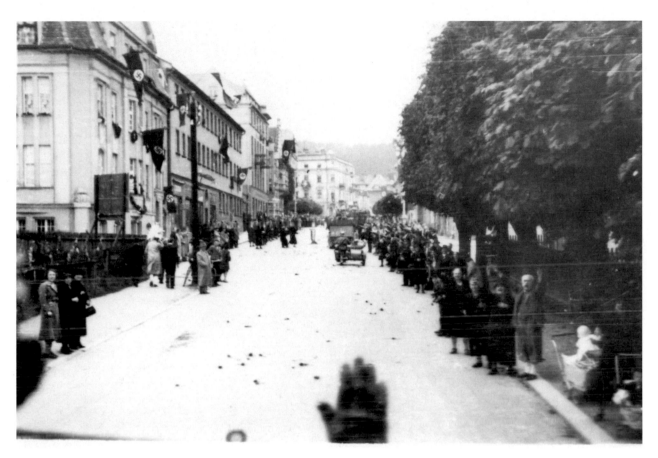

**Sudetenland, Czechoslovakia—
October, 1938**

Swastika banners fly in greeting as a procession of German vehicles parade into view, signaling another successful "annexation" for Greater Germany. A gloved hand seems to be giving the Nazi salute.

Hitler planned to conquer Czechoslovakia, which had been created out of parts of Austria-Hungary after WWI. It had some three million German-speaking inhabitants, and was rich in minerals as well as being a major munitions center. Neville Chamberlain became infamous for his policy of "appeasement" when he handed the territory over to Hitler in exchange for "guaranteed peace." Hitler's prestige skyrocketed at home.

After WWII ended, the German-speaking natives were forced from the Sudetenland and the area was repopulated by native Czechs.

188

Die Genaue Zeit: Anschluss

The Austrian clock shop's sign reads *"Die Genaue Zeit"* which translates as "The Exact Time." The unique image captures a pivotal moment in history, March 13, 1938, when Germany annexed Austria into the Greater Reich. Due to the exuberant welcome received by the German troops, the *Anschluss* was also known as the Battle of Flowers.

Oddly, only women and children stand along the roadside, their body postures and expressions not exactly overflowing with warm welcome although the "reunion" with Germany was popular throughout Austria. The *Anschluss* was a matter of agitation for years by both countries inasmuch as most of the German-speaking peoples of the geographically contiguous nations supported the concept, an idea forbidden by the Treaty of Versailles, which punished Germany for its role in the First World War.

While the Austrian Chancellor Schuschnigg sought to retain Austrian independence, Hitler brought troops to the border, forced his resignation and installed the leader of the Austrian Nazis, Artur Seyss-Inquart. One should remember that Hitler was born in Austria, the union of the two countries a top priority as soon as he assumed power in 1933. Schuschnigg was soon thrown into a concentration camp, but survived the war, emigrated to the U.S. and taught political science at Washington University in St. Louis and became an American citizen in 1956.

Austria's role in World War II seems to have faded from public consciousness along with the Axis collaboration of Romania, Hungary, Finland and Italy and enthusiastic volunteers from Latvia, Estonia and Lithuania as well as Ukraine.

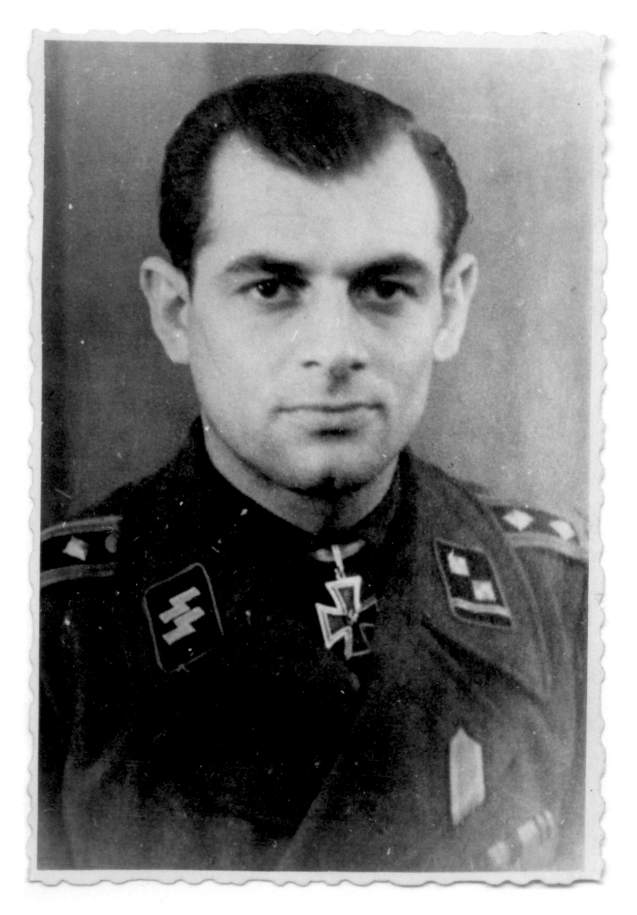

Who Dressed the SS?

Well, it was so theatrical. You know, I guess pure evil . . . whoever designed the Nazi's uniforms was a theatrical genius. And the German cause was pure evil, that's all there was to it. I don't think there's been another war like that. —Kurt Vonnegut

You could read the whole history of the German *Soldat* by his uniform and its insignia. Volumes have been written on the wide variety of badges, pins, buttons, ribbons and patches created by the Third Reich. The soldier's uniform literally broadcast his accomplishments, in effect, his honor, and in far greater detail than his adversaries' uniforms. While film documentaries often show the black uniformed SS soldiers, in reality the SS wore the gray of the regular army. The black uniforms were worn mainly by members of Hitler's personal bodyguard, the SS—*Leibstandarte Schutzstaffel Adolf Hitler* during the 1934–1938 period when they appeared in parades or on ceremonial guard duty.

SS is an acronym for *Schutzstaffel* or "guard battalion." Its origins lay with a small group of tough street fighters formed as Adolf Hitler's personal bodyguard in the early days of the Nazi movement during the 1920s when the *Nationalsozialistische Deutsche Arbeiter Partei* (NDSAP) or German National Socialist Workers Party, was battling its opponents, both Communist and other right-wing groups, in the streets of Germany. Shortly after the November, 1932 and March, 1933 elections that would usher Adolf Hitler in as the new German Chancellor, and under the direction of his henchman, Heinrich Himmler, the SS would metamorphose into a "state within a state" and permeate all levels of the German infrastructure. Its ultimate allegiance was to the Party, the ideology of the NDSAP, its mission to carry on after the passing of Hitler, as the progenitors and the guardians of the New World Order and a pan-European alliance led by the Reich. In the short span of twelve years the SS would spawn legions of committed "political soldiers" who would murder millions.

Founded in 1923, a decade before Adolf Hitler was voted into office, the clothing company, Hugo Boss, would design and manufacture uniforms for the German armed forces and Nazi government officials, before and during World War II.

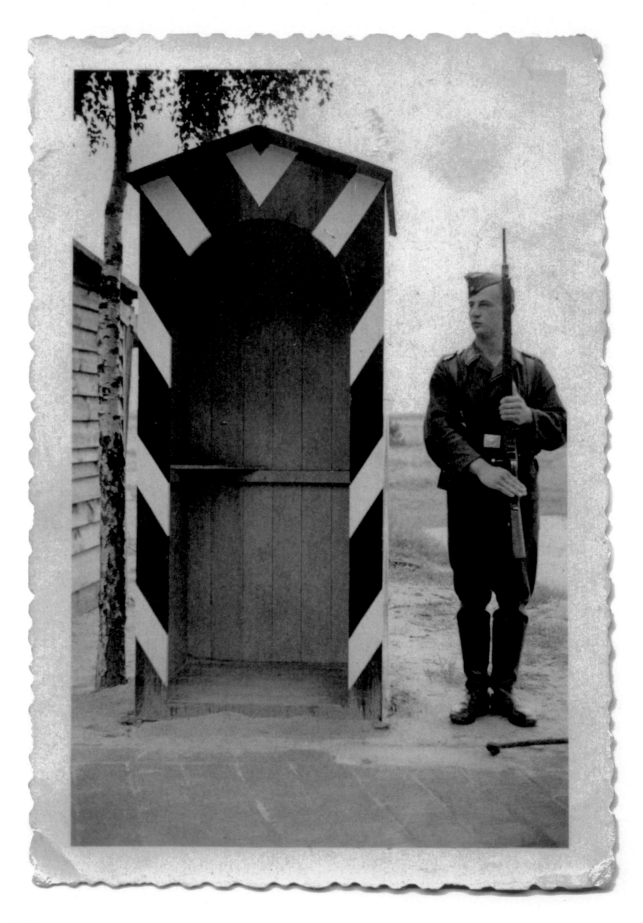

Navy Veteran

An older *Kriegsmarine* officer, perhaps a World War I veteran, wears a close-cropped Prussian style haircut and an immaculate white dress uniform.

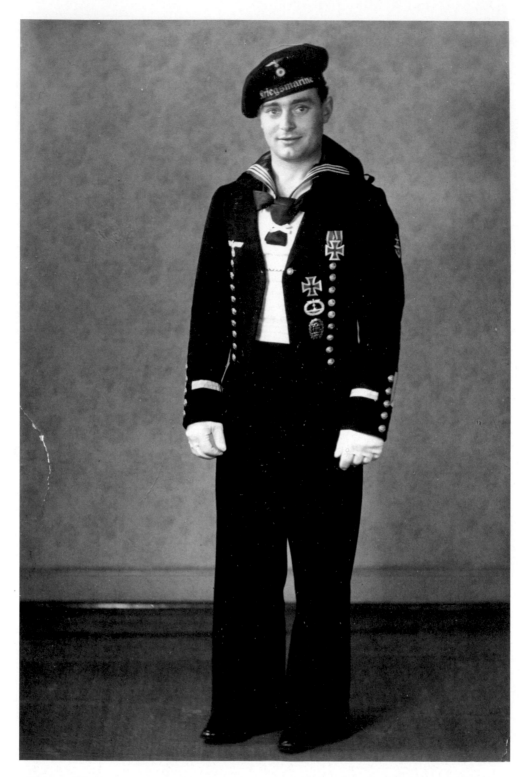

U-boat Hero

Λ rare portrait of a highly decorated German submariner. His awards include the Iron Cross First and Second Class as well as the *Unterseeboot* service medal.

Some 70–80% of U-boat sailors went to watery graves, the highest attrition rate of any service during the war.

Wehrmacht

In the officer's dining hall an army artillery officer faces the camera unflinchingly.

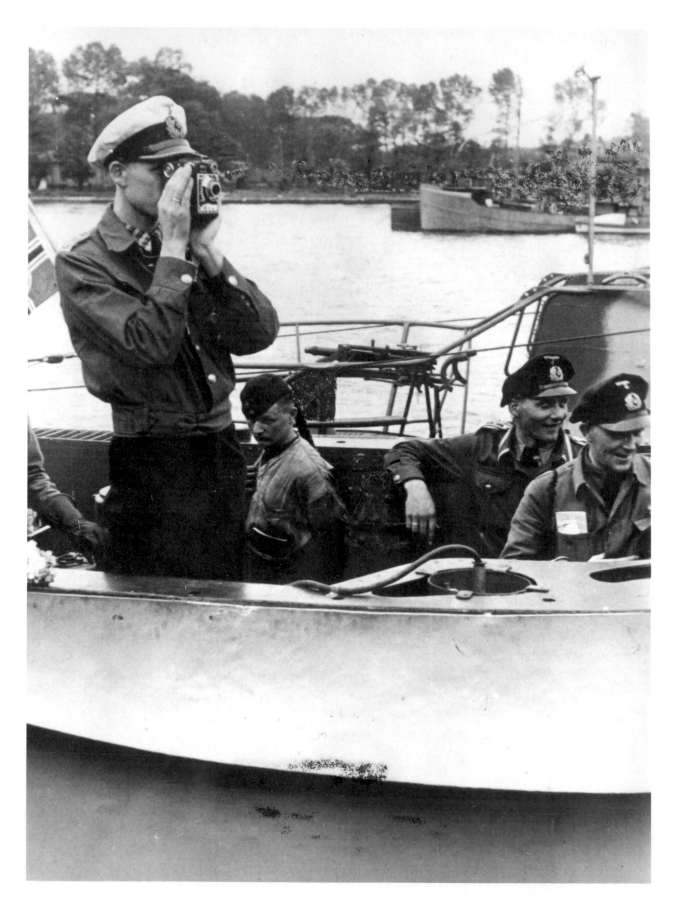

Album—U-Boat Captain/Cameraman on his way to New York

The original German WWII text attached to this official press release photo of submarine commander Reinhard Hardegen, written by an official war correspondent named Kramer, translates:

"After a special message from the OKW (Supreme *Wehrmacht* Command) of January 24, 1942, German submarines, by their excursion in North American and Canadian waters, directly before the enemy coast, torpedoed eighteen cargo ships totaling 125,000 BRT (tons) along with another escort. *Kapitänleutnant* Hardegen especially distinguished himself by alone sinking eight ships of 53,000 BRT, including three tankers off New York. Our picture shows *Kapitänleutnant* Hardegen with his film camera before setting sail on his mission."

Hardegen was born on March 18, 1913, in Bremen, Germany and served in the *Kriegsmarine* as a U-Boat Commander from 1934-42 ending with the rank of Battalion Commander, then served on land commanding the 2nd Marine Infantry Division. Having sunk twenty-two ships, he was ranked as the 24th most successful commander in WWII. While honored with military awards including the Iron Cross First and Second Class and the *Ritterkreuz*, he was not considered an ardent Nazi supporter.

One of the small percentage of German submariners to survive the war, he was held in captivity by British authorities for a year then released. Hardegen prospered in post-war Germany, running a successful oil company and serving in Bremen's Parliament for over 32 years.

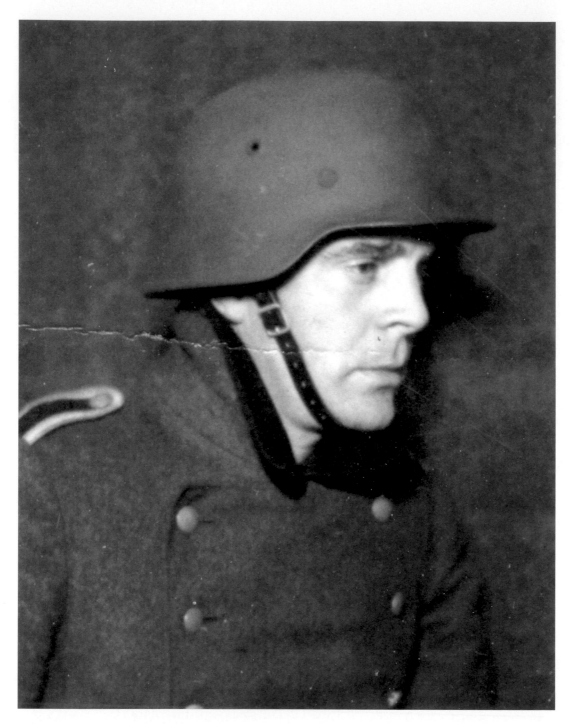

Stahlhelm

Designated the M35, referring to its
first year of issue replacing the former
M16 design of WWI vintage, the dis-
tinctive design of the *Wehrmacht's* steel
helmet still evokes a sinister response
more than a half a century after it was
worn by millions of German soldiers.

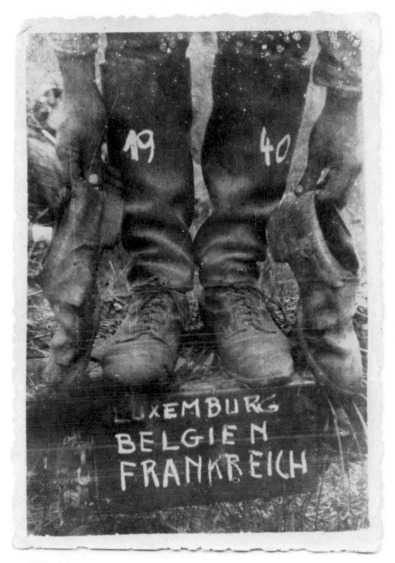

War Footing

These shoes and boots have slogged hundreds of miles across Belgium, Luxembourg and France, the owner having marked them "1940" and affixed a sign listing his campaigns.

After 1940, the German army's standard all-leather marching boots nicknamed "Dice-shakers" were replaced by laced-up ankle boots in order to save leather, although officers retained the taller, long-shafted riding style boots (*Reitstiefel*) as did members of the cavalry whose boots also featured nickel-plated spurs (*Anschnallsporen*). The marching boots featured the famous hobnails in the soles, which helped produce their distinctive sound as well as added increased endurance for the long miles traversed by the German foot soldier or *Landser*.

Ultimate Goosestep

A young soldier practices his radical version of the distinctive German marching style. Very strenuous and hard on the feet in hobnailed boots, the goosestep or *Paradeschritt* was reserved for parades or brief military reviews rather than for normal marching duties.

Norman Davies, author of *Europe: A History,* traces the origins of the march back to the 17th century Prussian Army where it "transmitted a clear set of messages. To Prussia's generals, it said that the discipline and athleticism of their men would withstand all orders, no matter how painful or ludicrous. To Prussian civilians, it said that all insubordination would be ruthlessly crushed. To Prussia's enemies, it said that the Prussian army was not made up just of lads in uniform, but regimented supermen. To the world at large, it announced that Prussia was not just strong, but arrogant."

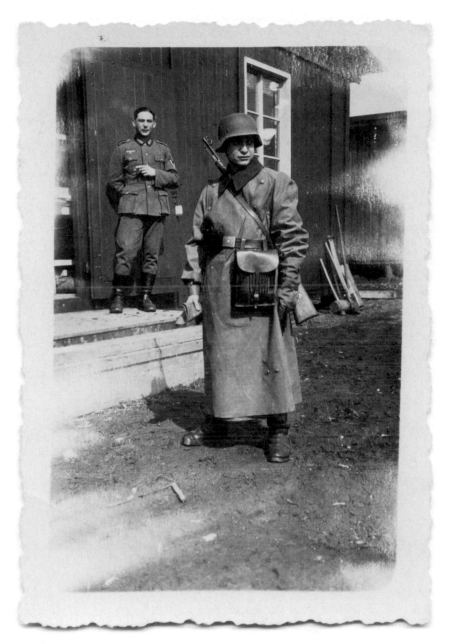

Courier

Striking a pose for the camera in Romania, a motorcycle courier wears the special protective clothing designed for his all-weather duties. A leather case carries the documents he will transport.

The distinctive M1934 protective coat, called the *Kradmantel*, was highly prized and could be worn only by soldiers in the motorcycle service, but was sought after by just about everyone, military and civilian alike. Made of a vulcanized, watertight material it afforded protection against the elements, if not the Russian winter. Air circulated through a design of inner panels and buttons allowed it to be snapped around the legs as well.

"Jump into Nothing"

So reads the inscription on the reverse of this commercially produced postcard heralding the exploits of the vaunted parachute troopers.

With their first jumps executed in 1936, the Parachute Troops or *Fallschirmtruppen* took part in the occupation of the Sudetenland and Czechoslovakia and later were initially very successful in special airborne missions, including the dramatic takeover by a small force of the seemingly impenetrable Belgian fortress of Eben Emael. They also took part in the invasions of Poland, Holland, Denmark, Norway and Greece and served in Russia as land infantry. The parachutists were badly mauled by British defenders during the attack on Crete on May 20, 1941, after which Hitler was loath to risk the elite group to airborne assaults, preferring to keep them earthbound. Because they were often used to plug holes in battle lines, they bestowed upon themselves the nickname "The Führer's Firemen."

During the February, 1944, German defense of Monte Casino after the Allies landed in Italy, the 1st Parachute Division withstood massive carpet bombing, the battle broken off. In praise of their tenacity as soldiers, Britain's Field Marshall Alexander said, "No other troops in the world but German paratroops could have stood up to such an ordeal and then gone on fighting with such ferocity."

The last stanza of the fatalistic *The Song of the Paratroopers*:

Our numbers are small, our blood is wild,
we fear neither the enemy nor death,
we know just one thing: with Germany in
 distress,
to fight, to win, to die the death,
To your rifles, to your rifles!
Comrade, there is no going back.
In the distant west there are dark clouds,
come, don't lose heart, come along!

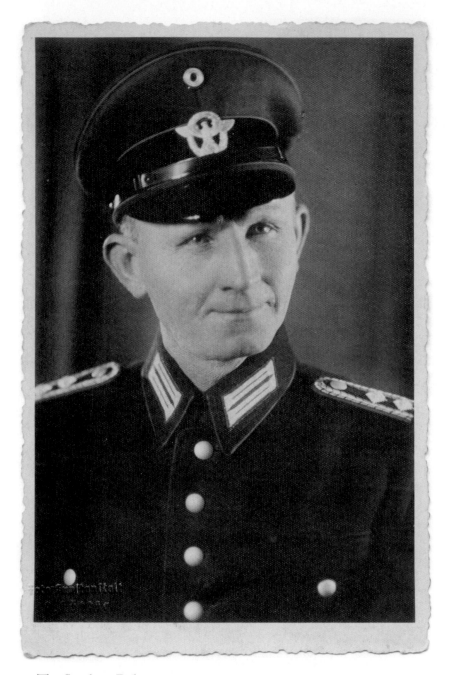

The Smiling Policeman

The distinctive emblem on his cap identifies this man as a member of the Police Battalions.

Germany and Austria's civilian police were assimilated into the SS with Police Battalions fighting on the front lines and conducting anti-partisan warfare. Referred to as "Hitler's Green Army" because of their distinctive green uniforms, many were also instrumental in the implementation of the Third Reich's anti-Jewish campaign across Eastern Europe.

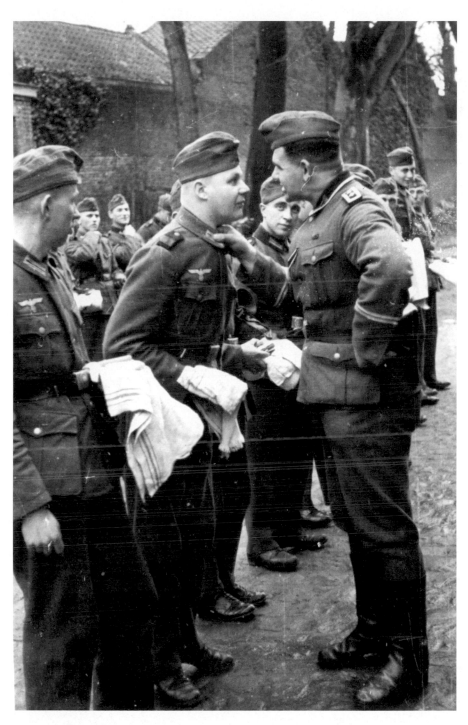

By the Throat

An NCO chews out a new recruit. German military discipline was often brutal resulting in injuries and deaths. Training also emphasized "comradeship," strong bonds formed between individuals often deliberately selected from the same towns and villages.

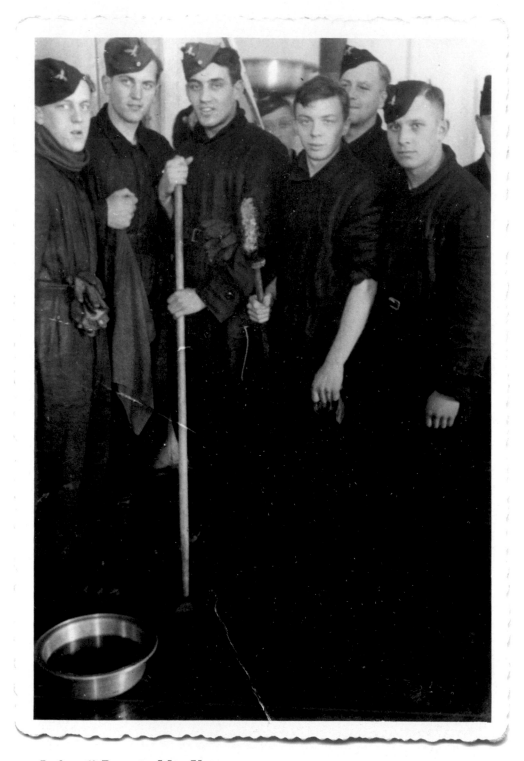

Luftwaffe Recruits Mop Up

A group of young air force technical students in Munich take a photo break from their labors. The date March 3, 1940, the month Hitler orders his forces to attack Denmark and Norway.

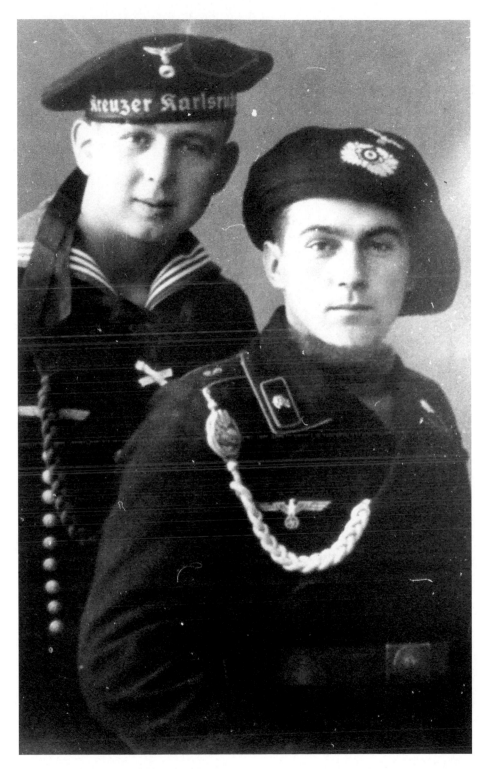

Kriegsmariner und Panzermann

Two young friends, one a crewmember of the cruiser *Karlsruhe*, the other a tanker in the *Panzer* corps, pose for a studio portrait.

The *Karlsruhe*, commissioned in 1929, would be sunk by the submarine *Truant* on April 9, 1940, in a battle between German and British ships off the coast of Norway.

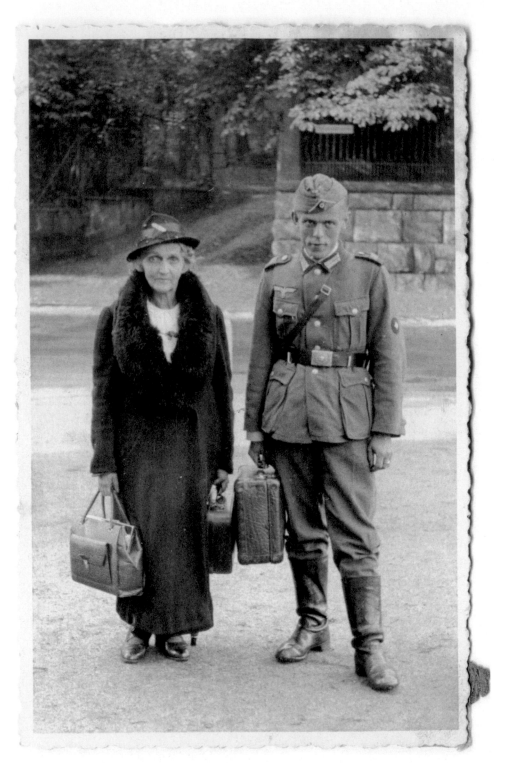

Off to War

Leipzig, September 9, 1940. A well-dressed mother and her soldier son carry luggage. Perhaps she is seeing him off to war as he is wearing an overseas cap and a somewhat menacing expression.

MuzzleFlash

A German 88 cannon lights up the
night sky.

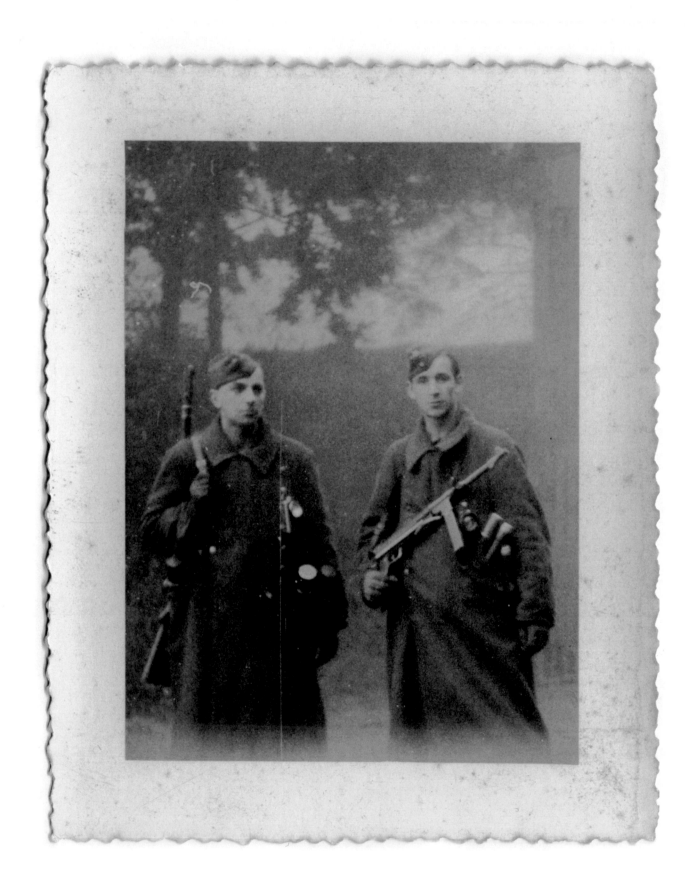

Waffen

Two soldiers carry the tools of their trade, one a K.98b carbine slung over his shoulder, the other an MP38/40 submachine gun across his chest as well as pocketfuls of M24 "stick" hand grenades.

The German foot soldier was armed with the standard issue *Mauser Karabiner 98* carbine based on an 1898 design. While five cartridges could be pressed into the magazine, it required a manual opening and closing of the bolt-action to eject a spent round and cycle a new bullet into the chamber, whereas the standard U.S. issue Garand, a gas operated semi-automatic design, required no bolt action, which greatly enhanced its fire power. Many veterans on both sides agreed this was often the difference between life and death on the battlefield. Some elite troops were issued with the new *Sturmgewehr* 7.92 MPi 43/44 "assault rifles," predecessors of the modern infantry weapons of today.

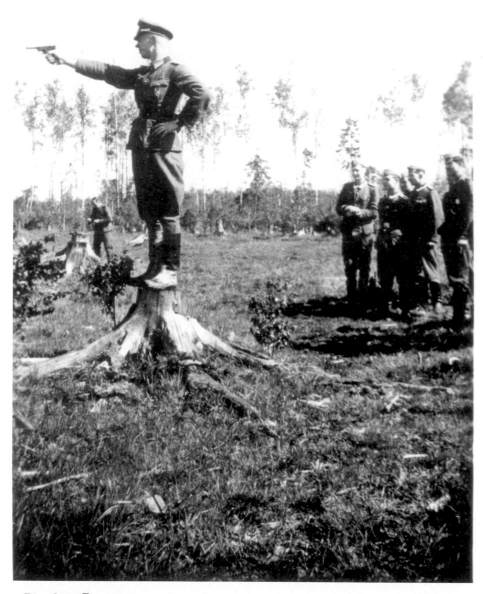

Pistole 08 **Practice**

An officer stands atop a tree stump and assumes an elegant pose while firing his automatic 9mm *Pistole 08*, better known as the *Luger*.

The accurate handgun, expensive to manufacture, had been the German army's standard sidearm since 1908 and saw action in WWI. Along with their carbine, officers, sergeants and medical personnel carried the weapon. Between 1939–1942, nearly 500,000 were supplied to the various military branches after which a new pistol, the *Walther P-38* replaced the aging *Pistole 08*.

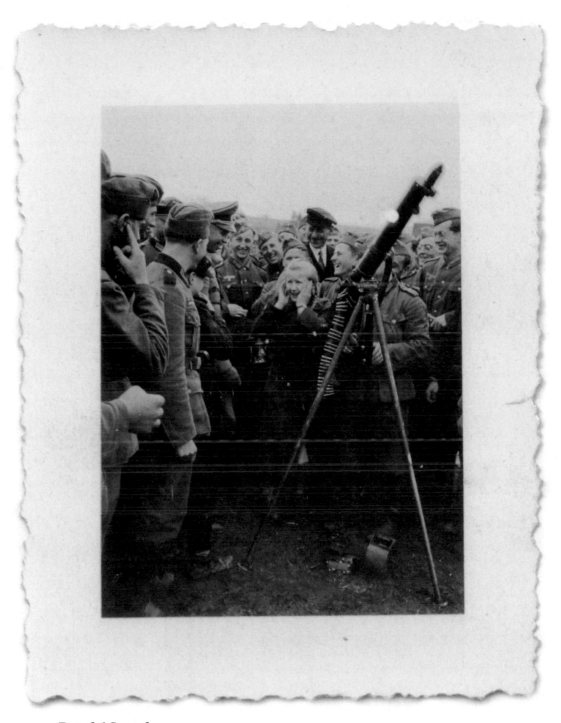

Painful Sounds

To the amusement of the young soldiers crowding around her, a girl reacts to the sound of a machine gun she has just fired.

The machine gun pictured is an early pre-war MG .08 set up in anti-aircraft mode via the tall tripod. Germany would go on to develop many advanced machine guns, including the MG .42 that would go on to influence modern weapons of today. The weapon's nick-name was "Hitler's Saw."

88

A member of a *Luftwaffe* anti-aircraft battery cradles a shell for the versatile and deadly German 88mm cannon also used as a potent anti-tank and anti-personnel weapon.

X Marks the Spot

Windows taped in anticipation of an air raid frame the scene as German artillery officers examine a captured Polish cannon.

216

Lights in the Sky

A soldier's camera captures the eerie beauty of anti-aircraft tracer shells and searchlights crisscrossing the night sky over Alexandria, Egypt, during an aerial bombardment.

Germany relied on the leadership of Erwin Rommel, the "Desert Fox," to capture the strategic Middle Eastern oil fields and to kill the Jews of the area. At first successfully routing Allied forces, eventually his vaunted *Afrika Korps* was thrown back. Rommel was later implicated in the unsuccessful assassination of Hitler and given the choice of suicide and a hero's funeral or dishonor and retributions against his family. He ended his life with a capsule of cyanide.

Death from Above: Stuka

A German 25 *Pfennig* (plus 15 pfennig charity) postage stamp pays homage to one of the *Luftwaffe's* most successful aircraft.

* * * *

Likened in appearance to a vulture and one of the "signature" weapons of WWII was the German single engine dive-bomber, the gull-winged Junkers-87, better known as the "Stuka." Special sirens were attached to the plane's wings so that as it swept into a steep dive to deliver its bomb load, a shrill whistling sound added psychological terror signaling death from above. Initially highly successful in the coordinated mechanized attacks on Spain, Poland and France, the aircraft, relatively slow at a top speed of 232 mph, were easy targets for more advanced Allied fighters including British Spitfires and Hurricanes during the Battle of Britain.

Death from Below: U-Boat

A Third Reich postage stamp captures the sinking of a ship at sea by submarine. The regular postal charge of 3 *Pfennigs* has been increased by a charity fee of 2 *Pfennigs*.

The Third Reich began with fifty-seven submarines, but by mid-1942 there were 101. By the end of the war, German U-boats had sunk more than 2,000 ships, taking the lives of 30,000 men of the British Merchant Navy alone and nearly winning the war by cutting off much needed supplies. However, Allied anti-submarine techniques turned the tide and sent 783 of the 1,162 subs to watery graves. Thirty-two thousand of 41,000 German submariners died.

Gas Masks

Wearing their denim "fatigues" to protect their uniforms, young recruits don their gas masks for the camera.

Carried in metal cylinders by ground forces, gas masks were considered essential equipment because of the use of various poisons, including mustard gas, on WWI battlefields by both Allies and Germans. Hitler himself was temporar- ily blinded during a gas attack while a private first class in the trenches. However, neither side employed chemical or biological weapons during WWII with the notable exception of the German use of Zyklon B in the extermination camps.

Disappearing Act

A soldier demonstrates the art of concealment by slipping into a hollowed-out tree trunk, a good vantage point for a forward observer from which to call in artillery fire upon enemy forces or to serve as a sniper's nest. The top German sniper, Mathias Hetzenhauer, was credited with some 350 kills.

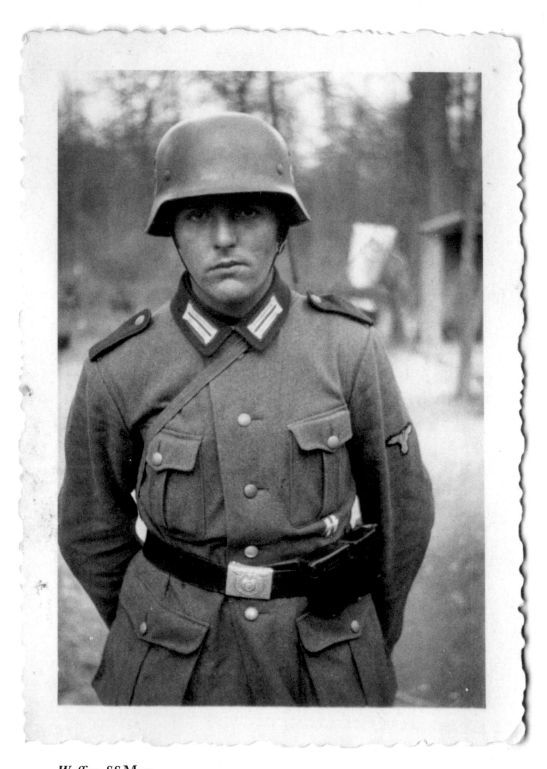

Waffen-SS Man

A member of the *Waffen-SS* seems to glare unhappily at the camera.

Characterized by some military historians as "elite forces," the *Waffen-SS* or "armed SS" were highly trained combat troops, as opposed to the regular SS, who were principally involved in "racial warfare." *Waffen-SS*, however, considered themselves honorable soldiers fighting for their country, although many were subsequently charged with numerous crimes against humanity.

The motto of the SS was "Believe! Obey! Fight!"

Politically motivated and trusted over the regular *Wehrmacht* by Hitler, the *Waffen-SS* grew to over one million in number, composed of thirty-nine divisions from fifteen nationalities including volunteers from Holland, Italy, Estonia, Latvia, France, Ukraine, Norway, Belgium, Denmark, Romania, Hungary and Yugoslavia. While the *Waffen-SS* performed well in battle, the regular troops of the *Wehrmacht* bore the brunt of the fighting and carnage.

Of the 3,000,000 soldiers sent against the Soviet Union on June 22, 1941, the elite troops of the *Waffen-SS* numbered 160,405. Of an estimated 950,000 who entered the *Waffen-SS* during the war, 253,000 were listed as killed or wounded. While *Waffen-SS* units took part in the most intensive offensive and defensive actions, many were involved solely in anti-partisan actions in Russia, while none fought in Africa or Sicily.

* * * *

In May, 1985, President Reagan laid a wreath at a memorial to 2,000 German soldiers including forty-nine *Waffen-SS* in Bitburg, then West Germany. After protests about this, Reagan made a speech that included the phrase "old wounds have been reopened." A *New York Times* article mentioned that West German Chancellor Kohl, who had insisted on the visit to the cemetery, brushed tears from his eyes. The article went on to report on Reagan's visit to the Bergen-Belsen concentration camp where he made a short speech at a mass grave of 50,000 victims. "Here they lie," Mr. Reagan said in a trembling voice. "Never to hope. Never to pray. Never to love. Never to heal. Never to laugh. Never to cry."

The *New York Times* article reported that the ceremonies at the two grave sites were "designed to merge past and present—to pay homage to the millions of victims of Nazi Germany and to honor West Germany's emergence as a powerful democracy and ally of the United States."

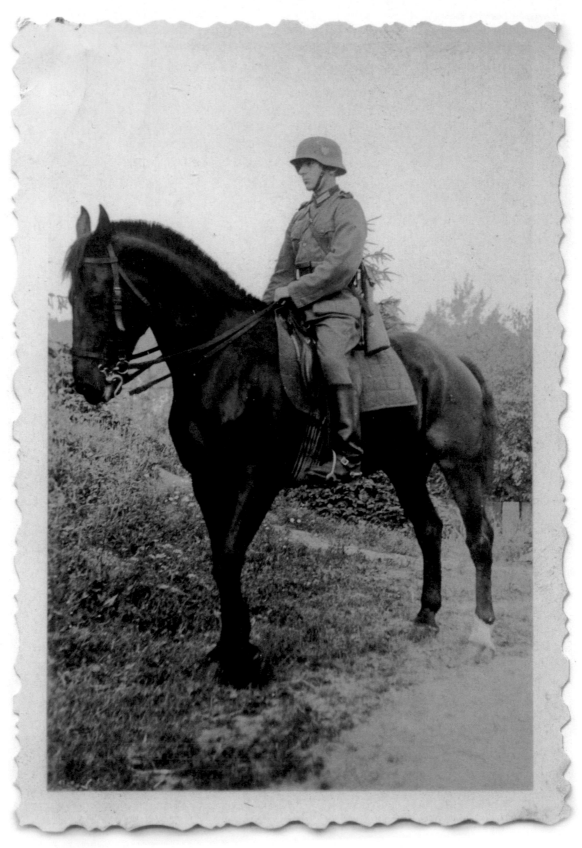

The Cavalry

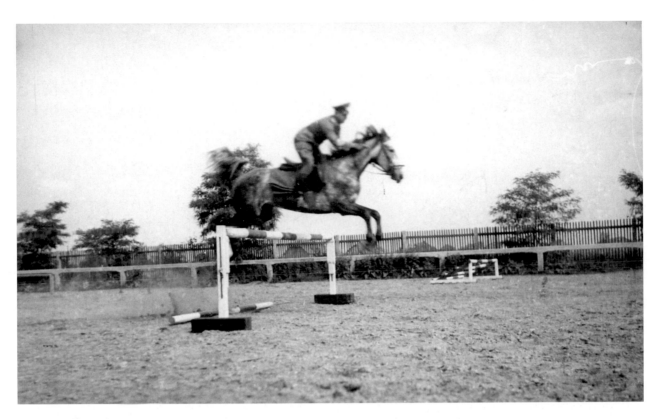

Leap of Faith

German riding schools produced horses and riders of the highest caliber that from 1930–1940 competed in every important international event. The crowning achievement came at the 1936 Olympics when the German team won all six gold medals and one silver, dominating all three disciplines of dressage, jumping and military, a victorious sweep of awards never repeated.

By 1939, the German Reich possessed 3,800,000 horses while 885,000 were initially called to the *Wehrmacht* as saddle, draft and pack animals. Four hundred and thirty-five thousand horses were captured from the USSR, France and Poland while others were purchased from Hungary, Romania, Czechoslovakia and Ireland.

In addition to cavalry duties, horses were employed by other elements of the army including the infantry, artillery, pioneers (engineers) and medical units. They were also the main form of locomotion for supply units, including mobile field kitchens, blacksmith wagons and ammunition and weapons wagons.

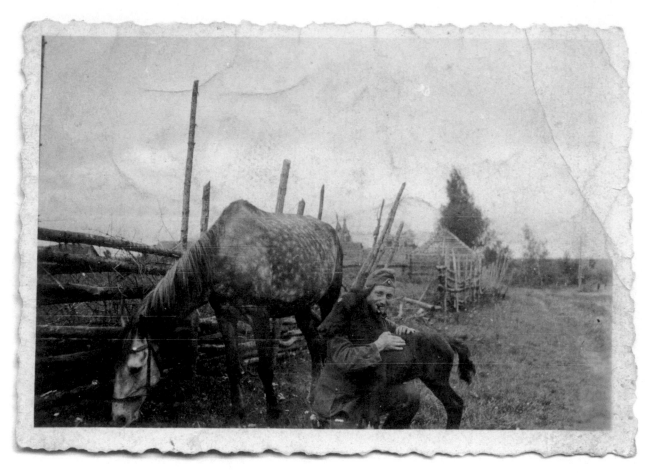

Tender Mercies

A soldier tends to a newborn colt somewhere in Russia.

Many German recruits grew up in the rural countryside tilling rich farmlands where animals were an integral part of their lives, especially horses. They had a special bond with them, a bond of blood and soil. While the popular conception of the German military machine is of a massive array of tanks, armored vehicles, mechanized troop transports and trucks, in fact much of the heavy hauling was horse drawn.

In addition, thousands of troops went to war on horseback in the German cav-

alry. Their mounts were chosen by special committees that purchased three-year-old horses with training beginning at four and continuing for two more years in a program unsurpassed by any other nation. Heavy draft horses (the ssZ class) also entered service as the wagon loads grew heavier while a number of Berber horses were incorporated into the *Wehrmacht* after the fall of France. Unloaded wagons themselves could weigh over 1,000 kilograms and required four to six horses, especially along what stood for Russian roads.

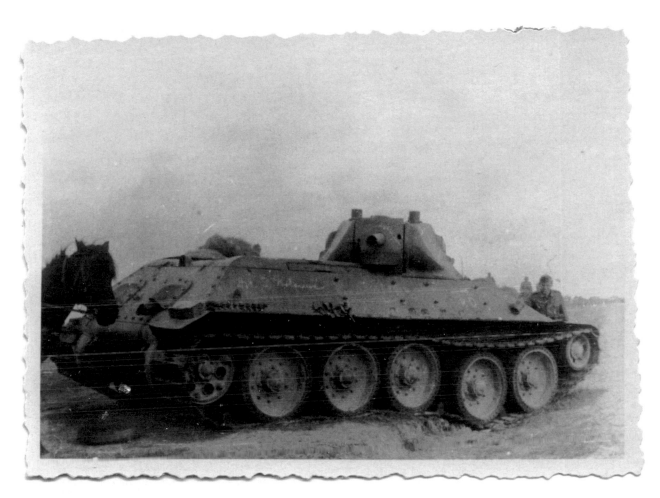

Opposing Forces

The juxtaposition of horseflesh with a steel tank underscores the reality that the *Blitzkrieg* depended in great part on the four-legged beasts of burden. The tank is knocked out of action, often for lack of fuel, but not so the horse.

The German military set the standard for modern warfare in great part focusing their sights on designing and building the most advanced tanks, their *Panzers* spearheading the lightning war unleashed on Poland, France and rest of Europe.

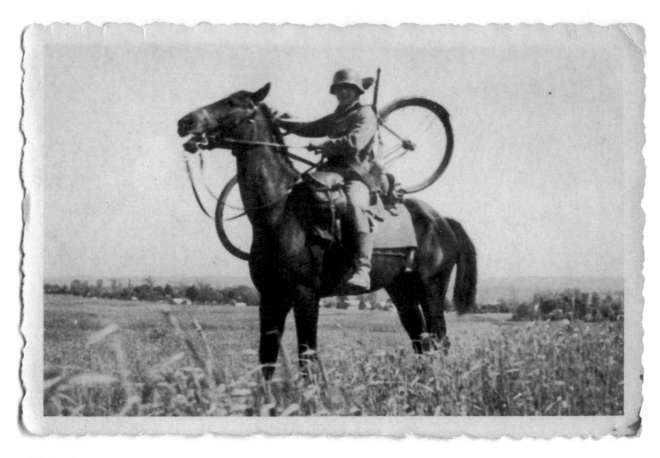

Hybrid Horseman

The German cavalry corps in wartime consisted of horse, bicycle and motorcycle troops.

As the war ended, in March, 1945 the surviving cavalry brigades took part in the failed defensive operation "Awakening of Spring" along the Danube. They eventually surrendered in good order to the British in Austria with a final horse march through Württemberg in June, 1945. Kept as POWs for only a brief period, they were released while their horses returned to the fields under the care of local farmers.

The two *Waffen-SS* Cavalry Divisions, after fighting for two years on the Eastern Front, were destroyed during intense fighting around Budapest, which fell to Soviet forces on February 13, 1945. In addition, cavalry formed by anti-Communist Cossack volunteers from Soviet occupied areas, while surrendering to the British, were forcibly repatriated to the Soviets who considered them collaborationists and traitors. As a result, the common soldiers received eight years in the Gulag while the higher ranking officers were hanged including corps leader General von Pannwitz.

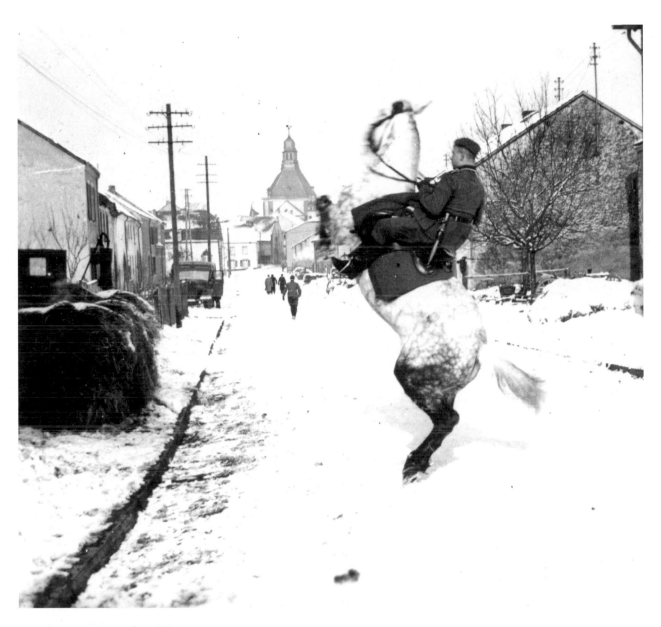

White Snow, White Horse

An intricately dappled white horse rears in a snow-covered street, sharp hooves slashing at the cold air. The expertly trained cavalry man remains in relaxed control.

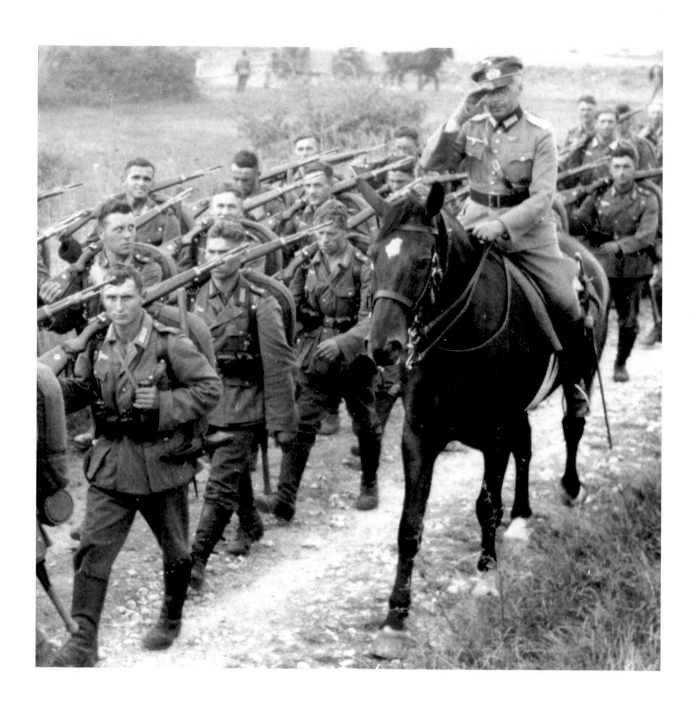

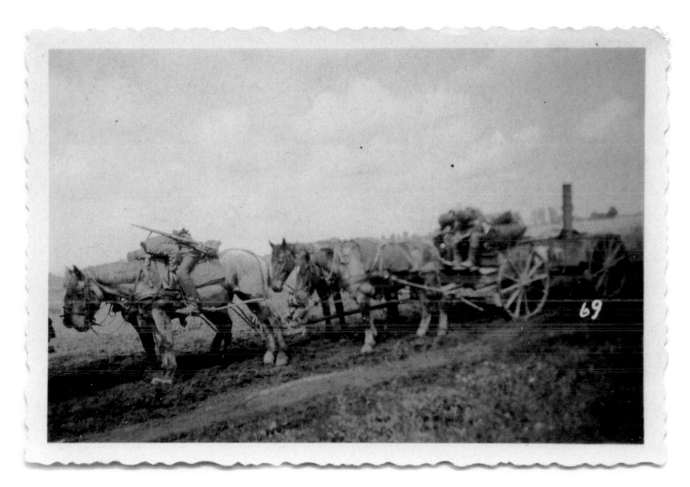

Sleep of the Dead

Somewhere on the Russian front a
soldier has brought out his camera to
record the exhausted members of a
horse-drawn field kitchen.

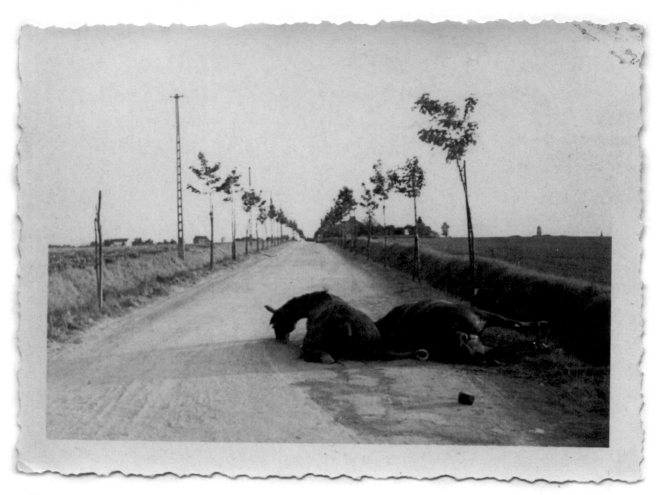

Horsemeat

The horses and mules used by the German military eventually numbered 2,750,000. Of these, severak hundred thousand died during the war. These figures do not account for horses lost by the other countries fighting for or against the Third Reich.

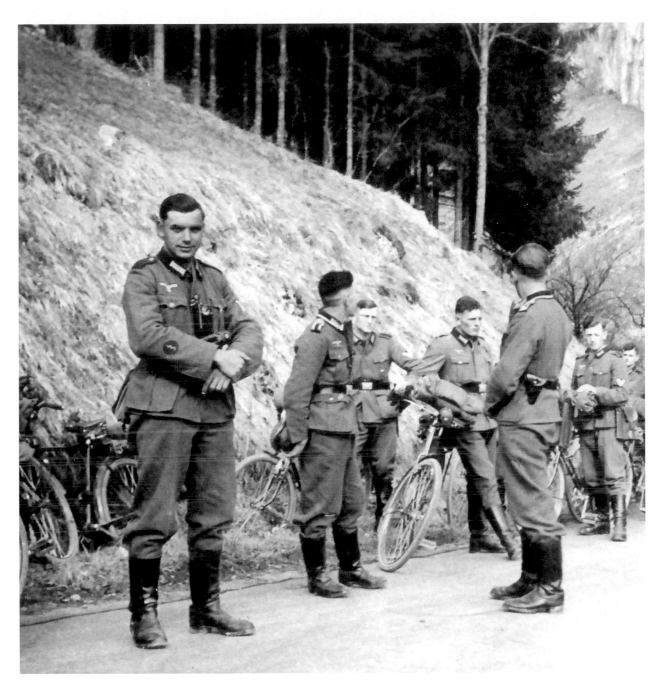

Combat Cyclist

A group of cycle soldiers rest from a long ride up a mountain road. The man in the foreground, facing the camera, wears an insignia on the forearm of his uniform identifying him as a medic. He also wears a ribbon on his tunic indicating the awarding of an Iron Cross Second Class.

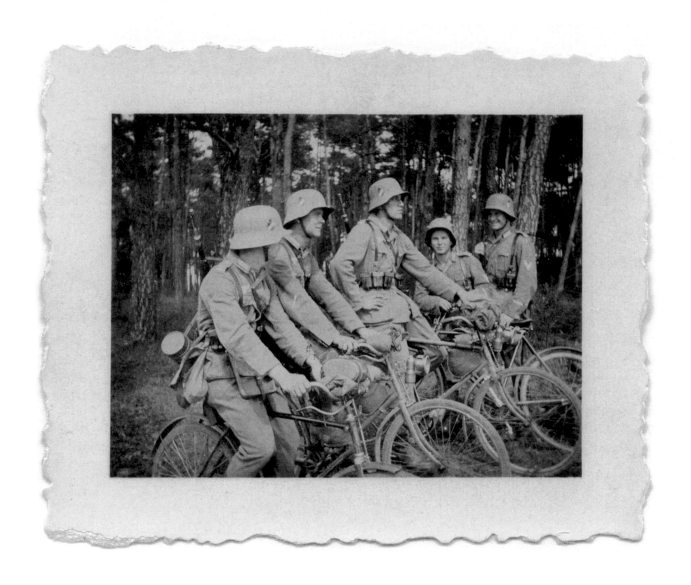

234

Bicycle Soldiers

By their early helmets, this group of young cycle troops have not yet ridden off to war.

The German foot soldier also pedaled to war, the bicycle troops under the control of the Cavalry Brigade with the first formations appearing in 1936. Prior to hostilities, a regular bicycle troop consisted of 195 men, their mounts painted black and manufactured first in Germany, then as the war progressed the bicycles were from suppliers in Holland, Belgium and France.

While cycle soldiers wore uniforms much like that of the horse-mounted soldiers, they also wore an additional "cape." A bicycle troop carried nine light and two heavy machine guns and three 50-mm mortars and were trained like the infantry. The advantage to bicycles was that they moved with little noise and could traverse areas more quickly in some situations. The highly mobile bicycle troops were considered enormously successful during the Western European campaigns. In addition, each bicycle troop fielded a motorcycle section that, with sidecars, carried the troops, heavy machine gun and mortars. Bicycle troops were expected to cover seventy-five miles a day, although the usual distance was fifty to sixty miles.

The role of the bicycle soldier was summed up in a 1939 document entitled "The Versatility of the Cavalry" by a Lt. Elert of the 17th Cavalry Regiment. "The bicycle patrol works its way toward the enemy over roads and paths no matter how narrow. No sound betrays them. They are completely independent of fuel and fodder. The bicyclist can advance as long as his strength allows." Despite this early optimism, the rainy season in Russia and the ensuing rivers of mud effectively immobilized the bicycle troops.

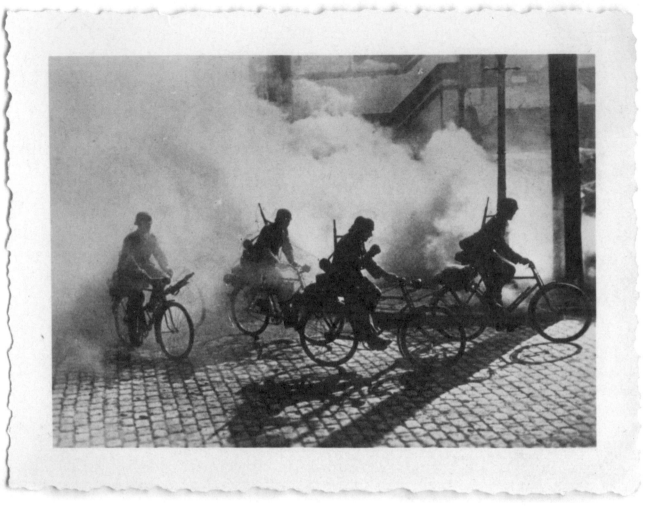

Light Casualties

Shadows play on cobblestones as bicycle
soldiers emerge from the fog of war.
One is coughing from the smoke,
another has strapped his carbine to the
front of his cycle rather than slinging it
over his shoulder like his comrades.

Another historical fact fogged by time
and politics is the Non-Aggression
Pact signed between arch enemies Nazi
Germany and Stalinist Russia, both
eager to slice up Poland caught between

them. In the ensuing attacks on Poland,
Germany counted 45,000 casualties
while the Red Army incurred only
2,600. The Poles suffered 200,000 dead
and wounded.

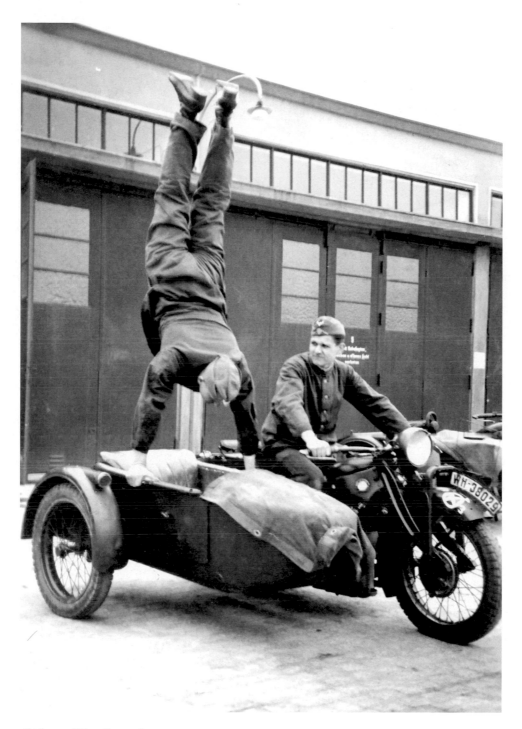

Sidecar Handstand

Motorcycle acrobatics were a popular entertainment prior to the war and many of the skilled riders who joined or were conscripted into the military would find themselves performing dramatic stunts in public demonstrations or just grandstanding for the cameraman.

The "WH" on the license plate affixed to the front fender of the BMW indicates the machine belongs to the *Wehrmacht Heer* or regular Army. The white circle surrounding crossed spokes is the sign of the motorcycle troops.

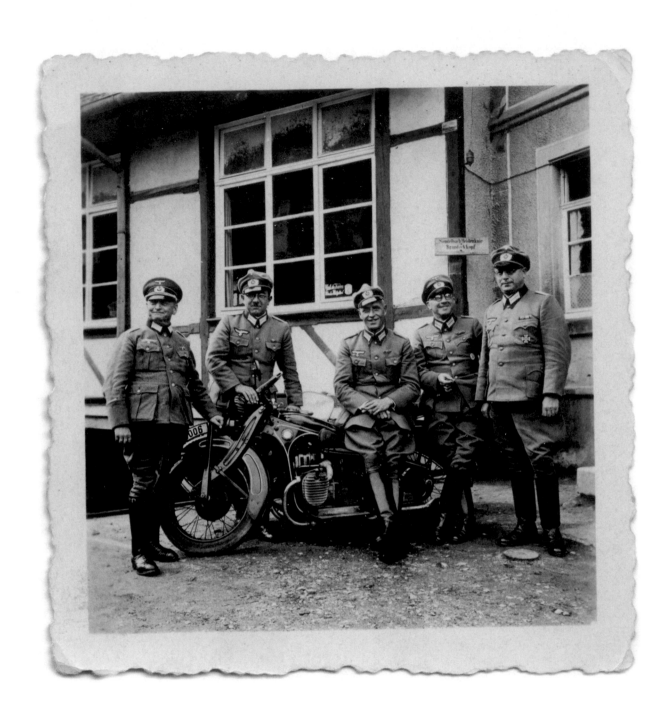

238

Bikes of the Blitzkrieg

A group of officers gather for a portrait around a rather pristine BMW motorcycle that apparently has not seen combat and still wears its "civilian" paint.

Motorcycles, since they first emerged, have gone to war. American Harley-Davidson and Indian; British Triumph, BSA Matchless and Norton; Italian Motor Guzzi and Gilera; French Terot and Gnome Rhone; Belgian FN and Gillet . . . if you had a war to go to, motorcycles would get you there, often faster and through terrain inaccessible to other vehicles. The German military were the largest employers of motorcycles during World War II. In addition, as German forces swept across conquered lands they acquired a wide array of British, French and Belgian machines, painted them *Wehrmacht* gray and sent them into battle. German military motorcyclists played an important role either in solo courier or scouting capacity, as teams of tank hunters or in divisions of rifle troops.

The Germans' mechanized lightning war or *Blitzkrieg* required machines of high caliber in more ways than one. Although horses and even bicycles carried battalions of combatants, as did trucks and tracked vehicles, motorcycles often led the way . . . purpose built BMW and Zundapp military bikes as well as civilian models made by NSU and DKW and a host of others either by contract or requisition.

A count of manufacturers in pre-war Germany indicates over 500 different brands in existence. All civilian motorcycles were eventually confiscated by the Nazi regime, frequently both machine and owner inducted into the military.

Stunt Rider

A member of an army motorcycle stunt
team jumps through a hoop of fire.
Such teams often staged demonstrations
for the public.

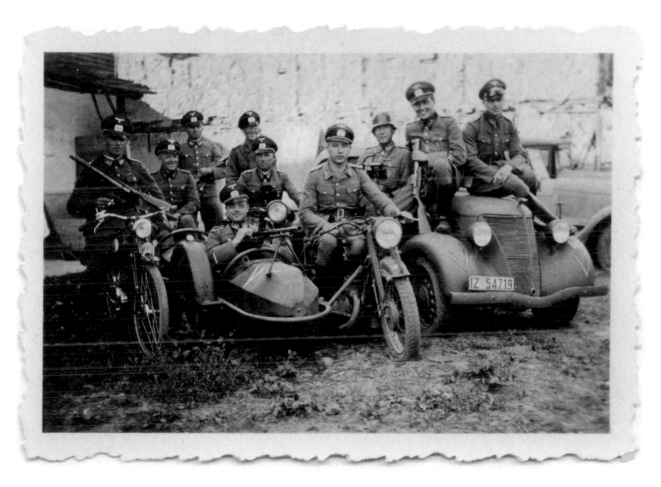

Mechanized Customs Police

What appears to be a rather cheerful group of *Wehrmacht* Customs Police poses with its machine gun–equipped DKW/sidecar while others carry *Schmeisser* submachine guns. Only one wears the distinctive steel helmet. The Border Customs Protection Service was controlled by the *Sicherheitspolizei* or Security Police, which was composed of the *Gestapo* and *Kripo* (criminal police). By their car's license plate they appear to be located somewhere in the Rhineland, an area re-occupied in violation of the Versailles Treaty by Germany on March 7, 1936.

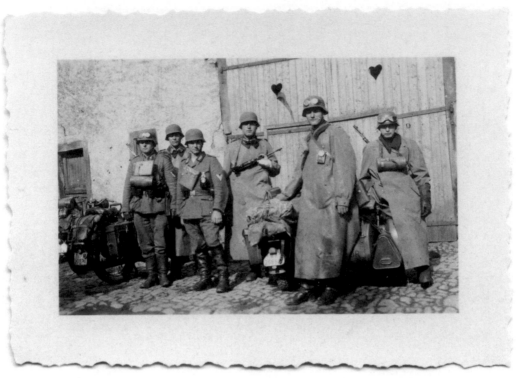

Heartless Hunters

Three motorcycle troopers stand at the ready. The hearts carved into the doors behind them offer an ironic commentary.

Over three million German soldiers invaded the Soviet Union on June 22, 1941, during Operation Barbarossa. In effect, they were simply the advance guard for a much smaller group of men, less than 3,000, that would follow in their wake to wage Hitler's war of extermination. These were the members of the *Einsatzgruppen* or mobile killing units that went from city to city, town to town, village to village, house to house seeking out their victims . . . man, woman, child. When they were finished, over 1,300,000 Jews had been murdered by machine gun, gas, flame or club.

The Killing Teams were augmented by members of the Order Police who played a major role in the implementation of the racial war of annihilation. Some 12,000–15,000 directly contributed to the murder of over 460,000 men, women and children, one third of the lethal total amassed by the *Einsatzgruppen* as a whole. After the war, few members of the Order Police were brought to justice; rather they went back to their duties as regular police officers in Germany and Austria and as a result were able to conceal their crimes and those of other war criminals as well. In addition, several thousand "locals" enthusiastically joined the German killing groups, especially in Lithuania and Ukraine, and for the most part, once again, went unpunished.

In nie erlöschender Liebe
und zum steten Gedenken
an unseren innigstgel. Sohn und Bruder
Grenadier

Josef Hamperl
von Kollenzendorf
gefallen am 23. Aug. 1944
bei Montélimar in Südfrankreich
im 19. Lebensjahre.

*Milder Jesus, Heiland du,
Schenke ihm die ewige Ruh'!*

Mein Jesus Barmherzigkeit
Süßes Herz Jesu, sei meine Liebe!
Süßes Herz Mariä, sei meine Rettung!

Buchdruckerei Lohr Cham

Death Card for a Motorcyclist, Son and Brother

"In never ending love and lasting memory" the "death card" for Josef Hamperl tells us he is from Kollenzdorf and fell in action on August 23, 1944, at Montelimar in the south of France at the age of 19.

Kollenzdorf is a farming village in West Prussia. Montelimar is a market town well known for its chewy almond nougat produced there since the 17th century.

On August 15, 1944, the Allied invasion of southern France code-named "Anvil" was a major, though generally unknown, success of the war followed by capture of the ports of Toulon and Marseilles. The battle raging around Montelimar was joined by elements of the U.S. 36th Division and the German 11th *Panzer* Division and 19th Army infantry. The battle lasted from August 21–29.

It was on August 22 that an armored reconnaissance battalion of the 11th *Panzer* launched an attack from Montelimar, but were turned back by the Americans. The flanking attack was repeated by the Germans on August 23, involving a series of indecisive counterattacks from both sides. This was the day that Josef Hamperl would die aboard his motorcycle.

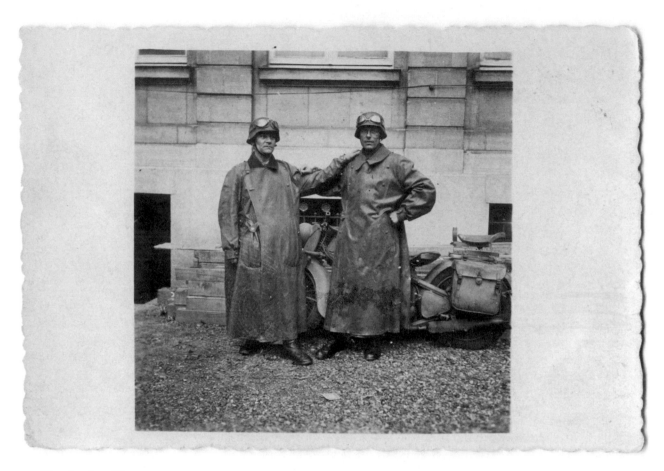

Kradmelder Twins

Two motorcycle troopers, wearing their special vulcanized overcoats, stand shoulder to shoulder for their portrait.

Motorcycle Rifle Troops were established in 1935 and designed to transport three fully equipped soldiers into action as quickly as possible. The Armored Division alone had 4,400 motorcycle troops. Most of the soldiers were trained as motorcyclists as well so they could take turns at the handlebars. Tactically considered the "fastest earthbound weapon," the Rifle Troop went through rigorous motorcycle training at special schools. Initially, drivers did not take part in combat, but were responsible for keeping their mounts ready to retrieve their passengers after battle.

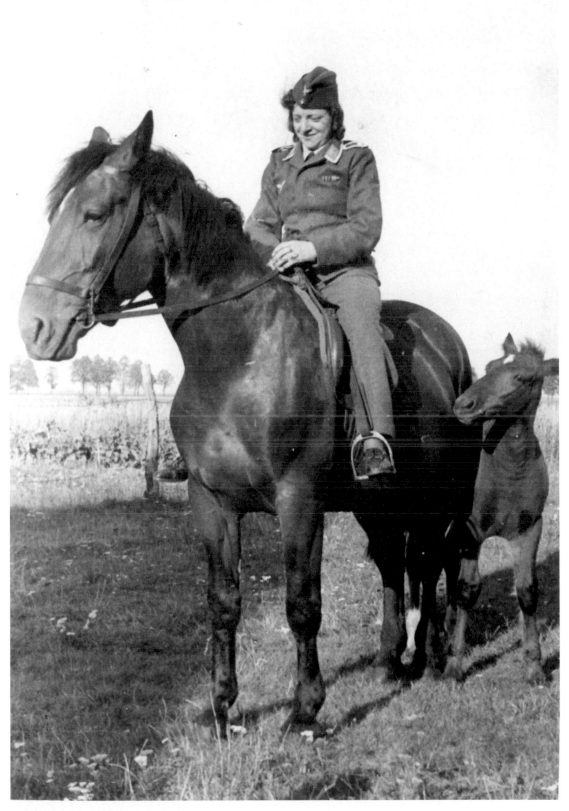

Women in the Service of the Fatherland

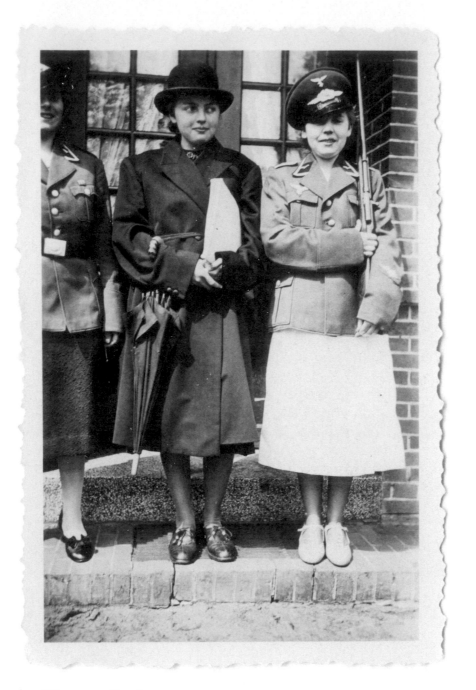

Women in Uniform

Women apparently enjoyed wearing men's uniforms, perhaps that of a particular man.

Hitler was diametrically opposed to women serving military functions and even in the heavy machine industries such as munitions, but relented both because women had already become an established part of the work force after WWI, but also because of manpower shortages that continued to escalate as the war went on.

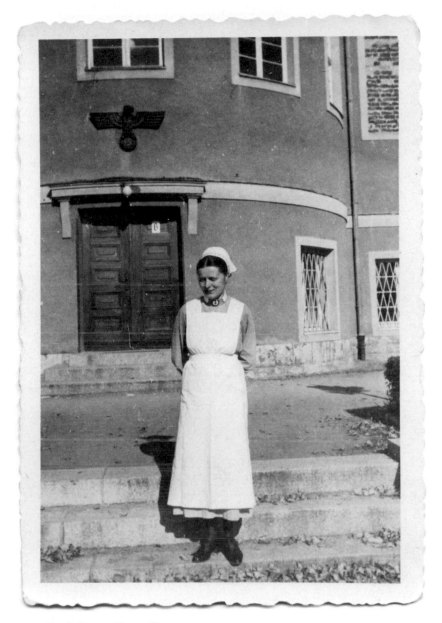

Red Cross/Iron Cross

A pretty young nurse poses shyly for the camera, a swastika over her shoulder.

DRK (*Deutsches Rotes Kreuz*) nurses were often in the thick of battle serving in front line field hospitals. Several were awarded commendations for their valor in attending the wounded under fire including Elfriede Wnuk, the second woman after test pilot Hanna Reitsch to earn the Iron Cross. She was also wounded several times. Another recipient was Countess von Stauffenberg, a volunteer nurse and also a pilot. Her husband would later find his place in history as the staff officer who placed the bomb in Hitler's command post in the abortive assassination plot.

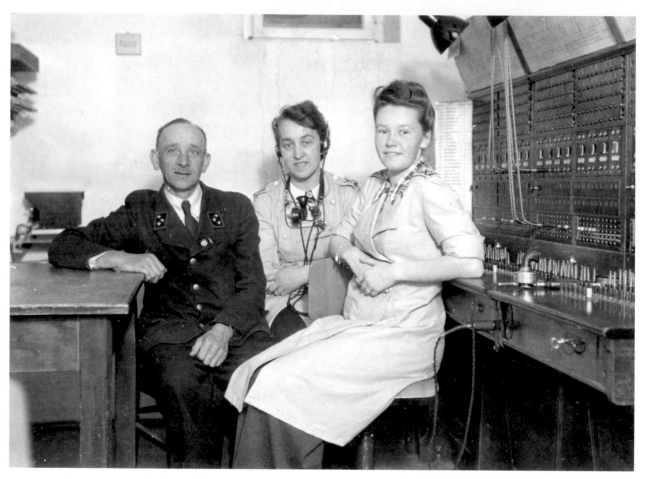

At the Switchboard

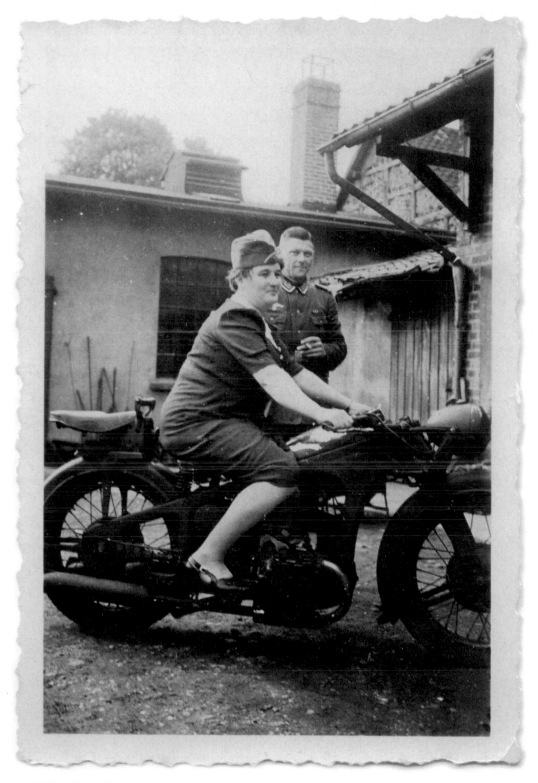

Biker Fräulein

Smiling wistfully, a *mollig* (buxom) young lady sits astride a military motorcycle, she herself wearing the uniform of the *Luftwaffe*. Many women took administrative and support roles in the *Wehrmacht* despite the Nazi's party line that the role of the female was reserved as the "womb of the Third Reich."

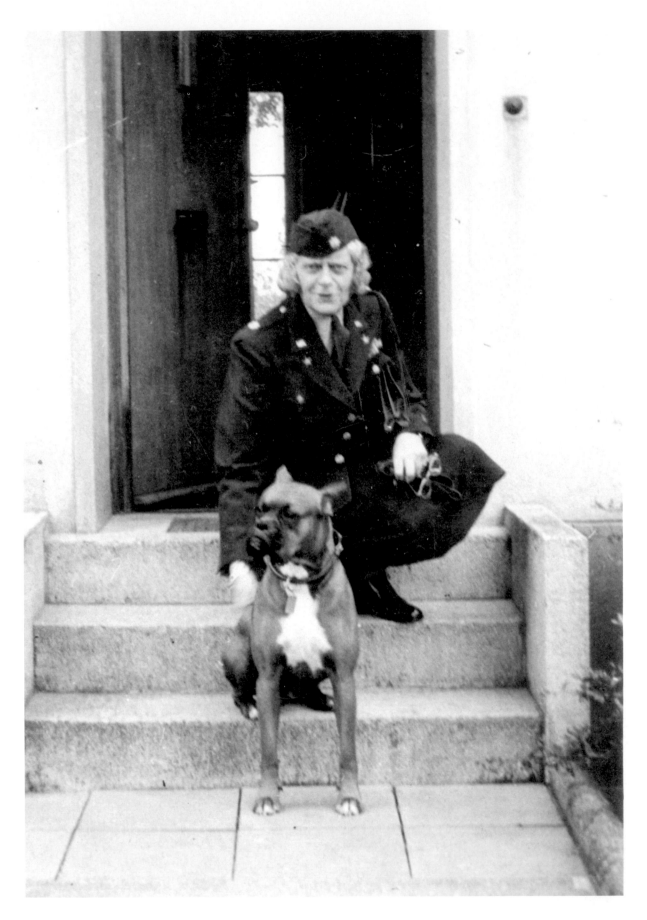

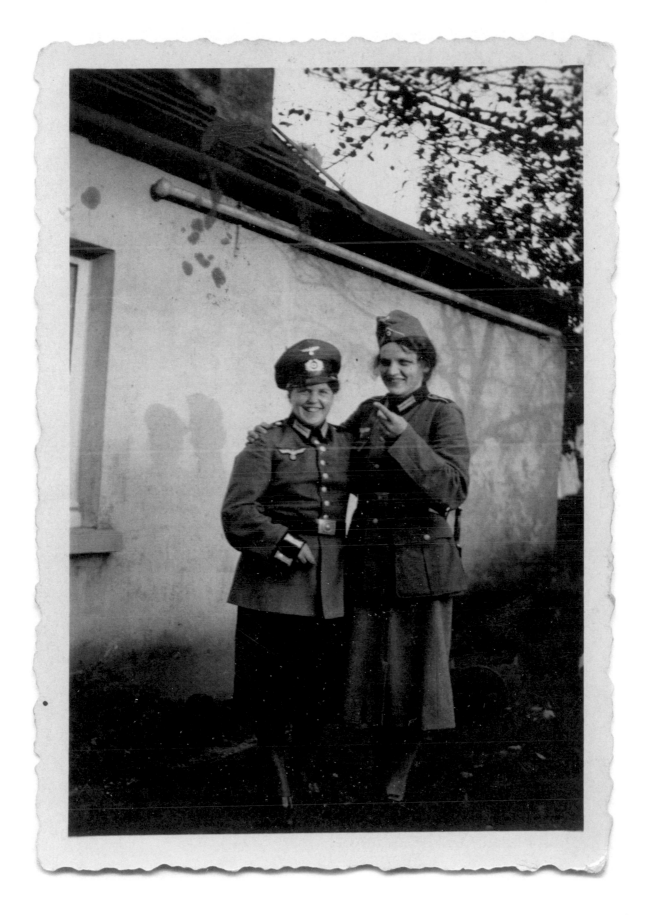

251

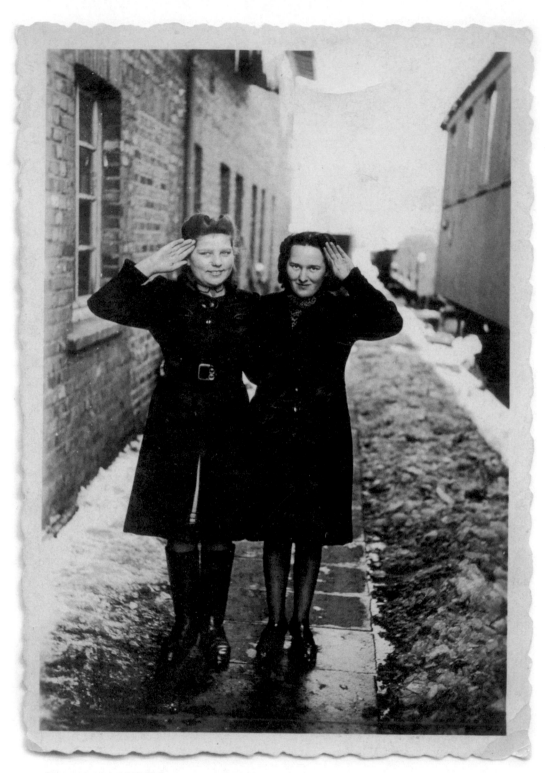

Asymmetrical Salute

German women joined the war effort on all levels, particularly in the signals and air defense services. These two young women salute asymmetrically for the cameraman.

PART THREE

The Battlefront

The War in Poland · The War in France · Axis Allies and Collaborators · The War in the East · The Maiming of the Master Race · Murderers, the Murdered and Places of Murder

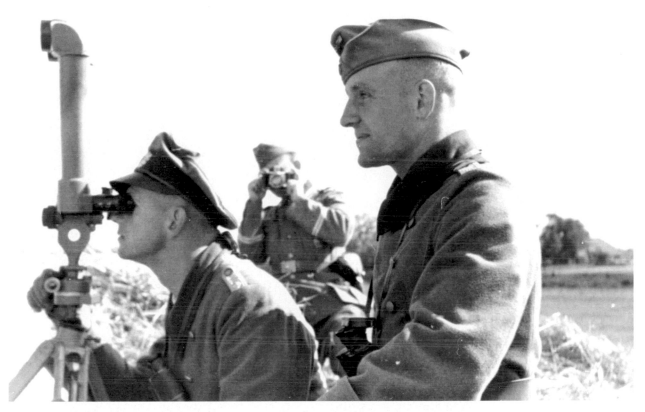

A War with a View

This photograph was taken on September 1, 1939, literally the day World War II began as the result of Germany's invasion of Poland. While a photographer can be seen documenting the moment, a German Army officer peers through periscope binoculars to scan the Polish side of the border, all in readiness for the assault, the provocation a carefully staged "attack" on a German border radio station by "Polish soldiers" whose bodies were recovered after the thwarted attack. In fact, the bodies, dressed in Polish army uniforms, were corpses "harvested" from a German prison camp for the deception.

The instrument employed by the officer to gain a view of the impending war was most likely manufactured by Leitz although Zeiss was also involved in designing and supplying such equipment to the *Wehrmacht.* It was an invaluable instrument for the gauging of distances and its periscope design also provided protection from snipers for the soldiers in the trenches.

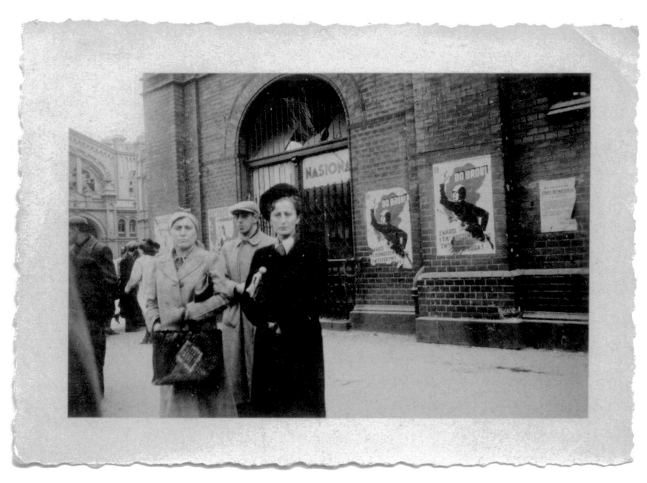

Polish Posters

Along with torn patriotic posters in the background urging Polish soldiers to arms, a German soldier has caught sight of a fashionably dressed attractive young woman.

The Third Reich considered the Poles to be subhuman and worthy only of serving Germany as slaves. To cripple the Polish culture, Hitler ordered the immediate murder of more than 3,500 leaders and 3,000 professors and priests—the cream of the intelligensia.

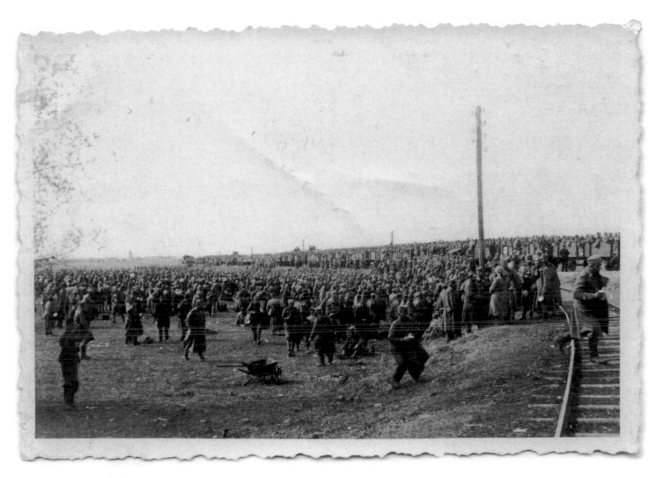

A Sea of POWs

Tens of thousands of Polish POWs, the result of Germany's September, 1939 *Blitzkrieg* invasion, gather beside a railroad siding while thousands more stand crammed into open cars on their way to prison camps. In the right foreground, a lone woman is selling food while far to the left a single, unarmed German soldier, glances at the camera.

An estimated 664,000 Polish soldiers would die in battle or as POWS. Another 5–6,000,000 Polish civilians died from execution, starvation and disease as the result of the German occupation. The statistics include individuals targeted by the Nazis for elimination: 25% of the Polish Catholic clergy, 20% of Polish school teachers and 25% of Polish scientists.

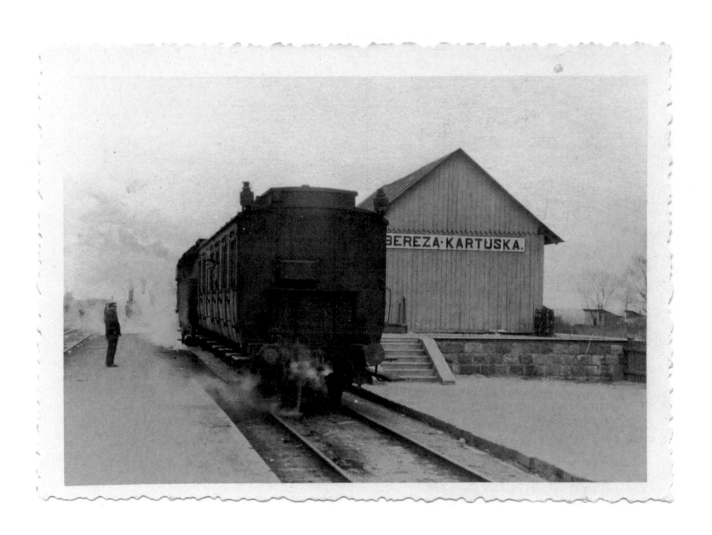

258

Lesser Known Concentration Camp: Bereza-Kartuska, Poland

Bereza-Kartuska was a small city east of Brzec situated in the marshes of eastern Poland. The town was first mentioned in 1477 and its name is derived from the prevalent birch trees (Bereza) and a Catholic monastery. It was also the location for the Battle of Bereza-Kartuska, which is considered the first battle of the Polish-Bolshevik War (between the forces of the Second Polish Republic and Soviet Russia) when on February 14, 1919, sixty-two Polish soldiers attacked Soviet forces capturing eighty.

Later, it gained some notoriety as the location of an "isolation camp" constructed by the semi-Fascist government of Poland under Marshal Pilsudski. It shared the claim, along with Dachau, as one of the first such installations in Europe outside the USSR. Built to incarcerate the politically "undesirable," the camp contained Communists and Ukrainian, Belorussian and Lithuanian nationalists seen as a threat by the Polish government.

In an effort to further improve their nation's image, the ruling colonels sought "colonies" like the other prevailing powers. In 1939, Poland helped Hitler to dismember Czechoslovakia and was rewarded with a small strip of Czech territory called Tesin or Téschen, a temporary "loan" as it would turn out. German planes bombed Bereza on June 22, 1941, at five o'clock in the morning, the day of the invasion of the Soviet Union (Operation Barbarossa), taking control of the town the next day. During its occupation, the Germans killed more than 8,000 Jews. Nearly 200,000 Polish Jews would go on to fight against Nazi Germany in the ranks of the Polish Armies on Polish soil and while in exile from their country.

Twin Targets

Two tiny Polish boys, old beyond their years, pose for a German cameraman, one child stands "at attention" while his mother looks on apprehensively.

The Germans, in their search for "legitimate German blood" to nurture the growth of the Greater Reich, also kidnapped 200,000 Polish children who matched their racial criteria. Destined for "Germanization," they were deported from their homes and sent to institutions and individual families in Germany. After the war's end, 150,000 of the children never returned to their rightful parents, some of whom never stopped looking. A total of 350,000 Polish children were left orphaned, abandoned and neglected.

In addition, an estimated 2,225,000 Polish children, Jewish and Gentile, were casualties of the Nazi racial and political war of annihilation.

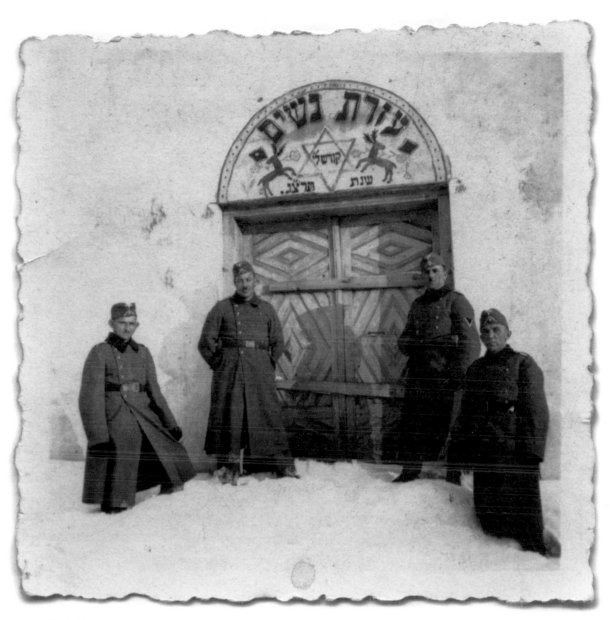

Polish Synagogue

Waiting for their souvenir photo to be snapped, four soldiers of the German army stand in the snow before the doorway to an orthodox Jewish house of worship in Poland. They no doubt can't read the Hebrew inscription that indicates this particular door is reserved for the entry of female worshippers. Images of gentle deer decorate the doorway lentil, doors that will never again open for the synagogue's congregation. The patterns on the wooden doors seem to form two large eyes staring out at the camera.

On the back of the photo is the date, February 20, 1940, a Tuesday, some six months since Germany invaded the country. The name of the town is recorded but the handwriting is difficult to decipher although it begins with "Synagogue im Przjsnc. . . ."

Ein polnischer-Jude

"Ein Polnischer Jude"

A well-to-do Polish Jew is forced to do menial work by his German tormentors prior to meeting his fate. The photo, with its handwritten caption, was found in a German soldier's personal album.

Dehumanizing the Third Reich's victims made them easier to kill: Slavs were characterized as "subhuman"; Gypsies as "asocial"; Jews as "parasitic" and "shirkers of all legitimate labor." For all those caught within the grasp of the Third Reich, "work" became a euphemism for death. The cynical concept was no more explicit than that written over the entrance gate to Auschwitz . . . *Arbeit Macht Frei*. "Work Makes You Free."

So-called "work camps" as opposed to "death camps" were designed to accomplish the same goal, but over an extended period of time to allow for increased suffering through physical torment, starvation and disease. Working oneself to death took on a literal meaning. In Poland alone, the Germans succeeded in killing six million civilians, half Polish Catholics, half Polish Jews.

Lodz Becomes Litzmannstadt

Two German motorcycle troopers stand
out sharply against a fading cityscape.
Handwriting on the back of the photo-
graph provides the name of the city as
"Litzmannstadt" and the date August
10, 1942.

In Polish, Lodz means "boat," but there was no rescue from their sinking fate for the 220,000 Jews of the area who were forced into the city's ghetto from which only 900 survived, most exterminated at the Chelmno death camp and later at Auschwitz-Birkenau. There were also two *Jugendverwahrlage* or children camps, *Dzierzazna* and *Litzmannstadt*, to which were sent hundreds of children and teenagers considered not good enough to be "Germanized" and later transported to the extermination centers. Non-Jews suffered as well, including Gypsies and Polish children selected for a number of concentration and death camps the Germans erected for them.

The Lodz death toll suffered by war's end included 300,000 Jews (including Jews deported from other locations) and 120,000 Poles. The city itself suffered relatively minor physical damage and, along with Kracow, was the only large Polish city that survived the war largely intact and as such served as Poland's capital until 1948 and the resurrection of Warsaw.

Nine days after this photo was taken, on August 23, 1942, the Germans would make their fateful attack on Stalingrad, another city they intended to obliterate, but which instead signaled the death knell for the Third Reich.

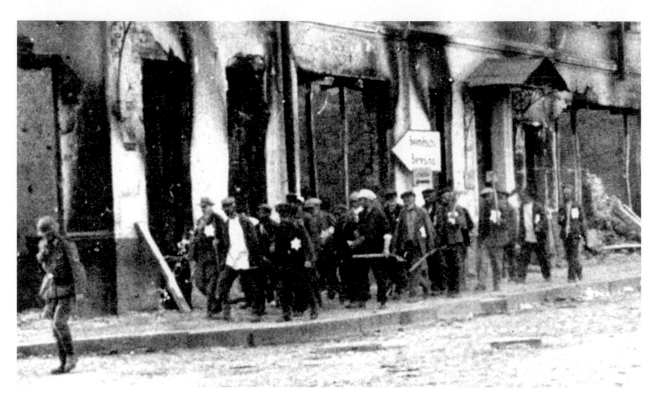

Street Cleaning

With most wearing large Jewish stars,
a group of men trudge along with their
shovels following a lone German soldier
leading the way to the day's work detail.

It was not enough to simply kill Jews.
They had to suffer for their alleged sins
against Germany. For example, Jews
who were recaptured after escaping
from a Polish labor camp were required
to work three days cleaning streets to
pay for the ammunition used to kill
them.

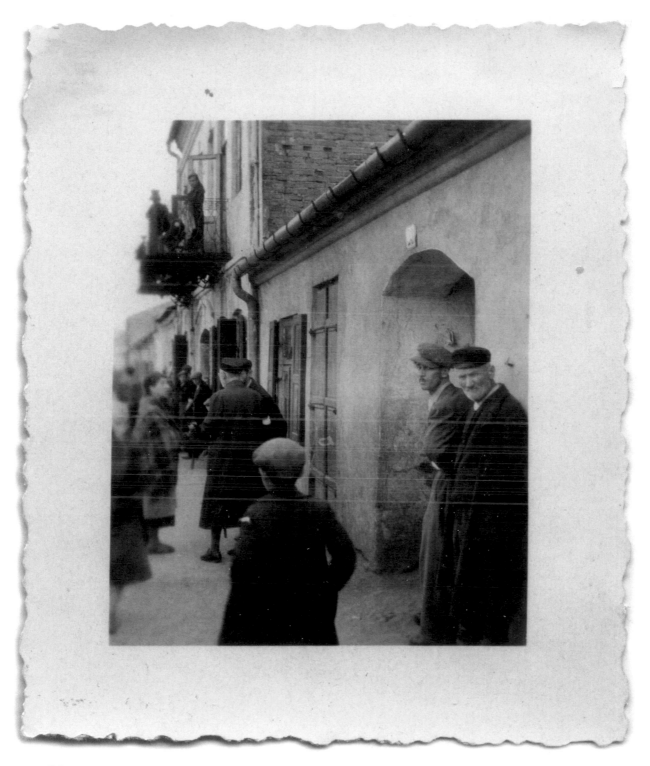

Ghetto

Residents of a Jewish ghetto are caught
by a German soldier's camera.

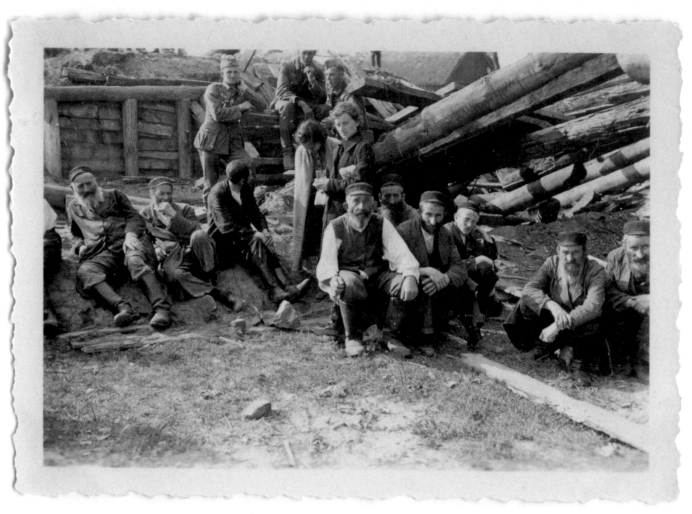

Labor Camp Tableaux

A portrait of Polish Jews, apparently
newly arrived as their clothes are rela-
tively neat and clean, is captured by a
German cameraman while his fellow
soldiers, unarmed, loll casually in the
background. One well-dressed woman
glares at the camera.

Companies that wished to employ the survivors were required to rent the prisoners at a fixed rate of four Polish *zlotys* per day for women, five for men or between 1,825–1,460 *zlotys* annually, though none were expected to survive that long. By comparison, on the 1941 Polish black market, a pair of shoes, very difficult to find, cost 400–600 *zlotys*.

Slave labor employers also were responsible for building camps for the workers so that the ghettos could be torn down. And thirdly, all work produced by the Jewish slaves had to contribute to the war effort.

While millions of foreign slave laborers enabled Germany to continue wartime production and reconstruction even in the face of constant Allied bombing, the millions of Jews who came under German control were for the most part "unutilized" and consigned to destruction, the Nazi prime directive. In some ghettos and labor camps (some contiguous to death camps), Jews produced uniforms for the German army, in effect clothing their killers. In others, skilled jewelers were employed by the Germans to cut and polish rough diamonds stolen from other Jews on their way to the gas chambers.

An estimated 10,000 concentration and labor camps were established throughout the Third Reich, including 645 forced labor camps in Berlin itself and more than 2,000 in the Greater Berlin area.

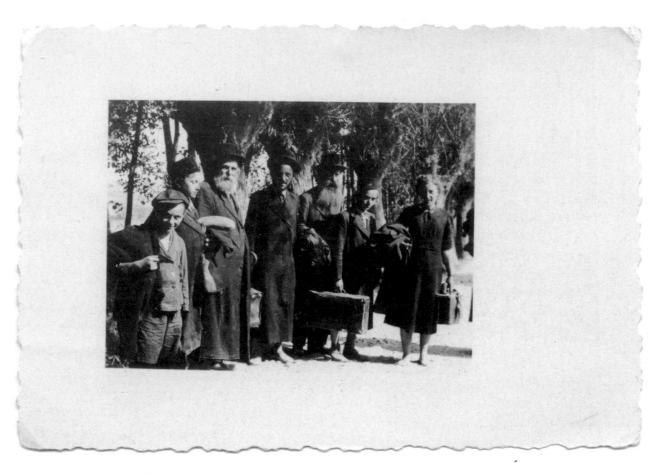

Beyond Sophie's Choice

A German soldier somewhere in Poland snaps a family portrait, three generations of Jews . . . grandfather, father, children . . . carrying their suitcases bound for a one-way trip to oblivion, although they probably believe, as the Germans have promised, that they are being sent to a work camp, there to be productive and thus earn their lives. They wear a mixture of expressions . . . some smile, some glare at the camera while one turns away from it.

One day in the nightmare world of Auschwitz, the SS ordered a "selection" of 1,400 Jewish boys between the ages of 14 and 18. A board was nailed up at a certain height and those who did not measure up were to be sent to the gas and fire. Fathers could on occasion bribe the guards to save their child's life, at least for the moment. However, the guards, required to produce a specific number of children to be murdered, would then select another child in its place.

One very pious father came to Hungarian Rabbi Zevi Hirsch Meisels who was among the prisoners and asked for a Talmudic "ruling" as to whether it was permissible to save his son at the expense of another's life. The rabbi pondered, but ultimately could give no judgment. The father took the lack of a reply as follows: "This means to me that the verdict is that by law I am not allowed to do it. This is enough for me. It is clear that my only child will be burned according to the Torah and the law, and I accept this with love and rejoicing. I will do nothing to ransom him, for so the Torah has commanded."

All that day, which happened to be Rosh Hashanah, the Jewish New Year, the father walked about the camp, talking to himself, "murmuring joyfully that he had the merit to sacrifice his only son to God . . ."

Rabbi Meisels would survive the death camps and later write of this moment of decision.

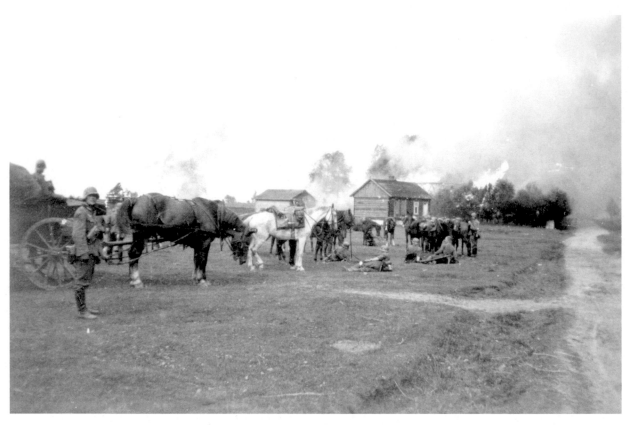

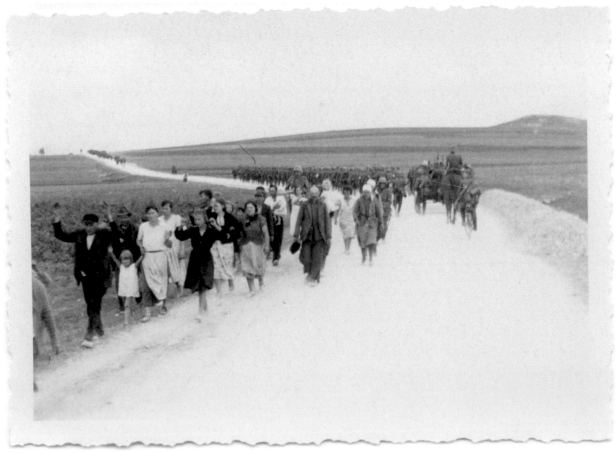

Poland—Three Photos
Taken September 2–3, 1939

These photographs were taken just one day after Germany invaded Poland.

In the first photo we see a village in flames.

In the second, civilians . . . men, women, children, infants . . . are marched down a road while German forces move in the opposite direction deeper into Poland.

In the third image, the villagers have reached the edge of a forest where they have been forced to lie face down on the ground. It was a common tactic employed by execution squads, often making their victims remain in that position for hours without water. What exact fate awaits them is unknown. The fourth photo is missing.

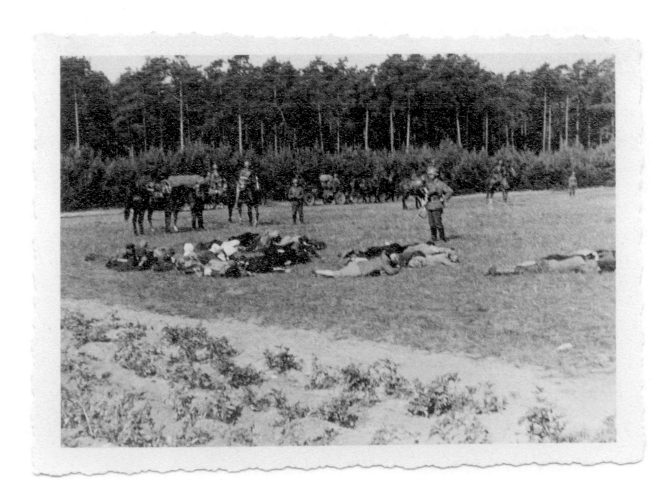

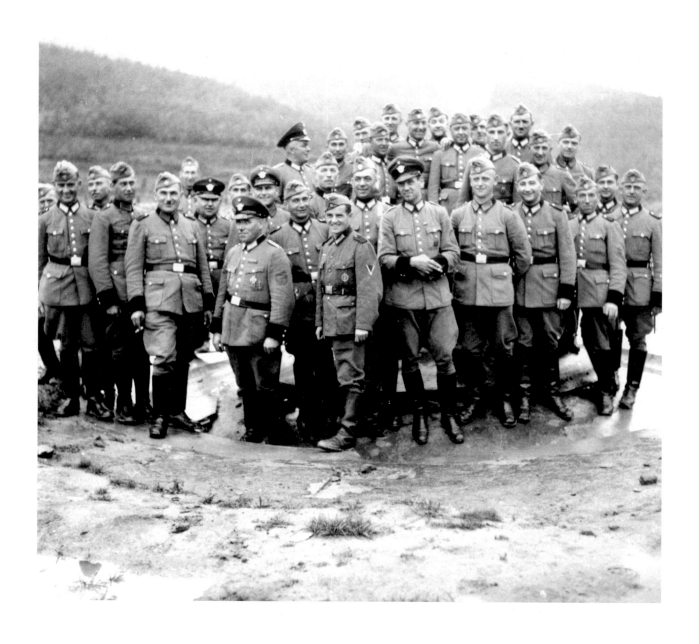

274

Group Portrait of Police Battalion 322

Thirty-three members of the Police Battalion 322 pose for a group portrait somewhere in the Soviet Union.

The former training battalion No. 56/41 was redeployed as Police Battalion 322 and from April 16, 1941 served in Special Actions as a Cycle Battalion. On June 9, 1941, the battalion was sent to Warsaw where it joined the Police Regiment *Mitte* (one of the three Order Police regiments sent to the USSR).

The battalion records include the following terse notation:

August 18, 1941

4.00 Jewish action in Narewka-Mala. 259 women and 162 children transported by lorry to Kobryn. 282 Jews were shot.

Narewka-Mala is located in the area of Bialystok in northeastern Poland near the border with then Soviet Belarus. In 1937, Poland's population was 21.9% Jewish, the largest concentration of any country in the world. Sixty percent of Bialystok's pre-WWII citizens were Jewish, giving it the highest concentration of Jews of any city in the world at that time. 3,000,000 Polish Jews died at the hands of the Germans.

Police Battalion 322's personal contribution included the following:

Bialystok—July 12–13, 1941—3,000 Jews shot

Mogilev—October 19, 1941—3,700 Jews shot

Minsk—November 1941—19,000 Jews shot

Minsk—July 28–30, 1942—9,000 Jews shot

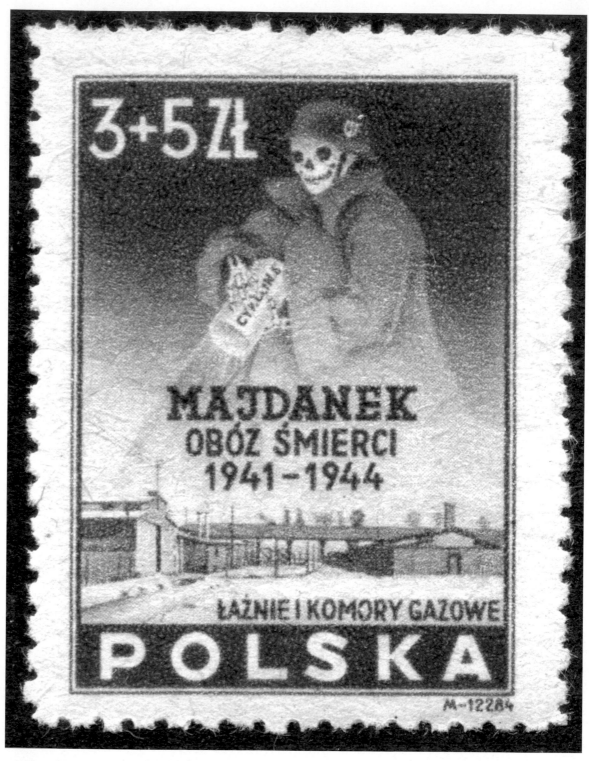

Oboz Smierci—Death Camp

A postage stamp issued in post-war
Poland memorializes the suffering at
Majdanek and the use of Zyklon B gas
to murder its inmates.

While the major extermination centers were located in Poland, both Polish and Jewish organizations have spoken out against the common use of the phrase "Polish Death Camps" as they were actually German Death Camps in Poland while the former phrasing seems to place the onus on Poland.

* * * *

When a Slovakian prisoner learned that his friend Walter Rosenberg planned to escape from Auschwitz, he gave him proof of the gassings, a label from a canister of Zyklon B.

Rosenberg made good his escape and reached safety and published a report on the death camp that reached the West and broadcast on the BBC. The general reaction was disbelief, even among some young Germans. One Berlin resident Ursula von Kardorff, herself an anti-Nazi, in December, 1944 wrote in her diary, "Is one to believe such a ghastly story? It simply cannot be true. Surely even the most brutal fanatics could not be so absolutely bestial."

In August, 2006, a label from a can of Zyklon B was auctioned off on eBay. It sold for $241.28.

* * * *

Some Holocaust deniers or "revisers" as they prefer to be called, protest that it was impossible for so few Germans to have killed so many Jews. Statistics prove otherwise. Majdanek, located only two miles from Lublin, illustrates the math of mass murder. On Wednesday, November 3, 1943, at pits dug near the Majdanek concentration camp, a few dozen Germans shot 18,400 men, women and children. One can also note that at Treblinka only twenty to thirty

Germans were assigned to that killing center where almost a million men, women, and children were murdered. In this instance, the SS relied on about 90 to 120 Ukrainian volunteer auxiliaries to kill the arriving multitudes and to guard the inmate work force.

Second only to Auschwitz in size, Majdanek was initially a POW and transit camp, then slave labor camp/extermination center. The camp employed gas chambers fed by carbon monoxide, then Zyklon B. The camp went into operation in October, 1941, and was liberated by the Soviets on July 22, 1944. Forty percent of the prisoners were Jews, another 35% Poles with 50 different nationalities represented in all. Some 70% were young men and women, aged 20–25. Majdanek also had the highest percentage of children up to fifteen years old. A film documenting the death camp was also made public and helped serve as a rallying cry for Soviet troops. While the official Majdanek Memorial web site states that 230,000 died in the camp, other sources cite an estimated 1.5 million, 60% from outright murder, 40% by starvation, disease and maltreatment.

Of the some 10,000 Germans operating the Majdanek killing center, only a fraction, 1,300, were eventually listed as identified. Of that number, only 387 were officially investigated and eventually only sixteen charged with offenses. This reflects a general trend in the prosecution of the Third Reich war criminals.

If you were to travel to the Majdanek Memorial today and view the remains of the camp, you can still see the blue residue left by Zyklon B on the walls of the gas chamber.

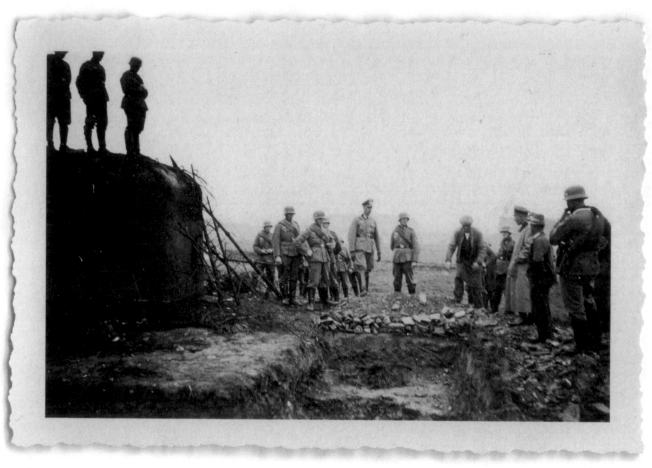

Stepping into the Abyss

German soldiers gather as spectators,
all eyes seem fixed on a civilian stepping
toward a trench, or perhaps a freshly
dug grave.

While giving a speech on October 4, 1943, on the occasion of a convention of SS Major Generals in Posen, Heinrich Himmler, head of the SS, praised the mass killings of Jews, calling it "a glorious page in German history." A portion of his speech reads as follows:

Most of you will know what it means if a hundred bodies are piled high, five hundred or a thousand. To have endured this and yet to have remained decent in the process, aside from those exceptions of human weakness—that is what has steeled and hardened us. This is an unwritten, and a never to be written page of glory in our history. Because we know how difficult the situation for us would be today if in that city—given all the air raids, the burdens and deprivations of the war—we were still saddled with the Jews· as secret saboteurs, agitators and rabble-rousers. By now, we would probably be back facing a situation similar to that of 1916/1917—if the Jews were still lodged within the body of the German people. We took from them the assets and riches they possessed. We had the moral right, we had the duty toward our own Volk, to destroy that people which wished to destroy us. In general, however, we can say that—out of a feeling of love for our people—we have fulfilled this most arduous of tasks. And that we have suffered no damage or harm as a result—in our inner being, our souls, our character.

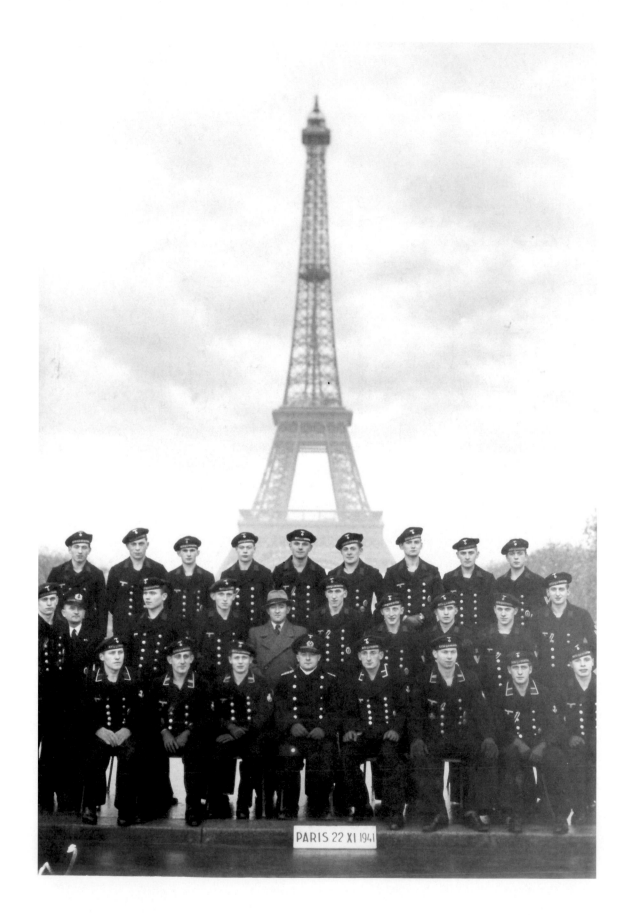

PARIS 22 XI 1941

280

Paris . . . November 22, 1941

A picture of crewmembers of the *Scharnhorst,* posing against the backdrop of the Eiffel Tower.

Considered one of the most beautiful warships ever built, and the pride of the German Navy, the *Scharnhorst* was commissioned in January, 1939. Fully loaded, it displaced 34,080 metric tons, spanned a length of 231 meters and was capable of thirty-two knots thanks to twelve boilers and three turbines producing some 160,000 horsepower. Heavily armored and armed, and fitted with radar, it was designed to wreak havoc on convoys transporting Allied war materiel, a mission it accomplished in no small measure. In 1940, off Norway, the *Scharnhorst* and her sister-ship *Gneisenau* sank the British aircraft carrier *HMS Glorious* and her escort destroyers *Acasta* and *Ardent.* One thousand five hundred nineteen men were lost from the three ships. Although there were thirty-eight survivors, none was picked up by the German warships.

The *Scharnhorst* and crew met their fate on December 26, 1943, when she was sunk by the British Royal Navy during the Battle of the North Cape off the coast of Norway. Of her 1,968 crewmembers, only thirty-six were saved from the frigid waters of the Barents Sea. On October 3, 2000, the sunken remains of the *Scharnhorst* was located sixty-six miles north-northeast of North Cape at the depth of some 290 meters.

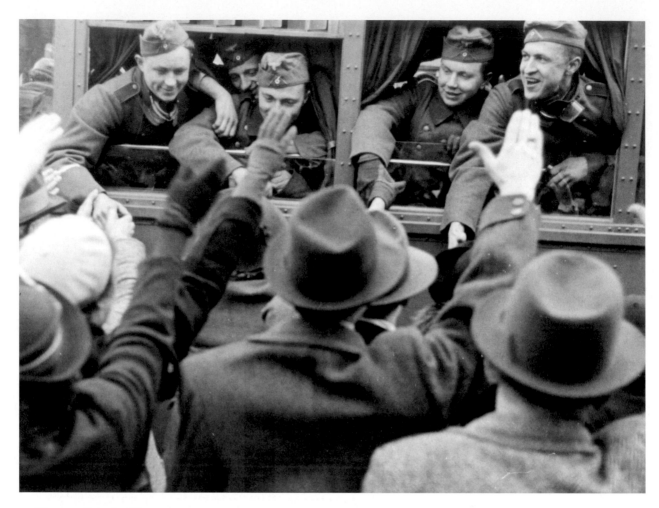

Forward to the Front

Soldiers off to the Western Front are bade farewell by their parents and countrymen, their young faces aglow. Poland lies at the feet of Greater Germany, France will follow. But the same troop trains will eventually transport them to the Eastern Front from which hundreds of thousands will never return.

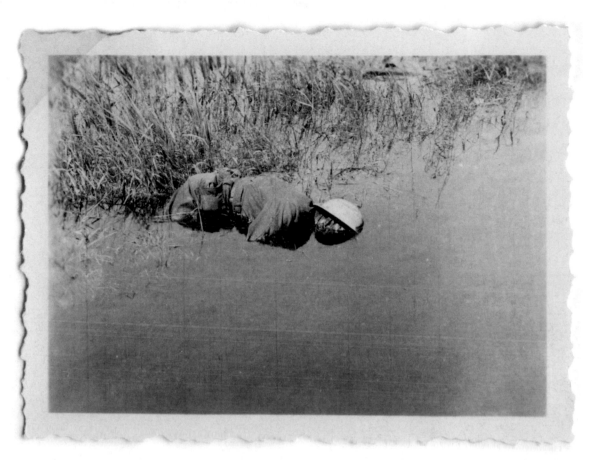

Fallen French Fighter

The image of a French soldier lying in the still waters brings home the terrible poetry of the battlefield. The image seems to epitomize the lonely, unattended, desperate death of the individual, only his distinctive French helmet giving him some measure of identification. We cannot know what thoughts or emotions were experienced by the German soldier taking the photograph, but he did stop to record the moment.

The French were forced to pay for the German occupation. Vichy French forces fought against Allied troops including Free French soldiers when they sought to capture French-controlled Syria. The Vichy government also formed the *Milice*, with over 35,000 operatives. Similar to the *Gestapo*, they used terror and torture against the French Resistance, the *Maquis*.

After the victory over France, Hitler paid one visit to Paris and never returned.

France, with a 1939 population of 41,700,000 would suffer 217,600 war-related military deaths, 267,000 civilian deaths as well as the murder of 83,000 of its Jewish citizens, a total of 567,600 deaths.

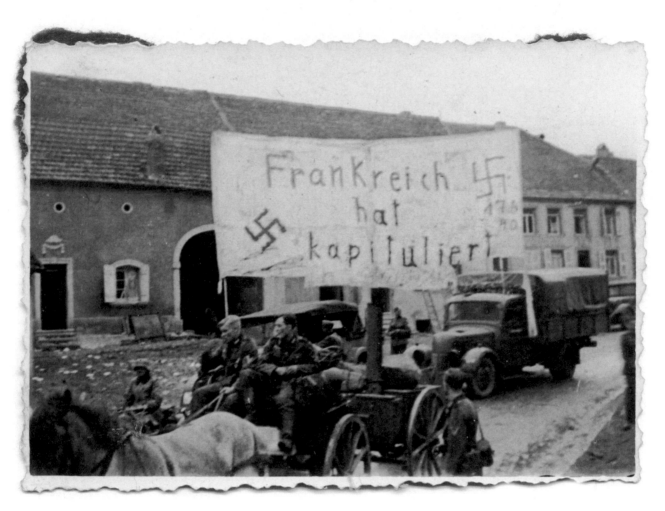

"France has Capitulated"
June 17, 1940

Somewhere in France, a horse-drawn
field kitchen passes before a handmade
banner proclaiming the victory of Ger-
man forces.

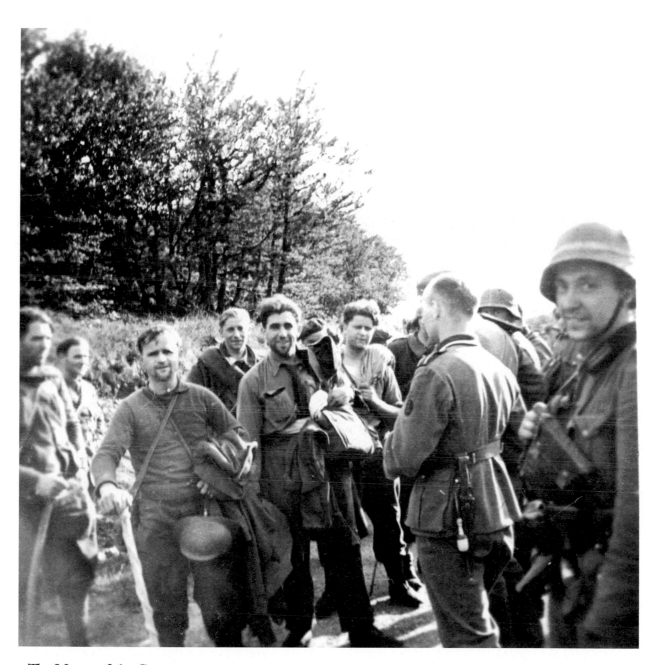

The Magic of the Camera

In the midst of a brutal war both Germans and their French POWs turn to smile for their photo.

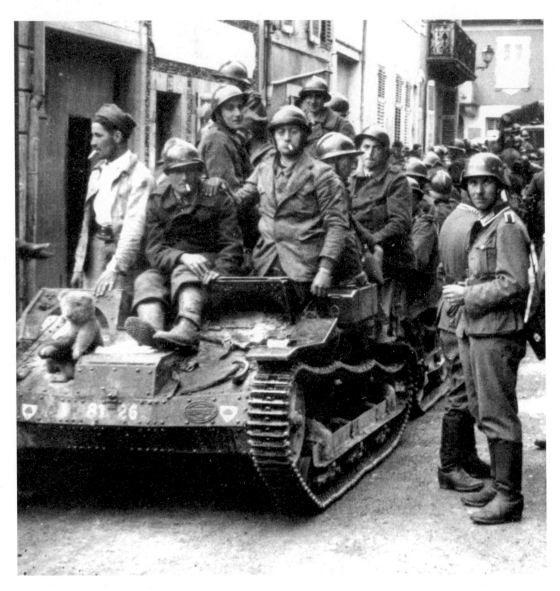

Teddy Bear Tankette

German troops casually stand about as cigarette-smoking French soldiers roll in aboard their tankettes to surrender after France signed an armistice ending six-weeks of fighting in June, 1940. French troops under German control would later engage in combat with Allied forces while members of the Free French would help liberate their country in August, 1944.

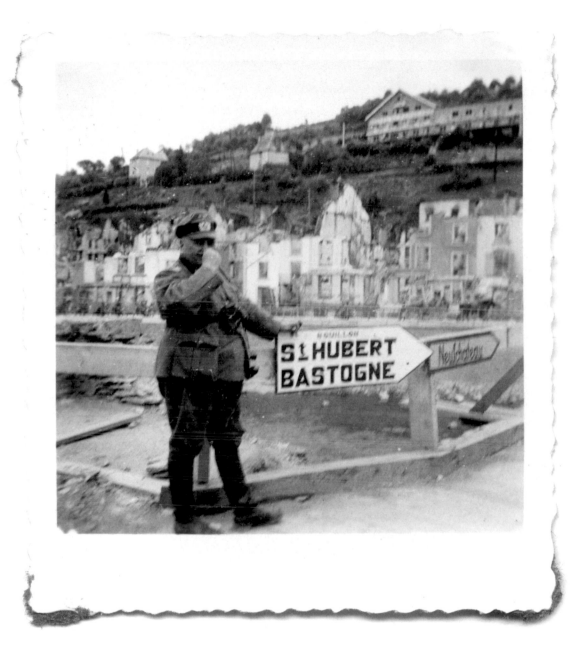

On the Road to Bastogne

Basking in the victorious short war against the French in June, 1940, and with a backdrop of shattered buildings, a rather portly German army officer seems to be making a comment about the French as he poses for his portrait in front of signs pointing off to a future unknown to him as yet, that of the famous Battle of the Bulge when on December 16, 1944, German forces launched a surprise counterattack in the Ardennes against American forces. While they met initial success, the Third Reich's last-ditch effort failed and Allied forces held. In response to a German ultimatum to surrender, the American garrison commander sent back the famous one-word reply . . . "Nuts!"

The Two Roads To Moissy

Three very young soldiers loll in the grass beneath the sign indicating Moissy, a town situated in north central France. After the six-week whirlwind battle that saw France defeated by the German onslaught, these boys, their boots still shiny and clean, must have enjoyed basking in the sunshine and in the *Wehrmacht's* glorious victory. The road to Moissy, paved in golden light, would, some four years later be repaved in blood as the Allies pressed home their invasion of Fortress Europe from the beaches of Normandy. With U.S. air superiority ruling the skies, fire and steel rained down upon the German troops and their war machines, earning one country road east of Moissy the sobriquet "le Couloir de la Mort: the Corridor of Death." In the surrounding area, some 3,000 tanks, guns and vehicles were destroyed, while at least 10,000 German soldiers were annihilated. The road to Moissy had indeed led in two directions, fleeting glory and fiery oblivion.

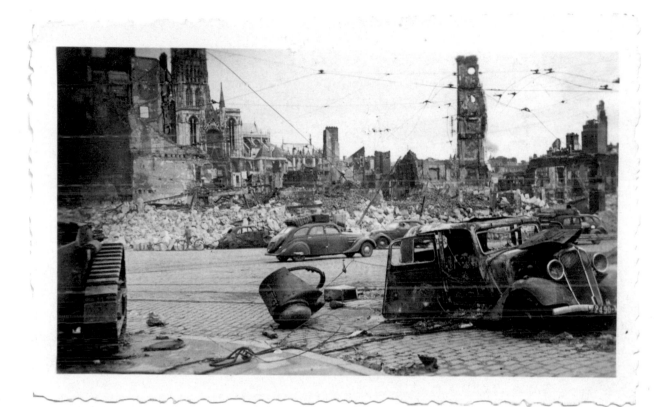

French Cityscape

A German soldier's camera captures the
movement of cars against a tableau of
rubble and destruction

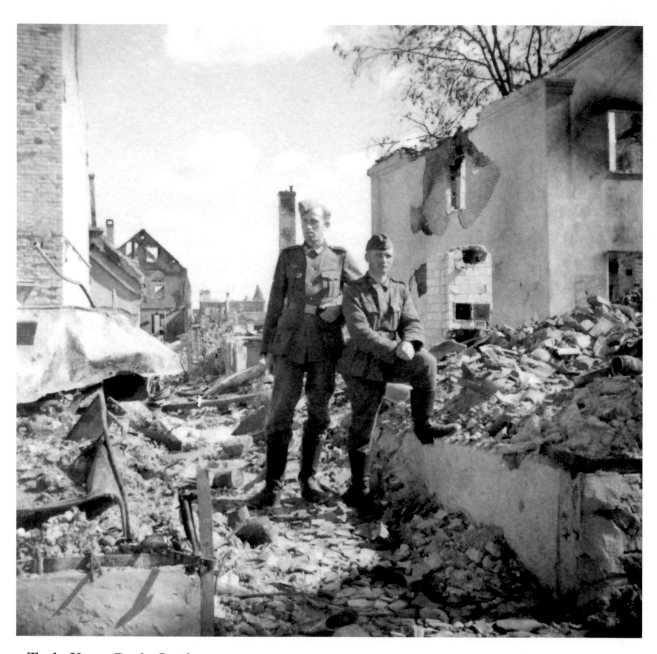

**To the Victor Go the Spoils,
France 1940**

Two soldiers use the rubble of a defeated
France as backdrop for their
"formal" portrait.

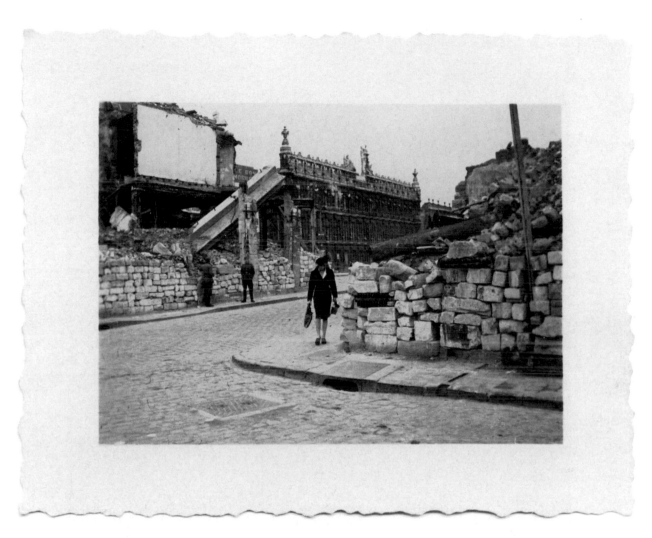

Study in Contrasts

Under the gaze of the German occupiers, a trés chic Frenchwoman traverses the rubble of her city. Her gaze is downcast as she has no doubt noticed the soldier snapping her photo.

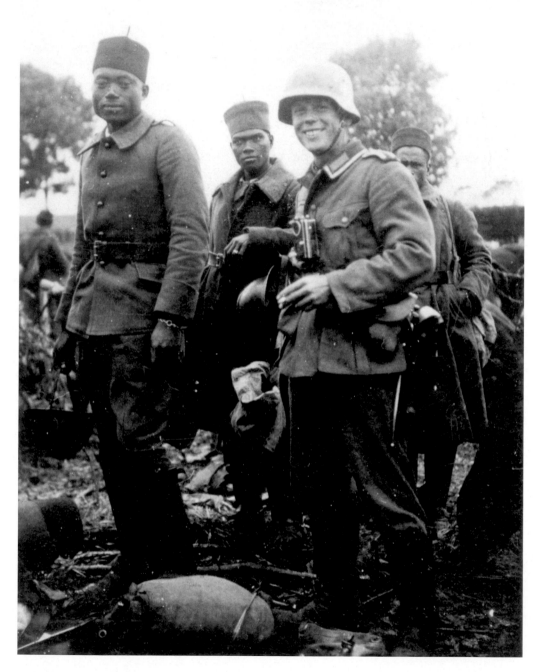

A Curiosity of War

A German officer takes a smoke and smiles for the cameraman as he shows off his curiosity of war, a French colonial soldier. Most Germans had never seen a black person.

On May 13, 1940, the German army invaded France, crossing the Meuse at Sedan. On June 22, the Franco-German Armistice was signed, a portion of France under German occupation, the other left on its own, the so-called Vichy government in control.

When the Germans surprised even themselves by conquering France in six weeks, they found themselves with thousands of POWs, among them a large number of colonial conscripts from Algeria, Morocco, Senegal and French West Africa.

While the Germans considered the Senegalese and Moroccan soldiers fierce fighters, the Third Reich, in its racial war, classified blacks as subhuman and many were executed upon capture, both from the French and American armies. This treatment of blacks was foreshadowed in 1936 when the Germans reoccupied the industrial area of the Ruhr Valley.

In this group of photos the Germans seem amused at their captives and show them off to the camera as souvenirs.

Many colonial POWs spent the war as prisoners, while those who came under the authority of Vichy France were then sent to protect French interests abroad against the threat from the foes of Nazi Germany, specifically the Allies. By 1943, due to a turn in the war, the *Tirailleurs* or riflemen, were again utilized by de Gaulle's Free French and helped fight for the liberation of Europe.

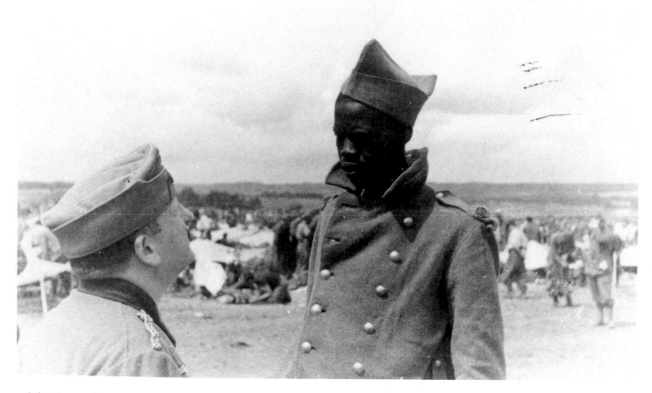

The Stare-Down

A member of the Security Police
examines a French colonial captive
culled from the endless mass of POWs
glimpsed in the background. Perhaps
the German is captivated by the young
prisoner's height or perhaps deciding his
fate. Thousands of black soldiers were
executed upon capture.

Charles N'Tchoréré was born in Libreville, Gabon, to a notable Mpongwe family. Although a top student, he had to leave school at sixteen to work with his father in German Cameroon. Fighting during WWI with *Tirailleurs Sénégalais* he was promoted to sergeant, and in 1927 became one of the few Africans afforded an officer's commission. He worked to improve military training of African soldiers and became a battalion chief in 1937, retiring as a lieutenant.

With the outbreak of WWII he served as a captain in the *Infanterie Coloniale Mixte Sénégalais*, engaging the Germans on the Somme River. With only ten Africans and five Europeans surviving and some 1,200 of his troops killed in three days of combat, they were forced to surrender. A German officer refused to treat N'Tchoréré, a black, as an officer and when N'Tchoréré stood his ground, the German shot him. A week later, in the same area around Amiens, his son, Jean-Baptiste, was killed in action.

Today, in the small French village of Airaines, there is a memorial to Charles N'Tchoréré, and in 1962 he was honored on a postage stamp of Gabon.

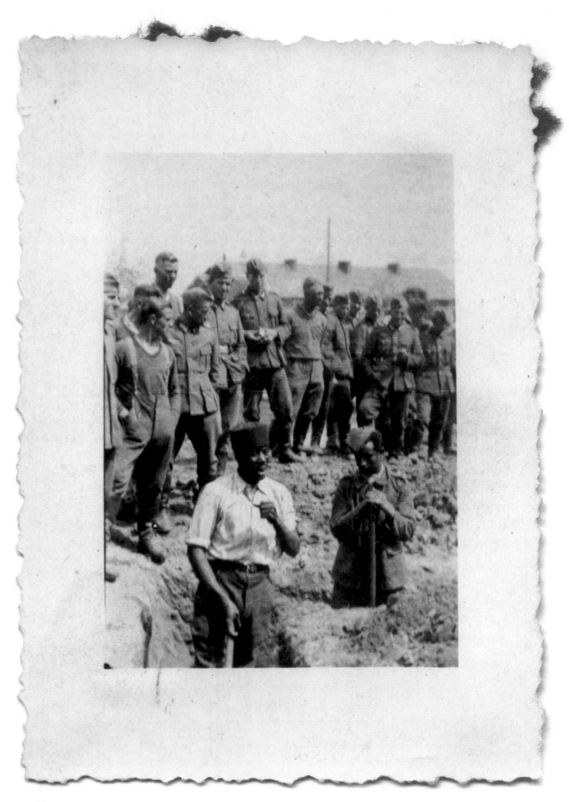

Spectators

Regular *Wehrmacht* troops gather to watch black French colonial POWs dig what could be trenches, latrines or graves.

WWI Memorial

A German soldier has stopped to photograph a memorial to Jewish French soldiers who died in service to their country during the First World War. The tablets represent the Ten Commandments.

After the WWII capitulation to the Germans, French authorities helped to round up and deport 75,000 French Jews to German death camps.

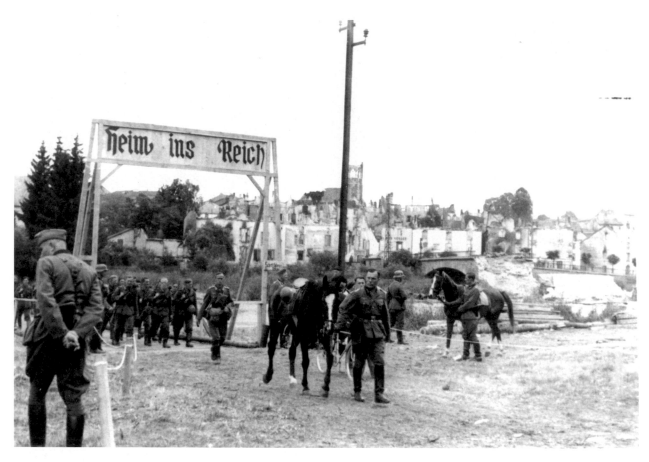

"Home to Germany"

So says the wooden arch of triumph
through which the battle-weary soldiers
cross the border from France into the
Heimat. . . . homeland.

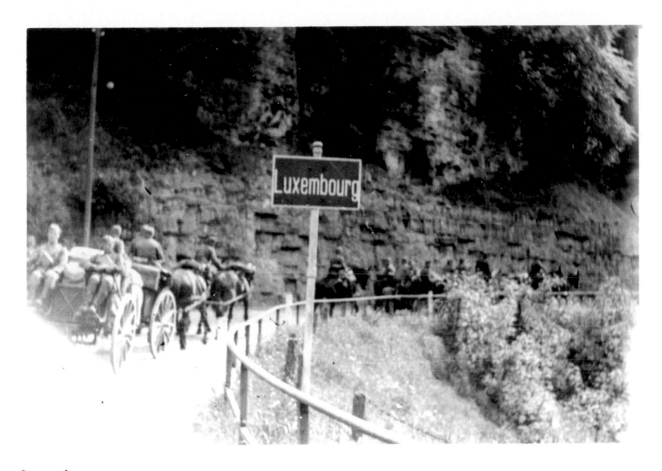

Luxembourg

A soldier's camera captures the moment
he and the unstoppable German
war machine invades the Grand Duchy
of Luxembourg in May, 1940.

While not entirely bloodless (seven
wounded), there was little resistance
from the tiny country when German
forces, on their way to France, crossed
its borders. Of 290,000 citizens about
17,000 were considered *Reichs-Deutsch*.
In a further effort at "Germanization,"
the various Nazi political and paramili-
tary organizations were forced upon the
citizens. Through intense recruiting
efforts, the Germans were able to enlist
1,800–2,000 volunteers and then in
August, 1942, when Luxembourg was
officially absorbed into the German

Reich, all of its citizens were forcibly
subject to conscription in the German
Wehrmacht. Of the 12,035 taken into
German military service, 2,752 were
KIA or MIA, another 1,500 severely
wounded or disabled. Approximately
2,000 of its Jewish citizens were "trans-
ported East."

After the war's end, hundreds of Lux-
embourgers were arraigned on charges
of collaboration, and eight of twelve
death sentences were carried out.

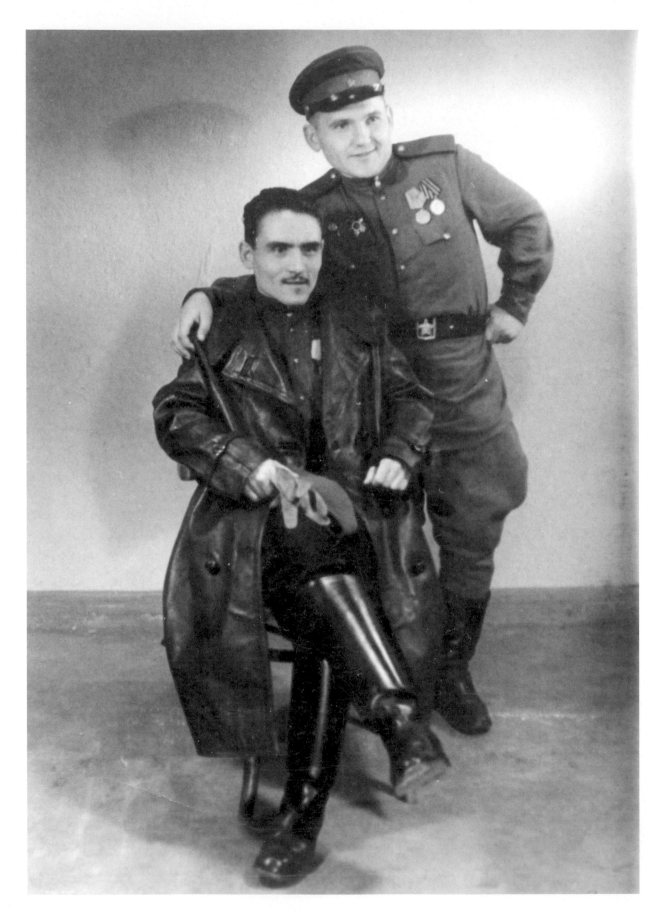

The Other Dictatorship

A Soviet officer and a black leather-clad member of the NKVD pose for a photo.

In the fog of war, compounded by the fog of politics, few remember that Fascist Germany and Communist Russia, antipodal ideologies, were for a time allies and collaborators at the expense of countries and peoples they mutually targeted.

The words "surreal" and "schizophrenic" barely describe the Russian and German alliance that preceded the attack on the Soviet Union in June, 1941. Stalin and Hitler had signed a Soviet-German Non-Aggression Pact on August 23, 1939, in which they agreed not to wage war against each other, but rather to cooperate in an attack upon Poland and then share the dismembered country between them.

The Germans invaded on September 1, 1939, the Soviets on September 17. While the Nazi's declared racial war on the Jews of Poland as well as the Polish intelligentsia, clergy and leadership, the Soviets sought to eliminate the Polish military command in their plan to weaken Poland and prepare the way for a Communist takeover. The Soviet security forces and secret police, the NKVD, were responsible for numerous mass murders including the execution in the Katyn Forest near Smolensk of nearly 4,500 Polish officers, each shot in the back of the head. The atrocity was initially blamed on the Germans.

The USSR also attacked Finland in November, 1940, during which they bombed Helsinki. Meeting stiff resistance from the Finns, a peace treaty was signed in Moscow on March 12, 1940. Some fifteen months later, Germany would turn on its former Soviet ally and launch a war between the two countries that would consume more than 30,000,000 people.

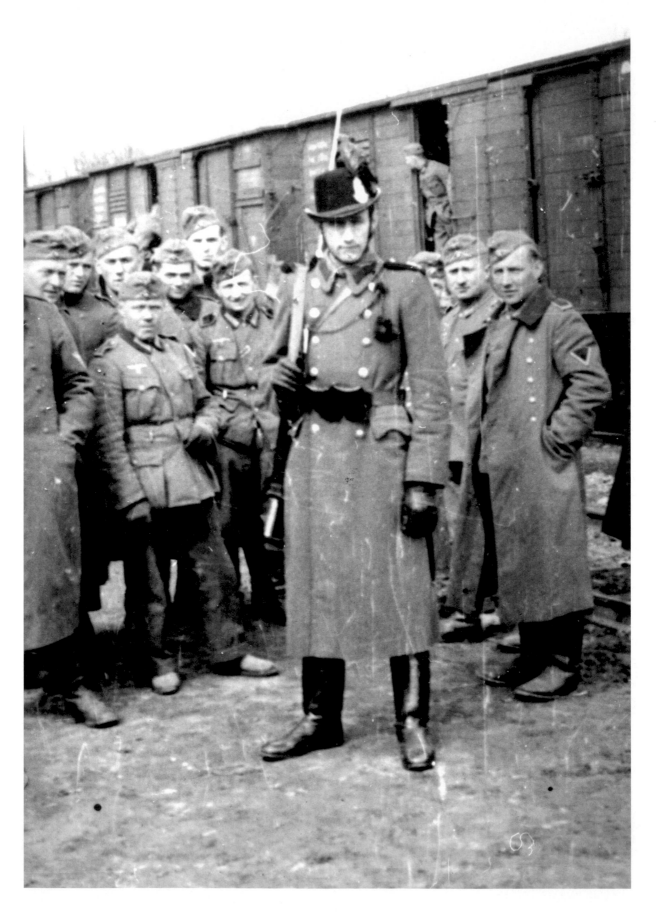

Rooster Feathers

The most distinctive feature of the Romanian soldier, the *Csendőr*, was a large rooster feather plume affixed to the left side of his black hat. The plumage became so identified with the *Csendőrség* that they were often referred to as the "rooster feathers" ("*kakas tollasok*").

As a result of giving up Romanian territory to the Soviet Union, Hungary and Italy in 1940, the army supported General Ion Antonescu, more anti-Russian than pro-German, in his seizure of control of Romania. In June, 1941, after declaring war on the Soviet Union and joining the German *Wehrmacht*, it regained lost territory. However, as the war was being lost by Germany, an August, 1944, coup led by King Michael deposed the Antonescu dictatorship and put Romania's armies under Red Army command. Romanian forces would then fight against the Nazis in Hungary and Czechoslovakia with losses of 17,000 soldiers.

Jews had lived in Romania for 1,800 years, and in 1939, the country contained the third largest Jewish population after the USSR and Poland. Anti-Semitism and anti-Communism were strident. The Romanian govern-ment, aided by the Fascist Iron Guard movement, took an active hand in the persecution of their Jewish population, alleging they were a threat as Communist agents. It implemented a program of extermination that was second to that of Germany. It began with anti-Jewish legislation similar to the Nuremberg Laws and culminated with the estab-lishment of ghettos, some 200 labor and concentration camps and, with the aid of German mobile killing teams, the murder of over 260,000 men, women and children. In addition, an estimated 10,000 Romanian gypsies were killed.

Romanian dictator Antonescu was condemned to death by the Russians in 1946. As the Communist firing squad fired, Antonescu fell to his knees, injured but not fatally. He called out, "You can't even shoot straight." Two more bullets were needed.

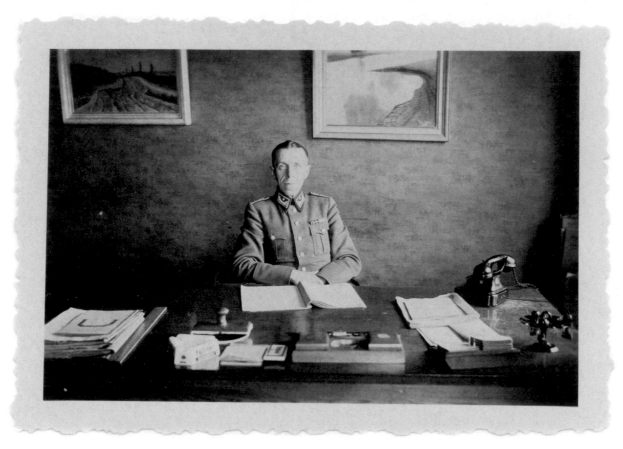

Bulgarian Officer

A stern veteran stares into the camera
lens held by his German ally.

Considered a "minor German ally," Bulgaria supplied transit rights for the German campaigns against Yugoslavia and Greece. While Bulgaria also occupied portions of Greece and Yugoslavia, it did not take part in the invasion of the USSR.

The subject of who saved the Bulgarian Jews was discussed by an international symposium in the Bulgarian capital, Sofia, on February 1, 1995. The conclusion of years of research was that it was a "combined effort by the Bulgarian people, including leading intellectuals, parliamentarians, civil servants and politicians, the Orthodox Church and the King, who were the actual saviors of the Bulgarian Jews" rather than an act of the Communist government in 1943, as claimed. The report concluded that "not a single person from the territory of Bulgaria proper was deported to the death camps." However, the Jews from Bulgarian occupied Macedonia and Southern Thrace were deported to their deaths.

Bulgaria turned against its former ally when in September, 1944, it declared war on Germany and attacked *Wehrmacht* positions in Yugoslavia. After an armistice was signed with the Allies in Moscow on October 28, 1944, Bulgarian forces fought against the Nazis in Hungary and Austria. Some ten thousand Bulgarian troops died in the battles against the Nazis, another 30,000 were wounded. (After a stormy meeting with Hitler in 1943, during which he again refused to turn over the country's Jews or supply troops, King Boris died from what some called a "mysterious death," while others believe the stress led to a heart attack.)

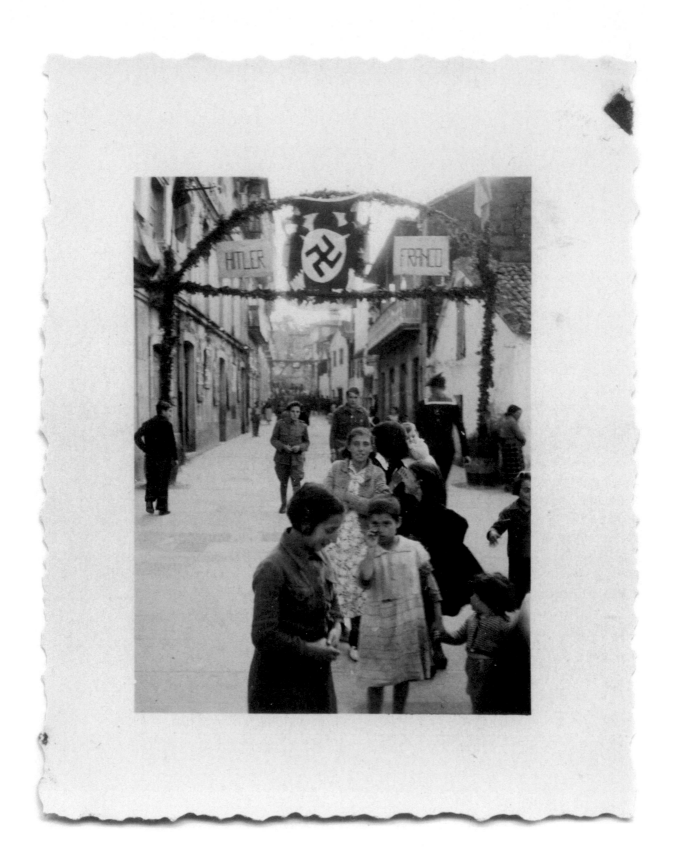

Hitler and Franco Fanfare

A banner acknowledges the Fascist links between the two dictators. However, the ideologies were only shared to a point, one that kept Spain officially neutral during the war.

Spain served as a proving ground for Germany's armed forces, lessons on terror well learned. On June 17, 1936, a bloody civil war broke out in Spain, with Generalissimo Francisco Franco leading the Fascist Nationalists against the Spanish Republicans. Hitler sided quickly with Franco, who he saw as fighting the forces of Bolshevism. Elements of the German air force, the Condor Legion, proved decisive in the war beginning with the transport of troops and munitions from Morocco, and later with the bombing and strafing of Republican troops and towns, the latter immortalized by Picasso's painting "Guernica."

In addition to some 19,000 German soldiers, Franco was assisted by larger detachments from Italy. The war ended with victory for the Fascists and Franco on March 2, 1939. Estimates of executions by Franco's regime begin at 35,000. The Republicans killed thousands as well, targeting the Catholic clergy for their support of the Nationalists.

The collaboration with Germany reached an impasse during the hostilities of WWII when Franco declined to join the Axis war effort and furthermore refused passage for German troops through Spain, retaining the country's neutrality as a "nonbelligerent." Franco's policies saved an estimated 17,000 Jews from the Nazis and also granted asylum and provided an escape path for many European Jews. Though a well-kept secret, especially from Hitler, was the fact that Franco was part Jewish.

Franco did send the Blue Division of Spanish infantry to the Russian front in 1941 in support of his struggle against Communism and as payment to the Germans for their aid during the Spanish Civil War.

Franco remained in power until his death in November, 1975. Within three years, King Juan Carlos had helped establish a fully democratic constitutional monarchy.

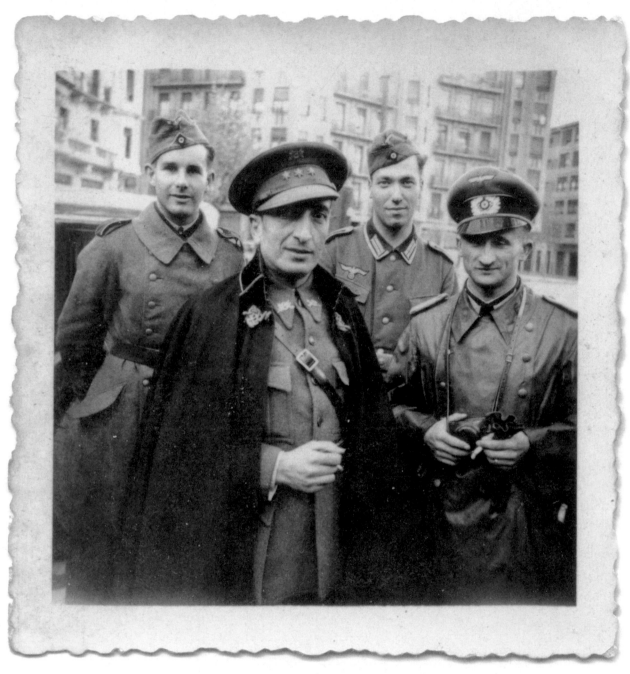

When in Spain

A Spanish officer poses for a snapshot
with his Fascist allies.

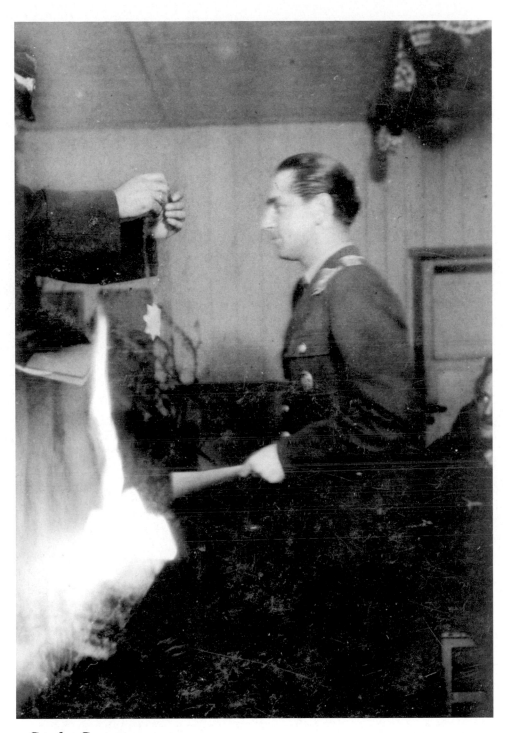

Condor Ceremony

What could be mistaken for a six-pointed Jewish star is actually an eight-pointed star insignia worn by members of the German Condor Legion posted to the Spanish Civil War in 1936, a practice ground for the Third Reich's use of aerial warfare.

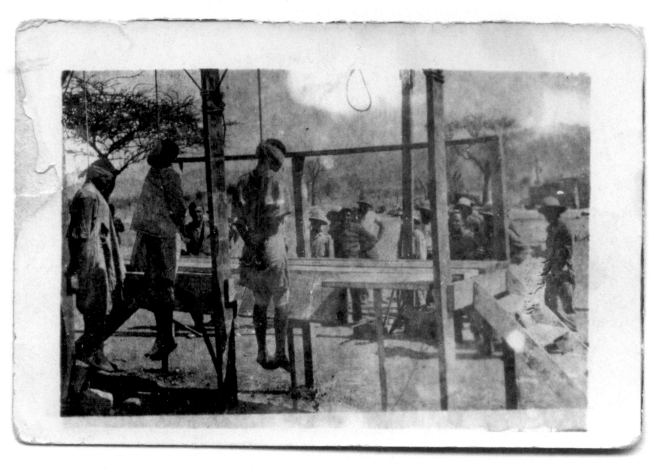

Italian soldiers witness the hanging of several Ethiopians.

Ethiopians are hanged by Italian soldiers during their seven month war (1935–1936). Many atrocities were attributed to the Italians, who used mustard gas against both military and civilians.

Temporary Comrades in Arms

An Italian and German soldier stand guard together. Body language speaks volumes as to their mindsets, the Italian casually looking directly into the camera, his ally striking a military pose. On October 13, 1943, after Mussolini was deposed, Italy's new government declared war on Germany.

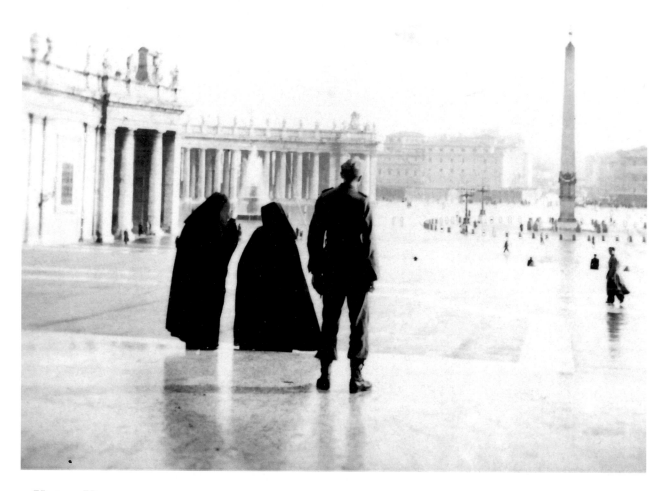

Vatican Vista

A German soldier seems transfixed by a mirage-like lake and the figures skating over it.

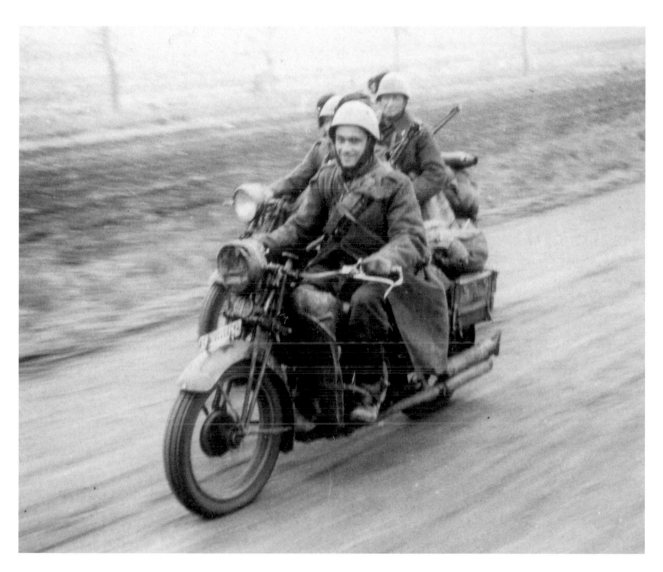

Moto Guzzi Troopers

As Axis allies, Italians fought in North Africa alongside Rommel's *Afrika Korps*, but large numbers also served on the Eastern front. Here, Italian troops with their distinctive plumed Bersanglier helmets ride their Italian motorcycles somewhere in Russia. According to Professor John Erickson (*The Road to Berlin*) of the 230,000 Italian soldiers sent to Russia, 170,000 never returned home . . . a 74% casualty rate, a tale of mass death and destruction rarely told.

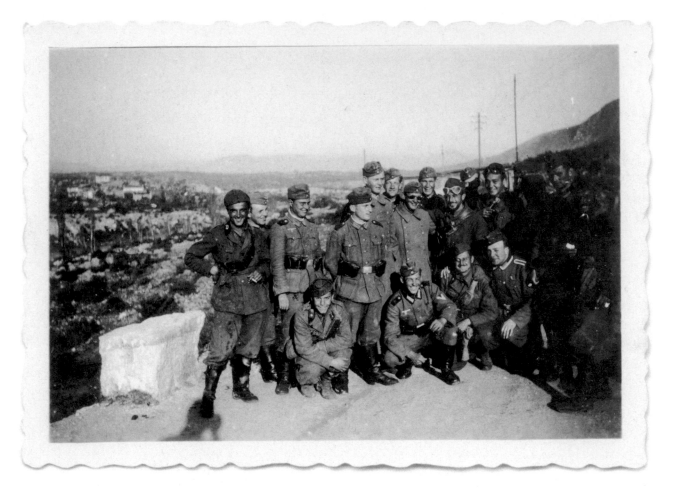

Italian-German Solidarity

A group of German and Italian soldiers, in good spirits, clown for the camera somewhere in Italy. Although the Fascists would fight alongside their German comrades on the Russian front as well as in North Africa, the Germans held the Italian soldier in low esteem, while the Italians had similar thoughts about their brutal allies. Eventually, they would turn on each other. But for the moment they are *Kameraden*.

The Vatican and Italy's Fascist dictator Mussolini signed a concordat in 1929 with Pope Pius XI wherein the Vatican recognized the Kingdom of Italy and Mussolini recognized the Pope's absolute authority in the Vatican city state. Mussolini gained power in 1922.

The Third Reich in many ways echoed Mussolini's state, which had come into existence more than a decade prior to Hitler's ascension to power in Germany. Mussolini stabilized the economy, instituted youth organizations, popularized dramatic uniforms, eradicated "classes," and subjugated the individual to the will of the State—all echoed later in Nazi Germany. Another example was Mussolini's motto: "Believe! Obey! Fight!" Hitler's SS employed the exact wording in their exhortation for Führer and Fatherland.

While Mussolini and Hitler in 1934 almost went to war from competing claims over Austria, Italy would eventually ally itself with the Axis against the Allies. However, Mussolini, not sharing Hitler's anti-Semitism, refused to deport the nation's Jewish citizens. Italy's military operations were dismal failures, including the loss of 82,000 who died in combat in the Soviet Union. When Mussolini was deposed by his own people, Hitler ordered German occupation in 1943. The deportation of Jews followed resulting in over 9,000 deaths. As Italian soldiers turned against their ex-allies, the Germans shot thousands of them. Rome fell to the Allies on June 4, 1944, after which Mussolini, while fleeing to Switzerland, was captured by Italian partisans and executed.

On March 21, 1937, Pope Pius XI published an encyclical protesting against "violations of natural law and justice in Germany" and the persecution of Catholics. In the same month, he condemned atheistic Communism. He died in 1939. His successor, Pope Pius XII remained silent on the extermination of the Jews and did not excommunicate Hitler. His defenders reply that a vocal opposition would not have mitigated the situation and furthermore might have endangered Catholics. In addition, the Vatican needed to maintain its "neutrality" and also saw Communist Russia as a greater threat and did not wish to "undermine the struggle against the Soviet Union." The controversy over a lack of Vatican intervention, and post-war aid to Nazi war criminals continues.

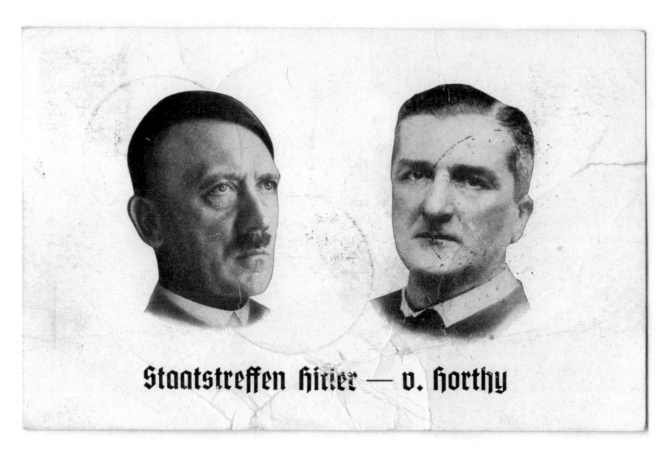

Staatstreffen hitler — v. horthy

Hungarian Ally

A postcard published in the Third
Reich commemorates the state meeting
in August, 1938 between Germany's
Chancellor and Hungary's Regent, Vice-
Admiral Horthy.

Following the post-WWI 1918 break-up of the Austro-Hungarian Empire, Hungary, not unlike Germany, fell into a state of chaos. Unlike in Germany, a Communist government took control proclaiming a Soviet Republic, which was overthrown in 1919 by Vice-Admiral Miklos Horthy. Hungary began to prosper economically and socially as Horthy was rather open-minded.

Seeing the Soviet Union as a common foe, Hungary, in 1939, joined the Anti-Comintern Pact along with Germany, Italy and Japan. However, it remained neutral when Germany invaded Poland. While they took part of Transylvania in 1940, the Germans, pressuring the Hungarians to play a more militant role, offered them previously lost territory. Then in April, 1941, Germany entered Hungary in preparation for their attack on Yugoslavia in which Hungary would field elements of its own armies.

It was not until Germany had invaded the Soviet Union that Hungary formally declared war against the Soviet Union and joined the German and Italian military ventures. An alleged bombing of a Hungarian city brought the Hungarians into the war although there is some evidence that the Germans staged the attack.

Although an Axis ally, the Hungarian government would not give up its Jews to the Germans, but some 400,000 would perish once the Germans invaded and took control of that country in 1944. Horthy tried to prevent the takeover and, moreover, to surrender to the Allies, which the Germans counter-manded. Hungary, in its alliance with the Third Reich, would also suffer the loss of some 300,000 soldiers.

Held in Bavaria by the Germans, Horthy was liberated by American forces and later testified at Nuremberg. He was interned by the Americans who refused his extradition to stand trial in post-war Soviet-controlled Hungary. Horthy subsequently settled in Portugal and died there in 1957 at age 88.

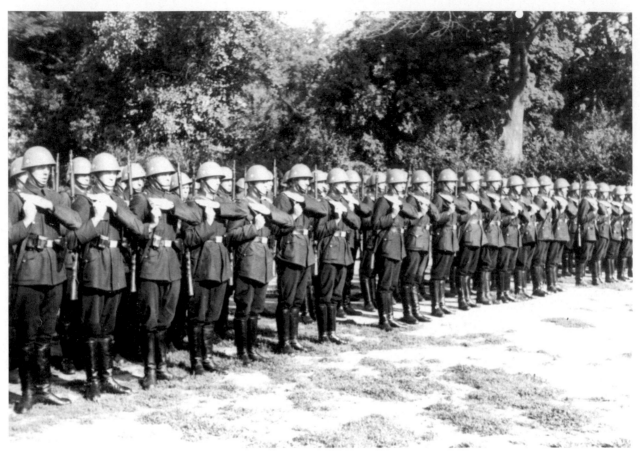

Slovakian Allies

Slovak troops line up for inspection by
their German masters.

Czechoslovakia, as the name implies, was composed of Czechs and Slovaks, the country a result of redrawn borders after WWI. The Czechs held power while Slovaks, desiring their own independence, eventually formed independent Slovakia in March, 1939. Slovak forces joined Germany in the attack on Poland and later the 45,000 troops of the Slovak Army Group joined in the invasion of the Soviet Union.

Slovakia cooperated with its German allies and deported nearly 60,000 Slovak Jews to extermination camps. As a result 80% of Slovak Jews died.

News from Finland

Two soldiers peruse a Wednesday morning newspaper sometime in March, 1940, with headlines concerning a peace treaty between the Soviet Union and Finland. The Soviet Union invaded Finland on November 30, 1939, after Finland had refused to provide the Soviets with the territorial concessions it demanded. While the much larger Soviet army was expected to defeat Finland in short order, the Finns bravely and effectively held off the Soviets for several months. However, Finland's Mannerheim Line of fortifications was breached early in 1940. On March 12, the Russian-Finnish treaty delivered some Finnish territory to the USSR. The Soviets did not occupy Finland; an armistice was signed in September, 1944. It was the only Axis country never to declare war on the United States.

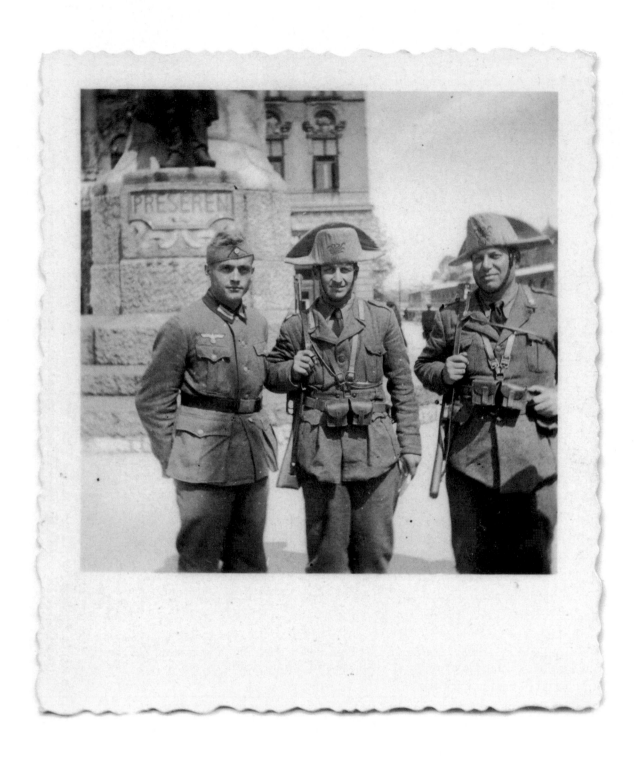

Croatian Ally—Slovene Soldiers

Apparently amused by his Slovenian ally's headgear, a German officer has himself photographed in Zagreb. In the background is a statue to France Prešeren (1800–1849) acclaimed as "Slovenia's Greatest Poet."

In the aftermath of WWI, the Kingdom of Serbs, Croats and Slovenes came into being in 1918 in an effort to unite the Southern Slav peoples of the Balkans under the Serbian Royal family's rule. Serbian and Croatian discord ensued, followed by a Serbian dictatorship and the establishment of a new country, Yugoslavia.

Some Croatians, seeking an independent state, formed the Ustaša led by Dr. Ante Pavelić. Taking aid from Fascist Italy and Germany, they also helped carry out the assassination of Yugoslavian King Aleksander. When the Germans invaded the country in April, 1941, the Ustaša declared a new independent state—Croatia. Civil war followed, with Marshal Tito leading the Communists.

Many of the best Croatian officers, NCO's and soldiers volunteered for the German or Italian armies and Croatian forces fought on the Eastern Front against the Soviets. Pavelić's Ustaša persecuted and murdered thousands of Serbs, Gypsies and Jews. With German defeat imminent and the Red Army in hot pursuit, the surviving Croatian Fascist forces fled toward Austria to surrender to the British who promptly sent them back to Tito's Communist Yugoslavia and certain death.

Pavelić died in 1959 from wounds received two years previously during an assassination attempt.

Estonia

A young *Luftwaffe* soldier poses for a studio portrait in Tallinn, Estonia, in late 1941.

This studio portrait was, according to a handwritten notation on the reverse, taken on November 18, 1941, in Estonia, the Nazi war machine having invaded and taken control of that Baltic state in June of that year. The soldier may be German or an Estonian volunteer.

The photographer's name, Alex Teppor, and location, Tallinn, are embossed on the photo. Pre-war Estonian Jews numbered around 4,000, most escaping into the Soviet Union. However the *Omakaitse*, Estonian police, were instrumental in rounding up about 1,000 Jews and between Sept 26–29, 1941, in conjunction with the German *Einsatzkommando*, shot 440 Jewish men. The remaining women and children were transferred to another location and later shot. When additional transport trains carrying deported Jews arrived in the area, the Estonian police continued their work while in a local concentration camp, staffed by German and Estonian guards, an additional 2,000 slave laborers were shot as the Russians moved into the area. Estonia was declared "*Judenrein*" or cleansed of Jews.

Ukrainian Volunteers

Three young Ukrainians have donned
the German uniform.

Highly nationalistic and seeking their
own autonomy, Ukrainians initially wel-
comed the Germans as liberators from
Soviet tyranny, and also shared in anti-
Jewish feelings, often cooperating in the
hunt for hidden Jews. Many volunteered
for service with the German army,
served in concentration camps and took
part in the liquidation of ghettoes as
well as participated in mass killings as
auxiliaries of German *Einsatzkommando*
execution teams. Some Ukrainians did
hide their Jewish neighbors and often
paid for it with their lives.

The Germans quickly suppressed any
nationalist efforts on the part of Ukrai-
nians under the direction of the brutal
German Gauleiter Erich Koch and
although some Ukrainians still collabo-
rated with the invaders, many became
partisans and fought both the Germans
and their fellow Ukrainians. The Jews
continued to suffer a similar fate under
both.

324

Latvian Volunteer

A young Latvian soldier stares into the camera. The photograph had been turned into a postcard and bears a Berlin postmark, but is otherwise blank.

Latvia became an independent nation in 1918 as the result of WWI, and had positive feelings for the British, French and American Allies for their support. Yet, after one year of Soviet absorption of the Baltic countries and the subsequent brutalities of the NKVD and mass deportations to Siberia, they welcomed the German invaders as liberators and as their protectors against the threat of Communist domination. They also held out hope of regaining their independence even after the war tide turned against their German allies.

Some 120,000 fought in German uniform against the Soviets, about 10% of whom were casualties.

In Latvia, the Germans established Jewish ghettos in Riga, Dvinsk and Liepaja. Some Latvians, along with their Ukrainian and Lithuanian counterparts, were also the Nazis' most enthusiastic accomplices in the elimination of their respective Jewish populations and, moreover, were employed beyond their borders as members of execution squads. Within the first six months of Nazi occupation, the Germans and their Latvian accomplices had killed 90% of these countries' 95,000 Jews.

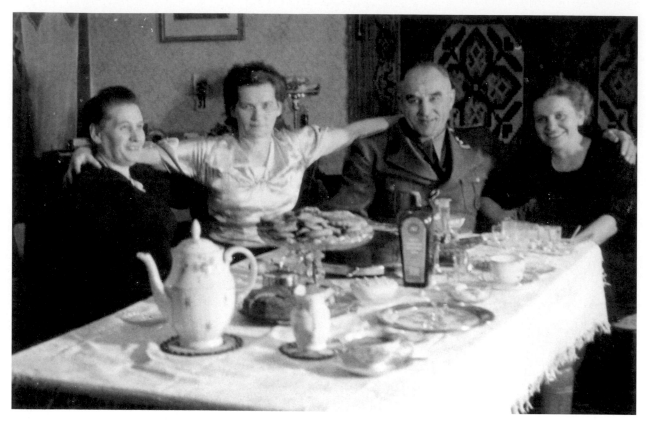

Dresden China for the SD Man

An SD man enjoys a table laden with
fine Dresden china, pastries, liqueurs
and the company of three women, one
of whom, with a rather intimidating
expression, seems to have taken an
assertive grip on him and the woman
next to her, perhaps mother and brother.
The SD man has his arm around the
shoulder of the third woman and her
arm nestles against his body, indicating
perhaps husband and wife. A calendar is
partially visible on the wall behind them
indicating the 31st of some month.

SD (Security Service)—
An Umbrella of Death

Created in 1932 by Reinhard Heydrich, it was the first Nazi Party intelligence organization to be established and was considered a "sister organization" with the *Gestapo*. On June 9, 1934, it became the sole "Party information service;" then, in 1938, it was made the intelligence organization for the State as well as for the Party, supporting the *Gestapo* and working with the General and Interior Administration.

The SD was tasked with the detection of actual or potential enemies of the Nazi leadership and the neutralization of this opposition. To fulfill this task, the SD created an organization of agents and informants throughout the Reich and later throughout the occupied territories. The organization consisted of a few hundred full-time agents and several thousand informants. The SD was the information-gathering agency, and the *Gestapo*, and to a degree the *Kriminalpolizei*, was the executive agency of the political police system. Both the SD and the *Gestapo* were effectively under the control of Heinrich Himmler as Chief of the German Police.

In 1936, the police were divided into the *Ordnungspolizei* (ORPO or Order Police) and the *Sicherheitspolizei* (Sipo or Security Police). The *Ordnungspolizei* consisted of the *Schutzpolizei* (Safety Police), the *Gendarmerie* (Rural Police) and the *Gemeindepolizei* (Local Police). The *Sicherheitspolizei* was composed of the *Reichs Kriminalpolizei* (Kripo) and the *Geheime Staatspolizei* (Gestapo).

The SD was the main source of security forces in occupied territories, and SD battalions were typically placed under the command of the SS and Police Leaders. The SD also maintained a presence at all concentration camps and supplied personnel, on an as-needed basis, to such special organizations as the *Einsatzgruppen*. The SD was also the primary agency, in conjunction with the *Ordnungspolizei*, assigned to maintain order and security in the Jewish ghettos of Poland.

The SD spied on civilians as well as members of the party with absolute power over life and death. The ultimate terror organization, its members executed thousands of victims, cleared the ghettos and helped send 80% of Polish Jews to the death camps.

Heydrich was Chief of the Security Police and SD (RSHA) until his assassination in 1942, after which Ernst Kaltenbrunner became Chief. Kaltenbrunner took office on January 30, 1943, and remained there until the end of the war. The SD was declared a criminal organization after the war and its members were tried as war criminals at Nuremberg, where Kaltenbrunner declared, "I do not feel guilty of any war crimes." As he was hanged, he called out, "Good luck, Germany."

Murder Practice

We see uniformed members of the SD practicing their skills, perhaps at a weapons testing area. An officer is recording data while grim-faced civilians, perhaps *Gestapo* or local volunteer auxiliaries, wield submachine guns. One civilian, wearing a suit, loads a magazine with bullets.

Wannsee

Visitors to the popular resort area wait for the ferry boat.

A linked pair of lakes in southwestern Berlin is today the number one recreational and bathing attraction for the city's residents. It offers one of the longest inland beaches in Europe and is also a popular spot for nudists.

Wealthy Berliners enjoy their villas and holiday homes as they did prior to, and during, the Third Reich. During that latter period one of the better known homes was the Wannsee Villa, constructed during 1914–1915 and where,

on January 20, 1942, German officials met to implement the Final Solution. By this time, Nazi mobile extermination teams had already shot to death several hundred thousand Jews in Poland and Russia. The Final Solution involved the implementation of the extermination camps to process millions. Following Göring's call for the plan, Heydrich produced the proposal and called the meeting into session. Among the attendees was Adolf Eichmann. Luncheon was served.

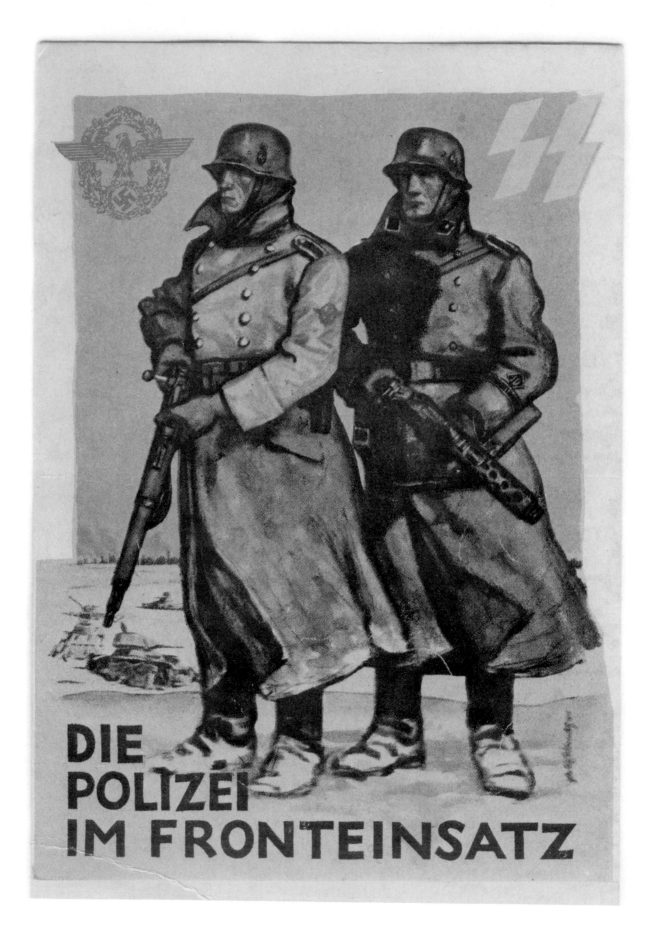

DIE
POLIZEI
IM FRONTEINSATZ

Police Postcard

A commercial postcard trumpets the services rendered by the Order Police on the front lines.

Heinrich Himmler, a member of Hitler's inner circle and *Reichsführer* of the SS, sought to integrate the Weimar Republic's civilian Police Units (*Ordnungspolizei*) into the new German military; moreover, the SS saw them as eventually evolving into combat soldiers as well as leading elements of the ideological war of extermination.

After participating in the annexation of Austria (*Anschluss*) and occupation of the Sudetenland in 1938 as well as the takeover of the western part of Czechoslovakia in 1939, and, later that year, the invasion of Poland, the Police Battalions took on duties of deportations and mass executions in addition to their work of policing and internal security.

During 1939, over one hundred Police Battalions were in operation, "political soldiers" at the forefront of enforcing the racial war in the East. Before the advent of the mass extermination camps, much of the process took place in the field, an estimated 1,000,000 Jews shot by killing squads across Eastern Europe and Russia.

A Change of Uniforms in Hamburg

A young, elegantly uniformed Hamburg city policeman, wearing the traditional *Tschako* cap, stands at duty in a busy street one moment, the next he wears the uniform of the *Wehrmacht*. His white gloves have been replaced by gray gloves, his job of protecting civilians transformed to shooting them, if he has joined the ranks of Police Battalions under Himmler's SS and sent to the East.

As recorded in Christopher Browning's landmark book *Ordinary Men—Reserve Police Battalion 101 and the Final Solution in Poland*, the exceptionally well-documented mobile killing force, PB101, was for the most part composed of residents of Hamburg. Some 500 strong, and mostly middleaged reservists, they were dispatched to Poland where PB 101 helped in the forced expulsions of Poles, the deportation of thousands to concentration camps and, beginning in mid-July, 1942, the mass shooting of Jewish civilians in towns throughout the Lublin district. *Aktionen* included the *Ernte-fest* or "Harvest Festival" massacres of November 3–4, 1943, during which an estimated 42,000 Jewish prisoners from the concentration camps of Majdanek, Trawniki and Poniatowa were murdered. Additionally, between July, 1942, and November, 1943, Police Battalion 101, acting alone, shot over 38,000 Jews.

The Reserve Police Battalion 101 at last came under scrutiny by the Office of the State Prosecutor in Hamburg. A trial of fourteen accused took place in 1967. Most were judged guilty, however only five received sentences of five to eight years, all of which were later reduced. Little investigation went into exploring the re-introduction of Police Battalion members into civilian service, although during the mid-1980s the Hamburg Interior Ministry began researching the history of the police in both the Weimar Republic and the Third Reich, which displaced it.

The Murderer at the Desk

The calendar tells us it is the 23rd, although the month and year are illegible. A map on the wall appears to be of the sphere of German occupation.

The Third Reich kept meticulous records of every aspect of its operation, from the number of typewriter ribbons used by these typists to the number of daily calories allotted its slave laborers (950), calculated to keep them just strong enough to work, too weak to resist and eventually resulting in death. The uniformed typists at work in their neatly organized office epitomized the new type of mass killer, faceless bureaucrats who prompted the coining of a new term, *Schreibtischmörder*. . . . The Murderer at the Desk.

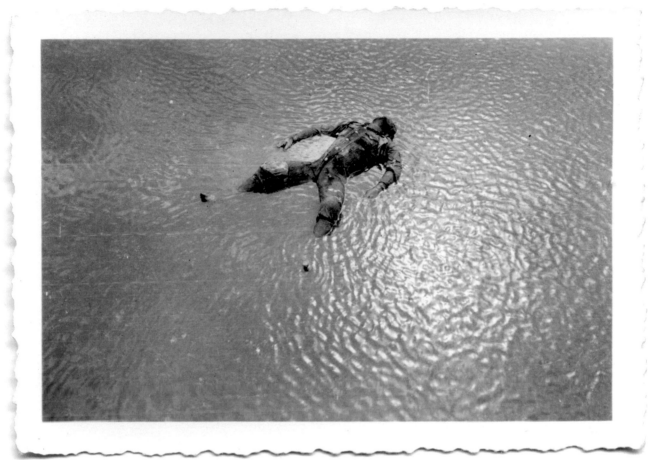

Dead Man Floating in the East

Unknown nationality, unknown river,
unknown death.

336

Riga Burns

When Germany invaded the Soviet Union in the summer of 1941, it also attacked the Baltic countries of Latvia, Lithuania and Estonia. A German soldier's camera captures the black cloud spreading over the city.

In Riga, the capital of Latvia, the Germans constructed a ghetto for the indigenous Jews. During December 7–9, 1941, 25,000 were transported to the nearby Rumbula Forest and there shot by *Einsatzgruppe A* of the SS. As a prelude to the mass execution, the SS entered the ghetto hospital and threw some thirty Jewish babies from the upper windows to their death as their mothers watched.

Einsatzgruppe A was composed of approximately 1,000 men from the *Gestapo* and Criminal Police, the *Sicherheitsdienst* (SD), the Uniformed Police and the *Waffen-SS*. Several thousand members of the four *Einsatzgruppen* (A, B, C, D) followed the regular army into the East where they shot more than one million men, women and children. Of that number, only about a dozen *Einsatzkommando* officers were executed for their crimes, another seventy-one given sentences from life to less than five years. The German government was not prone to exert effort in seeking further prosecutions. Many of the murderers, some of whom had personally killed a thousand people or more, died in their beds of old age in Germany.

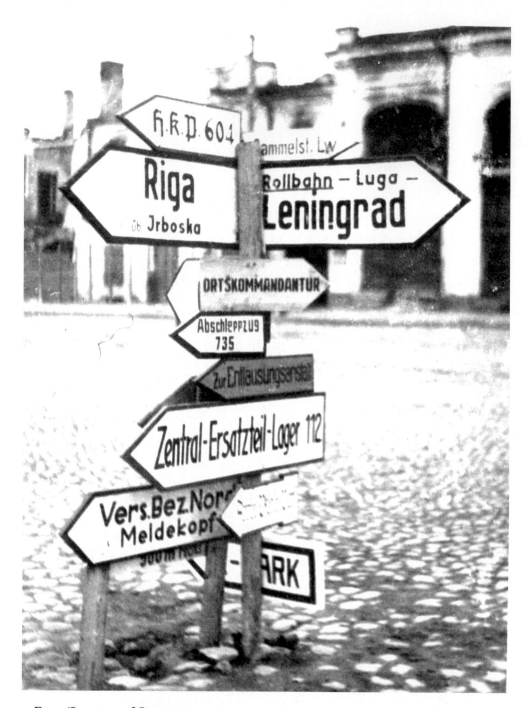

Riga/Leningrad Intersection

Somewhere in Eastern Europe, a mass
of road signs points in all directions
including Leningrad and Riga, the
capital of Latvia.

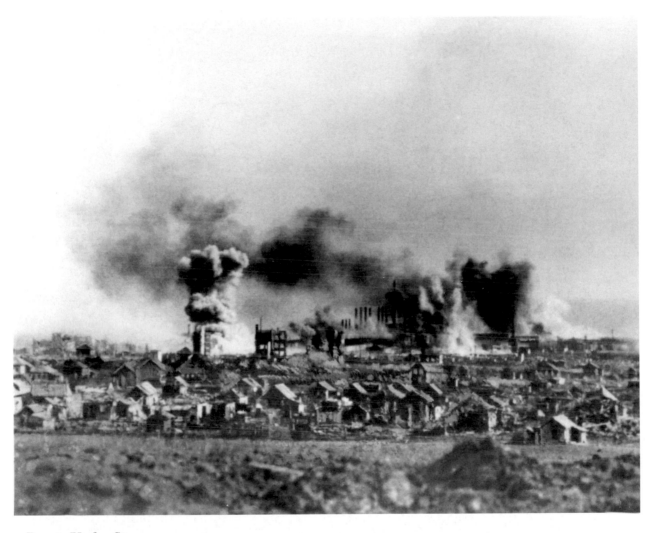

Russia Under Siege

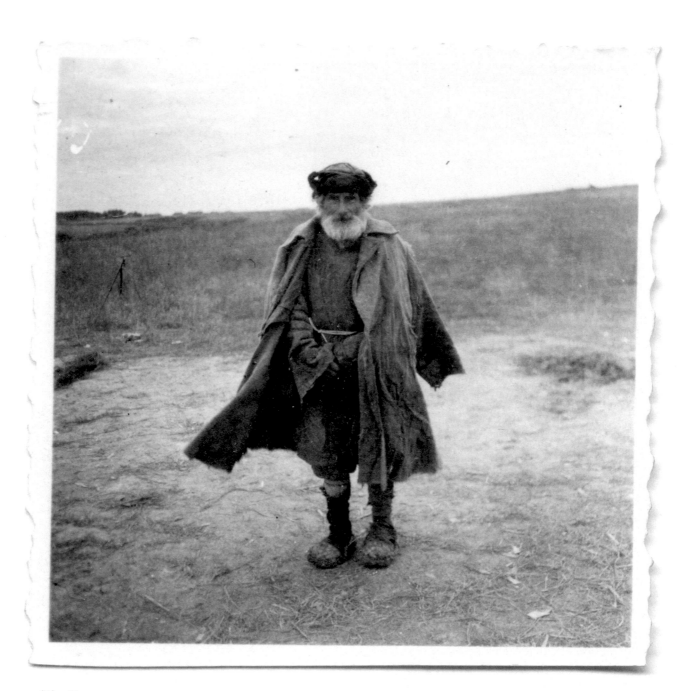

The Enemy

Somewhere on the vast Russian Steppes a soldier stops an old man to snap his photo. Perhaps he is adding to his collection of *Untermenschen* photos to fit the images of the Slavic people as espoused by Nazi doctrine, which called for killing millions and enslaving the rest in servitude to the Third Reich.

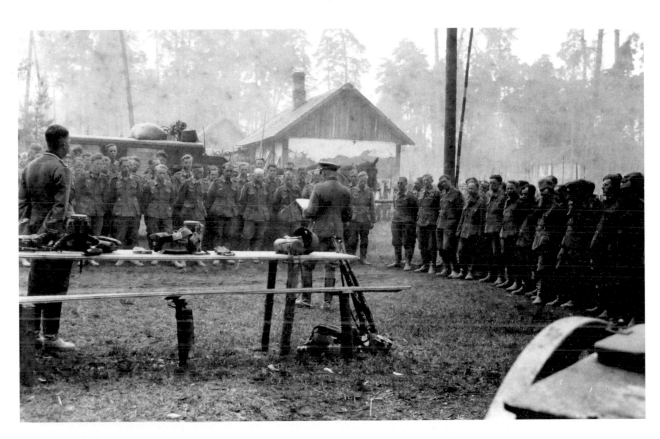

First Light of *Götterdämmerung*

An officer addresses his troops, no doubt remarking on the great crusade upon which they have embarked, the destruction of the Jewish-Bolshevik conspiracy that threatens Germany and Western Civilization. A notation on the back of this photo tells us it was taken on June 22, 1941, the day of the German invasion of the Soviet Union, the first step on the Third Reich's path to annihilation and defeat.

Portrait of a Russian Family

With some photographic skill, a German soldier has captured the image of a Russian peasant family. While the women and children go barefoot, their clothes are unpatched and clean, their wooden home well-wrought and sturdy.

While the father, perhaps deliberately placed off to the side of the composition and out of focus, appears somewhat apprehensive, the womenfolk and children seem to smile for the cameraman.

Nazi ideology characterized the Russian people as far inferior to the German Aryan *Volk* and took every opportunity to highlight the material and cultural disparity they imagined; for example, the lack of shoes and the rough hewn log house. Yet the blond-haired children could tell another story, as the Germans were prone to kidnapping those young who they felt could be "Germanized," thousands forcibly taken from their parents and brought to Germany.

342

Ukrainian Wedding

The bridegroom seems none too eager to be photographed on his wedding day by a German cameraman. His bride and her bridesmaid look even less happy with the situation.

Like most of their compatriots, Ukrainians initially greeted the German invaders as their liberators from Stalinist tyranny; after experiencing Nazi oppression and mass murder, they would strike back with partisan warfare.

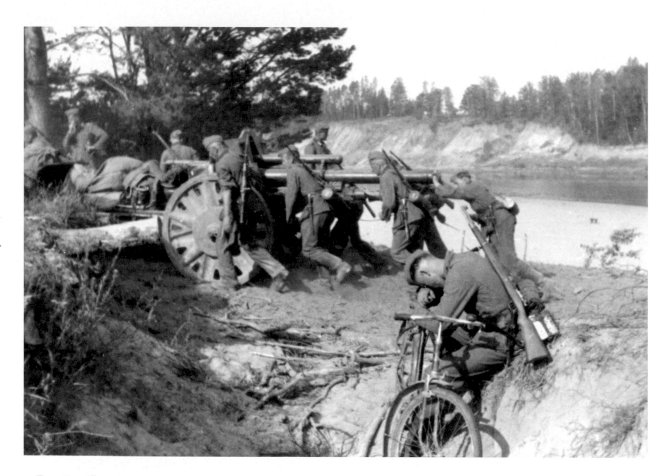

Russian Summer

The heat has overcome a bicycle-mounted soldier as his comrades struggle with their field artillery. And in the background yet another Russian river to cross.

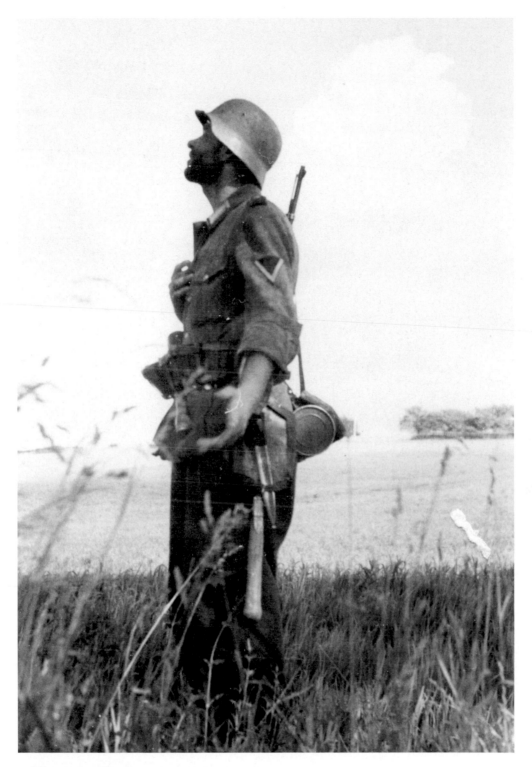

Ukrainian Grain

A bearded German veteran of the war in Russia stands in an endless field, his face upturned as if beseeching the heavens with an unknown question.

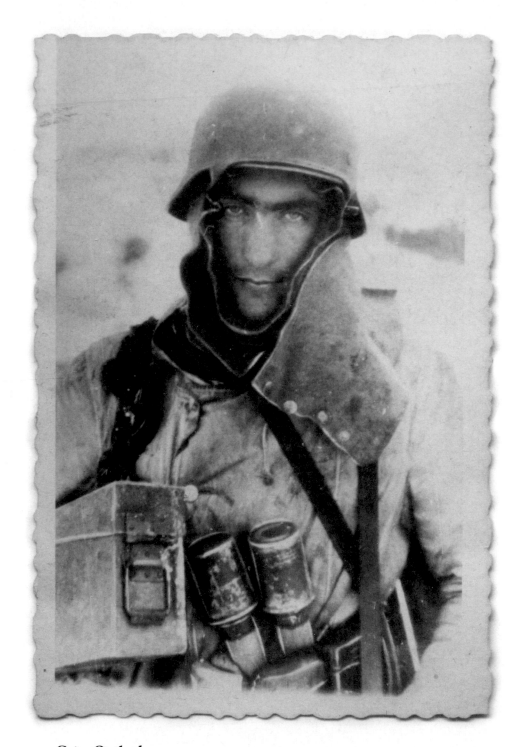

Grim Outlook

A member of a machine gun crew on the Russian front carries ammo boxes and two stick grenades stuffed in his belt. He has wrapped his boot leggings around his face in an effort to cut the killing wind. This picture was made into a postcard and sold in Nazi Germany.

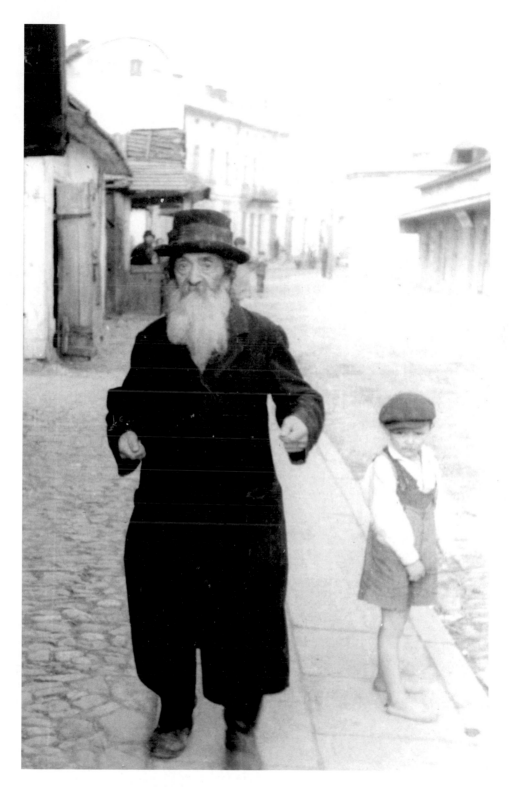

Residents of a Russian Ghetto

An old man is startled while a young barefoot boy stares at the German cameraman. In the background can be seen helmeted soldiers in a guard station.

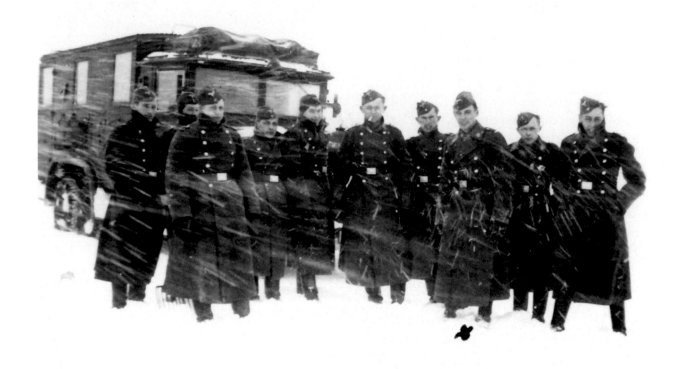

Flurry

A group of German soldiers pose in the midst of a snowstorm, the horizon blurred out of existence, leaving no points of reference in the seemingly endless tracks of the vast country. The Russian winter with its -40° F temperatures and six-foot snow drifts would freeze motor oil and lubricants in gun barrels. "General Winter" would very likely bury these ten soldiers and thousands more in a white shroud, over 30% of German deaths on the Eastern Front being caused by the freezing weather.

In this photo a black cross marks one individual, no doubt added to identify himself to whomever received it. Perhaps it was sent home to family or if added to his wartime scrapbook, he may have pondered it decades later— if he survived—an indelible image from his personal war in the East.

The Russian winter was followed by the Russian spring thaw that would turn the dirt roads into an impassable morass and bog down the German *Blitzkrieg*. While the combat engineers of the Pioneer battalions constructed log roads in an often futile effort to provide traction for the heavy tanks and vehicles, the Russian heat, cold and mud, and the sheer vastness of the Soviet Union, wore away at the Third Reich's weapons and means of transport. Lack of fuel and massive Russian force of arms would provide the final blow as the German invaders were thrust out of Mother Russia.

"With Hans in Zhitomir"

Two German bicycle troopers, Hans and his comrade, grin at the camera as they repair a tire—the summer heat baking the western Ukraine and a town called Zhitomir. A handwritten notation identifies the place and his comrade.

In their attack on the Soviet Union, German forces targeted the major Ukrainian city of Kiev and by mid-July, 1941, the *Panzers* had overrun two strategic towns along the route of their advance, Zhitomir and Vinnitsa.

Zhitomir, due west of Kiev, in a matter of days after its capture, was visited by *Einsatzgruppe C*. Using the common excuse that the local Jews were aiding the partisans, they, with the assistance of Order Police Battalion 303, began the special actions. During September of 1941, they shot 18,000 Jews. Among the killers was *Obersturmführer* (1st Lt.) August Hafner of *Sonderkommando 4a* which, before being disbanded in 1943, had murdered 59,018 people. In 1973, German courts sentenced Hafner to eight years in prison.

When the Germans captured Vinnitsa, seventy-five miles south of Zhitomir, it was an industrial town of some 60,000, half of the residents Jewish. Today, the town cultivates beds of beautiful roses in a nursery that shares space with two long rectangular and one square grassy bed without flowers. A low wrought-iron fence, painted white, sets them off. A marker explains that beneath the grass of the long beds lie some 4,000 Jews shot by *Einsatzgruppe C* on April 16, 1941. Beneath the smaller square bed of grass, a living shroud as it were, rest the bodies of a thousand murdered children.

By this time, the killers had gained experience at the special techniques needed to kill small children. To avoid bullets passing through their bodies that might ricochet and endanger their comrades, they would toss the children high into the air and then fire. Often they would simply use their rifle or pistol butts as bludgeons.

"A man is the lord over life and death when he gets an order to shoot 300 children-and he kills 150 himself."
> Lothar Heimbach, Captain,
> *Einsatzgruppe D*
> *Never brought to trial.*
> *Total Group Killings: 91,728*

Today, the mass grave remains unexhumed; a thousand children still lay where they were murdered, not far from the rose bushes of Vinnitsa.

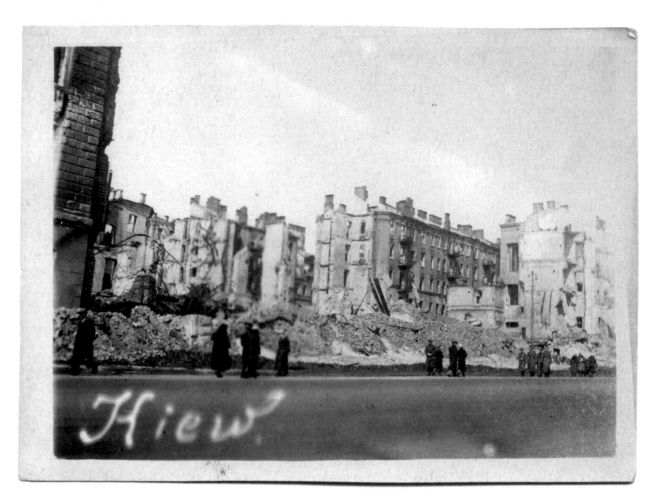

Kiev—The Math of Mass Murder

Soldiers and civilians walk through the rubble of Kiev, the location identified by a notation made by the soldier cameraman.

In late September, 1941, between the Jewish New Year and the Day of Atonement, at a ravine called Babi Yar, outside Kiev, witnesses described a mass grave larger than a football field, corpses lying layer upon layer, new victims forced to lie face down upon the dead and dying as two Germans walked over their bodies, efficiently firing a bullet from their rifles one by one into the back of the neck . . . ad infinitum. At the end of three days of almost incessant gunfire, 33,771 men, women and children had been shot to death. Months later, in retreat with Soviet troops on their heels, the SS sent in 300 slave laborers to dig up and burn the bodies. Large bone-crunching machines were utilized in an attempt to obliterate the evidence. The 300 upon the completion of the job would be added to the toll at Babi Yar. A very few survived to give witness.

On Wednesday, November 3, 1943, at pits dug near the Majdanek concentration camp, a few dozen Germans shot 18,000 men, women and children. One can also note that at Treblinka only twenty to thirty Germans were assigned to that killing center where almost a million men, women and children were murdered. In this instance the SS relied on about 90 to 120 Ukrainian volunteer auxiliaries to help "process" the arriving multitudes and to guard the inmate work force.

Other testifying statistics . . .
After a typical day of gassing children at Auschwitz, a witness counted 1,000 baby carriages left standing empty at the railroad platform. In one forty-seven-day period in late 1944–1945, German civilians received 100,000 sets of children's clothing, also from Auschwitz.

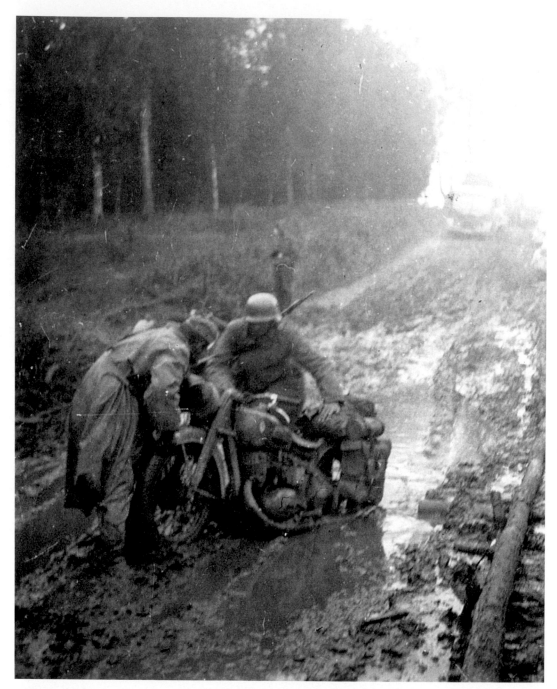

Mud Cycle

Motorcycle troopers try in vain to extract their heavy motorcycle sidecar from the morass of sucking mud.

By autumn, the Russian roads had turned into nearly impassable bogs, the fields over which the motorcycles traveled turning in to "seas of jelly three feet deep." Pack horses sank to their bellies, boots were sucked off the soldiers' feet. Motorized forces that had once traveled over seventy miles in a day now were lucky to make ten.

Desecration

A German soldier relaxes in front of a well-built brick building with a neatly thatched roof. Garish posters warn of the evils of the Jews and Bolshevism while a pair of rough-hewn swastikas adorns the bullet pockmarked walls of what may have been a village meeting hall or even a Jewish house of worship.

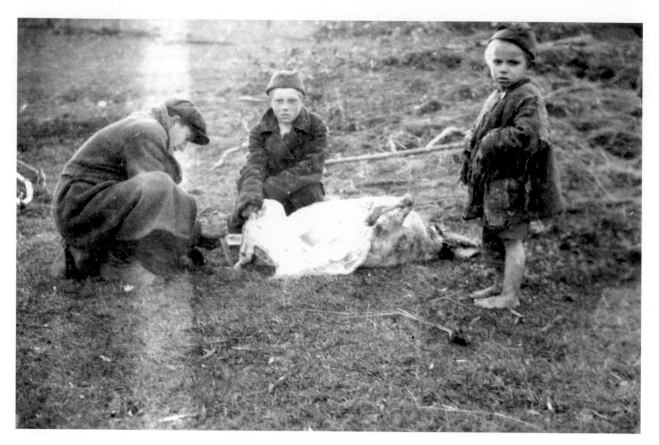

Hunger

Three children are caught by the camera in the process of skinning some animal.

Part of the German policy of racial warfare included the programmed starving to death of the alleged enemies of the Third Reich . . . Jews, Slavs, Russian POWs. By limiting food supplies to the indigenous populations, the ghettos and inmates of concentration camps, individuals were weakened so that they had little resistance to disease as well as less ability to put up any physical resistance to their German overlords.

Enough calories were allotted to sustain the suffering; for many, starvation begat passivity even unto death. The very young and very old died first. They died on the streets of the ghetto, their hollow eyes echoing the silent lamentation of the thousands of the walking dead who stepped over their shrunken forms. Of the 3,000,000 Polish Jews who perished, 500,000 succumbed to starvation and disease.

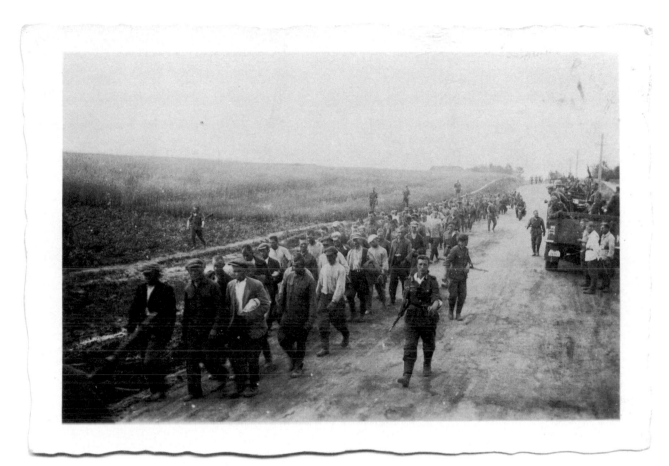

Trail to Oblivion

Some of the Russian POWs who would
end up in German camps.

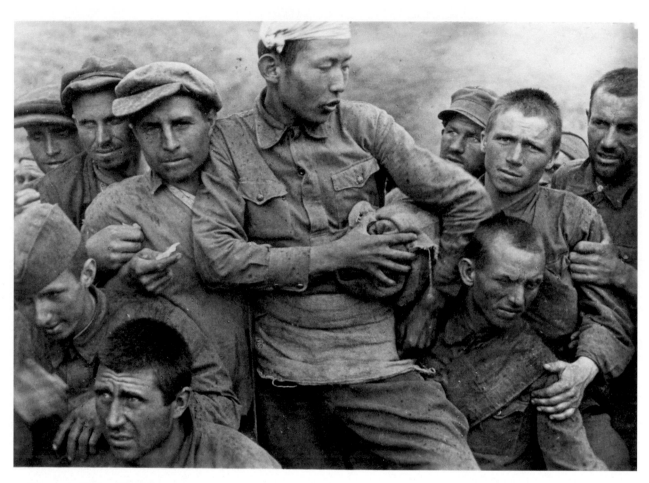

Untermenschen En Masse

Russian POWs form a sculptural mosaic of bodies writhing in anguish, their faces pleading, hands grasping some scrap of paper they hoped would save them. In the center of the image is a soldier from one of the Soviet Asiatic republics. The Germans often singled them out as representative of "Asian hordes" and further proof of the threat posed by the Soviets to Western civilization.

When the Germans launched Operation Barbarossa on June 22, 1941—the invasion of the Soviet Union—the Russians, who had signed a Non-Aggression Pact with Germany, were unprepared to meet the threat. Stalin had "purged" his own military of its most able officers, killing hundreds out of his own paranoia. The German juggernaut advanced quickly and captured many hundreds of thousands of Soviet prisoners. Since the Slavs were considered subhuman by the Germans, many Russian POWs were shot out of hand while "trying to escape," a euphemism employed by the Germans for a wide range of killings. Thousands were simply surrounded by barbed wire in the middle of the Russian vastness, guarded by a few soldiers and left to starve to death. An estimated 2,600,000–3,000,000 Russian POWs died as a result. Those who survived the war met a terrible fate at the hands of Stalin, who considered them all traitors for being captured by the Germans, sending them to the Gulags and a lingering death.

One account by a German soldier describes a scene during which his fellow guards threw the carcass of a dog into a mass of 50,000 prisoners and the frenzy that ensued. Another remarked how water was withheld for days, then salted meat tossed into the mass of starving POWs.

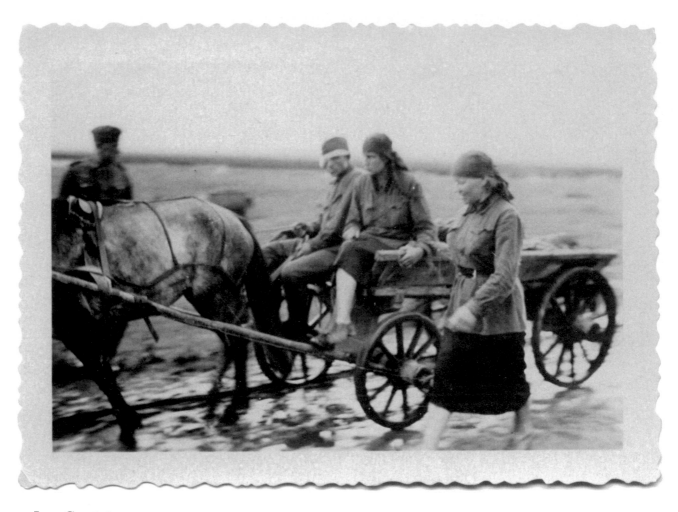

Into Captivity

A German soldier's camera chronicles
Soviet *Gefangene* or prisoners as they
slosh through the mud on their way to
be interrogated or imprisoned. If he was
a Commissar (political officer) he would
be immediately eliminated, according
to Hitler's March, 1941, "Commissar Decree." Jews could expect similar
treatment.

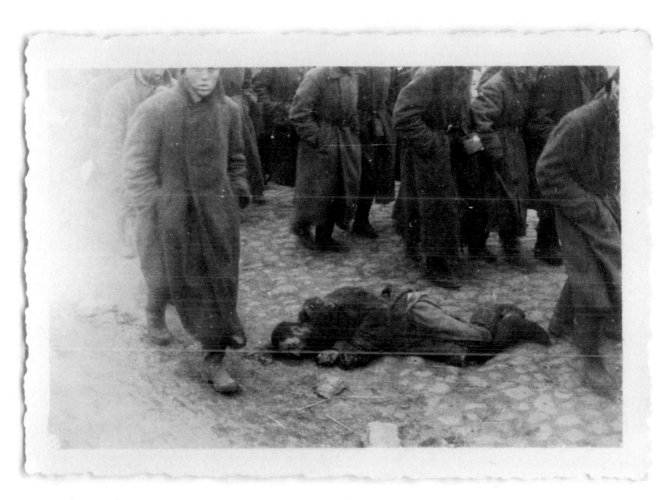

Death March

A Russian POW has fallen to the ground as thousands of his fellow soldiers trudge forward during one of countless "death marches" in which both soldiers and civilian concentration camp inmates were literally walked to death. Given little or no food or water or shelter from the elements, they died in droves. Those too weak to walk were shot, bayoneted or bludgeoned to death by their German captors. Jewish prisoners, upon the approach of Allied liberators in the last days of the war, were also force-marched to other camps, most dying along the way.

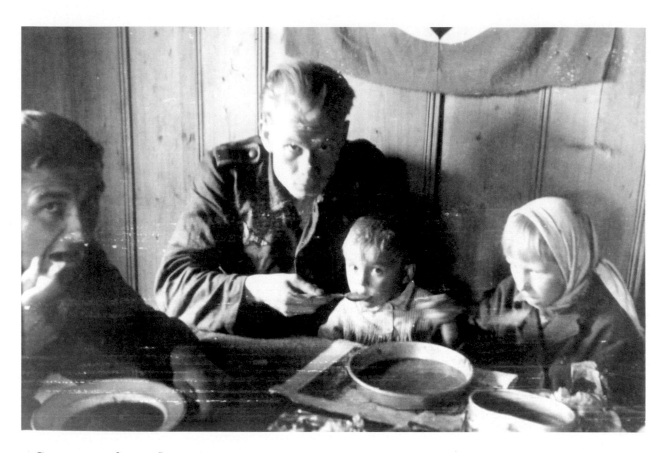

Compassion from a Spoon

A soldier looks anxiously at the photographer capturing him feeding Russian children. A swastika-emblazoned flag hangs on the wall behind them. He must be aware of the official policy toward the Slavs, children included, thus perhaps the worried expression.

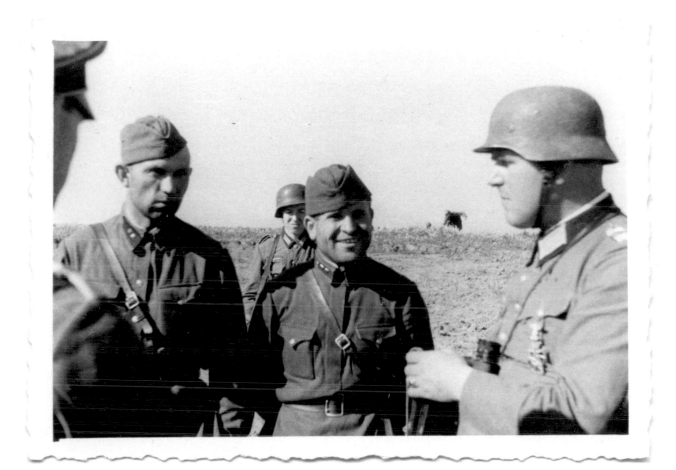

Mortal Enemies

Russian and German officers face each
other. One Russian POW seems to be
smiling at his captor.

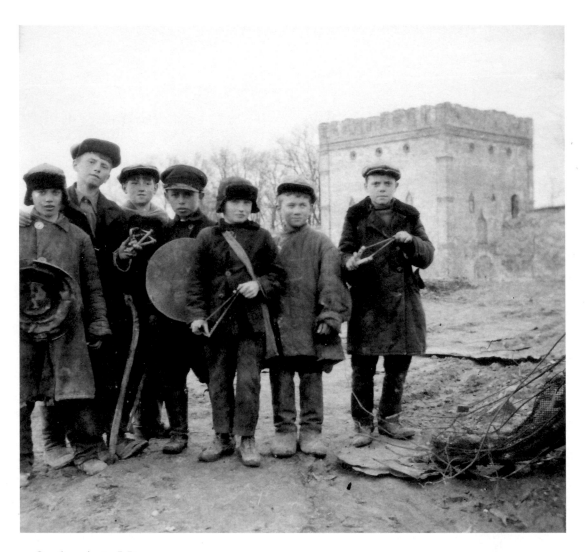

Onslaught in Microcosm

A group of Ukrainian boys, armed with slingshots and makeshift shields, resolutely face their German photographer.

Eventually, Soviet forces, in what the Russians called The Great Patriotic War, would rally to push the invaders from their homeland, but at staggering cost in lives. Some 17,000,000 Soviet civilian men, women and children and 12,000,000 Russian soldiers would die at the hands of the Nazis. Of the fifty million deaths in World War II on all fronts, nearly thirty million were suffered by the peoples of the Soviet Union.

Civilians paid dearly for World War II. By comparison, during World War I, 95% of deaths were incurred by the military, 5% by civilians. The percentages would change radically in World War II, the military sustaining 33% of the total loss of life, the civilian population suffering 67%.

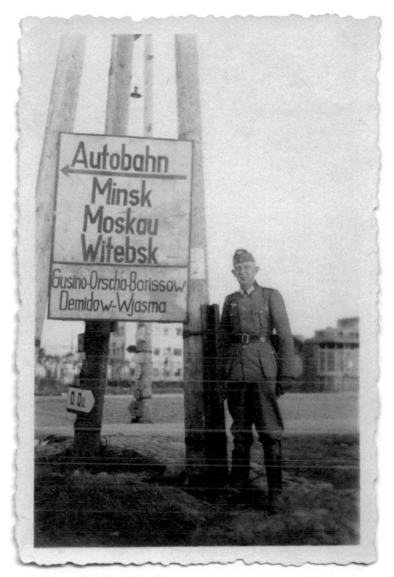

Closing In

Expecting to vanquish all of Russia within three months, an older German soldier unknowingly stands at the crossroads to German defeat. Although within six days after the invasion of the Soviet Union on June 22, 1941, Germany had captured Minsk as well as large parts of Lithuania, Latvia and Ukraine, that would all change. On September 30, the offensive began against Moscow, the Nazis eager to tear out the heart of the country by capturing its capital. However, on December 5, the Russians struck back in a counter-offensive, the Germans retreating in December, January and Febru-

ary, 1942. The army's vaunted *Panzers* rolled to within 25 miles of Moscow and glimpsed the golden spires of the Kremlin. But they got no further and Moscow withstood the siege. After the loss of the 330,000-man 6th Army at Stalingrad in February, 1943, compounded by the attrition of the Russian winter and the increased effectiveness of the Soviet military, the tide of war would sweep away the *Wehrmacht's* earlier successes and lead to catastrophe for the German soldier and his Fatherland. Eighty percent of German soldiers who died in WWII were killed by Russians.

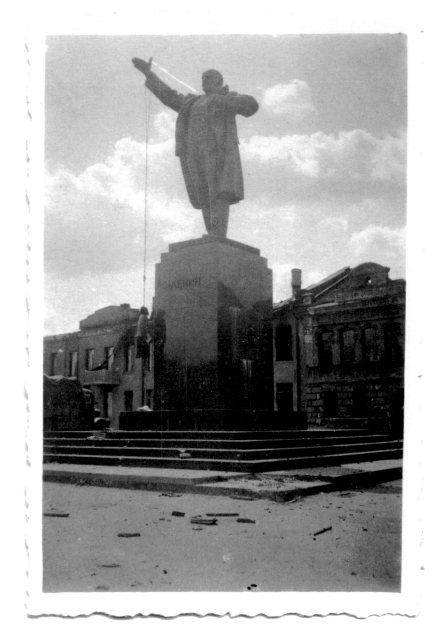

Monumental Gallows

German soldiers have just executed a Russian woman, perhaps a political official, and cynically used a massive statue of Lenin as the gallows, a violently contrived commentary on the Nazi's avowed anti-Bolshevik crusade. The photo has caught her scarf falling to the ground.

Hitler's infamous *Kommissar Erlass* or "Commissar Decree," issued in March, 1941 to the German military command,

ordered the liquidation of any Soviet political officers attached to the Red Army or otherwise identified as ranking Soviet officials. The war in Russia was not to be conducted like any previous war. It was a war to create "living space" for Greater Germany and, above all, to exterminate Soviet Communism, National Socialism's arch enemy. The operational orders made no distinction between men or women.

Trophy Shot

German soldiers pose with a Russian tank on which is impaled one of its crewmembers.

Estimates vary on the number of Soviet military war deaths because of the chaos of war, destroyed records, POW deaths and the unresolved variable of Missing in Action statistics. Statistics range up to 15,000,000.

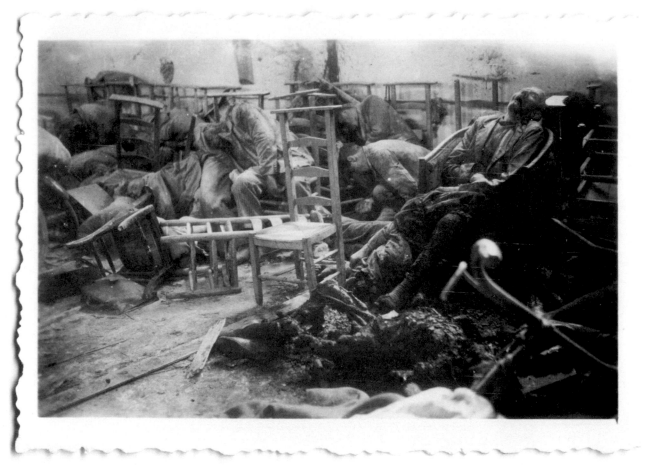

Room of Death

Somewhere in Russia an anonymous
German soldier happens upon this tab-
leau of terror and recreates this awesome
photograph.

One can only guess at the story behind
this scene of horror. Perhaps a dozen
corpses, many still slumped in the chairs
in which they died, fill this room of
death somewhere in Ukraine after the
German invasion of June, 1941. One
body is charred beyond recognition,
perhaps incinerated by a flame thrower
while the far wall is splattered with
blood. It is difficult to determine if the
victims are soldiers or civilians, whether
POWs, hostages, Soviet commissars or
Jews. No weapons are in view, and the
victims appear to have been shot as an
explosion would not have left the bodies
still seated. By the number and type of
chairs, the room could have served as
a classroom or meeting hall. Bicycles
may have transported some to their fate.
Clues, but no final judgment.

Christmas in Russia

A solider, wearing white winter cam-
ouflage gear and a wry smile, appears
to be posing with his interpretation of a
Tannenbaum or Christmas Tree.

A Bleak Christmas Back Home

News of the November, 1942, surrounding of the German 6th Army in Stalingrad sent a shiver of doubt through the homefront.

The sloppily decorated, stunted Christmas tree aptly expresses the Nazi spiritual corruption of Western values as well as the flagging morale in Germany as the war ground its way toward disaster for the Third Reich. The woman's wary expression stands in sharp contrast to the soldier's wan smile, although his image seems to be fading from the photograph, as if portending things to come.

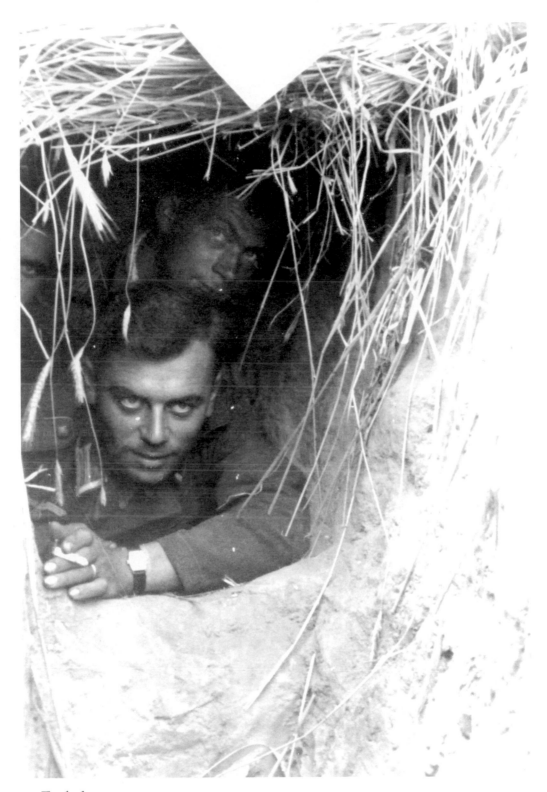

Foxhole

Three German soldiers hunker down
in a Russian foxhole. For hundreds of
thousands, these foxholes would become
their graves.

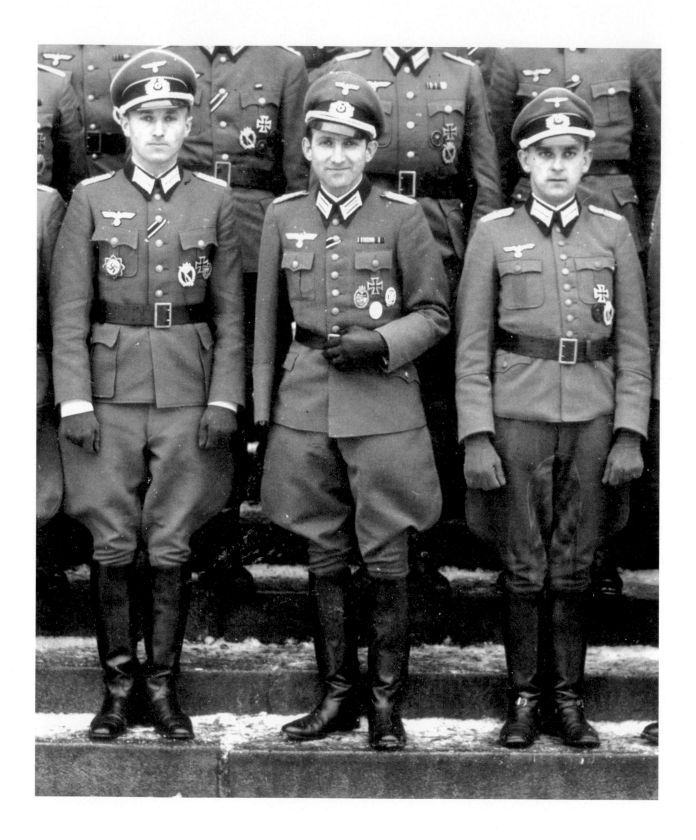

War of Attrition

Highly decorated officers pose for a group portrait. The soldier in the center has lost his right arm. While the others stand with their arms hanging by their sides, he alone has gripped his belt and smiles into the camera.

According to the figures established by the best study, German military losses included 5,318,000 dead, over four million falling in the war with Russia.

Soviet army wartime casualties were officially listed at 28,199,121 but actual numbers, as previously mentioned, suggest 30,000,000.

Dead and missing among Axis allies in the German-Soviet war included Hungary—350,000; Italy—45,000; Romania—480,000; Finland—84,000.

By D-Day, 35% of German soldiers had suffered at least one wound, 11% two wounds and 2% more than four wounds. Officers, highly motivated and often leading their men, suffered a high casualty rate, the average officer slot having to be refilled nine times. One hundred thirty-six Generals were killed in action, another 84 executed by Hitler.

In Russia, of Soviet males born in 1923, 80% did not survive the war; 413,000 American soldiers died as a result of the war.

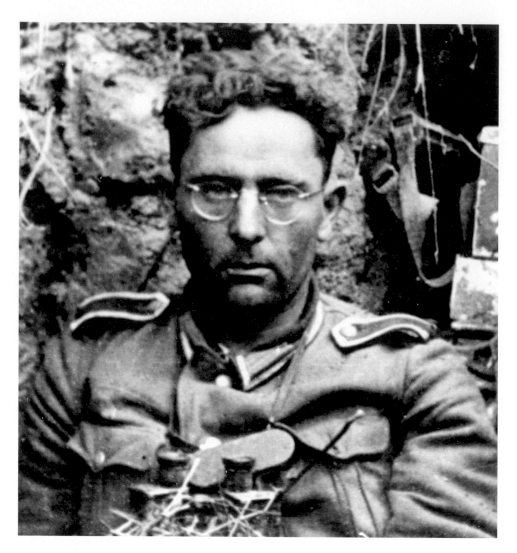

Thousand Yard Stare

A German soldier sits in a foxhole on the frontlines of Russia, his face telling the story of his ordeal. Oddly, the photo, not exactly a morale builder, was turned into a postcard.

"General Winter" would bury thousands of infantrymen in its white shroud, over 30% of German deaths on the Eastern Front caused by the freezing weather. The lethally cold conditions were aggravated by the fact that during the first winter offensive of 1941–1942, the German troops were equipped with only their summer uniforms . . . so certain were Hitler and his generals that Russia would fall "like a rotten house of cards" before winter overtook them. Such arrogance spelled death for countless German soldiers and ultimately contributed to the loss of the war against the Soviet Union.

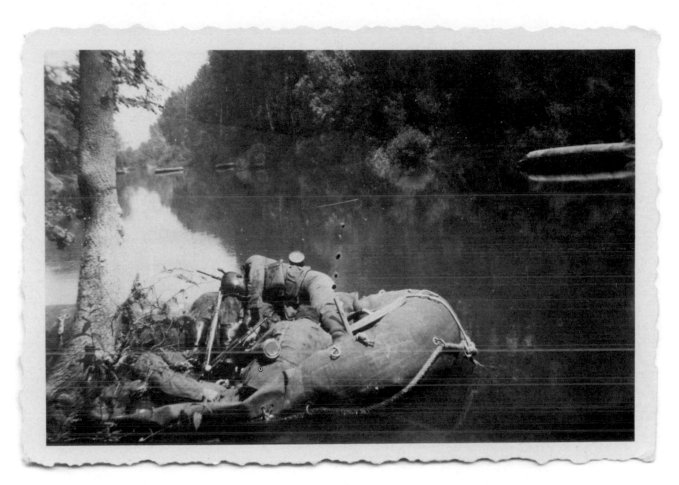

River Styx

A placid Russian river holds a raft of
dead soldiers in its watery embrace, their
corpses blackened with death.

For Honor, Volk and Führer

Scarred for life, far beyond the classic
Prussian dueling scars coveted by the
previous generation, this soldier faces
a lost war and a country scarred for
decades by its crimes against human-
kind.

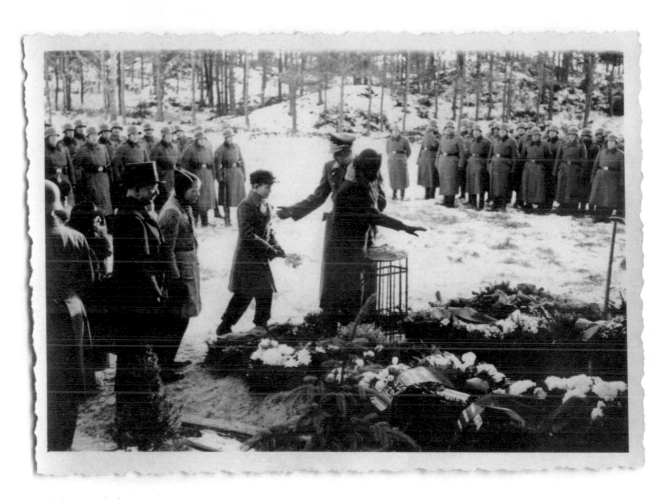

Ashes to Ashes

In a public ceremony, the wife and children of a fallen soldier scatter ashes over his flower-strewn grave.

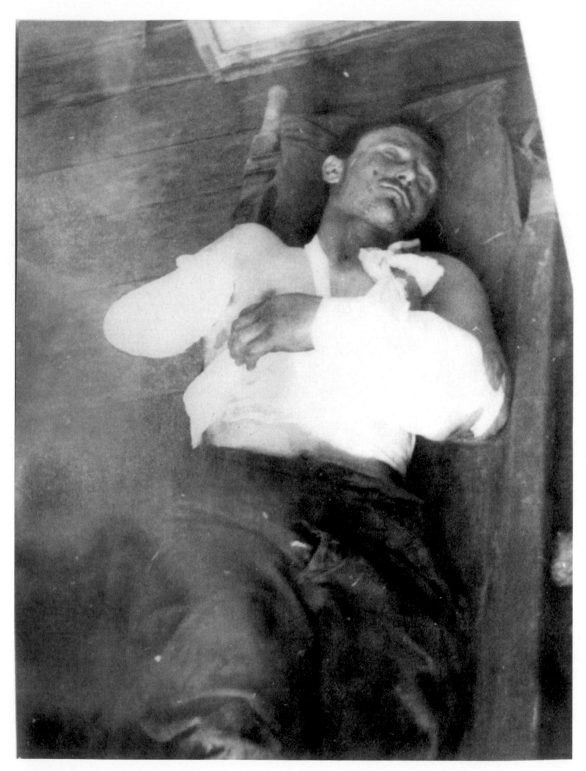

Traumatic Amputation

Someone, perhaps a comrade, has photographed a terribly wounded soldier on the Russian battlefront.

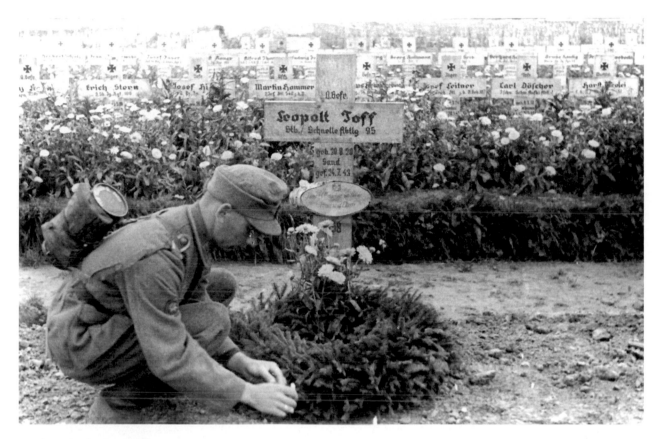

Flowers for Leopolt

A *Gebirgstruppen* or Mountain Corps soldier, identified by his Edelweiss flower arm patch, tends to the grave of a fallen comrade, Leopolt Toff, killed in action on July 24, 1943, a month before his 23rd birthday. He lies in a garden of flowers among crosses that stretch seemingly to infinity.

Also in July, Mussolini was deposed and the German army moved into Italy to take control while at the titanic tank battle in Kursk, Russia, the *Panzers* could not defeat the Soviet forces. The battle included 6,000 tanks, 4,000 aircraft and 2,000,000 men, and was fought to a draw. However, it signaled the end of major German offenses in the East and prompted the Soviet counter-offenses that ultimately forced the retreat of the *Wehrmacht*, and the necessity of even more cemeteries.

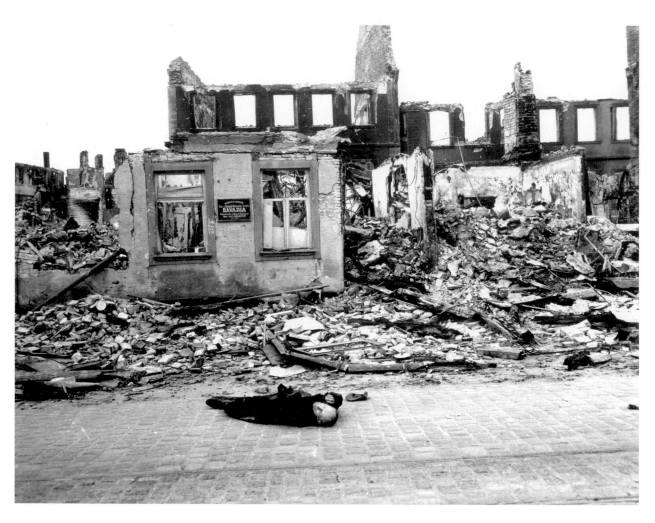

Aftermath in Würzburg

A German civilian lies dead in the rubble of the Bavarian city of Würzburg in this photo taken by a member of the U.S. Signal Corps. The partially standing building bears a plaque announcing that the places of business within included carpet cleaning as well as an inn. Scribbled on the walls is information to help friends and family members find each other in the ruins of the city which was leveled by a British air raid on March 16, 1945.

A subcamp of Flossenburg concentration camp (one of some 400) was located in the city. Between 1938–1945, some 96,000 prisoners passed through the network of camps where they worked in the granite quarries and armament-related industries as slave laborers. The camp was also used to train some 500 female camp guards.

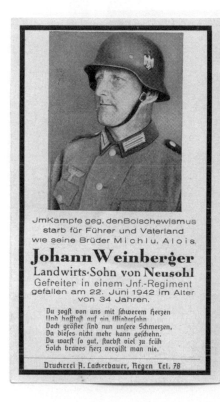

A "Hero's Death" for Three Brothers

Three separate *Sterbebilder* or Death Prayer Cards were issued by the family of the three Weinberger brothers . . . Michael, Johann and Alois . . . farmer's sons from Neusohl, an ethnic German town in Slovakia.

The first to die was Michael, a member of an anti-aircraft flak regiment, on July 27, 1941, at the age of 22. The second to die, less than two months later, was Alois, a member of an engineer Pioneer Regiment, age 23. Following his two younger brothers on June 22, 1942, was infantryman Johann, age 34. All three were killed in action on the Russian front. As formally stated on each "death card," each died "a hero's death for Führer and Fatherland."

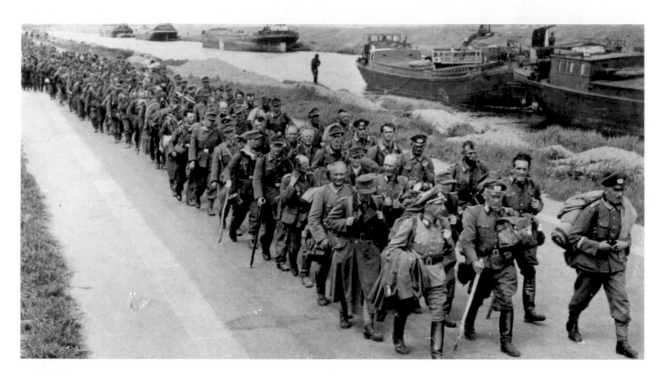

The Long Road Back

Somewhere in Holland, thousands of German soldiers trudge home to Germany to face at least temporary captivity and a desolated homeland. A "de-Nazified" new democratic West Germany would, in a relatively short time, rebuild itself and become a major economic force in Europe and the world. Its Soviet sibling, East Germany, would fall behind the Iron Curtain for decades, but following the 1989 opening of the Berlin Wall. Germany was united once again.

Buchenwald

A commercial postcard printed in post-war West Germany illustrates the Third Reich's meticulously designed architecture of death.

Located northeast of Frankfurt near the city of Weimar in a forested area, Buchenwald is about six hours by train from Berlin and about two hours from Nordhausen, site of another concentration camp. The camp opened in July, 1937, initially for German political prisoners and after Kristallnacht for Jews and later for Romani and Sinti peoples, Jehovah's Witnesses, criminals, POWs, resistance fighters and those the Nazi's classified as "work-shy" and "asocials." With its 88 subcamps, it was a major source of slave labor for various German armament companies, some 250,000 passing behind its barbed wire fences. Medical experiments contributed to a death count that is only an approximation: 56,000 males died, many by gassing or phenol injection, 11,000 of them Jewish.

The camp included a zoo where the camp guards fed bears in view of the starving inmates. As the Americans neared the camp, the prisoners mounted a revolt against their Nazi tormentors, the SS fleeing as a result.

If you visit Buchenwald today, you will notice that the entrance clock has been permanently stopped at 3:15. It marks the moment the camp was liberated by soldiers of the 3rd U.S. Army on April 11, 1945. Among the 20,000 survivors still clinging to life was Elie Wiesel, who was later awarded a 1986 Nobel Peace Prize for his Holocaust writings. CBS radio newsman Edward R. Morrow reported directly from the camp in 1945 and gave a first-hand account of what he saw.

Nordhausen—Postcard

This postcard, mailed September 22, 1938, shows a market, a bank and Carl Eggebrecht's jewelry shop in the city of Nordhausen, located on the southern Harz Mountains.

Prior to the picturesque town's military development of 1936, the nearby mountain of Kohnsteim featured gypsum mining operations, its tunnels turned into fuel and chemical weapons storage. Train tracks serviced the tunnels, the tunnels constructed by Buchenwald slave labor. A new concentration camp called Mittelbau-Dora was erected nearby in 1943, its inmates involved in the manufacture of V-2 rockets.

While Jews suffered greatly, hundreds of Italian prisoners who were sent to the camp were treated especially harshly as they were seen to be traitors after Mussolini was overthrown. Some 600,000 Italian soldiers were sent to slave labor in Germany after they refused to go on fighting for the Nazis.

—

An eyewitness to the liberation of the camp in 1945, Harry Kennedy of the Army's 104th Division said, "There were 6,000 dead inmates lying about on the ground. It was a ghastly sight. Worse than that, it smelled to high heaven." The American military made the people of Nordhausen come over and see what was going on right next to them. "I talked to German civilians and they always said, 'Well, we didn't know.' I'd say, 'You could smell it couldn't you?'"

* * * *

Allied bombing eventually destroyed most of Nordhausen including Herr Eggebrecht's jewelry store.

Nuremberg Rally/Nuremberg Trials

"The Faithful Give Strength to the Struggle" proclaims the banner. Nuremberg was the city famous for the annual Nazi Party Rally, the infamous Nuremberg Laws that targeted German Jews and later for the international justice wrought by the post-war Allied War Crimes Tribunals (1945–1949) where some of the leaders of the Third Reich and their henchmen were put on trial.

Cattlecars

A string of nondescript train cars stand dormant on a railroad siding. Several of the cars are empty, their doors open; others remained shut, their cargo unknown.

One "resettlement transport" described in Christopher Browning's *Ordinary Men* concerns some 8,025 Jews being shipped from Kolomyja in Poland to the Belzec death camp in the September heat of 1942. The official report of a captain in the Order Police described the conditions:

"Given the great heat prevailing on those days and the strain on the Jews from the long foot marches or from waiting for days without being given any provisions worth noting, the excessively great overloading of most of the cars with 180–200 Jews was catastrophic in a way that had adverse effects on the transport."

After running out of their own ammunition, and an additional 200 borrowed bullets expended on Jews trying to escape, the report goes on to say:

". . . for the rest of the journey they (the guards) had to resort to stones while the train was moving and to fixed bayonets when the train was stopped."

At the end of the journey, the report noted that "some 2,000 Jews were found dead in the train." In other words, 25% had died before they reached the gas chambers at Belzec.

Between 1939–1941, the number of Jews living in Kolomyja grew to 60,000. Two thirds were killed in Kolomyja, one third transported to Belzec. There were 200 survivors.

* * * *

Literally thousands of "transports" rolled across Europe toward the extermination centers, the victims crammed into the cars "like sardines" suffering in the choking heat of summer and freezing cold of winter without food or water, often for days. Between the fall of 1941 and spring of 1945, the following number of trains transported Jews to their Fate:

From Germany, Austria and Czechoslovakia—260; France—76; Holland—87; Belgium—27; Greece—23; Slovakia—63; Italy—11; Bulgaria—7; Croatia—6; Poland—number unknown (3,000,000 Polish Jews perished).

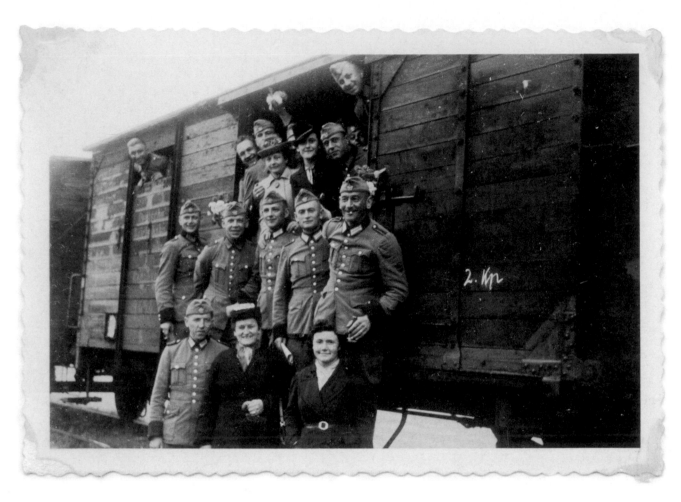

Polizei Stopover in Mauthausen

A festive group of police and civilians
take time for a photo at the train station
in Mauthausen, Austria.

Bill Aiken, a member of a U.S. Army engineering battalion, took part in the liberation of Mauthausen concentration camp on May 5, 1945. His words were recorded in 1994 by interviewer Rheba Massey for the Ft. Collins Public Library Oral History Archives.

"We didn't know about it. It was all a surprise. We had not heard anything about these concentration camps . . . We went into what's called Mauthausen. We buried (with the battalion bulldozers) 6,000 the first day we were there, 6,000 bodies. For six or seven years after the war, I could not watch a program where they were showing scenes of a prison camp because the stink, the smell would come back to me as if I were there. The burned flesh. It was only after six or seven years that I could watch one of those things. I must say this, that even at my age, which is 71, I don't know what I'd do if I ever met anybody face to face that told me it didn't happen. . . . I've seen these men that weighed 150 to 200 pounds. That's all that was left was a great big head on a 60-pound body. They were dressed most of them, either white, kind of like the southern Mexican Indians or some of them were striped and some of them were multicolored. They were so loaded with fear they were afraid of us. Those that got out and escaped, you could see them running over the countryside like wild animals. We couldn't even be nice to them. They were just as afraid of us as they had been of their German captors. I can understand it. It's terrible."

* * * *

The town of Mauthausen, located near Linz in upper Austria, became part of Greater Germany after the *Anschluss* of 1938. A concentration camp was almost immediately established for Austrian prisoners. The biggest influx of Jews took place in 1945 when thousands of Hungarians were transported there to work in the tunnels. The camp was known for its *Todesstiege* or "Staircase of Death," 164 steps that led to a granite quarry and upon which thousands would be worked to death, including captured Allied airmen. Although the large fortress-like structure was not officially an extermination camp, it did have a gas chamber and crematoria and recorded 36,318 executions during its six and a half "years of operation" and duly noted in the camp's *Totenbuch* or "death book." Thousands more would die in its tunnels from hunger, disease, injury and brutality. For relaxation, the guards built themselves a spacious swimming pool.

Unidentified Fort

One of many fortifications captured by German forces across Western and Eastern Europe.

On October 29, 1941, the Germans orchestrated one of several executions at a Lithuanian fortification known as the Ninth Fort. They and their Lithuanian volunteers shot 10,000 Jews taken from the Kovno Ghetto. A witness, Dr. Elchanan Elkes, the Jewish Council Chairman of the ghetto, wrote a letter that survived, although he did not.

". . . I am the man who, with my own eyes, saw those about to die. I was there early on the morning of October 29, in the camp that led to the slaughter at the Ninth Fort. With my own ears I heard the awe-inspiring and terrible symphony, the weeping and screaming of ten thousand people, old and young—a scream that tore at the heart of heaven."

Describing the executions, he wrote, "The Germans killed, slaughtered, and murdered us in complete equanimity. I was there with them. I saw them when they sent thousands of people—men, women, children, infants—to their death, while enjoying their breakfast, and while mocking our martyrs. I saw them—dirty, stained from head to foot with the blood of our dear ones. There they sat at their table—eating and drinking, listening to light music. They are professional killers."

Responsibility for making Lithuania *Judenfrei* was placed upon the competent shoulders of the Security Police *Einsatzcommando 3*. Its commander, SS Colonel Karl Jager, reported 137,346 Jews liquidated by "pogrom and execution." The work required 117 separate *Aktions* by his men.

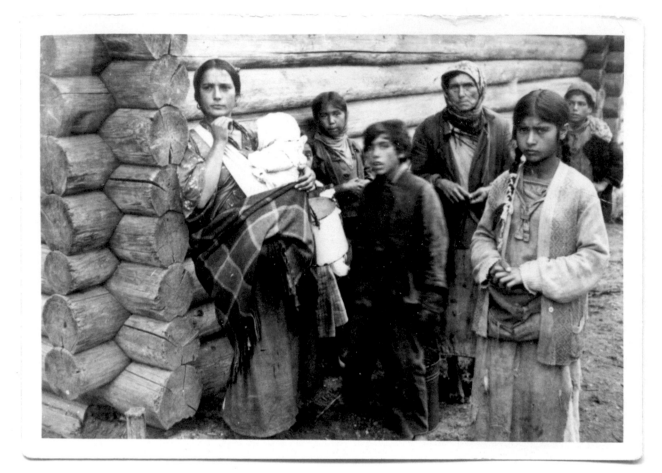

"Z"

German soldiers enjoyed taking photos of the local populations they encountered, particularly the "exotics" like the Roma and Sinti people. The Gypsies were designated as an "asocial" group and marked for eradication by the Third Reich. When sent to concentration camps they were often tattooed with numbers beginning with the letter "Z" for *Ziegeuner*, Gypsy.

Porraimos

The Romani word for the German mass murder of the Gypsy peoples is *Porraimos*, which translates to "The Devouring."

It began for the Gypsies when in November, 1933, the Third Reich announced the "Regulations for the Security and Reform of Habitual Criminals and Social Deviants." Under this law, Sinti and Roma people were considered "asocial," a threat to Germany and subject to sterilization.

German "racial scientists" conducted pseudo-scientific racial-biological research on thousands of Gypsies. Dr. Robert Ritter and his assistant, Eva Justin, gathered some 30,000 genealogies. Justin would pose as a missionary to gain information about Gypsies still living free. She went on to recommend sterilization for full and part-Gypsies. After her undercover interviews, many of her subjects disappeared into concentration camps.

Both Ritter and Justin were "de-Nazified" after the war and in February, 1964, Justin was acquitted of any wrongdoing by a Frankfort court.

In Auschwitz-Birkenau, the Germans prepared a special gypsy camp or *Ziegeunerlager* consisting of thirty-eight barracks. In the months of February through August, some 21,000 were gassed.

Dr. Josef Mengele, the infamous Auschwitz "Angel of Death," had a passionate curiosity about the Gypsies and was distressed that his research was disrupted when their mass liquidation was ordered. Because he often gave the Gypsy children candy, they would chase after him calling him "Uncle Pepi." As a result, they eagerly climbed into his personal car, unaware that he was ferreting out the last of the Gypsy children in order to drive them directly to the gas chambers.

In post-war trials, Germans successfully defended themselves by declaring that Gypsies were killed as punishment for being criminals. It seems only one person, an Ernst August-König, was convicted for crimes against the Gypsies. In September, 1991, after being sentenced to life, the 71-year-old former Auschwitz guard hanged himself in his jail cell.

Estimates of Gypsy deaths under the Germans range from 200,000–500,000.

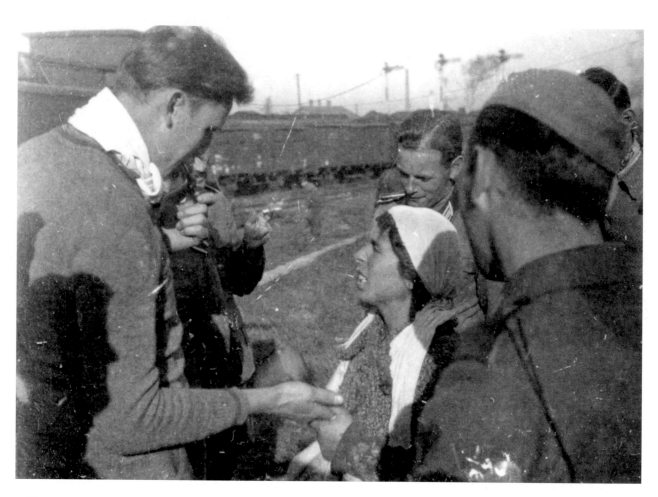

Fortunes of War

A Gypsy woman holds a German soldier's hand as he puffs on his pipe. Perhaps she has read his palm and divined his future . . . or her own. Her expression seems one of desperation. Not far from her loom the cattle cars intended for an unknown destination.

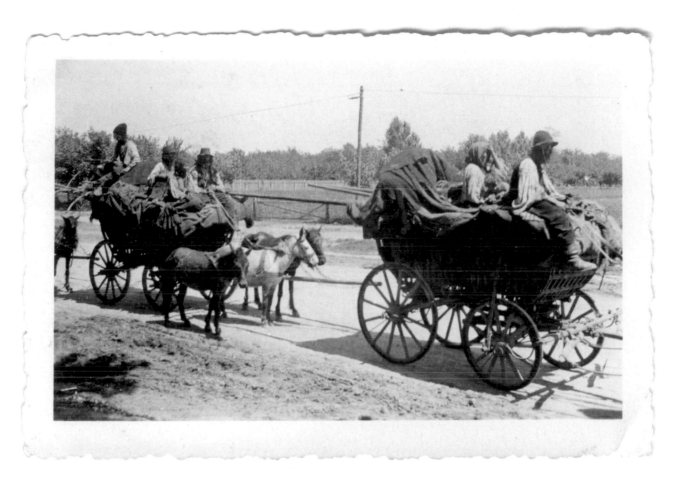

Wagon Train

Donkeys are dwarfed by the wagons
they pull, mobile homes for hundreds of
thousands of Gypsies as they traveled all
over Europe, a lifestyle the Third Reich
chose to end.

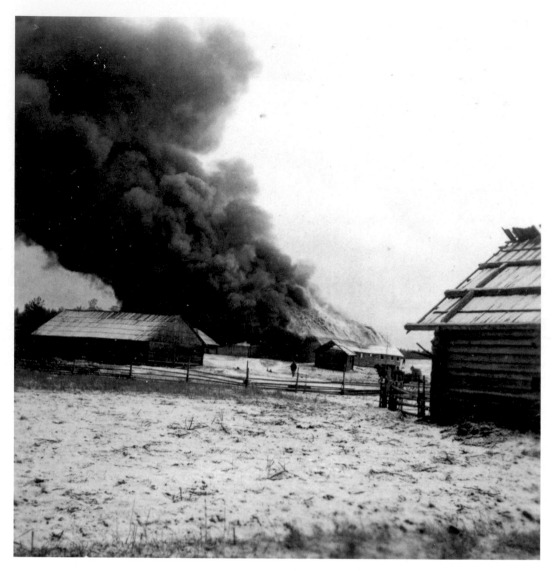

Burning Barn

Members of Police Regiment 9 put the torch to a Russian barn, perhaps a reprisal for aiding partisans, perhaps part of the scorched earth policy in retreat or perhaps to burn Jews, a frequently employed means of killing large numbers caught in villages across Eastern Europe and Russia.

One barn-burning of Jews did not require the outright participation of Germans. The case involves the Polish town of Jedwabne where, on July 10, 1941, its non-Jewish inhabitants rose up with club, knife, hatchet, pitchfork, hook and rock, and finally flame, to torture and murder its 1,600 Jewish neighbors, the horrific story chronicled in the prize-winning book *Neighbors* written by Jan T. Gross. Published in Polish and English, it created a firestorm of controversy within Poland by bringing to light Polish anti-Semitism and the fate of the country's Jews before, during and after WWII.

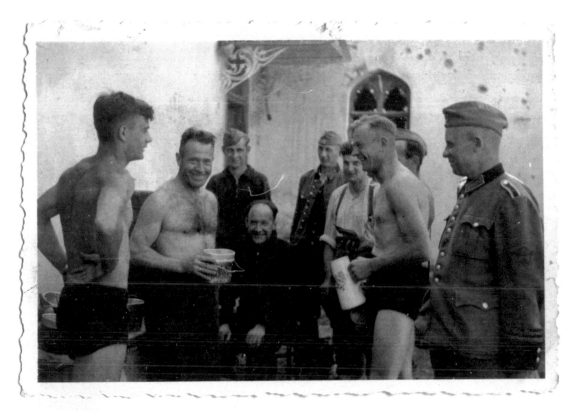

Stress Relief

This rare photo of members of a documented killing team, Police Battalion 322, finds them enjoying a break from their duties. A bullet-pocked wall can be seen behind them. The time is summer in Ukraine, a time for bathing suits and extra schnapps after a day of special actions shooting Jews. Between July, 1941 and July, 1942, these Germans would conduct a murderous campaign from Bialystock in Poland to Smolensk in Russia, leaving an estimated 39,000 corpses in their wake . . . men, women, children, infants.

Often, after a day of non-stop killing, the members of PB322 would gather round to sing songs, swap stories, perhaps a poetry reading, all part of what was described as a *Gemütliches Beisammensein* or a "cozy get-together" recommended by the Higher Command and designed to relieve the stress of their labors for Germany. However, the "work" was voluntary and any individual could opt for other duties away from the killing pits. Records indicate no one was ever punished for refusing to participate in the murders. Records also indicate there were often too many volunteers.

On occasion, the horror of the mass killings provoked strong reaction from members of the regular *Wehrmacht* who decried such acts as "un-German." On most other occasions, the High Command of the *Wehrmacht* either turned a blind eye or provided troops to assist in the killing. The myth of an "honorable regular army" is just that, a self-perpetuated myth. The cuffband on the soldier in the foreground reads "*Deutsche Wehrmacht*" while the distinctive design on his upper sleeve identifies him as member of the Police Battalions.

DIT WEZE U EEN VOLZALIG AANDENKEN VAN DE GEBROEDERS

Mr JAN - FRANS PAEPEN

Lid der Weerstandsbeweging A S. G L. Mol, geboren te Mol den 7 Januari 1917 en, uitgeput door ontbering, laffelijk neergeschoten te Dachau in Duitschland, op 14 April 1945.

Mr BENEDICTUS PAEPEN

Lid der Weerstandsbeweging A.S./G L Mol, geboren te Mol den 4 Januari 1924 en, uitgeput door ontbering, laffelijk neergeschoten te Flossenburg in Duitschland, op 19 April 1945.

Last Minute Murders

This "death card," sent out to relatives and friends, tells us that two brothers, both members of the Belgian resistance, were executed during the very last days of the war. Jan Frans Paepen, 28, was shot at Dachau in Germany on April 14, 1945. His brother, Benedictus Paepen, 31, was shot five days later on April 19 at Flossenburg concentration camp. The Third Reich surrendered on May 8.

A portion of the inscription reads: "O Lord, what a heartbreaking pain came upon us, my both brave sons, our good Brothers, our Frans and our Benedictus, they are no longer . . . They have fallen, as so many, as victims to the sad violence of war, by the bullets of the terrible German invader who crushed both their young lives . . . O what a terrible destiny of death." A deeply moved father and five brothers and sisters cry out.

"What a terrible 21 July morning 1944 when the brothers were without mercy taken away by the oppressor, without mercy kidnapped to an unknown place and never returning. A long nine months have left this peaceful house filled with pain and fear. The war went by, peace came, and nevertheless the boys did not come home. O what a painful feeling, what a torture because of their absence, until a certain day when the sad confirmation came to father . . . 'Your boys are no longer . . . Exhausted by the suffering and abuse of the heartless enemy, they were shot.' They have both died, by a torturous death, but for a good cause, they have fallen for Citizens and Nation. Although the oppressors took their bodies, their souls remain in eternal peace."

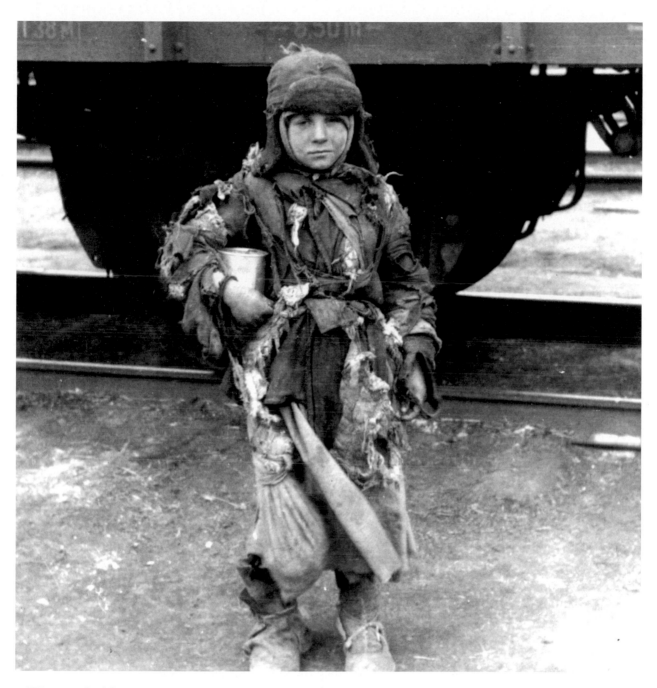

Waiting for Transport

A child wearing carefully knotted rags and holding a tin of precious food stands before a cattle car. A handwritten notation on the reverse of the photo, taken by an unknown German soldier, tells us the child was staring into the camera sometime in August, 1942, well into the mass extermination period when trains from all over Europe and Russia rolled toward the death camps. Prior to Germany's invasion of Poland in 1939, approximately 1.6 million Jewish children lived in the areas that would eventually come under Nazi domination. By the end of the war 1,500,000 had died. Of that toll, death trains had transported 216,000 children to Auschwitz. Four hundred and fifty-one survived to be liberated.

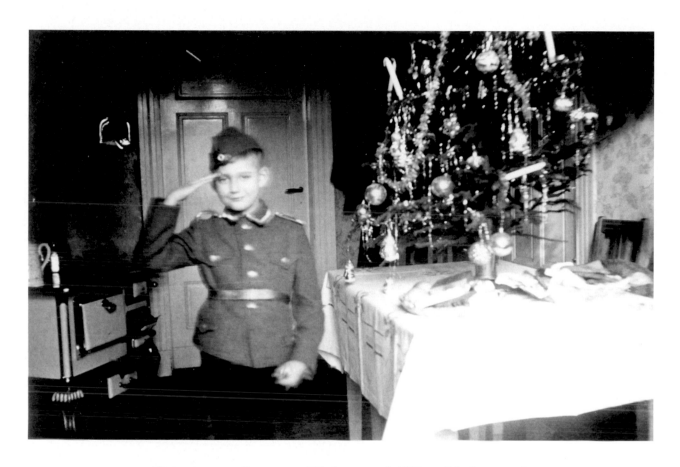

Postscript: Lessons Unlearned, Wars Unlimited

"The full impact of the Third Reich can be measured by the ways in which habits of thought remained intact long after its outward symbols and structures had been eliminated."
— Nicholas Stargardt,
Witnesses of War: Children's Lives Under the Nazis

Selected Bibliography

Ailsby, Christopher, *A Collector's Guide to World War 2 German Medals and Political Awards*, Ian Allan Publishing, Hersham, England, 1994.

Ailsby, Christopher, *The Third Reich Day by Day*, Zenith Press 2005.

Berenbaum, Michael, *Witness to the Holocaust*, HarperCollins, New York, 1997.

Barnow, Dagmar, *The War in the Empty Air: Victims, Perpetrators, and Postwar Germans*, Indiana University Press, Bloomington, IN, 2005.

Barr, William, ed., *War North of 80: The Last German Arctic Weather Station of World War II*, University of Calgary Press, 2003.

Baxter, Ian, *SS: The Secret Archives—Eastern Front, Amber Books*, London, England, 2003.

Bergschicker, Heinz, *Der Zweite Weltkrieg*, Deutsche Militarverlag, Berlin, DDR.

Bessel, Richard, *Nazism and War*, Modern Library, New York, 2006.

Bethell, Nicolas, *Russia Besieged*, Time Life Books, New York, NY 1977.

Bleul, Hans Peter, *Sex and Society in Nazi Germany*, J.B. Lippincott Co., Philadelphia and New York, 1973.

Breyer, Siegfried, *The German Battleship Scharnhorst*, Schiffer Military History, Atglen, PA, 1990.

Browning, Christopher R., *Collected Memories: Holocaust History and Postwar Testimony*, The University of Wisconsin Press, 2004.

Browning, Christopher R., *Ordinary Men: Reserve Police Battalion 101 and the Final Solution in Poland*, HarperCollins Publishers, New York, NY 1992.

Carrel, Paul, *Hitler Moves East 1941–1942*, Little, Brown and Co., New York, NY, 1965

Conot, Robert E., *Justice at Nuremberg*, Carroll & Graf, New York, NY, 1983.

Davis, Brian L., *Badges and Insignia of the Third Reich 1933–1945*, The Cassell Group, Wellington, England, 1983.

De Bruhl, Marshall, *Firestorm: Allied Airpower and the Destruction of Dresden*, Random House, New York, 2006.

Dupuy, Col. R. Ernest and Bregstein, Lt. Col. Herbert L., *Soldier's Album*, Houghton Miflin, Boston, MA 1946.

Doyle, David, *Standard Catalog of German Military Vehicles*, KP Books, Iola, WI, 2005.

Fonseca, Isabel, *Bury Me Standing: The Gypsies and Their Journey*, Vintage Books, New York 1996.

Geddes, Giorgio, *Nichivo: Life, Love and Death on the Russian Front*, Cassell & Co., London, UK, 2001.

Gilbert, Martin, *The Holocaust-Maps and Photographs*, Hill and Wang, New York, 1978.

Glantz, David et al, *Slaughterhouse: Encyclopedia of the Eastern Front*, The Military Book Club, Garden City, NY 2002.

Goldhagen, Daniel Jonah, *Hitler's Willing Executioners: Ordinary German and the Holocaust*, First Vintage Books, New York, NY, 1997.

Grossjohann, Georg, *Five Years, Four Fronts: The War Years of Georg Grossjohann*, Major, German Army (Retired), Aegis Consulting Group, Bedford, PA 1999.

Grossman, Mendel and Smith, Frank Dabba, *My Secret Camera, Life in the Lodz Ghetto*, Harcourt, Inc., New York, 2000.

Gruge, Frank and Richter, Gerhard, *Alltag im Dritten Reich: So Lebten die Deutschen 1933–1945*, Hoffman und Campe, Bonn, Germany 1981.

Hamburg Institute for Social Research, *The German Army and Genocide: Crimes Against War Prisoners, Jews, and Other Civilians, 1939–44*, The New Press, New York, NY 1999.

Hatheway, Jay, In Perfect Formation, SS Ideology and the SS-Junkerschule-Tolz, Schiffer Military History, Atglen, PA, 1999.

Haupt, Werner, *Army Group South: The Wehrmaht in Russia 1941–1945*, Schiffer Military History, Atglen, PA, 1998.

Hayden, Mark, *German Military Chaplains in World War II*, Schiffer Military History, Atglen, PA, 2005.

Hellman, Peter and Meier, Lili, *The Auschwitz Album*, Random House, New York 1981.

Hilberg, Raul, *Perpetrators, Victims, Bystanders: The Jewish Catastrophe 1933–45*, HarperCollins, New York, NY, 1992.

Hinrichsen, Horst, *German Military Motorcycles of the Reichswehr and the Wehrmacht 1934–45*, Schiffer Military History, Atglen, PA, 1997.

Hogg, Ivan V., *The Guns 1939–45*, Ballantine Books, New York, NY, 1970.

Hunt, Robert and Hartman Tom, *Swastika at War*, Doubleday & Co., Garden City, NY, 1975.

Jackson, Julian, *The Fall of France: The Nazi Invasion of 1940*, Oxford University Press, Oxford, NY, 2003.

Johnson, Eric A. and Reuband, Karl-Heinz, *What We Knew: Terror, Mass Murder, and Everyday Life in Nazi Germany: An Oral History*, Basic Books, 2005

Karpov, Vladimir, *Russia at War 1941–45*, The Vendome Press, New York, NY 1987.

Knappe, Siegfried and Brusaw, Ted, *Soldat: Reflections of a German Soldier 1936–49*, Orion Books, New York, NY, 1992.

Krawczyk, Wade, *German Army Uniforms of World War II in Color Photographs*, Motorbooks International, Osceola, WI1996.

Kurowski, Franz, *Knight's Cross Holders of the Fallschirmjäger*, Schiffer Military/Aviation History, Atglen, PA, 1995.

Littman, Sol, *Pure Soldiers or Sinister Legion, The Ukrainian 14th Wafffen-SS Division*, Black Rose Books, New York, NY, 2003.

Littlejohn, David, *Foreign Legions of the Third Reich*, Vol. 2, 3, 4, R. James Bender Publishing, San Jose, CA, 1985.

Lukas, Richard C, *Did the Children Cry: Hitler's War Against Jewish and Polish Children 1939–45*, Hippocrene Books, New York, 1994.

Lumsden, Robin, *A Collectors Guide to: The Allgemeine SS*, Ian Allen Publishing, Hersham, England, 1992.

Markham, George, *Guns of the Third Reich: Firearms of the German Forces, 1939–1945*, Arms and Armour Press, London, England, 1989.

McCombs, Don and Worth, Fred L., *World War II: 4,139 Strange and Fascinating Facts*, Wings Books, New York, 1983.

Michaelis, Rolf, *German War Decorations 1939–1945: Army-Waffen-SS-Police*, Michaelis-Verlgan, Berlin, Germany, 2003.

Moczarski, Kazimierz, *Conversations with an Executioner*, Prenctice Hall, Engelwood, NJ, 1977.

Mollo, *A Pictorial History of the SS 1923–45*, Stein & Day, New York, NY 1977.

Munoz, Antonio J., *Hitler's Green Army: The German Order Police and their European Auxiliaries 1933–45*, Europa Books, Inc., Bayside, NY.

Munoz, Antonio J., *Generalgouvernement: Internal Security of the Eastern Occupied Polish Territories 1939–45*, Europa Books, Inc., Bayside, NY.

Nicholas, Lynn H., *Cruel World: The Children of Europe in the Nazi Web*, Vintage Books, New York, NY 2005.

Overy, Richard, *Interrogations: The Nazi Elite in Allied Hands, 1945*, Penguin Books, New York, NY, 2001.

Poliakov, Leon, *Harvest of Hate: The Nazi Program for the Destruction of the Jews of Europe*, Holocaust Library, New York, NY, 1979.

Peukert, Detlev J.K., *Inside Nazi Germany: Conformity, Opposition, and Racism in Everyday Life*, Yale University Press, London and New Haven, 1987.

Rees, Laurence, *War of the Century: When Hitler Fought Stalin*, The New Press, New York, NY, 1999.

Richter, Klaus Christian, *Cavalry of the Wehrmacht 1941–1945*, Schiffer Military History, Atglen, PA, 1995.

Rikmenspoel, Marc J., *Waffen-SS The Encyclopedia*, The Military Book Club, Garden City, New York, 2002.

Rhodes, Richard, *Masters of Death: The SS-Einsatzgruppen and the Invention of the Holocaust*, Vintage Books, New York, 2003.

Segev, Tom, *Soldiers of Evil: The Commandants of the Nazi Concentration Camps*, Domino Press, McGraw-Hill Book Co., New York, 1987.

Snyder, Louis L., *Encyclopedia of the Third Reich*, Wordsworth Military Library, Cumberland House, UK, 1998.

Speer, Albert, *Inside the Third Reich*, Avon, New York, NY, 1970.

Thomas, Nigel, *The German Army 1939–45 (1): Blitzkrieg*, Osprey Publishing, Elms Court, UK, 1997.

Thomas, Nigel, *The German Army 1939–45 (4): Eastern Front 1943–45*, Osprey Publishing, Elms Court, UK, 1999.

Volakova, Hana (Editor), *Children's Drawings and Poems: Terezin 1942–1944*, McGraw-Hill Co., New York, 1962

Weber, Louis, *The Holocaust Chronicle*, Publications International, Lincolnwood, IL, 2001.

Westermann, Edward B., *Hitler's Police Battalions: Enforcing Racial War in the East*, University of Kansas Press, Lawrence Kansas, 2005.

Williamson, Gordon, *German Army Elite Units 1939–45*, Osprey Publishing, Elms Court, UK, 1999.

Wistrich, Robert, *Who's Who in Nazi Germany*, Bonanza Books, New York, 1982.

Archival Films:

Die Deutsche Wochenschau—original German newsreels—various segments 1939–1944

Selected additional Materials:

German Military Abbreviations: Reprint of *Military Intelligence Service*—War Department, April 12, 1943—Service Publications

Germany: Handbook for British soldiers entering post-war Germany—published November 1944.

Original documents: Police Battalion 322/Logbook for Georg Heinkel

Selected Internet Sources:

Axis collaborators: http://www.axishistory.com/index.php?id=62

Bulgarian Jews and WWII: www.b-info.com/places/Bulgaria/Jewish/symposiumFeb95.shtml

Police Battalion 322: http://www.skalman.nu/third-reich/polis-sspol-reg-5.htm

German Propaganda: http://www.calvin.edu/academic/cas/gpa/ww2era.htm

Wolf's Lair: http://www.dw-world.de/dw/article/0,2144,943998,00.html

France Preseren: http://www.preseren.net/ang/1_uvod.asp

SD: www.apawn.com

Additional Research:

Simon Wiesenthal Center Museum of Tolerance—Los Angeles, CA

United States Holocaust Memorial Museum—Washington, D.C.